CONEY ISLAND

Coney Island is classic vanishing America
that's somehow ceased to vanish.
—Diablo Cody

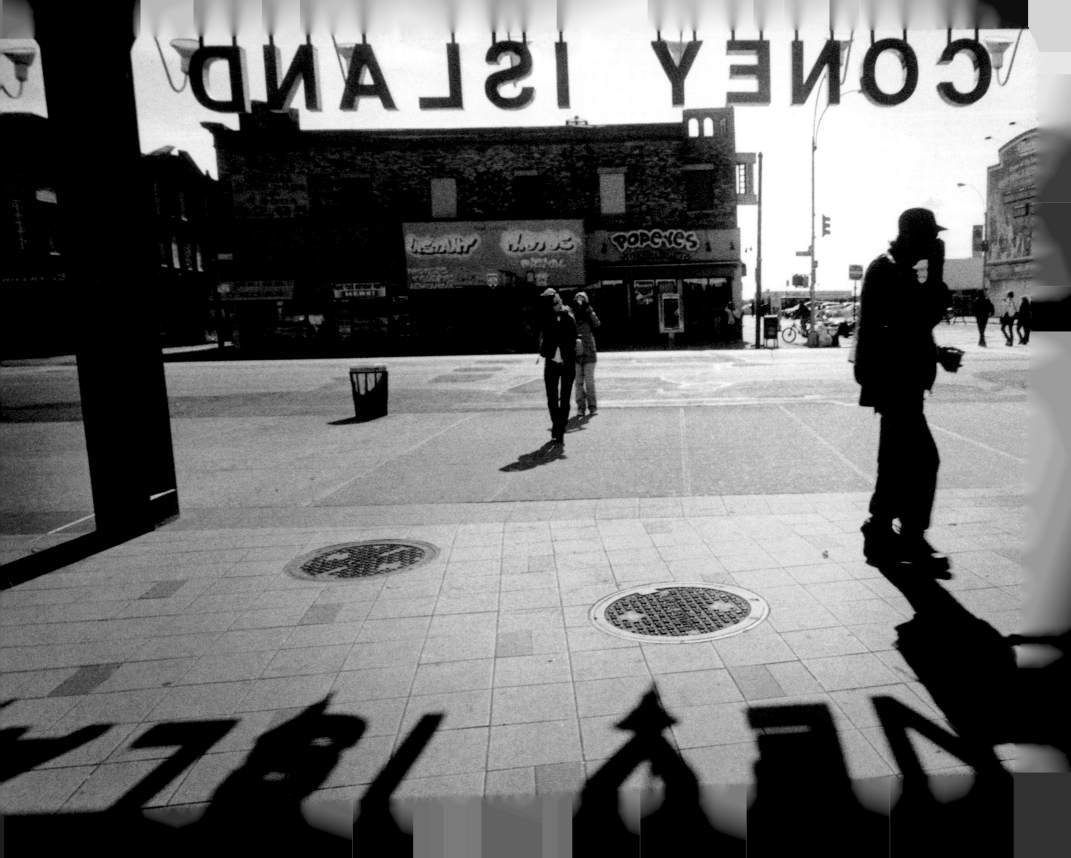

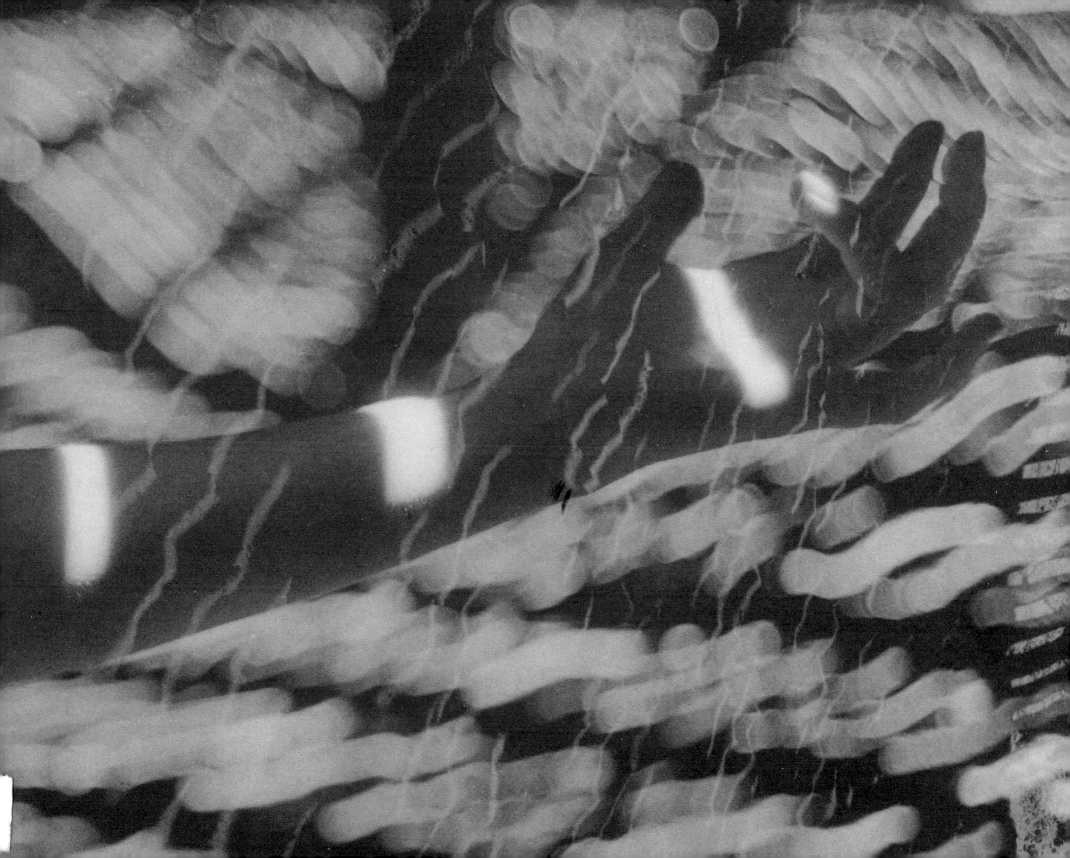

HARVEY STEIN

CONEY ISLAND

40 YEARS

1970-2010

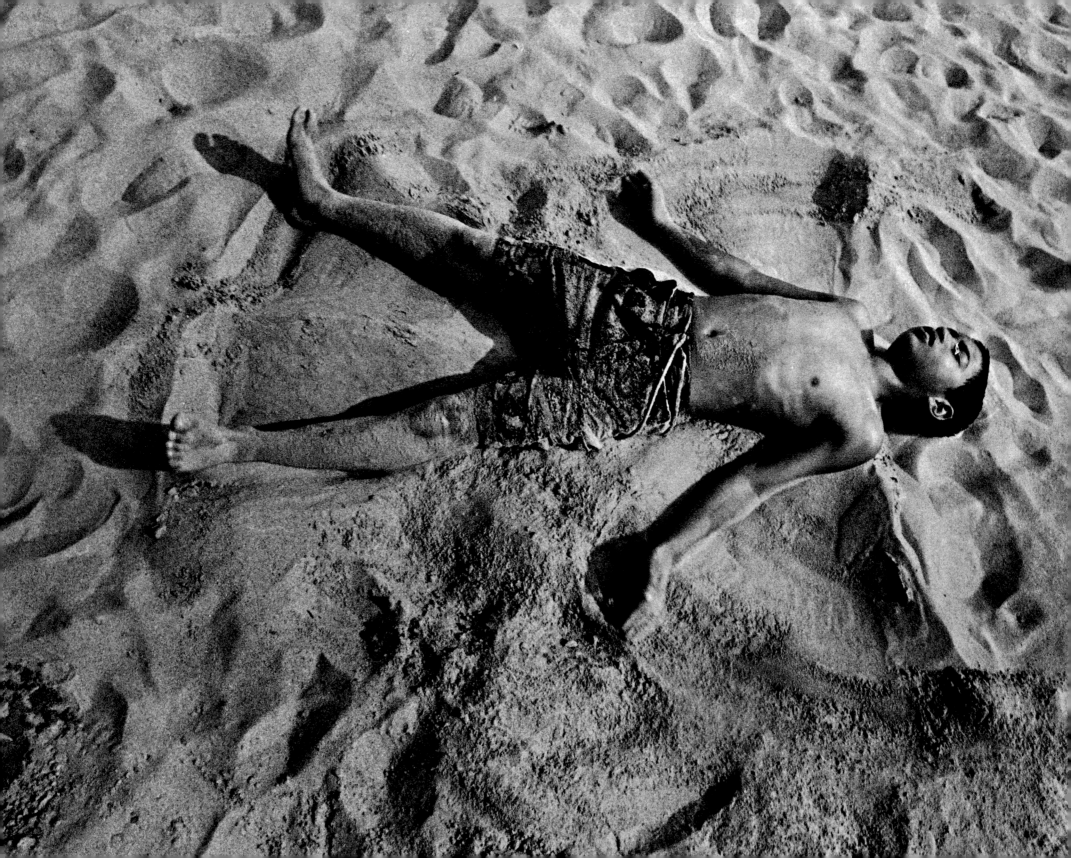

CONTENTS

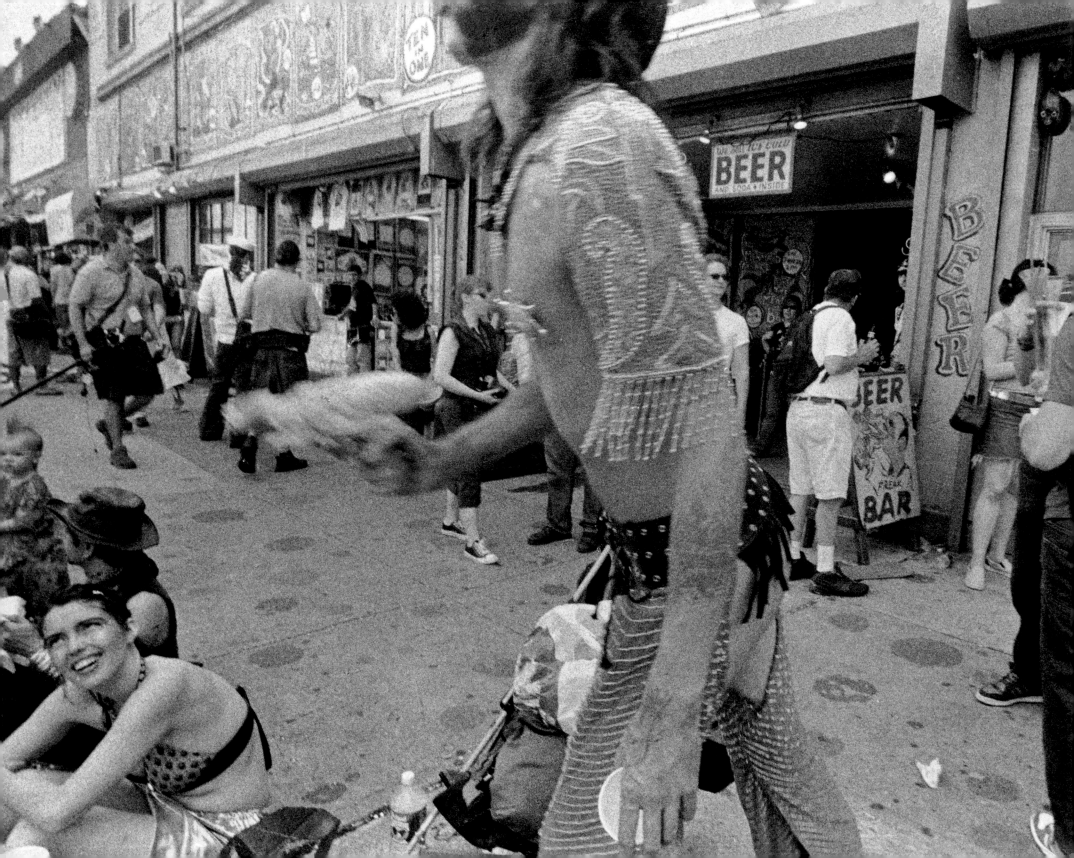

BETWEEN DREAM AND REALITY

HARVEY STEIN

For me, Coney Island has been there from the beginning. I discovered it and photography at the same time, in 1970. My first photography teacher, the wonderful and crazy Ben Fernandez, instructed me to get a Leica, use a 21 mm lens, and go to Coney Island. Being the dutiful student that I was, I complied. And obviously I have kept doing so. The earliest photographs in this book were taken in 1970 and I'm still photographing there in 2010, after 40 years.

The paradox of photography is that while it is not very difficult to do (especially with digital point-and-shoot and cell phone cameras), the more you do it, the harder it gets. As you progress, you want and expect more, you strive to improve and make stronger and stronger images. You progress and begin to understand what makes a photograph successful; the quest for the "magical" instant eternally frozen in time becomes an elusive and mostly unattainable goal.

My first Coney Island book was published in 1998, the result of a 27-year shooting adventure. But I continue to return; you would think 27 years is enough. Yet Coney constantly beckons, and I am unable to purge myself of it, it's like a catchy tune that keeps playing and replaying in my mind. Why do I keep going back to Coney Island? What constantly attracts me? Why do I always think about it? Why this compulsion to photograph there, even after I've done so more than

400 times in the last four decades? Perhaps because Coney Island is in my mind, heart, and soul. It's haunting and beguiling, ever changing and yet, at its core, the same.

Being in Coney Island is like stepping into a culture, rather than just experiencing a day's entertainment. There is a sense of excitement, adventure, the thrill and escape from daily worries, and much pleasure, whether riding the jarring Cyclone roller coaster, walking the boardwalk, appreciating the catch on the pier, viewing the mind-bending Mermaid Parade, or just sunbathing on the beach. Coney Island is an American icon celebrated worldwide, a fantasy land of the past with a seedy present and an irrepressible optimism about its future. It is a democratic entertainment where people of all walks of life and places are brought together in peace and harmony, despite the newly growing crowds. There isn't anywhere else like it and that is much of its attraction.

Photography and Coney Island are never boring. They are always challenging and enduring in one way or another, both ever engage me, keep me alert, alive, and sane, always looking, seeing, perceiving my surroundings and my fellow man. Without them, I would be so much less. With them I am much richer, kinder, and knowledgeable about the world and myself. What more can be asked?

If Paris is France, Coney Island, between June and September, is the world.
—George Tilyou

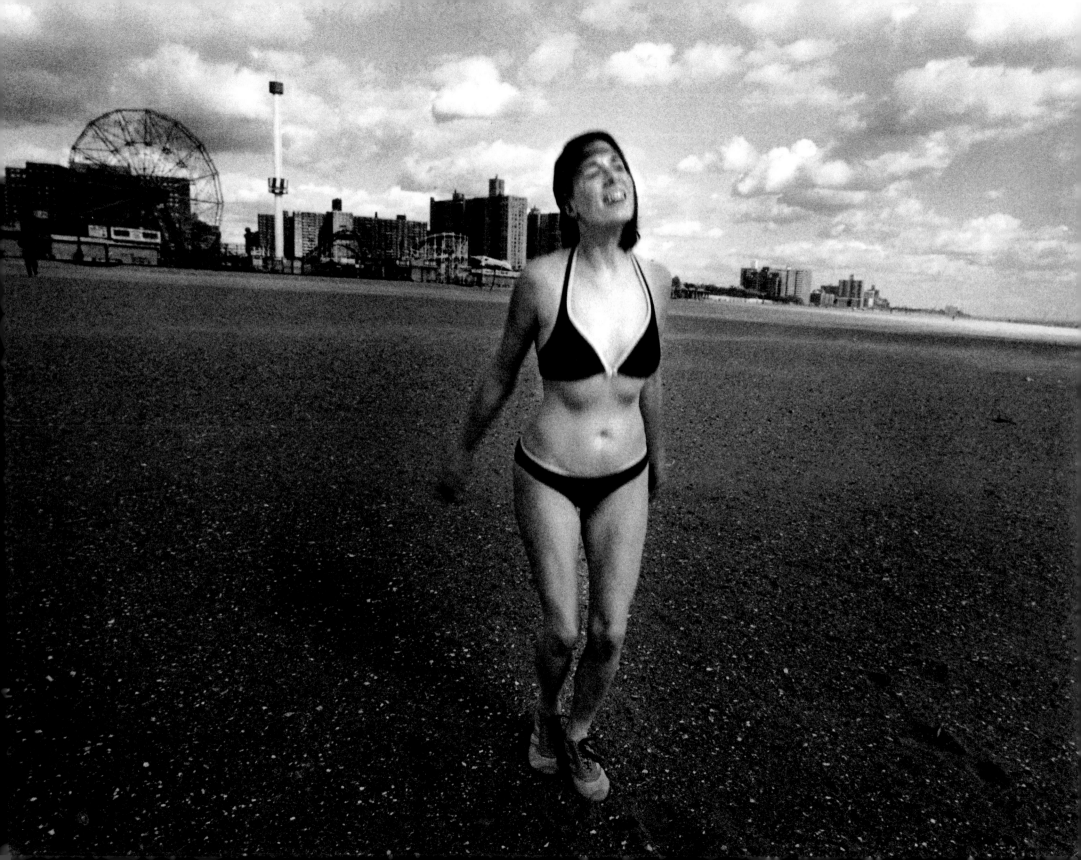

THE ETERNAL RETURN OF THE END OF CONEY ISLAND

LOLA STAR

I stepped out onto the street, carefully missing the rainbow pool of oil that had gathered on rainy Surf Avenue. Hurriedly navigating the skinny heel of my pink party shoes on the uneven pavement with dexterity, I raced down the street. The film was to begin in thirteen minutes and the autumn rain was cold and ruining my curls. Rushing across the pavement I heard it and suddenly stopped. It was the mysterious howling sound. I stood still and listened. It was the first time I had heard the sound for many months. I breathed it in like the first crisp breath of winter.

There are many myths about what causes this strange sound. Some believe it is screams from delightfully terrified Cyclone roller coaster riders from past summers echoing in the air. Some believe it is the ghost of Coney Island. The truth is that this enigmatic sound is created by the frigid winds whipping through the gears and steel of the iconic Astrotower and other abandoned amusement park rides, rides that hibernate during the dormant cold months, shrouded in tarps and duct tape.

Coney Island has closed for the winter. The abandoned looking amusement parks in the stillness are a dramatic contrast to the loud, crowded, technicolored, summer months in Coney Island. On hot summer days and nights the boardwalk is packed with people of every ethnic and economic background commingling beneath the carnival lights. Those days prove that although Coney Island has gone through many changes, it remains the "People's Playground."

I hurried up to the boardwalk in the cold autumn rain past the glowing neon yellow lights, which appeared to sparkle in the raindrops on the windows of the most famous hotdog holy land in the world. Today Nathan's Famous is a renowned hotdog culinary empire but it began with the dreams and innovation of Nathan Handwerker. He is just one of a long genealogy of visionary Coney Island entrepreneurs that have created unique empires here.

Navigating the rickety boardwalk in heels is a challenge. Any woman who has ever tried can relate to the tremendous focus required to not get one's heel stuck in the cracks between the boards. As I tried to focus on my steps, I couldn't help but become distracted and slightly disconcerted by a figure approaching on the deserted boardwalk. In front of the brightly spray-painted banner which reads "Shoot the Freak," I was relieved to recognize the familiar shape of Takeshi and his ever present walking companion, Sea Rabbit. Takeshi Yamada, wearing his usual suit and holding a purple umbrella in one hand and Sea Rabbit (half rabbit, half sea creature) in the other, is an expert taxidermy artist who resides in Coney Island and exhibits his mythical creations in a colorful makeshift tent on the Bowery.

Takeshi had been helping Captain Bob create realistic fish fins out of dried vegetables and seashells. Captain Bob is in the business of retelling his own invented Coney Island mythology on his walking tours of the area. He lives and has his quirky artist studio in the back of the bright yellow Grill House adorned with kitschy plastic flowers and hand painted corn on the cob, ice cream cones, and mermaids. Although it was only the beginning of November, he was already hard at work on the elaborate costume he was painstakingly crafting for the Mermaid Parade next June.

The fabulous spectacle of the Mermaid Parade takes place each year in Coney Island on the first Saturday of summer. It is a party beyond your wildest dreams. Coney Island is packed with brightly colored, half naked, feathered and glitter adorned mermaids and every other variation of exotic sea creature!

Apparently this year Captain Bob will be cheering them on while wearing an exquisite amphibious King Neptune costume hand crafted out of taxidermy remains and brightly colored fabric and glitter.

Takeshi scolded me for walking on the boardwalk alone at night and escorted me the rest of the way to the film festival while telling me about his newest taxidermy creation, The Fiji Mermaid!

We hurried down the dark, rainy street, past the boarded up Spook House, Polar Express, and dormant games along the Bowery.

The window of the Sideshow by the Seashore glowed in the vacant streetscape. It was fogged with breath from its full house of guests packed for the opening of the Coney Island Film Festival. The crowds of people, music, burlesque dancing, and boisterous partying inside are a dramatic contrast to the dark, rainy, vacant street.

Once again Coney Island is on the cusp of transformation. It has gone through many changes throughout its illustrious history but its vibrant, creative, diverse spirit has always remained strong. Coney Island continues to entertain and provoke visitors by challenging their social boundaries and perceptions of reality.

History has proven that flames cannot consume the spirit of Coney Island and corruption cannot crush it! The annual end of Coney Island continues, but it lives on. With the dark and mysterious rides closed for the winter amplified by this ominous and mysterious sound, Coney Island has persisted. The crowd marvels at the wonder of the amusement park that refuses to die, an ephemeral and ever changing miracle that might never have existed at all.

Long Live Coney Island! May it return, again and again, after each and every last summer....forever.

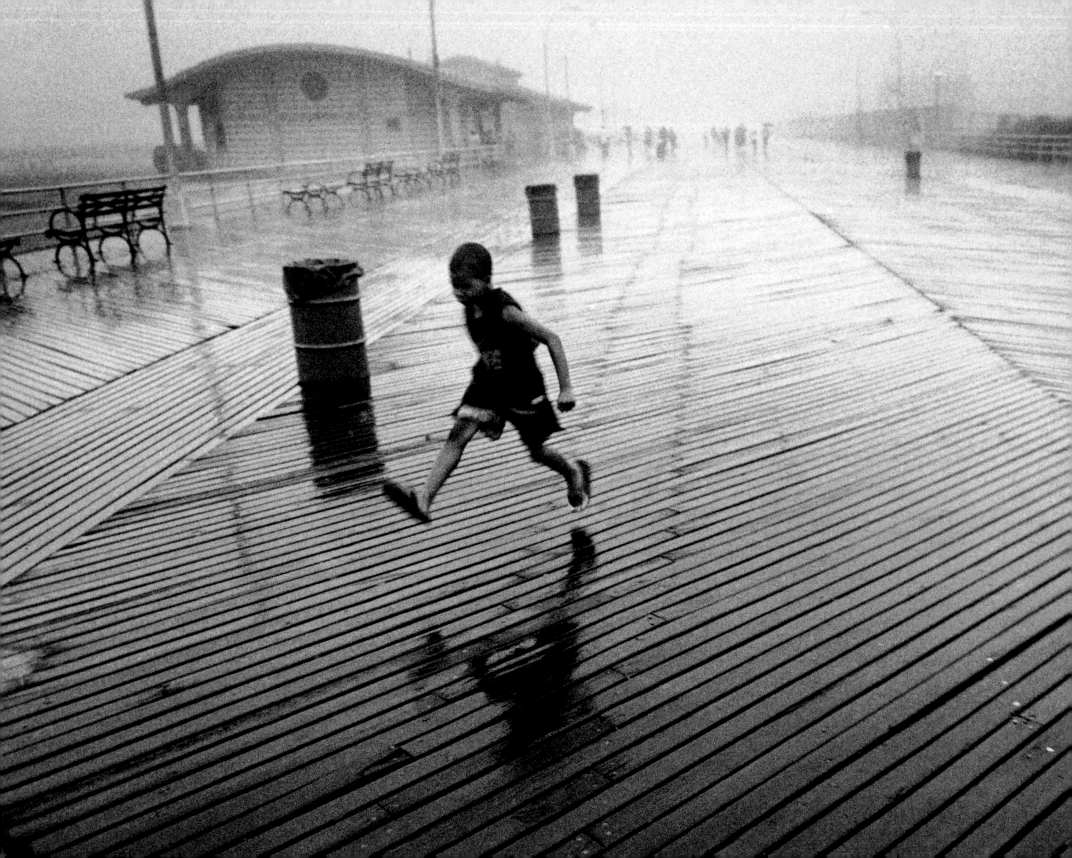

THE BOARDWALK

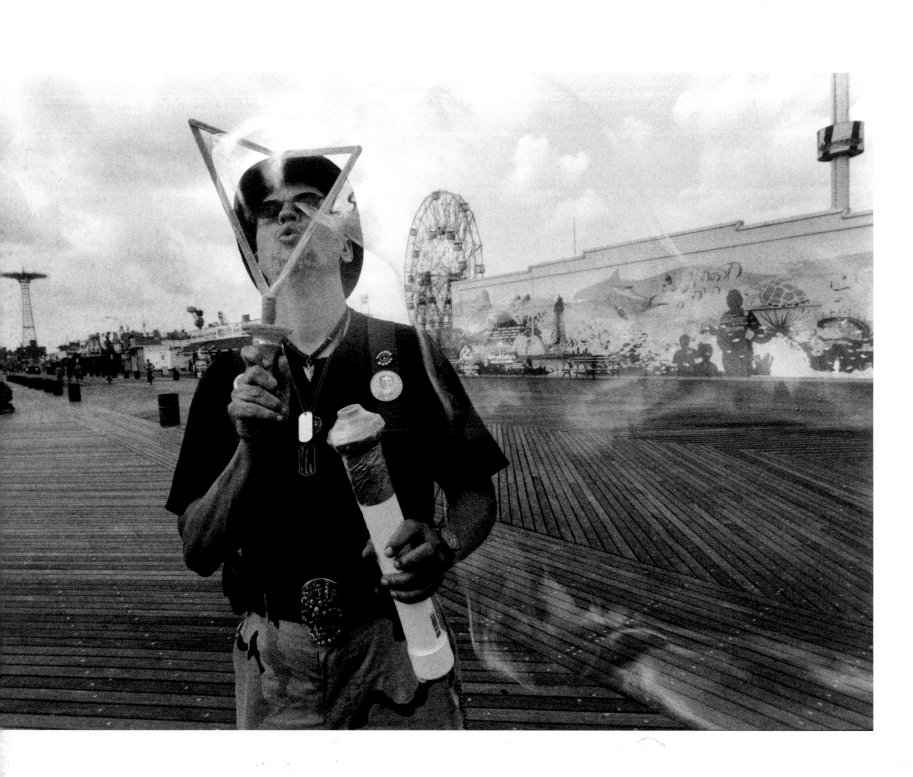

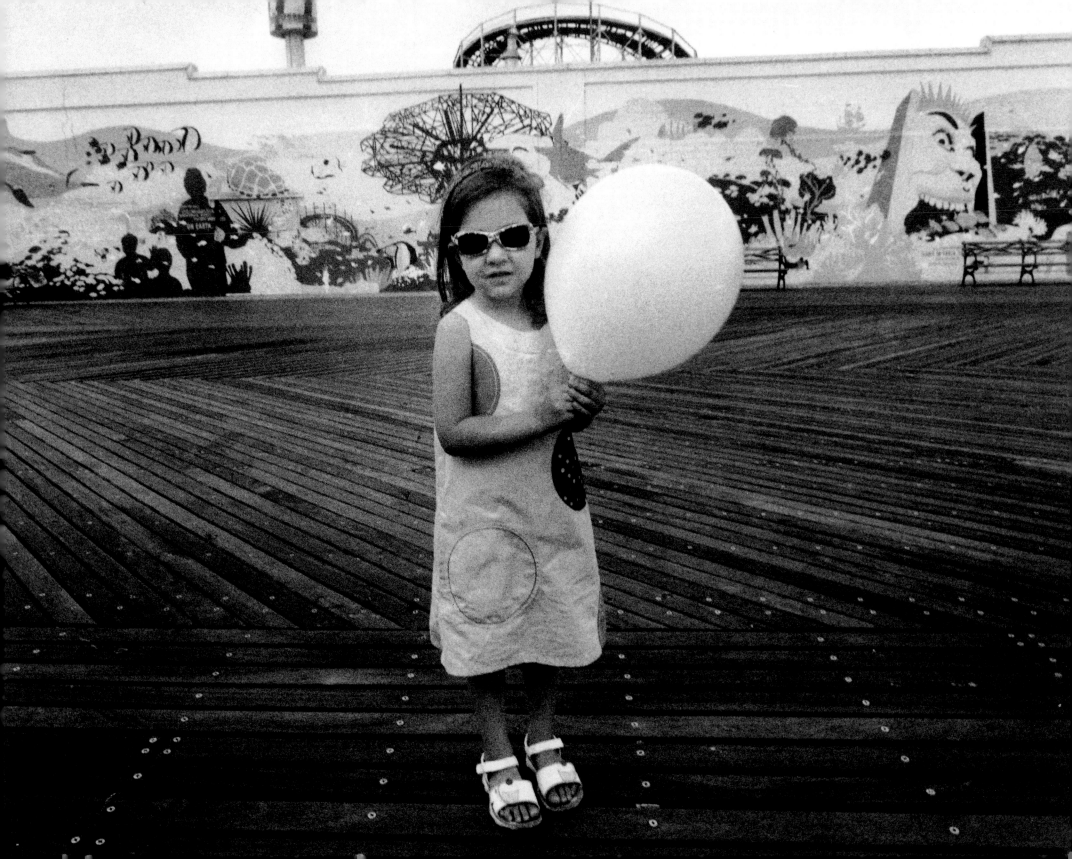

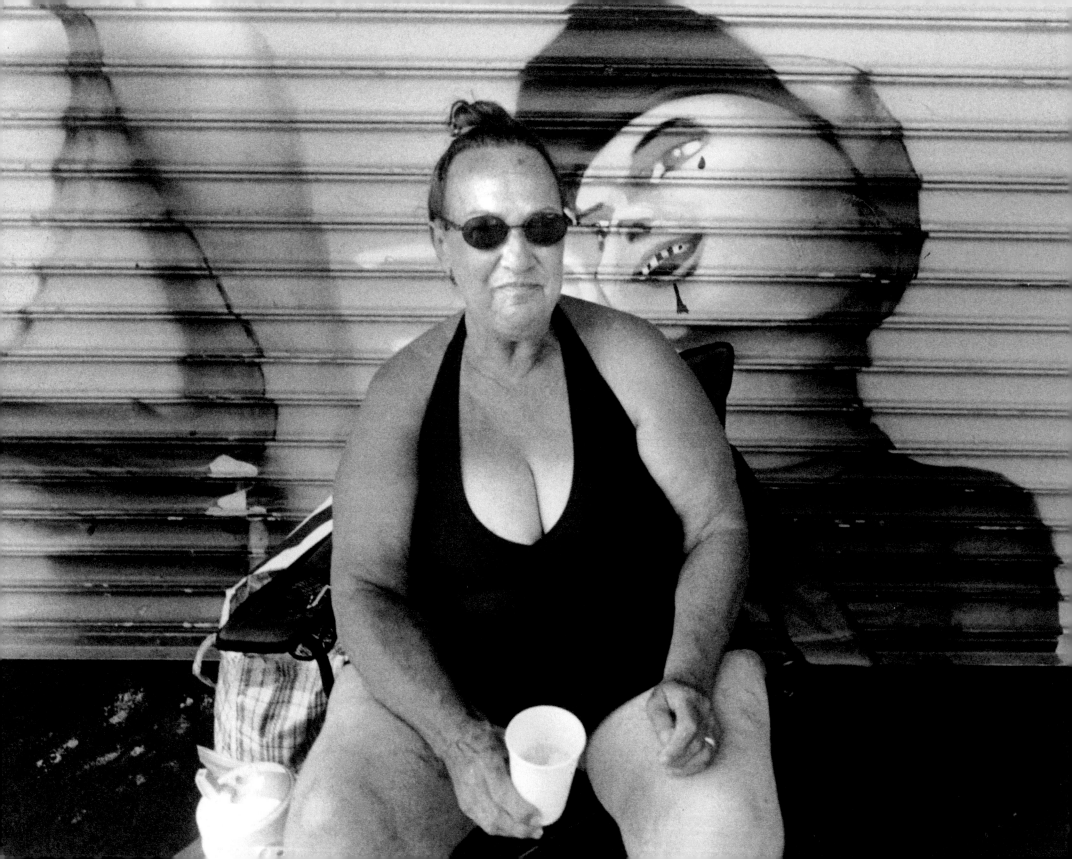

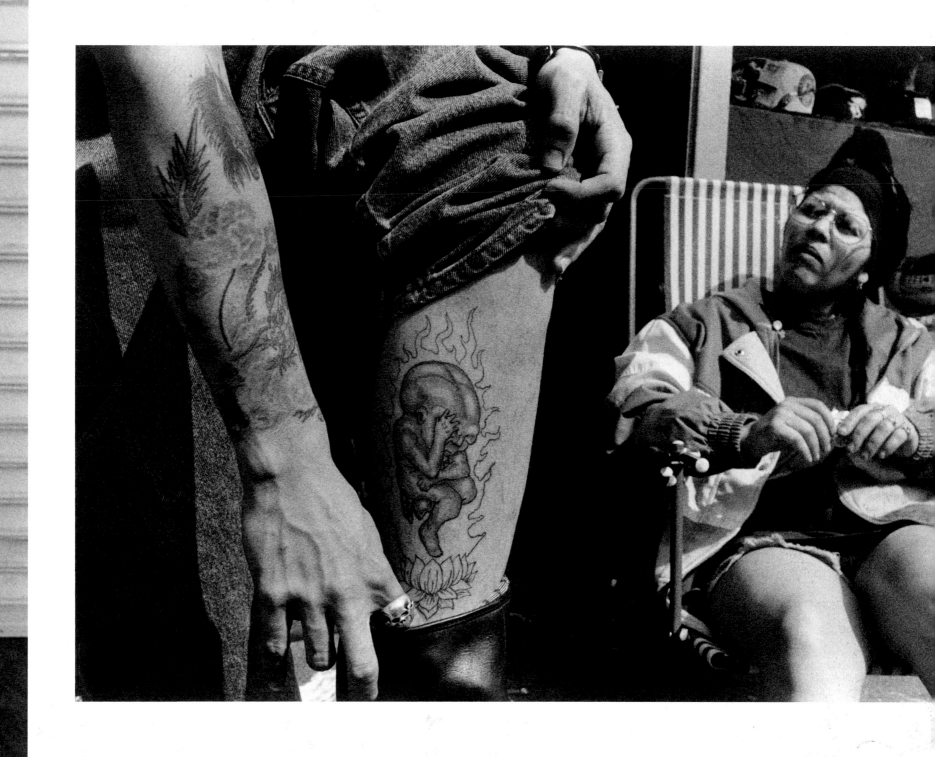

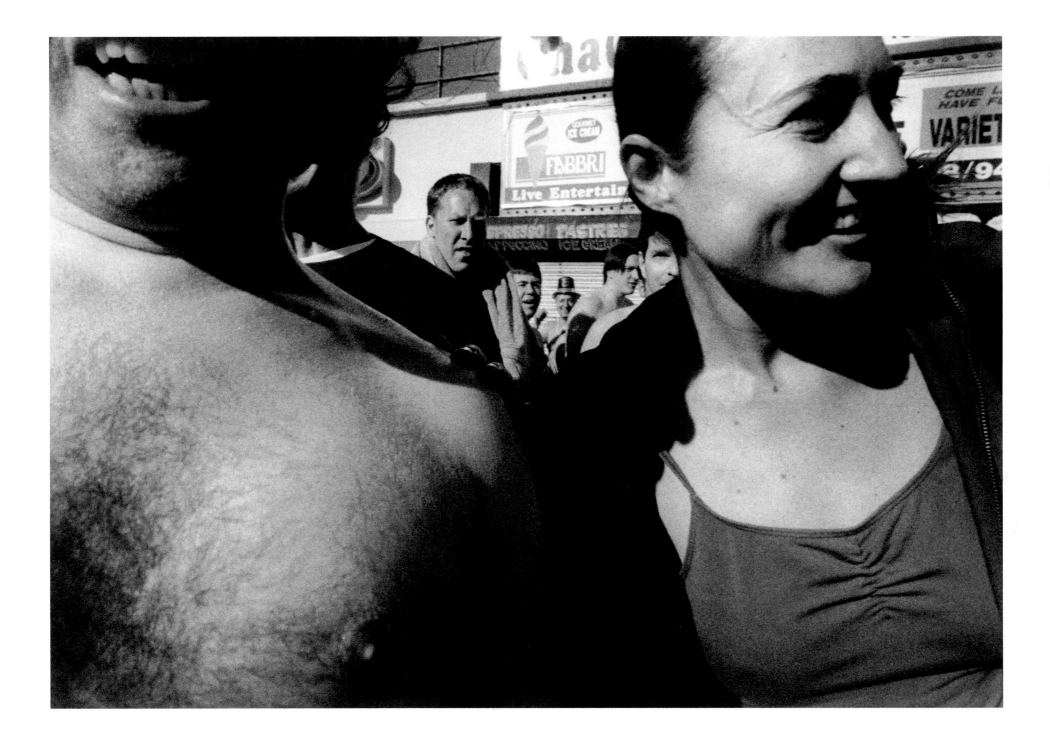

16

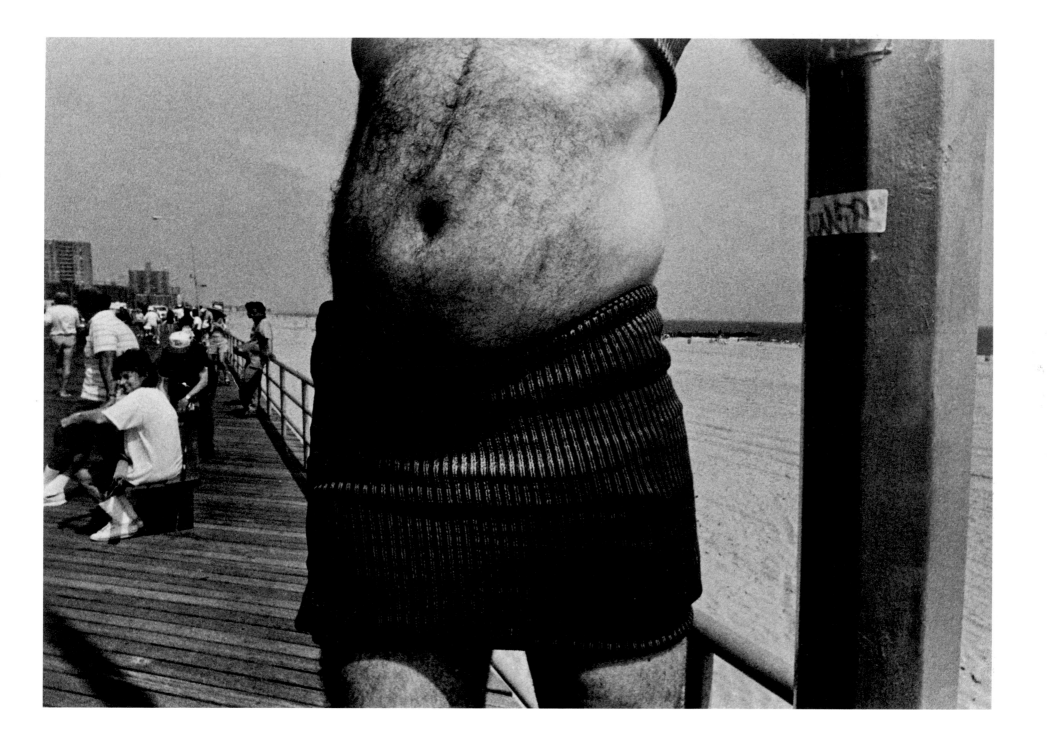

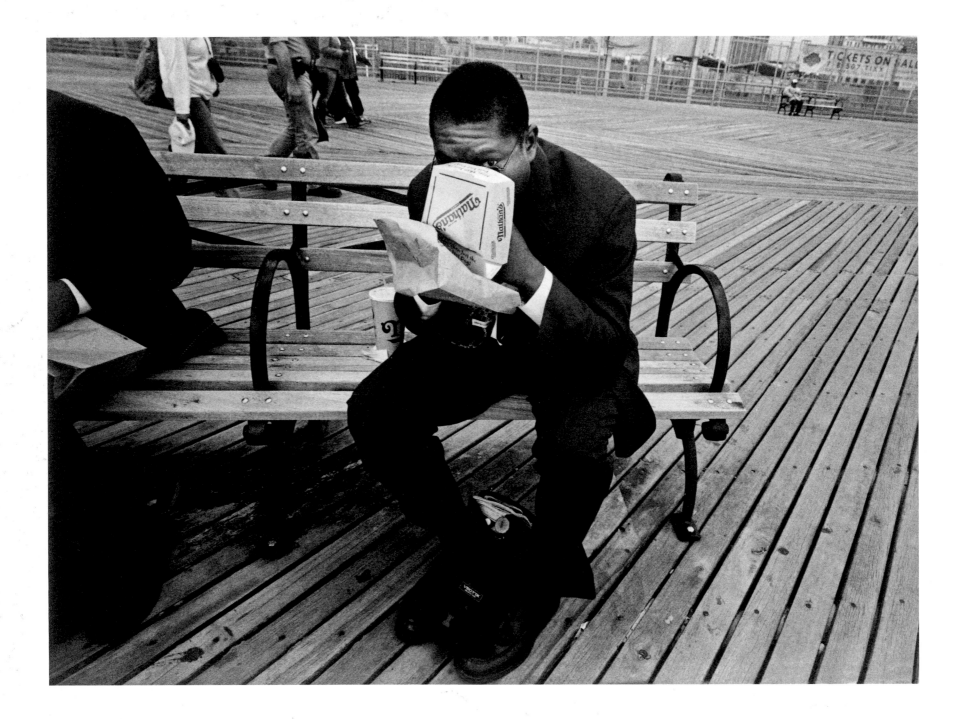

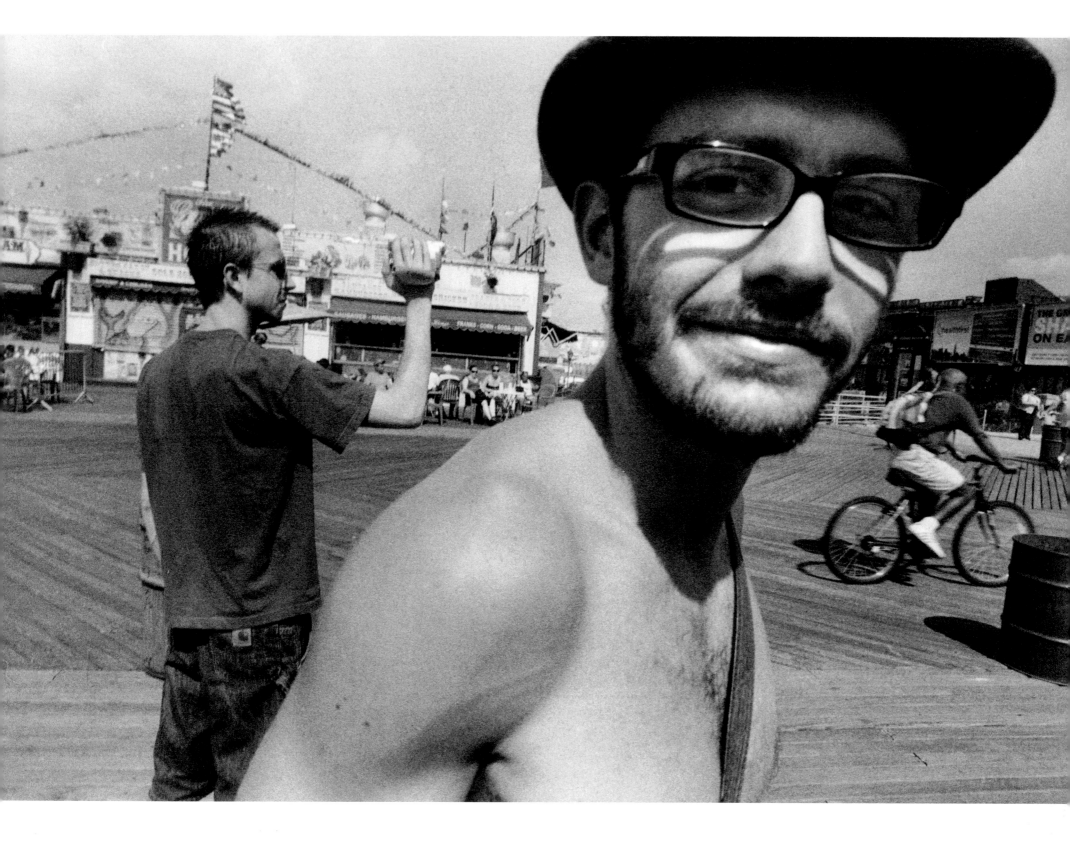

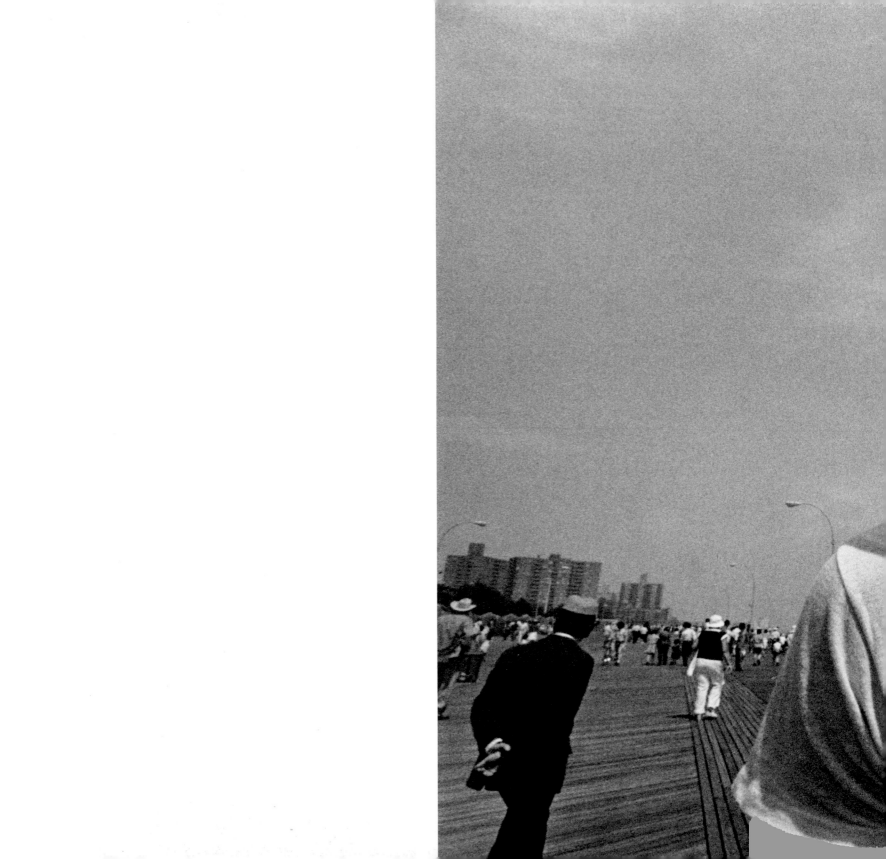

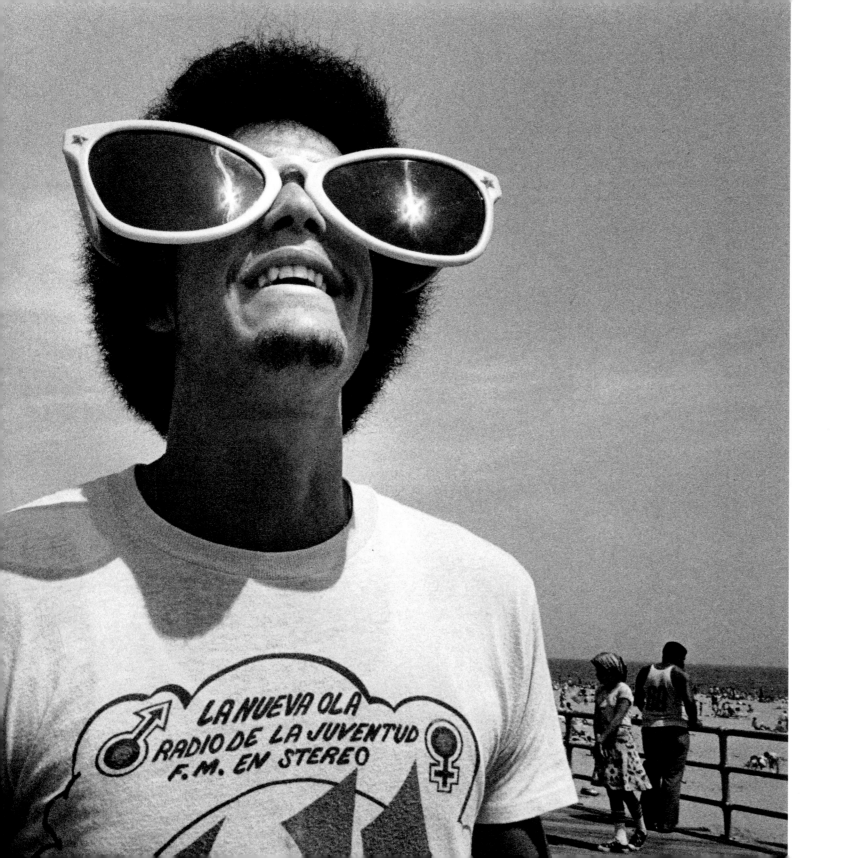

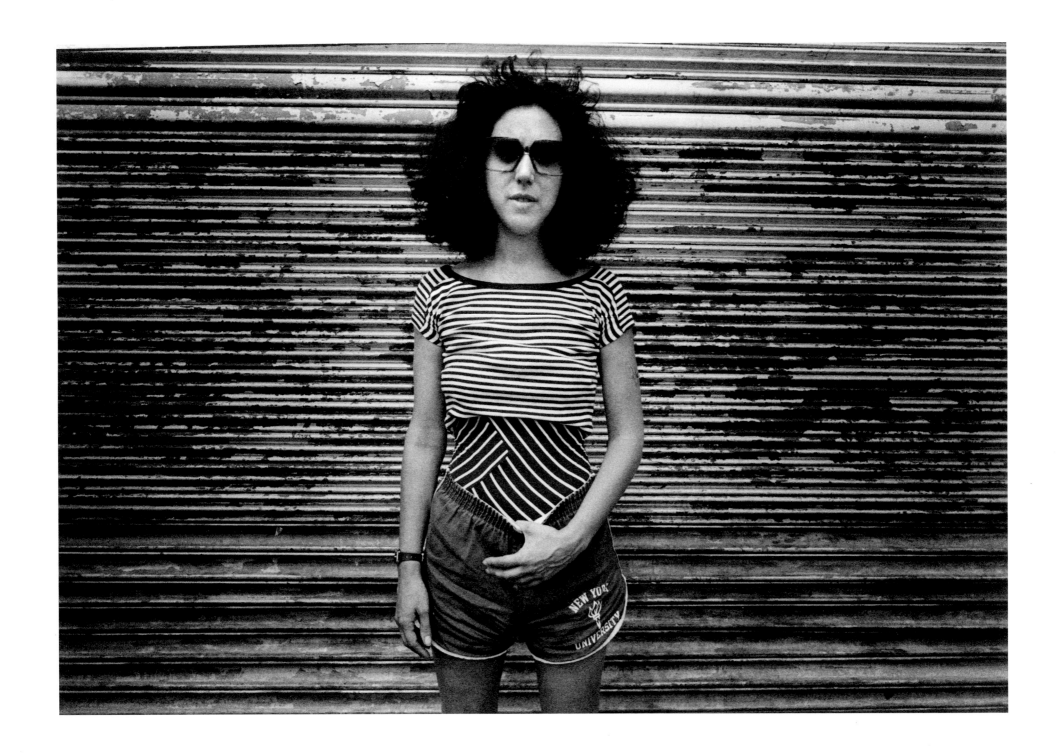

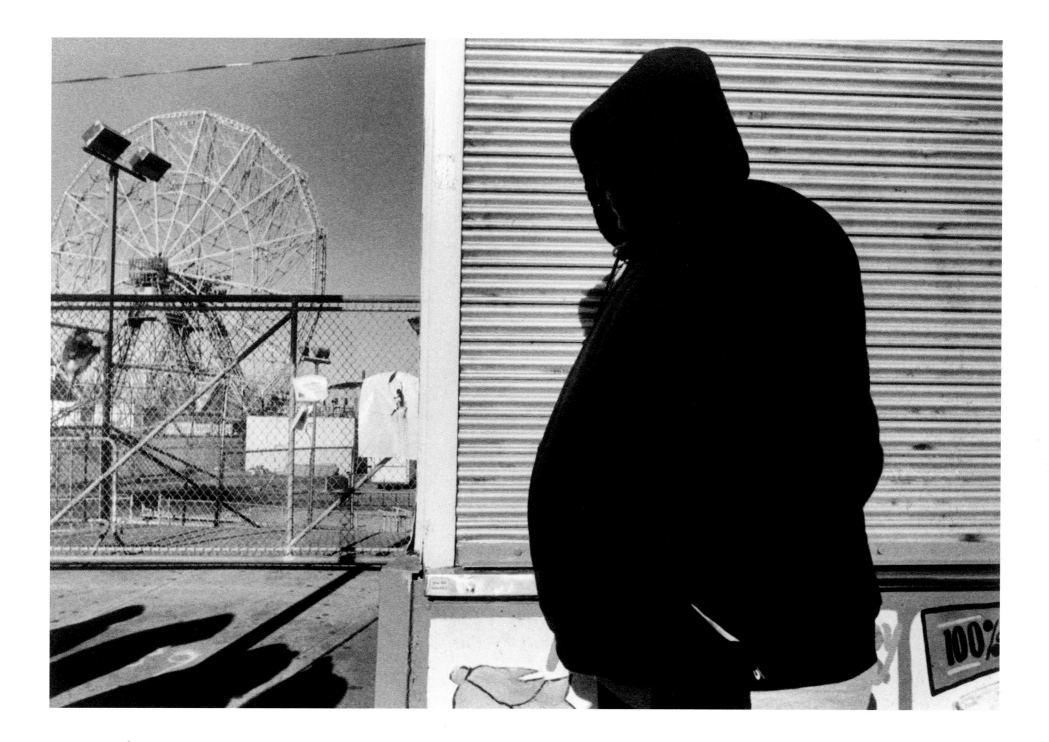

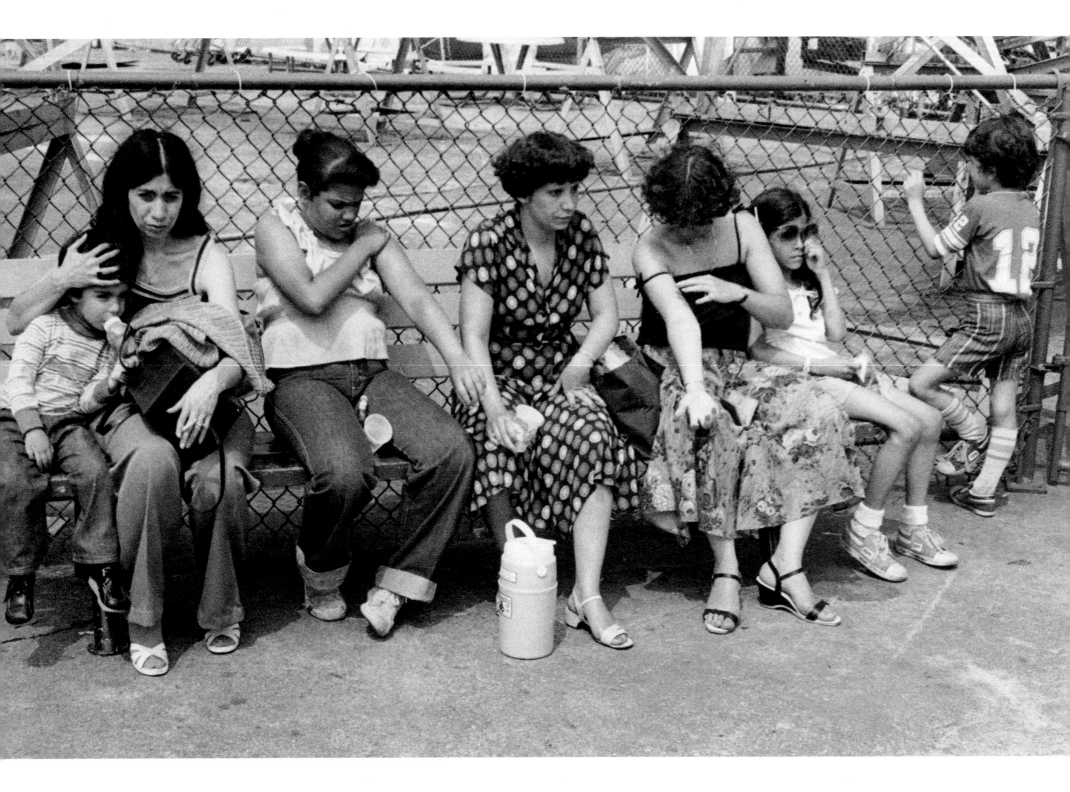

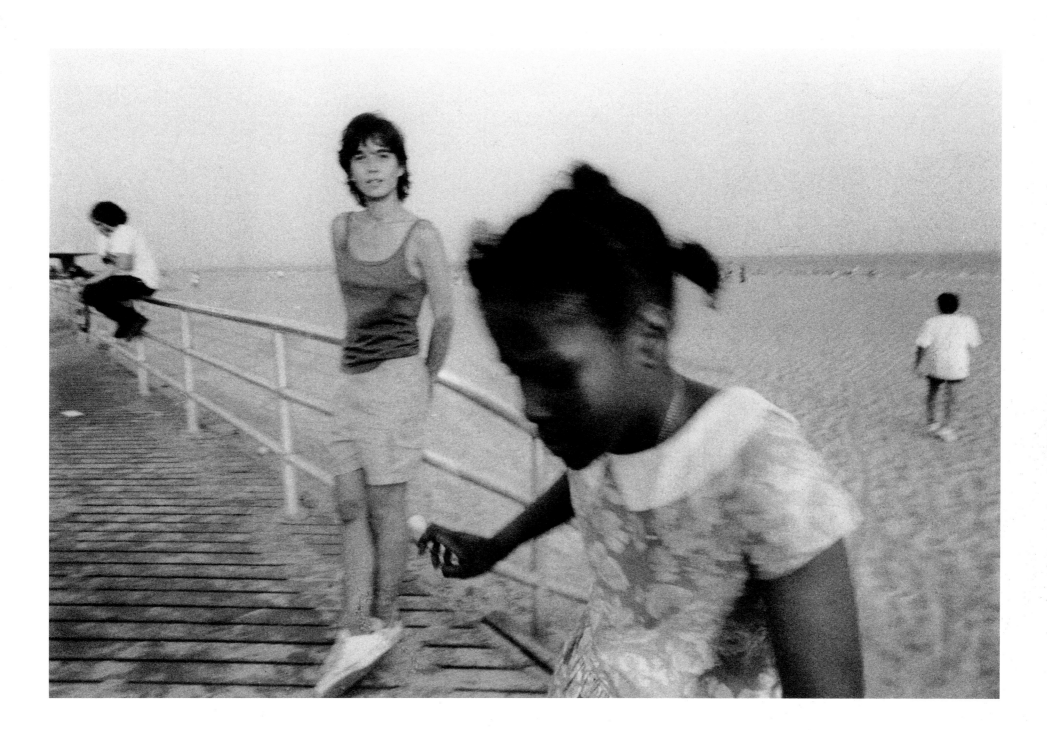

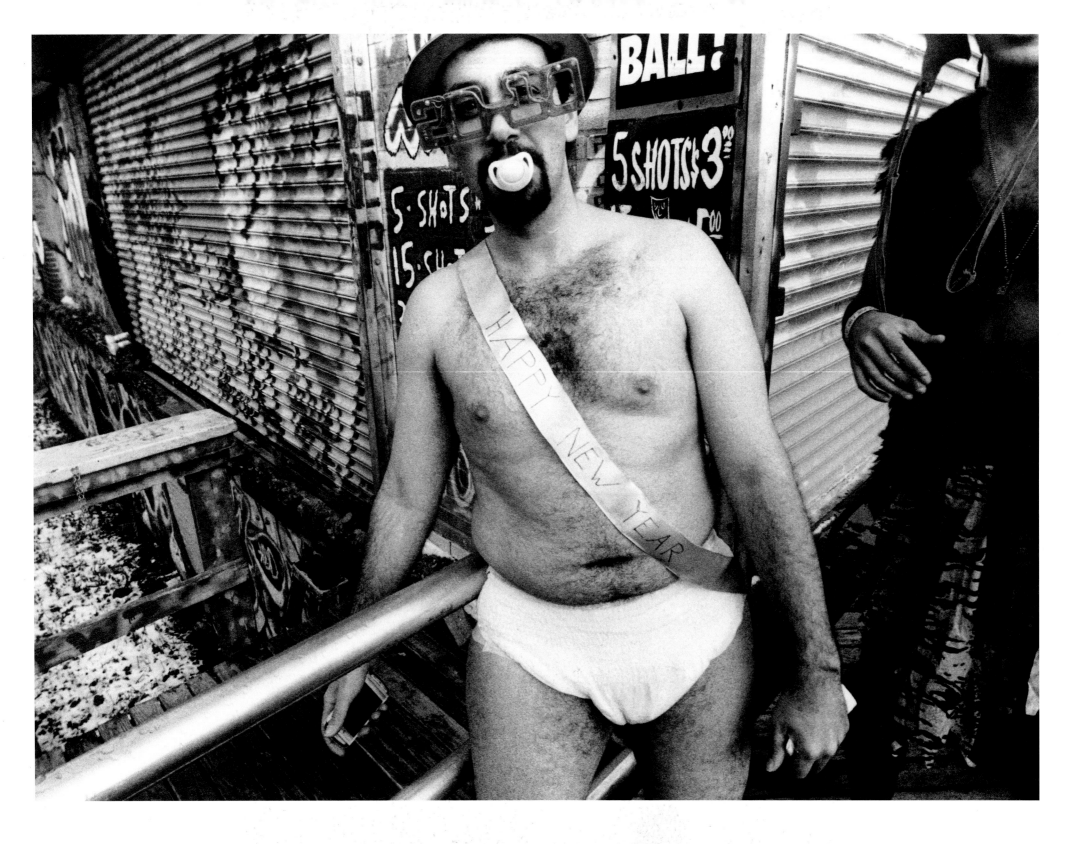

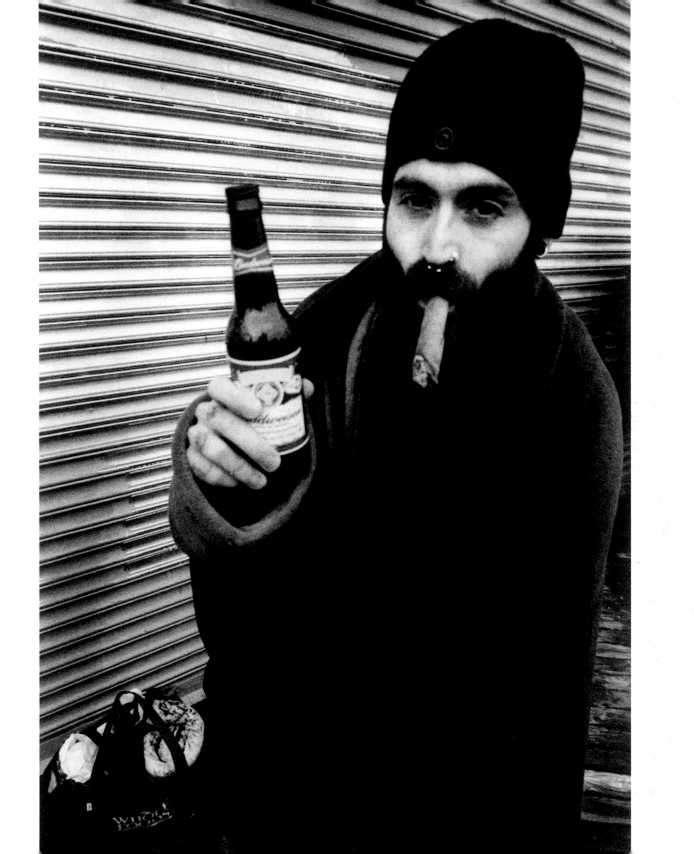

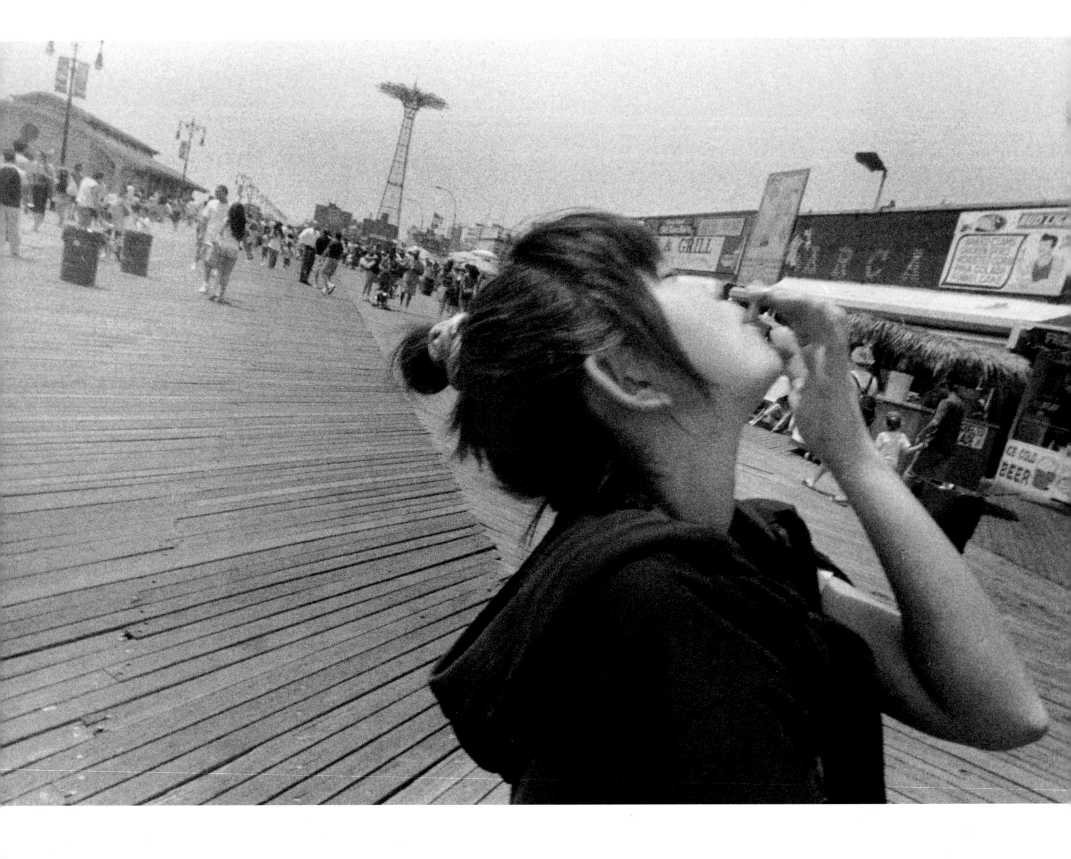

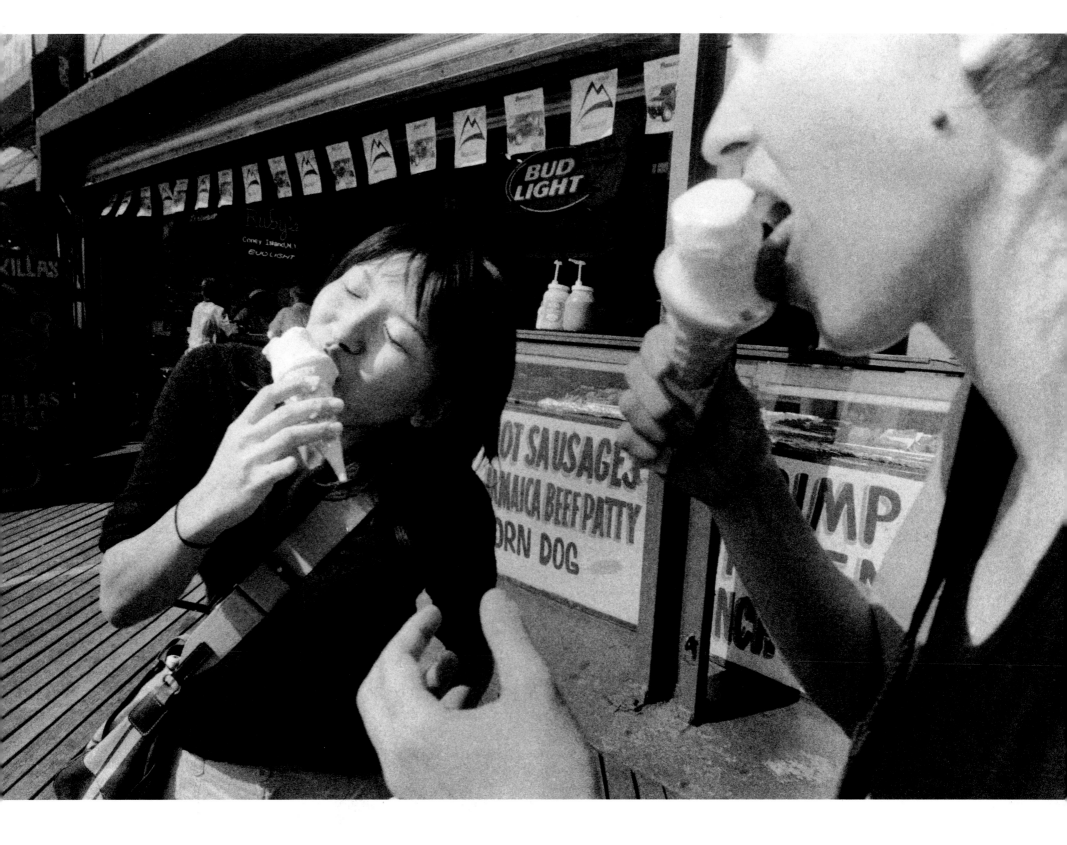

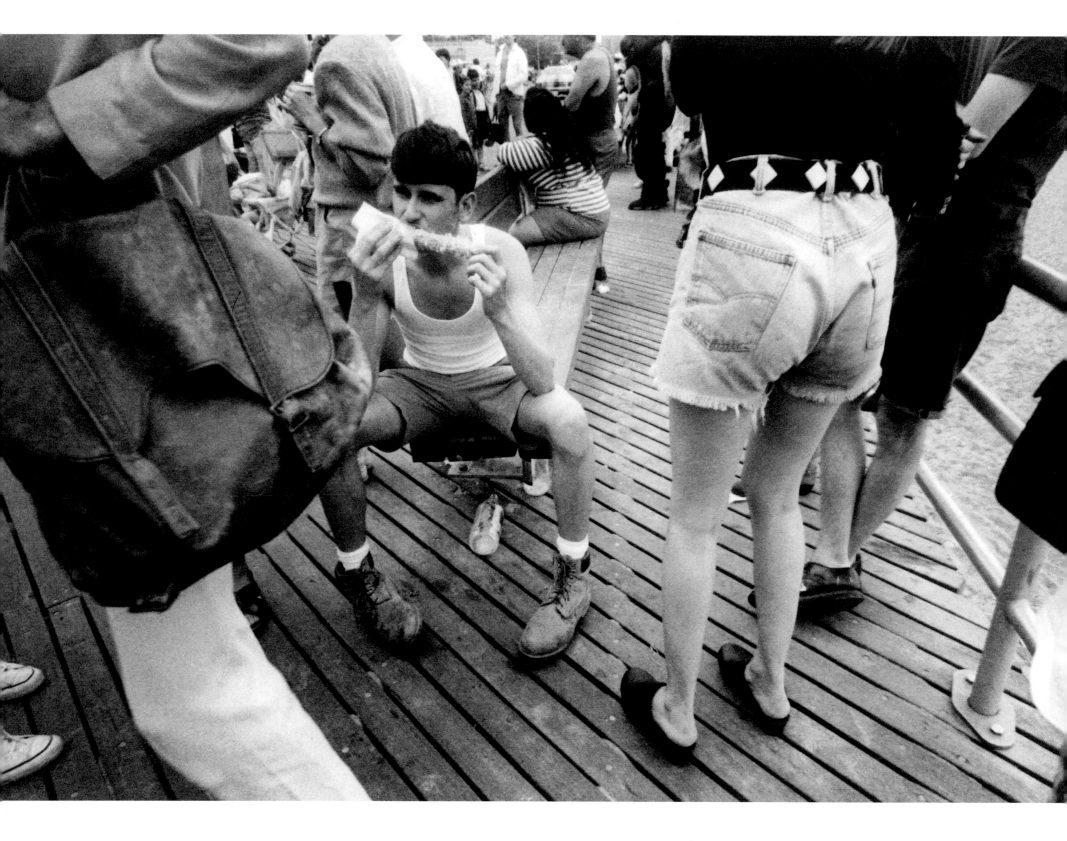

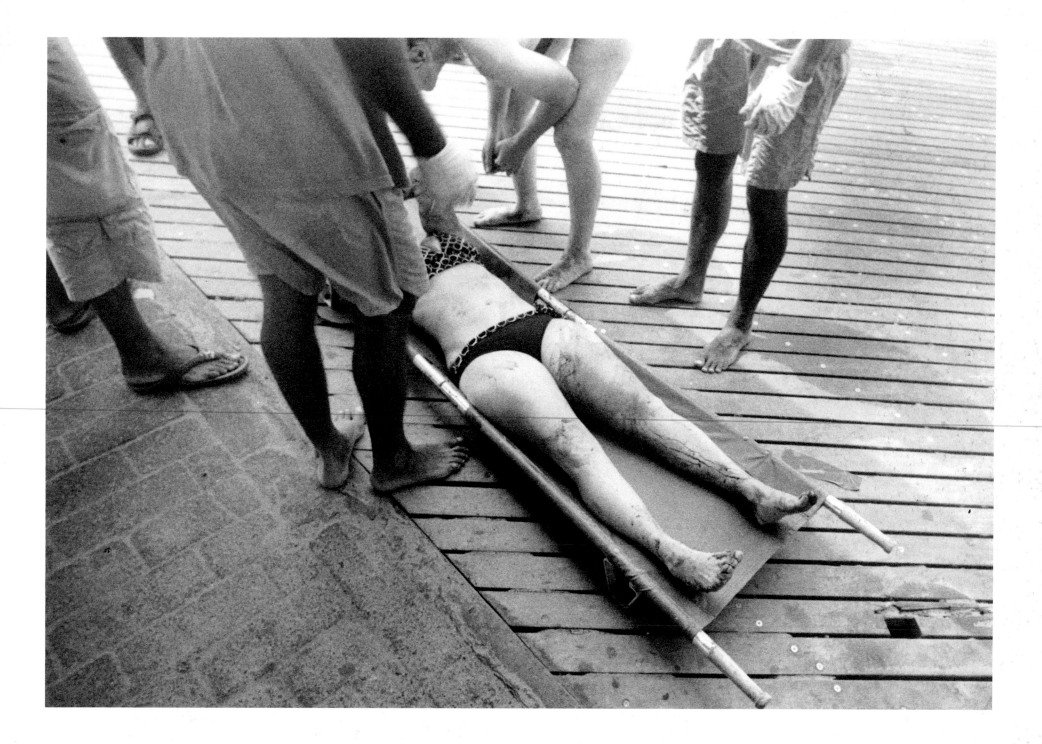

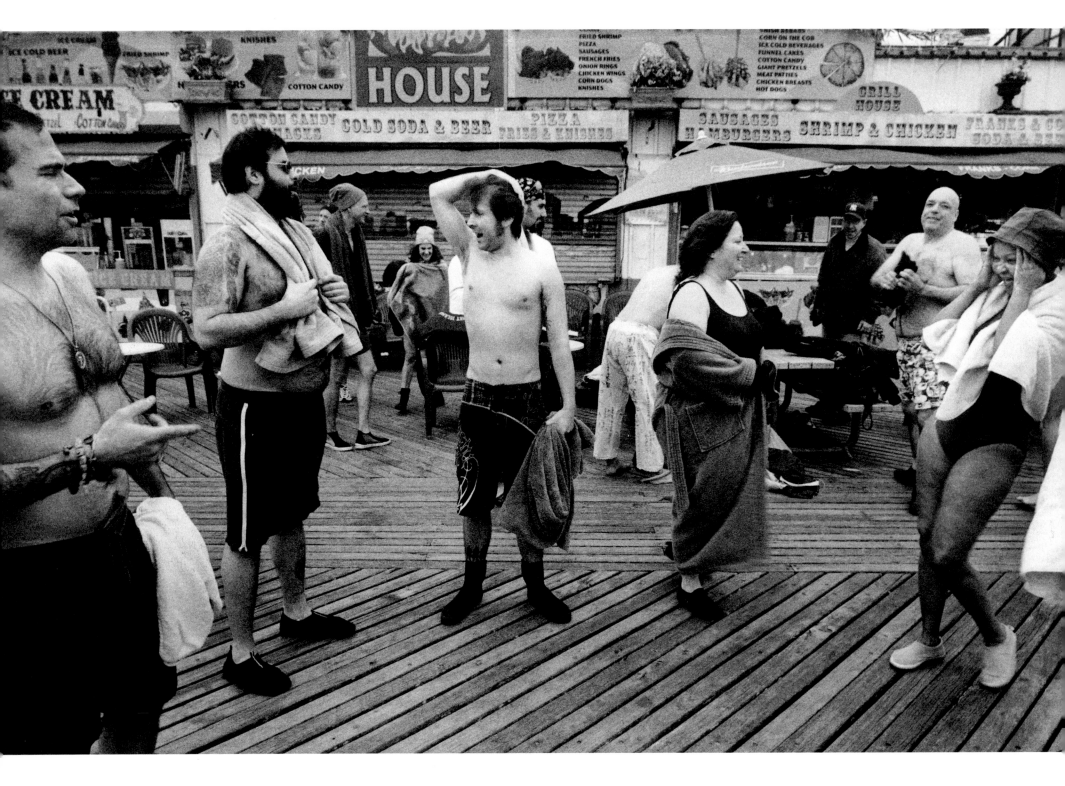

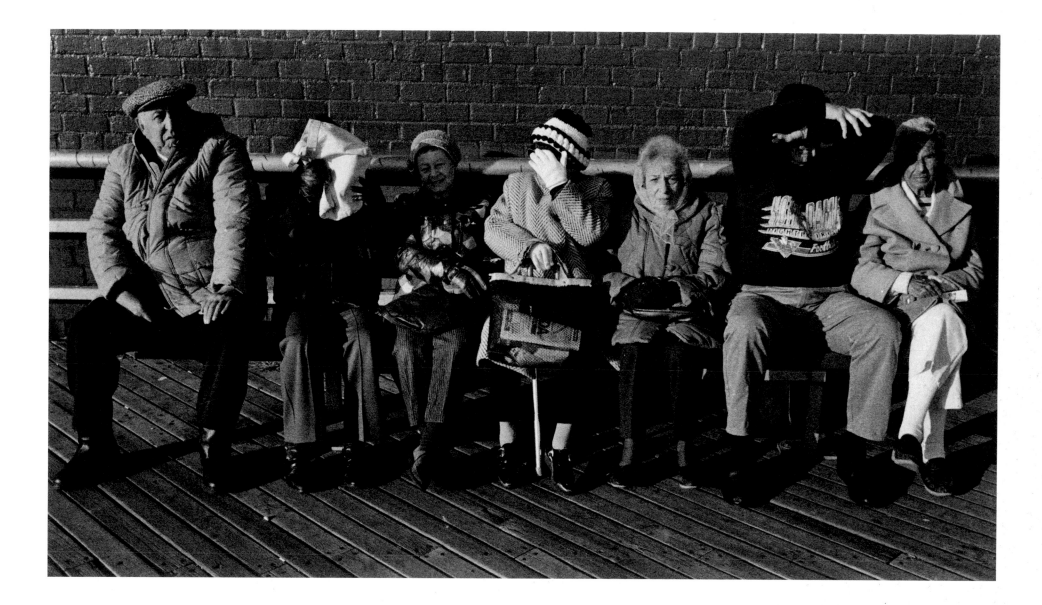

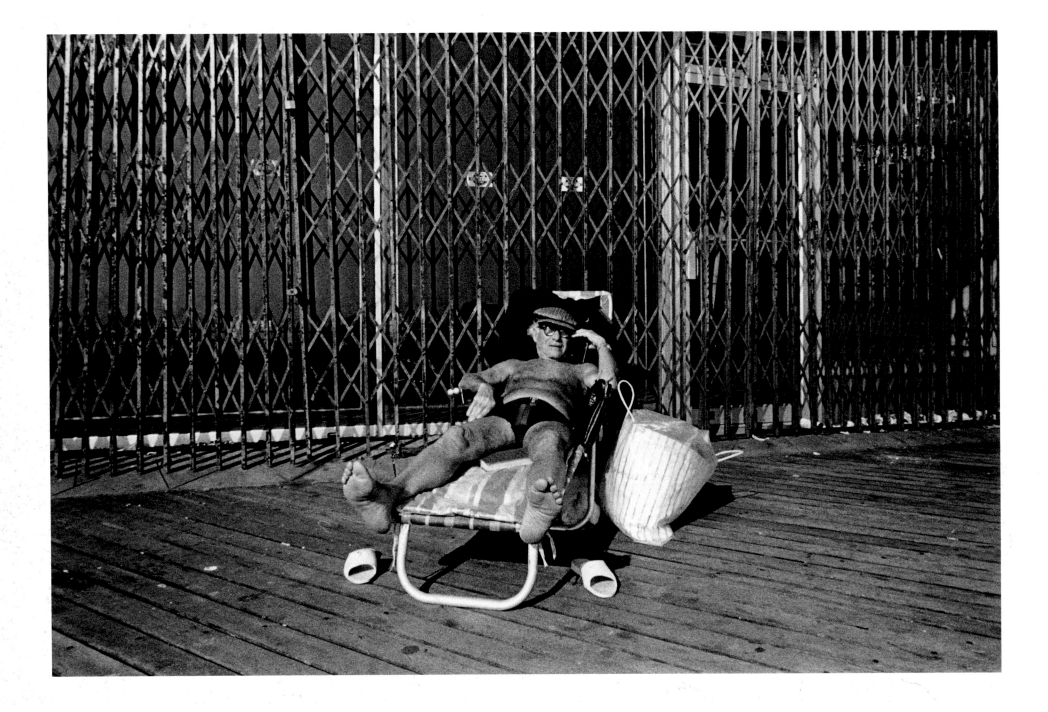

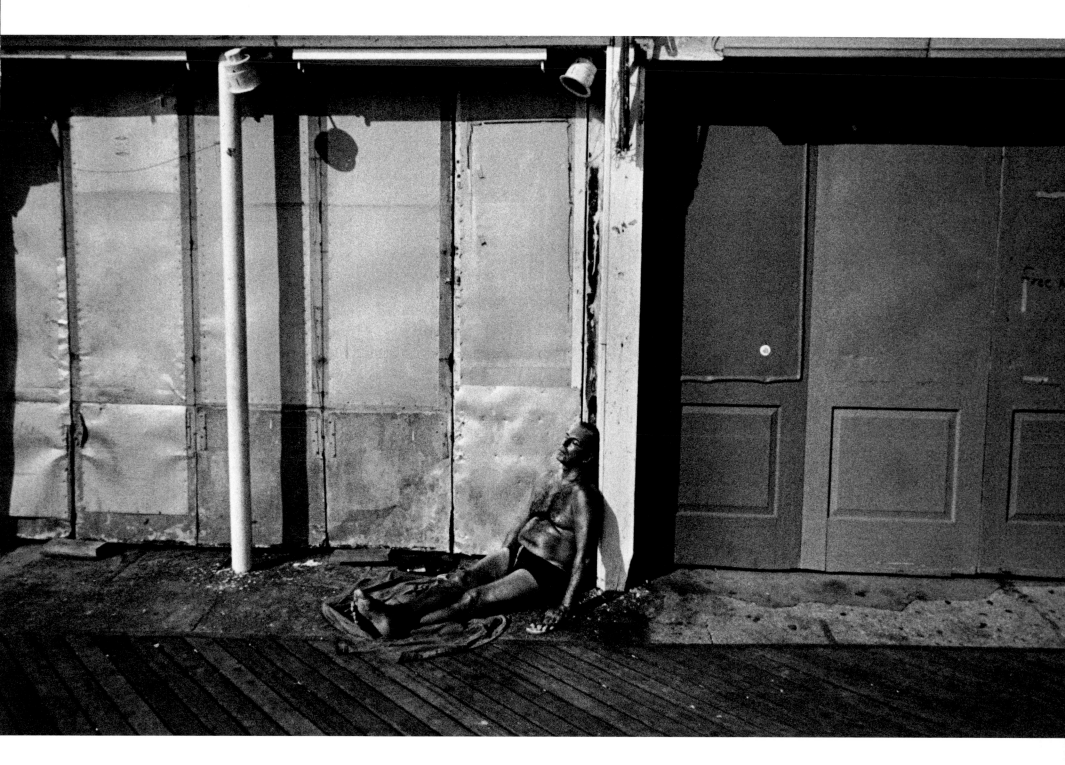

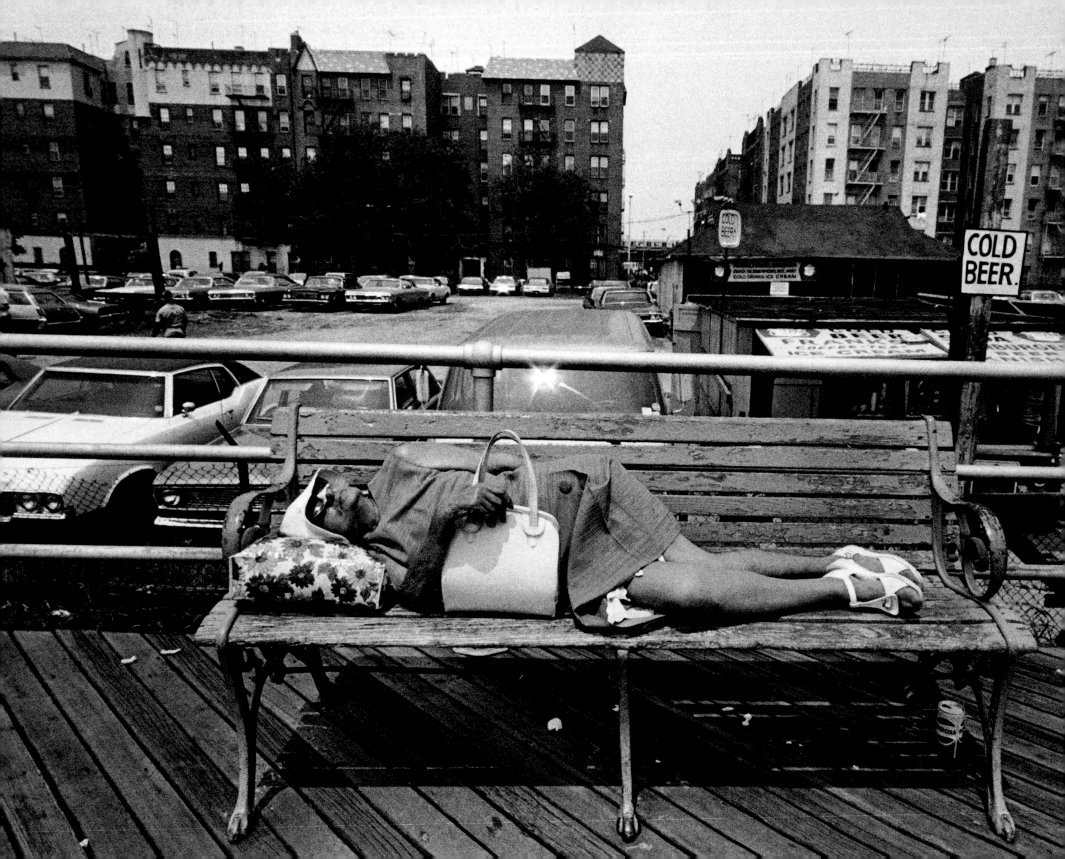

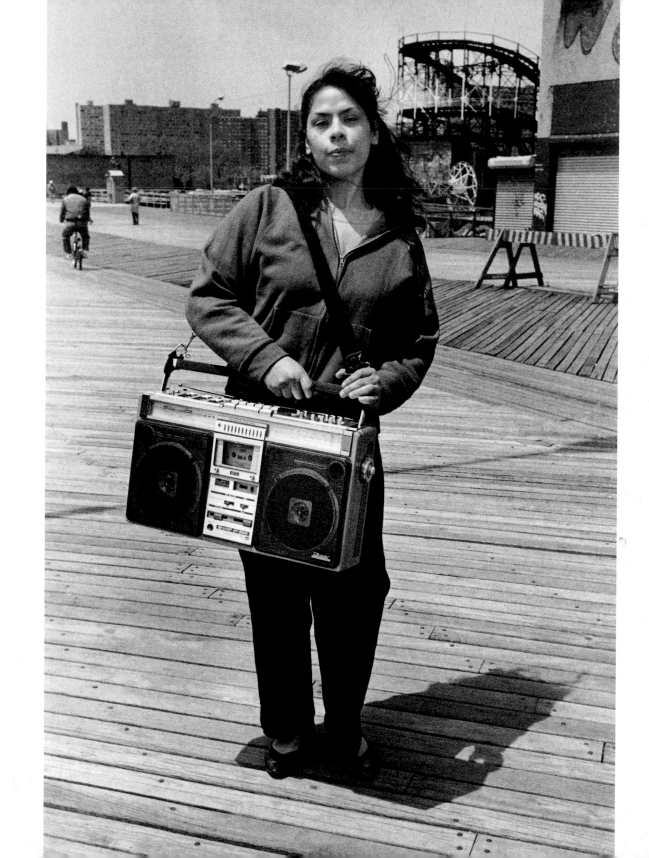

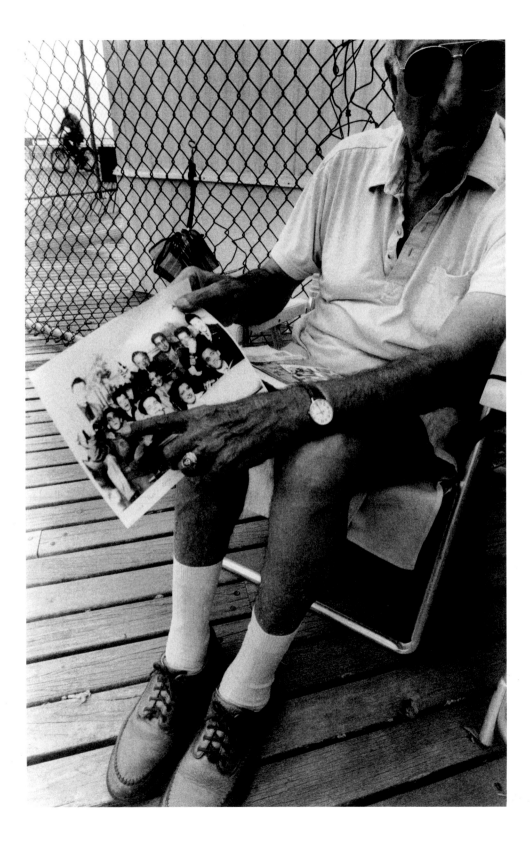

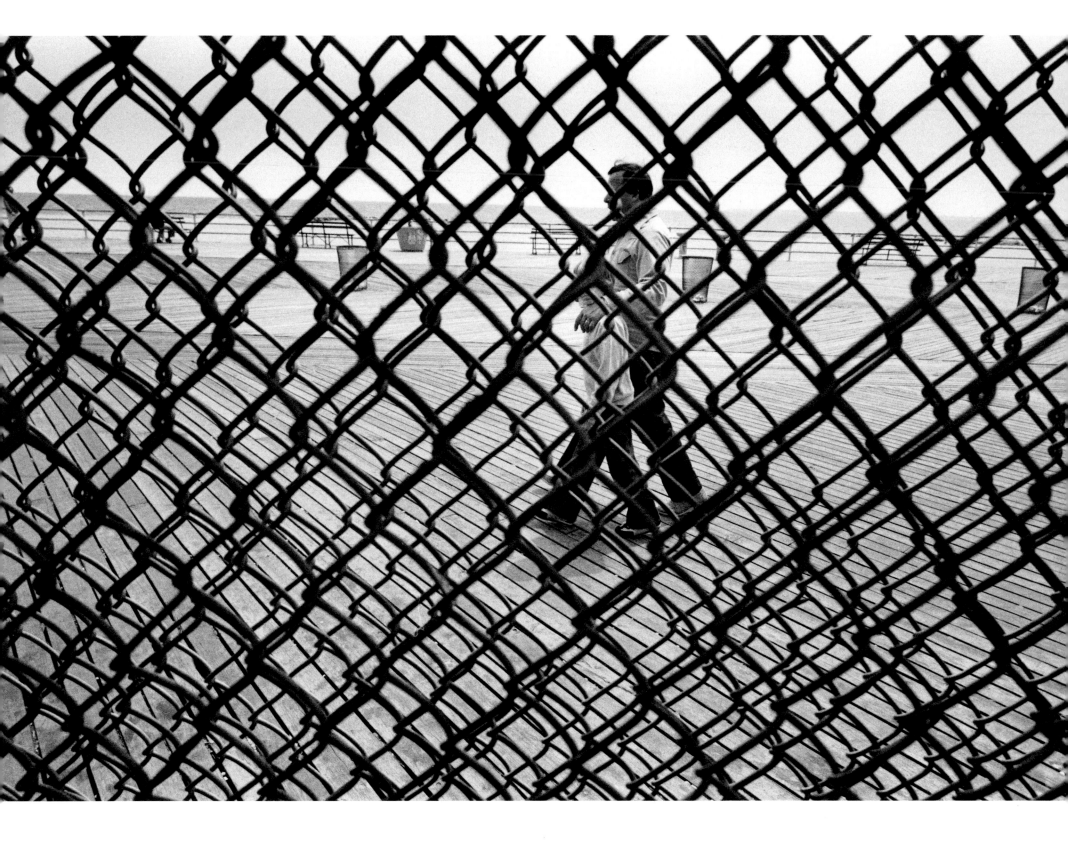

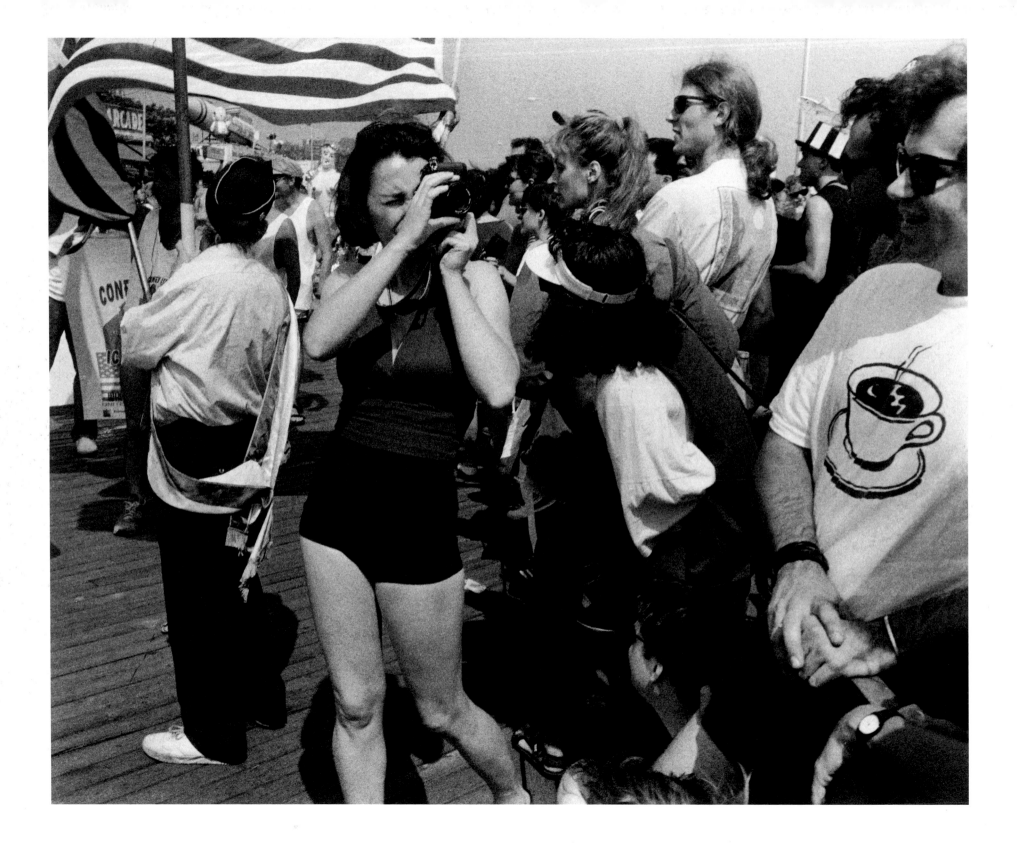

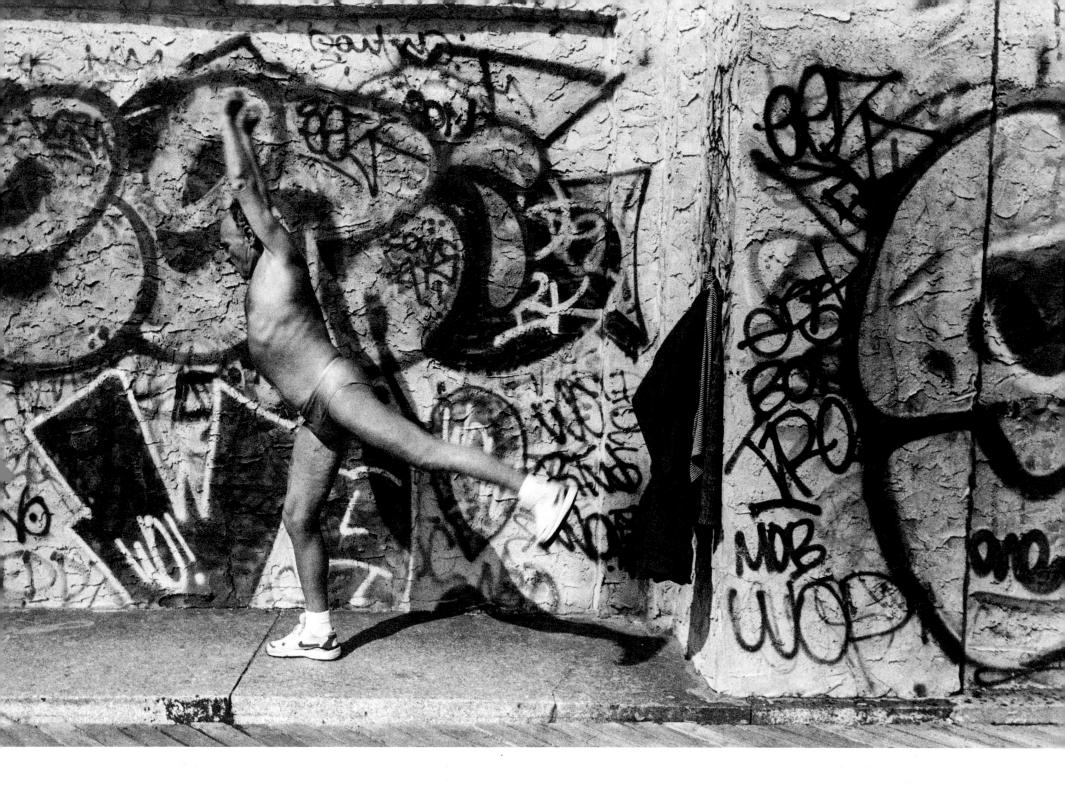

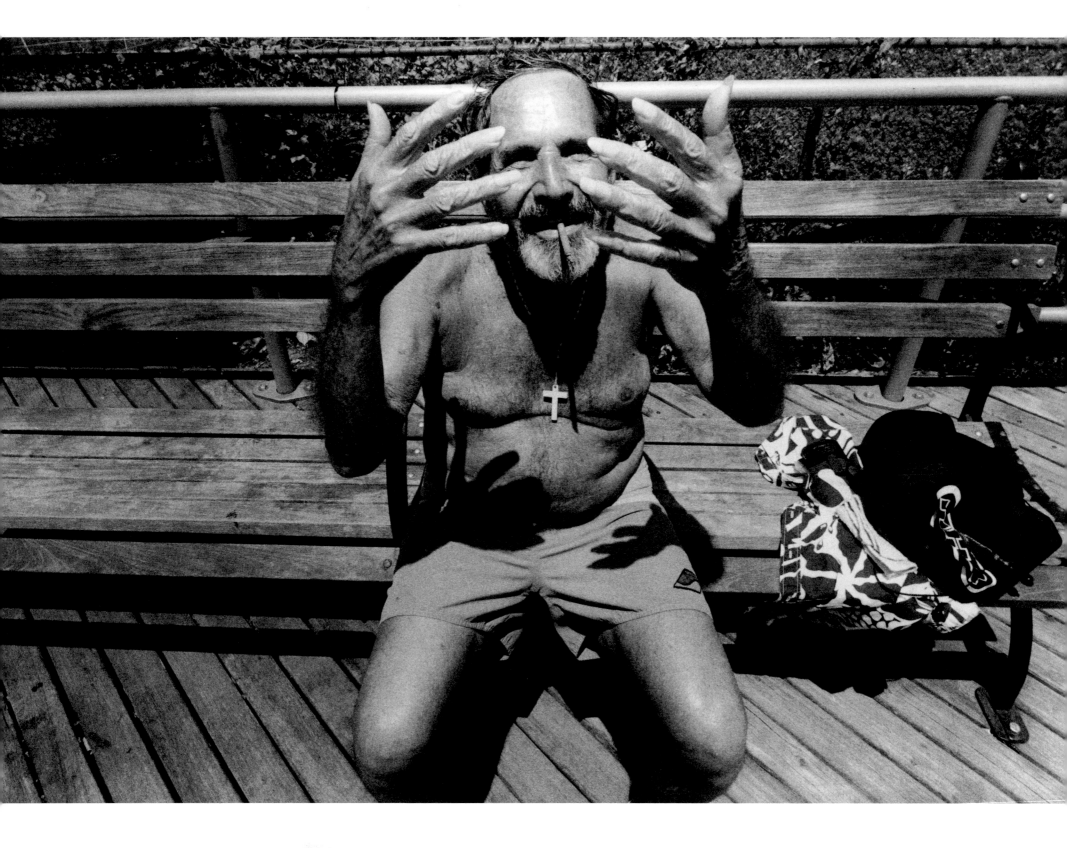

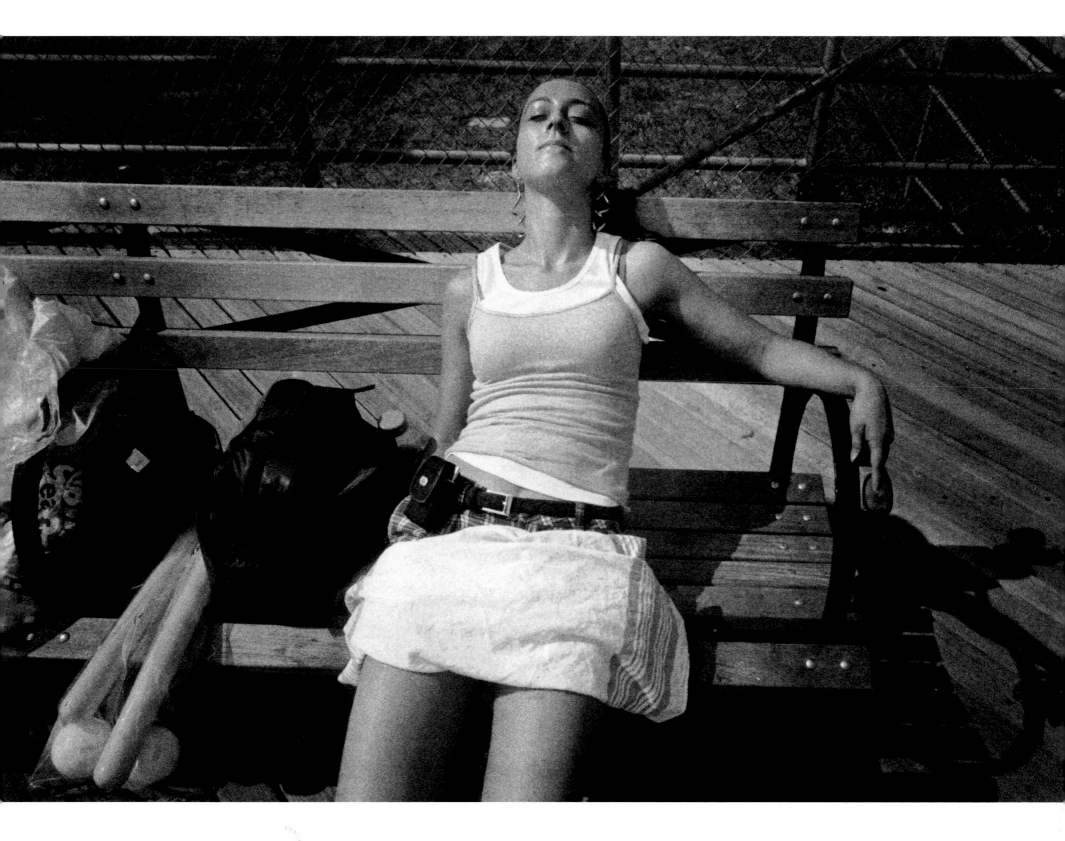

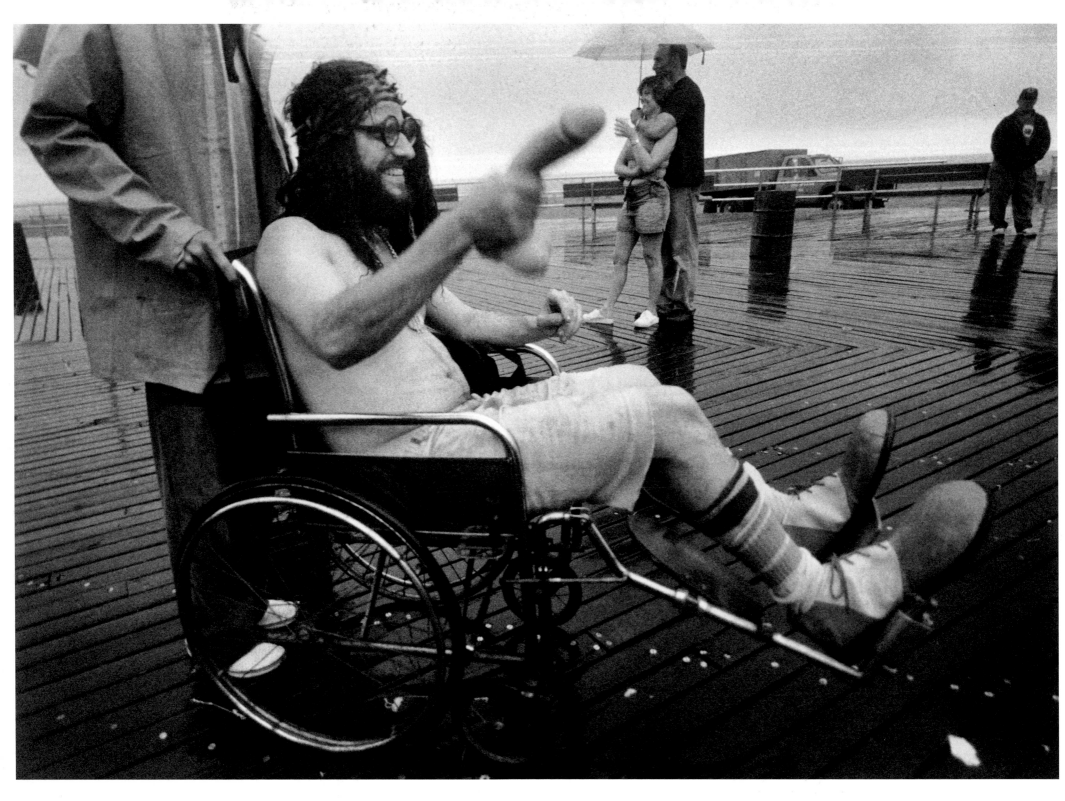

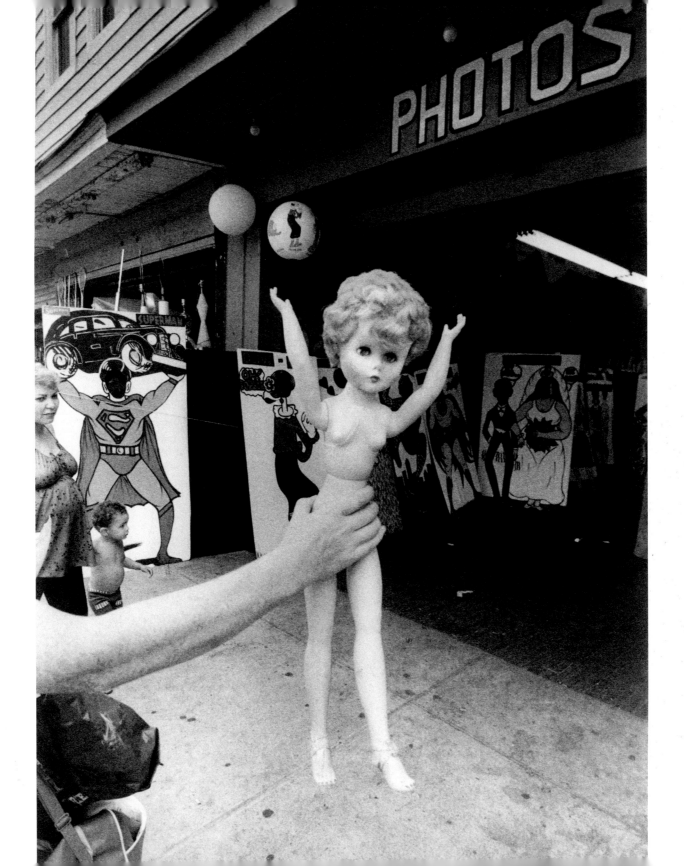

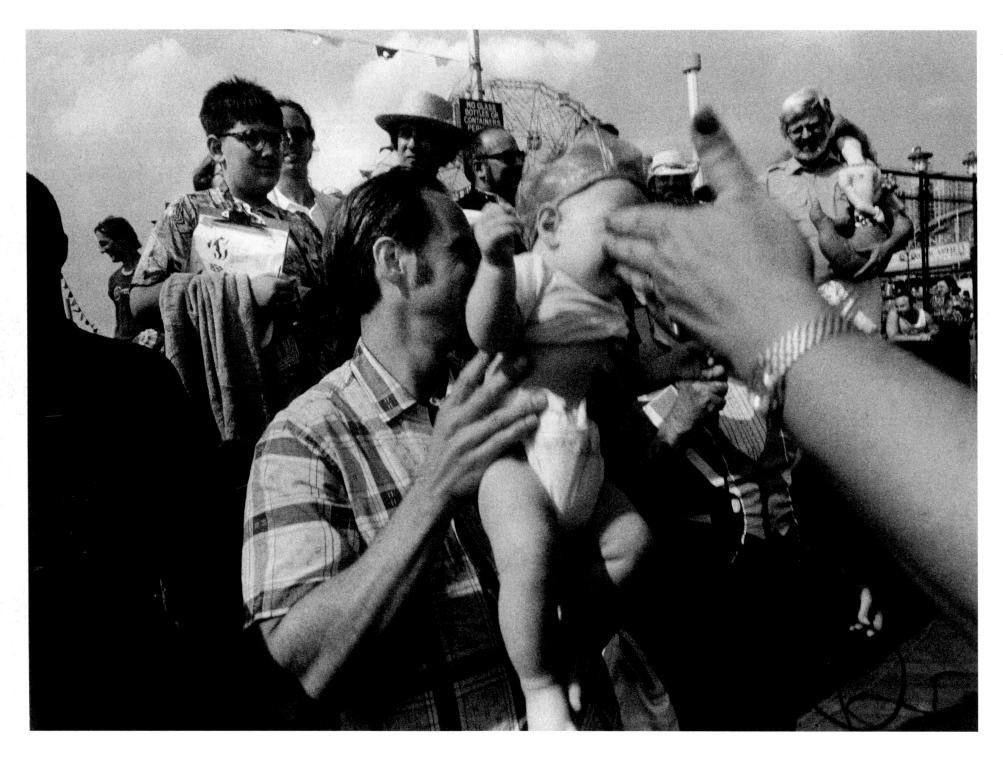

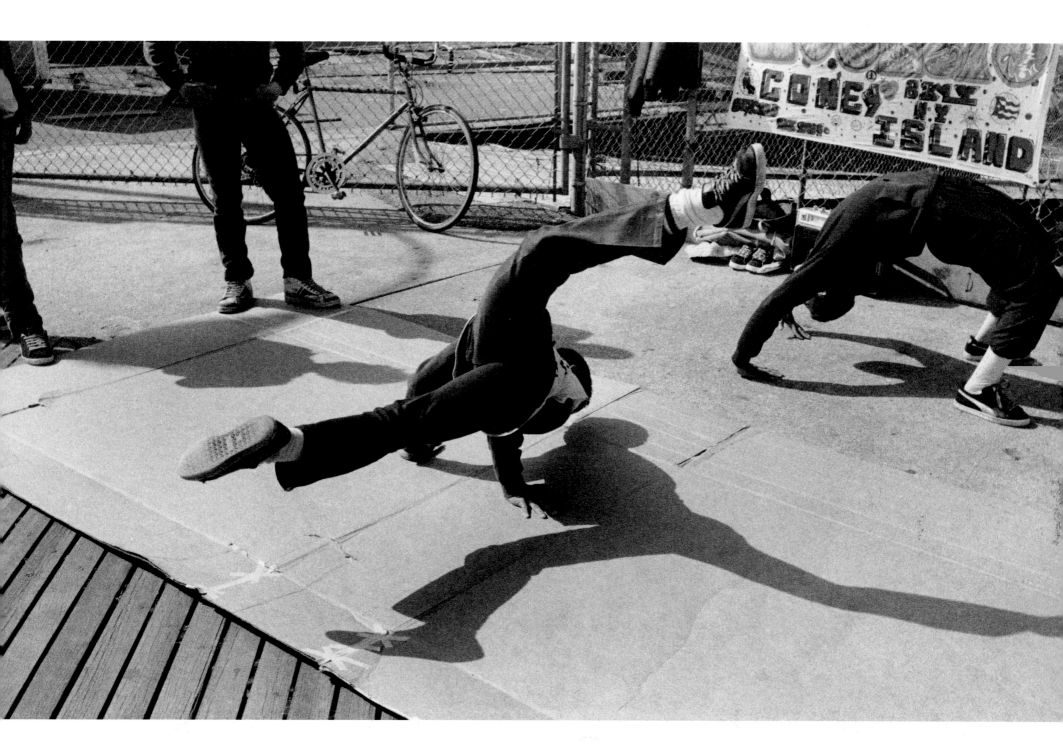

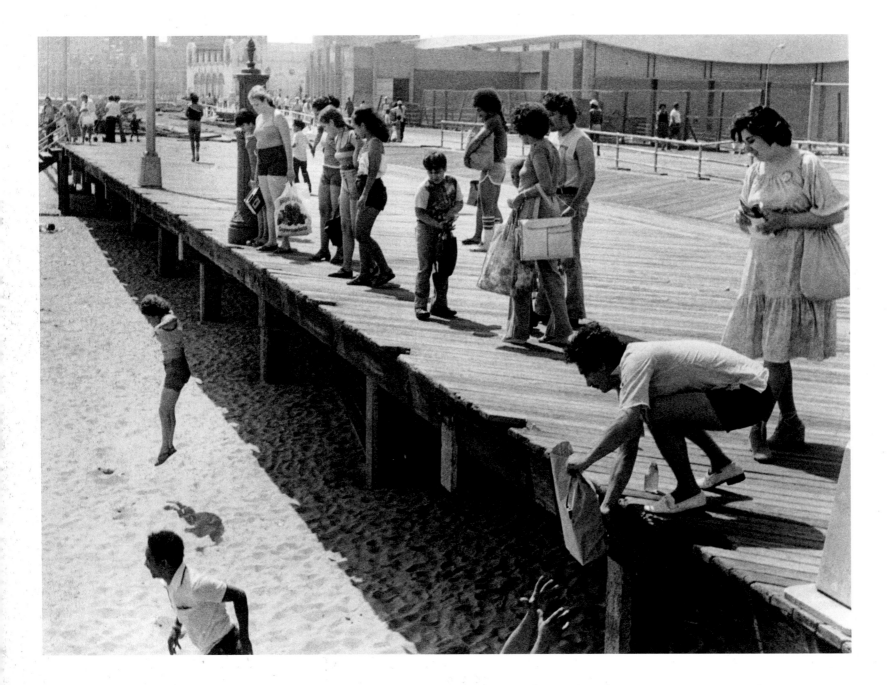

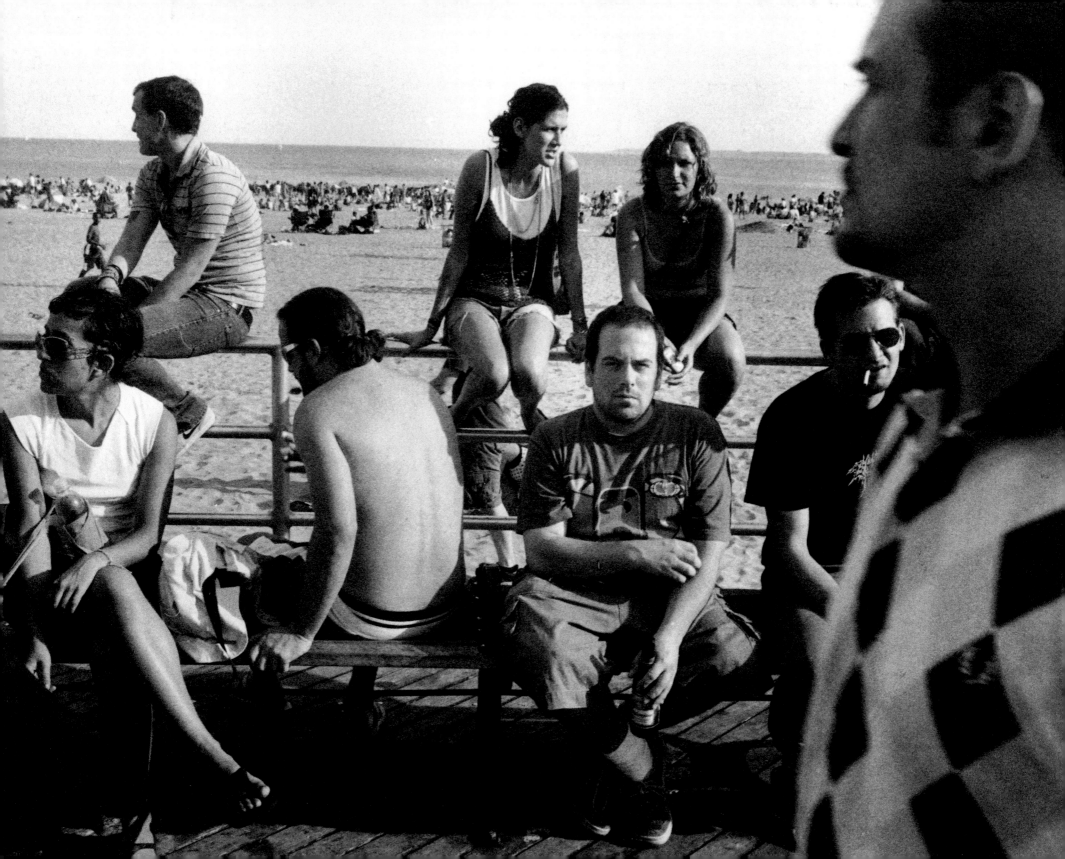

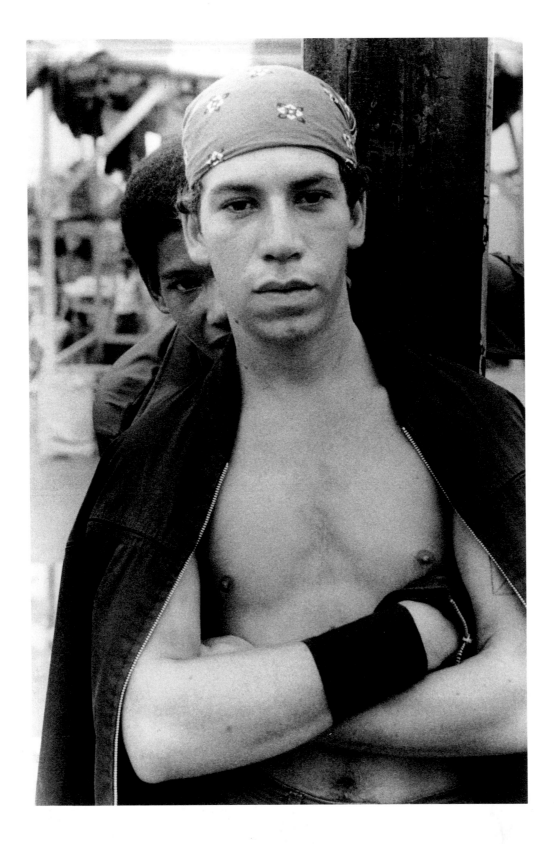

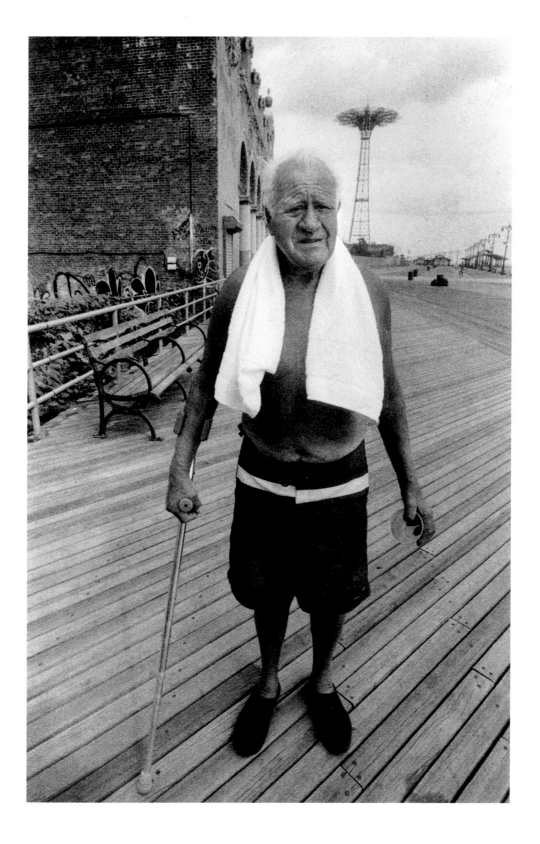

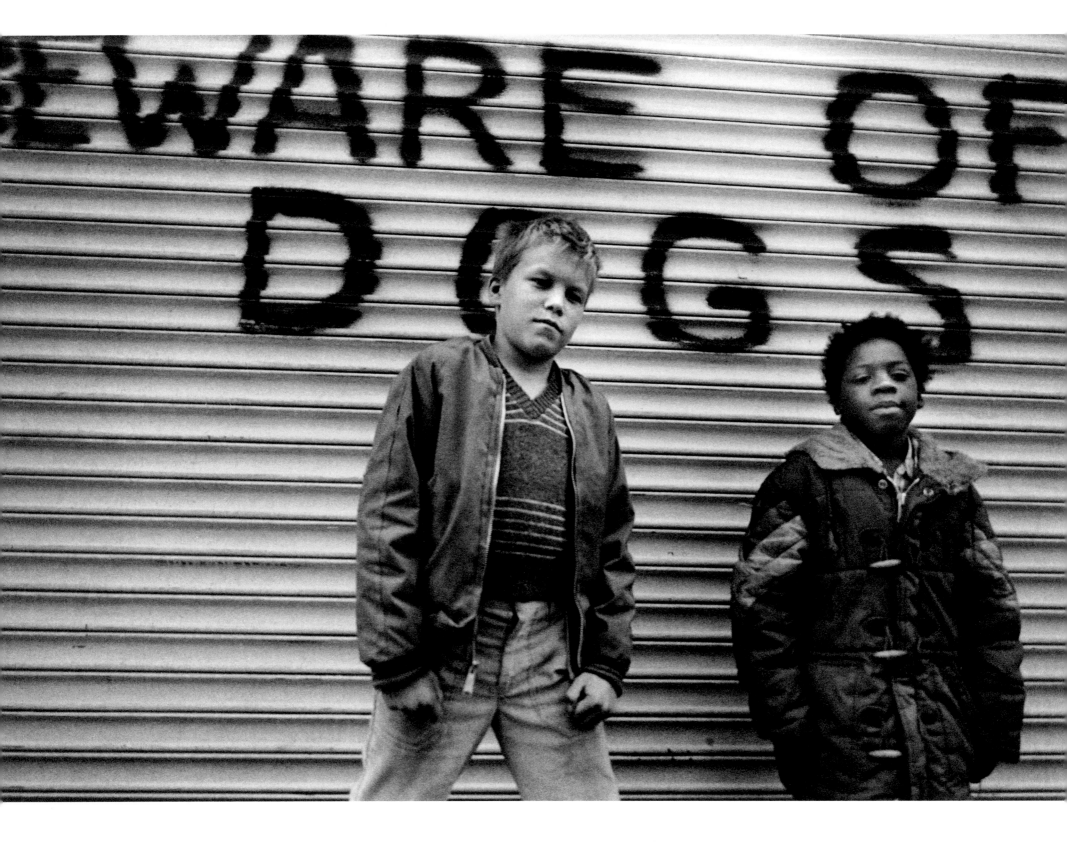

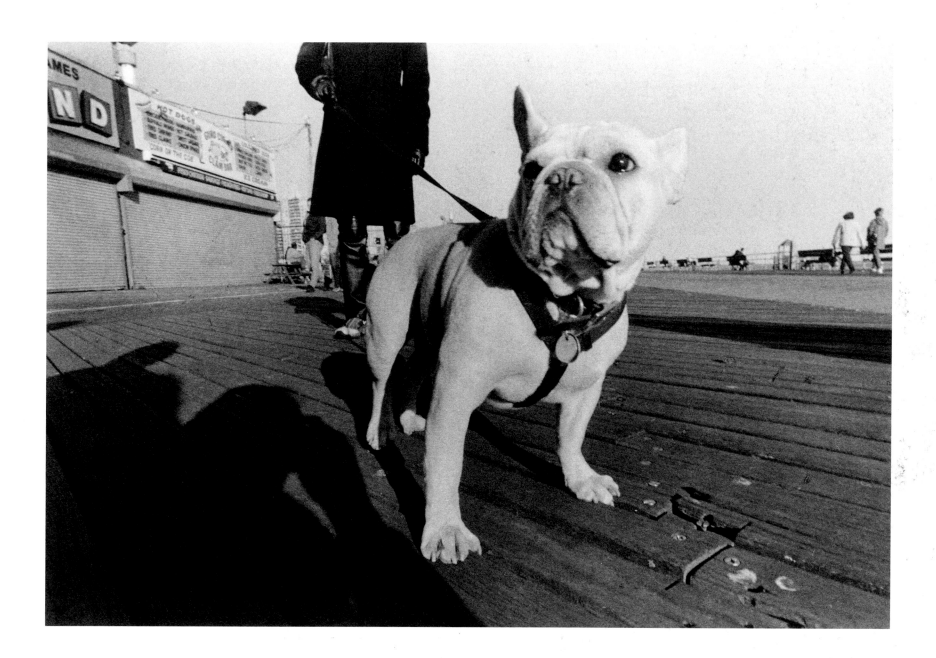

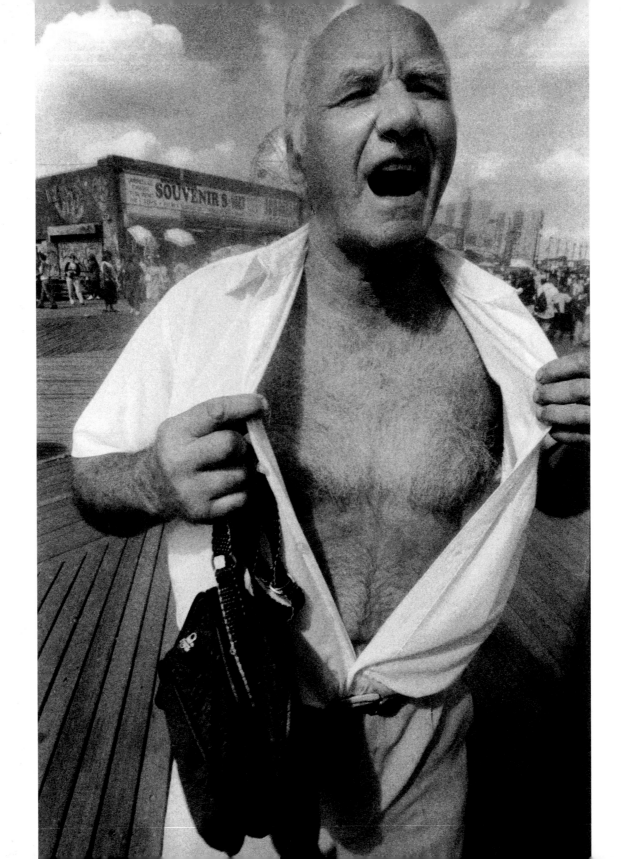

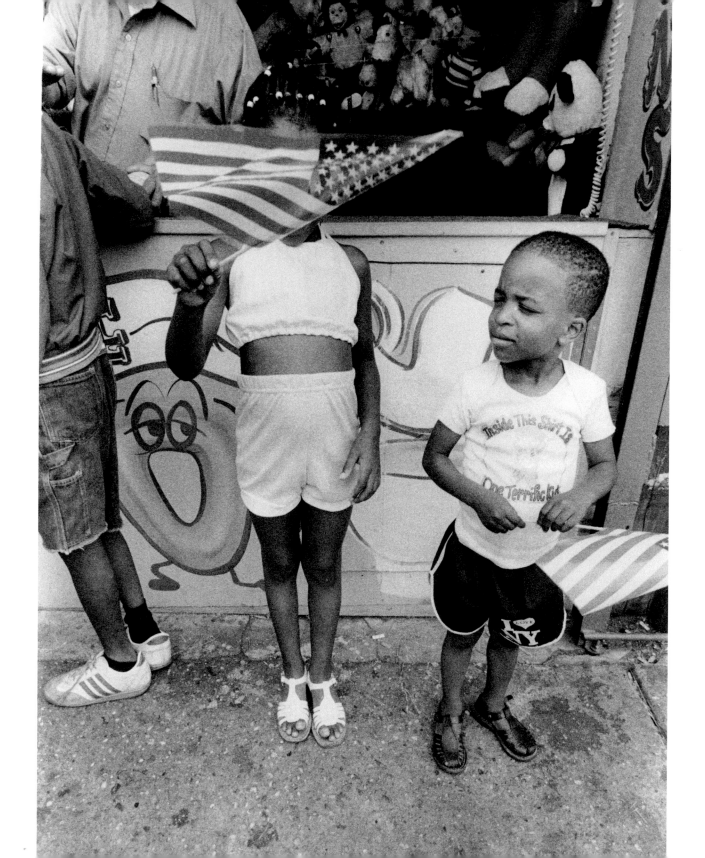

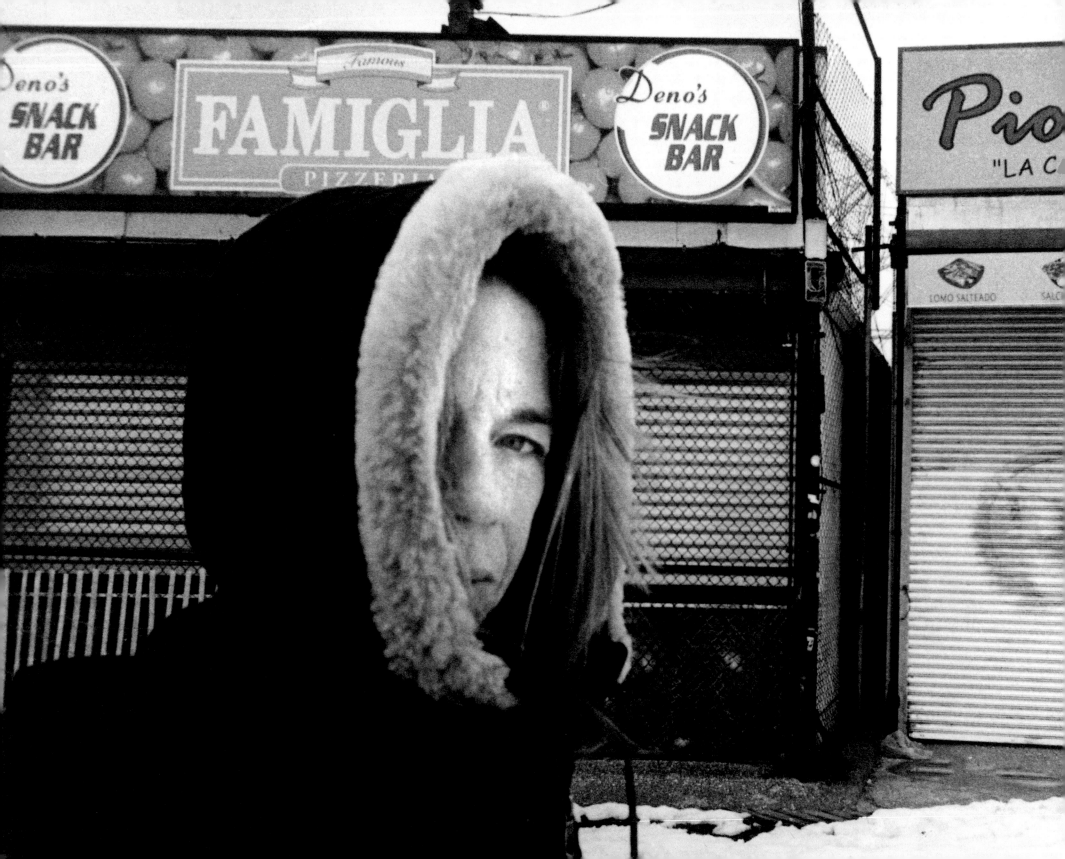

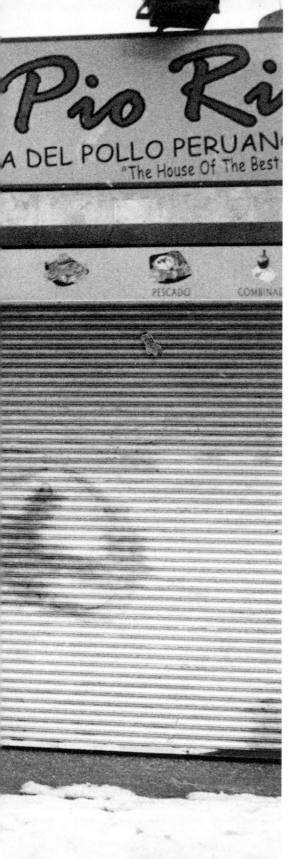

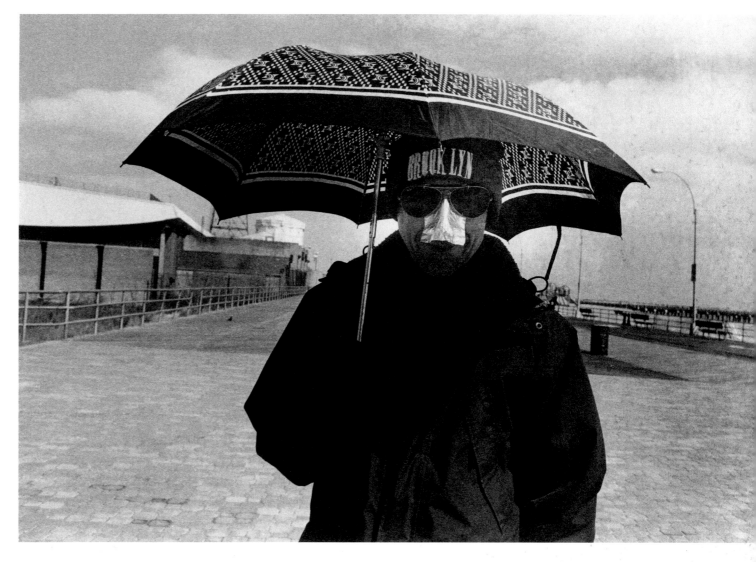

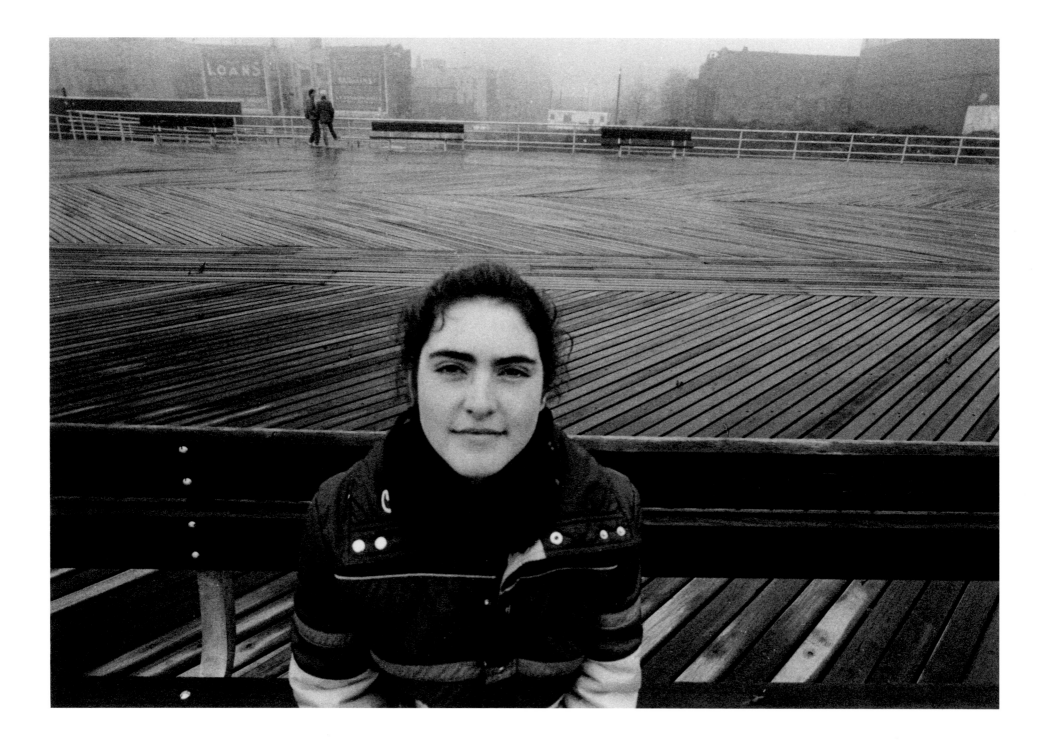

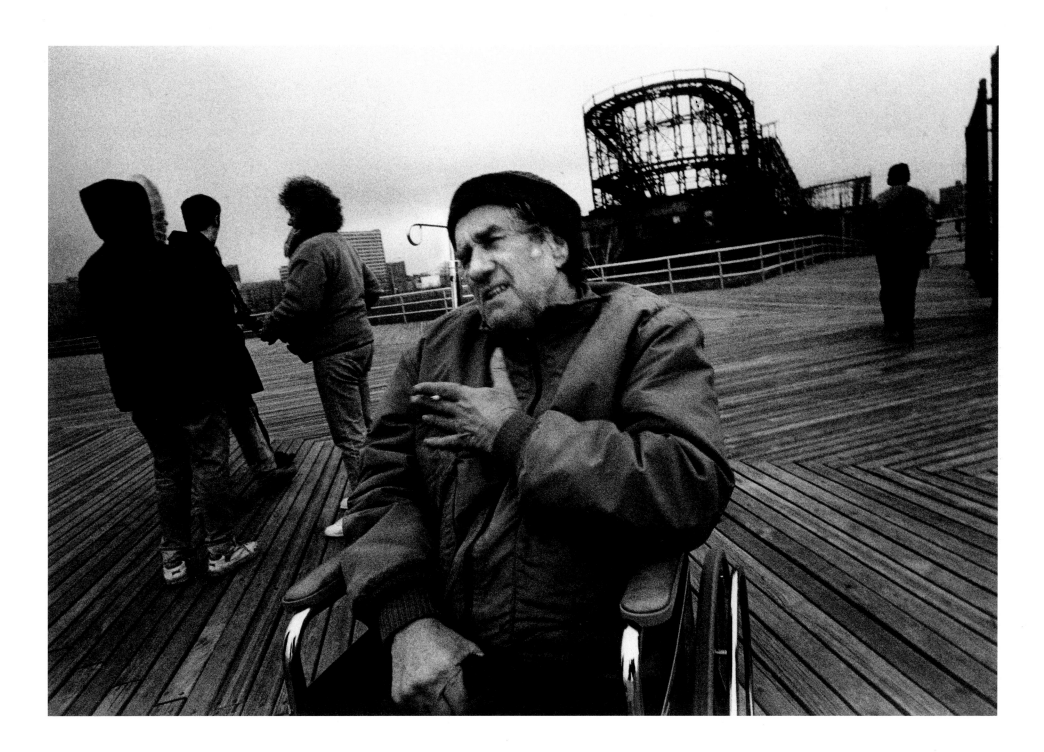

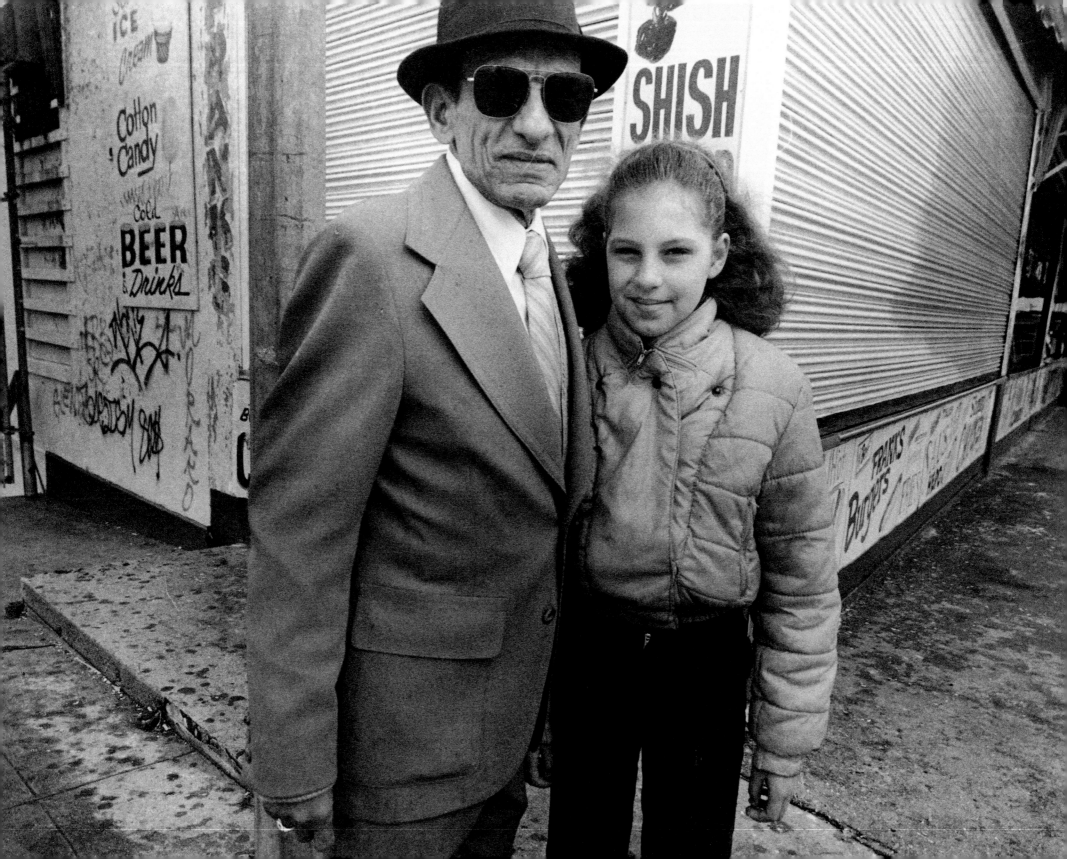

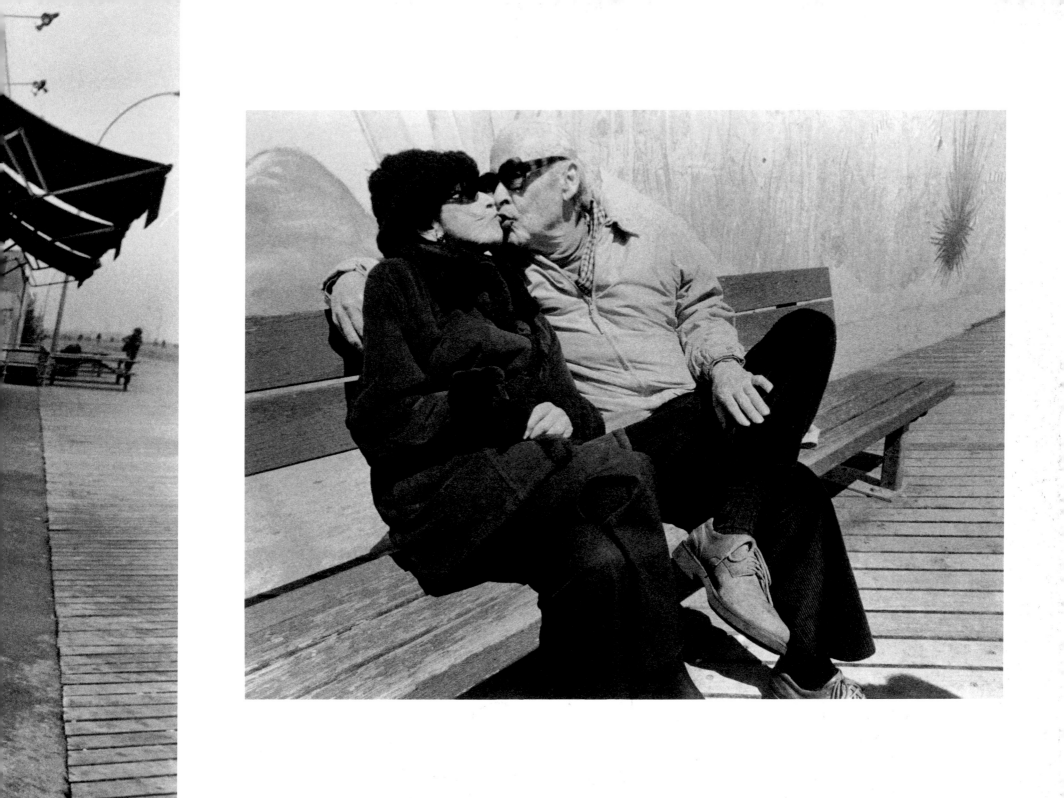

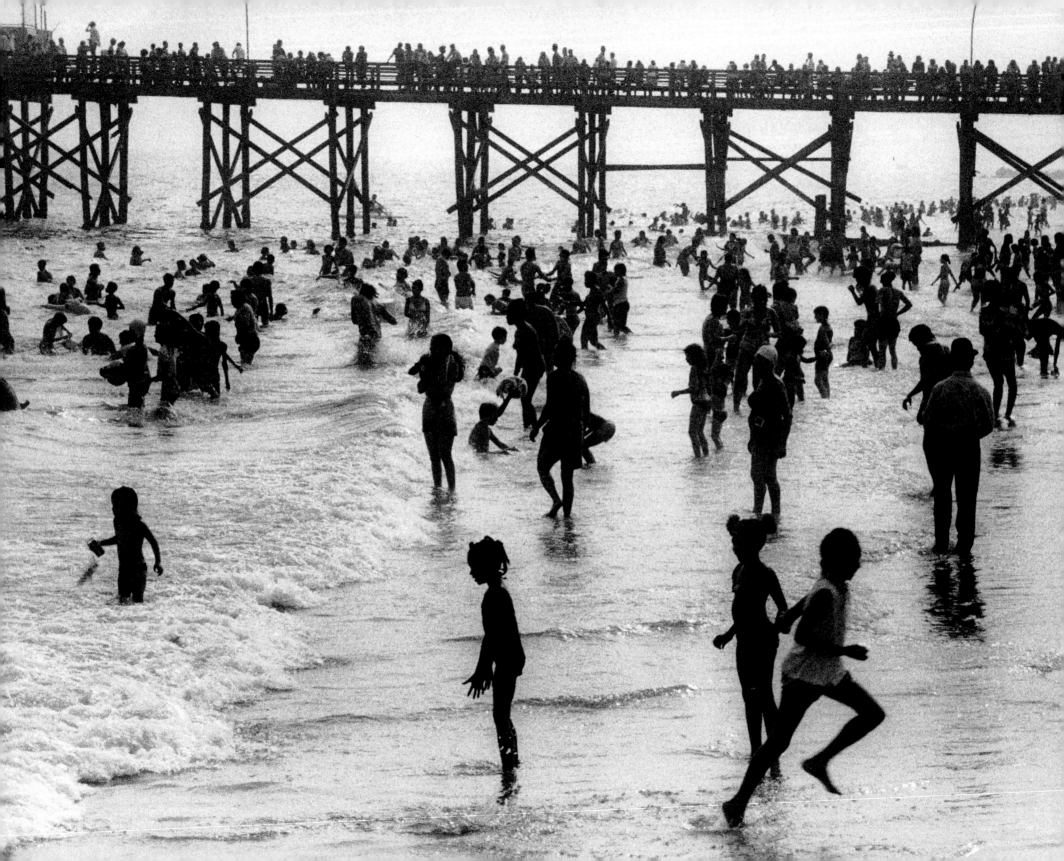

THE PIER

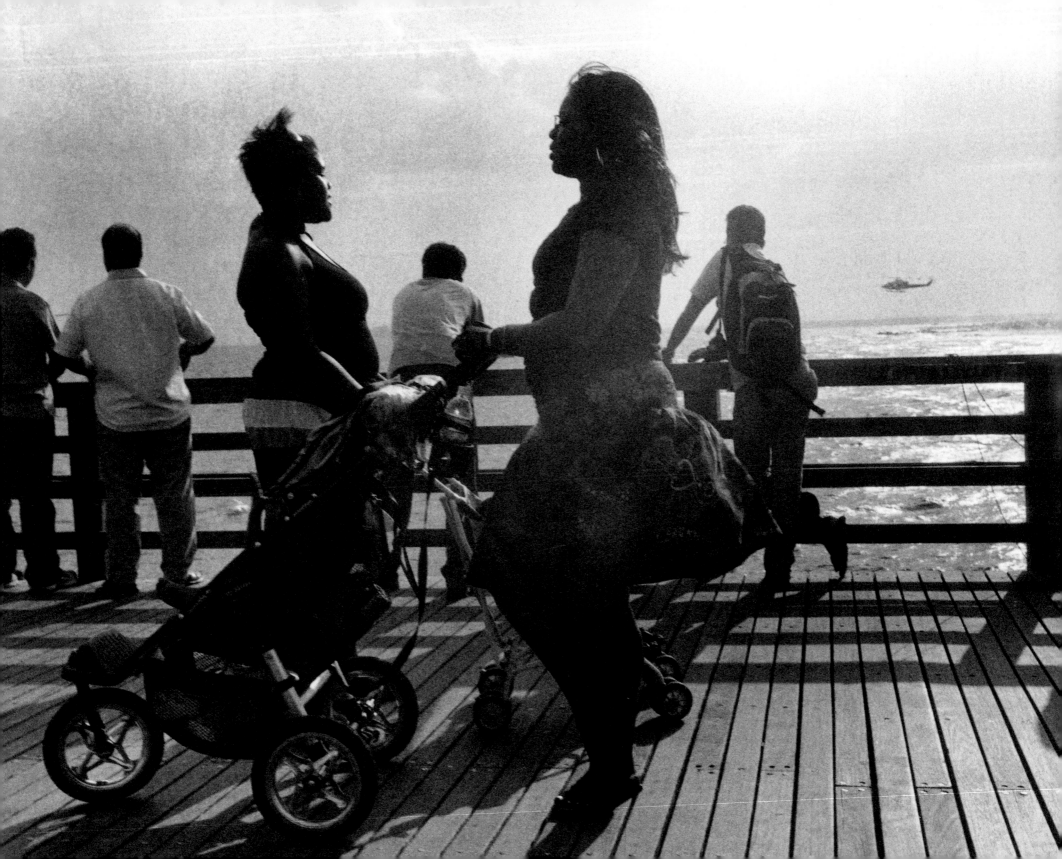

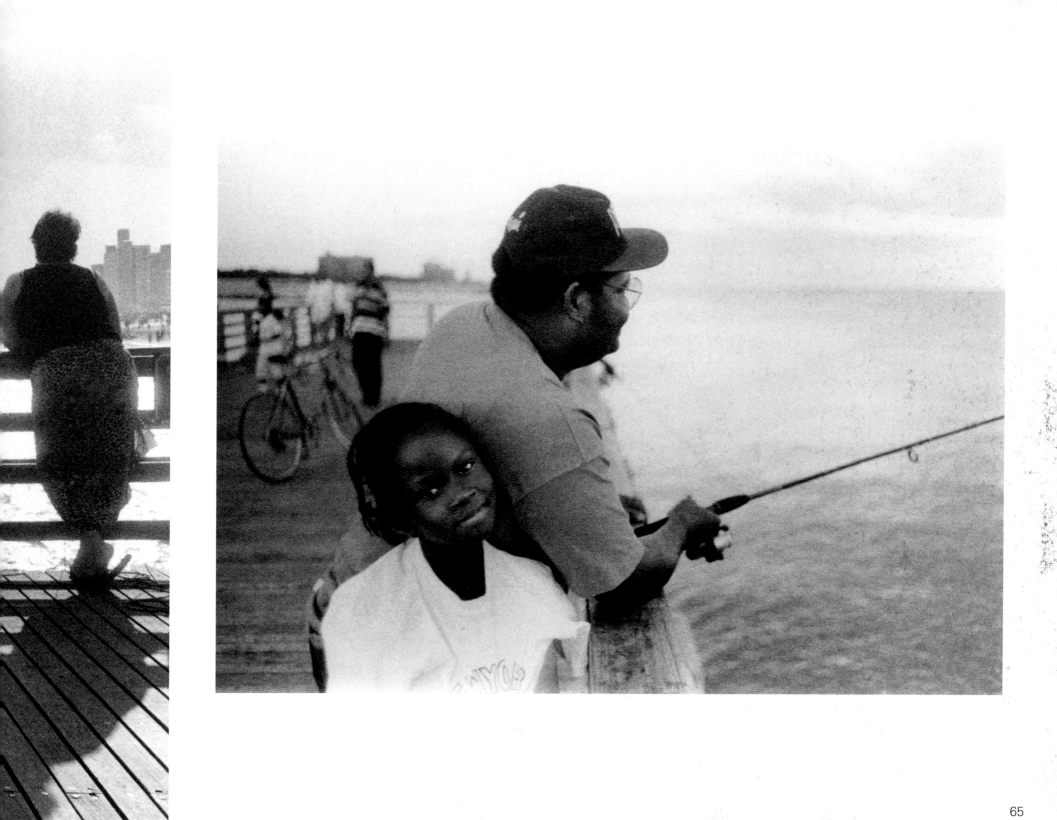

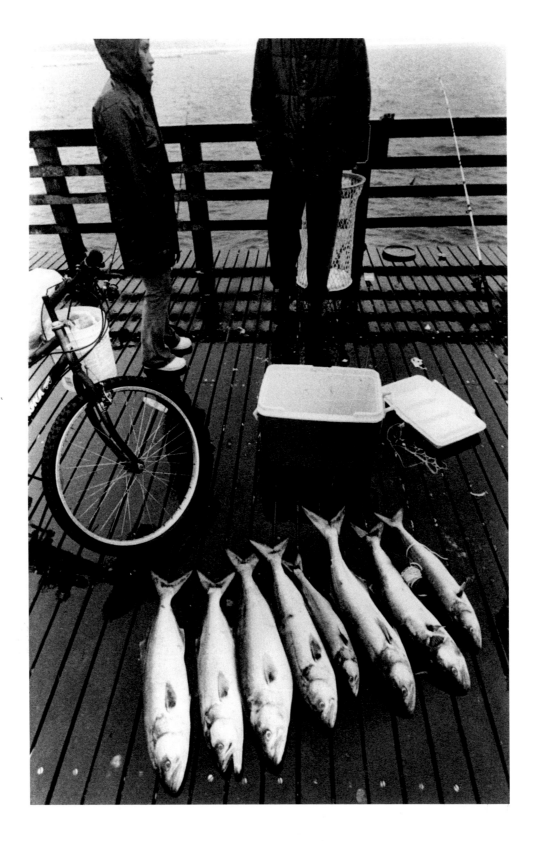

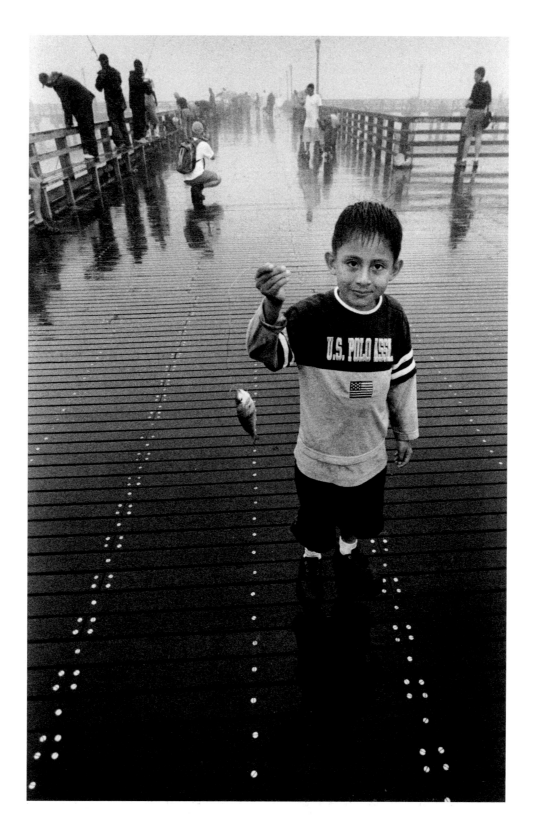

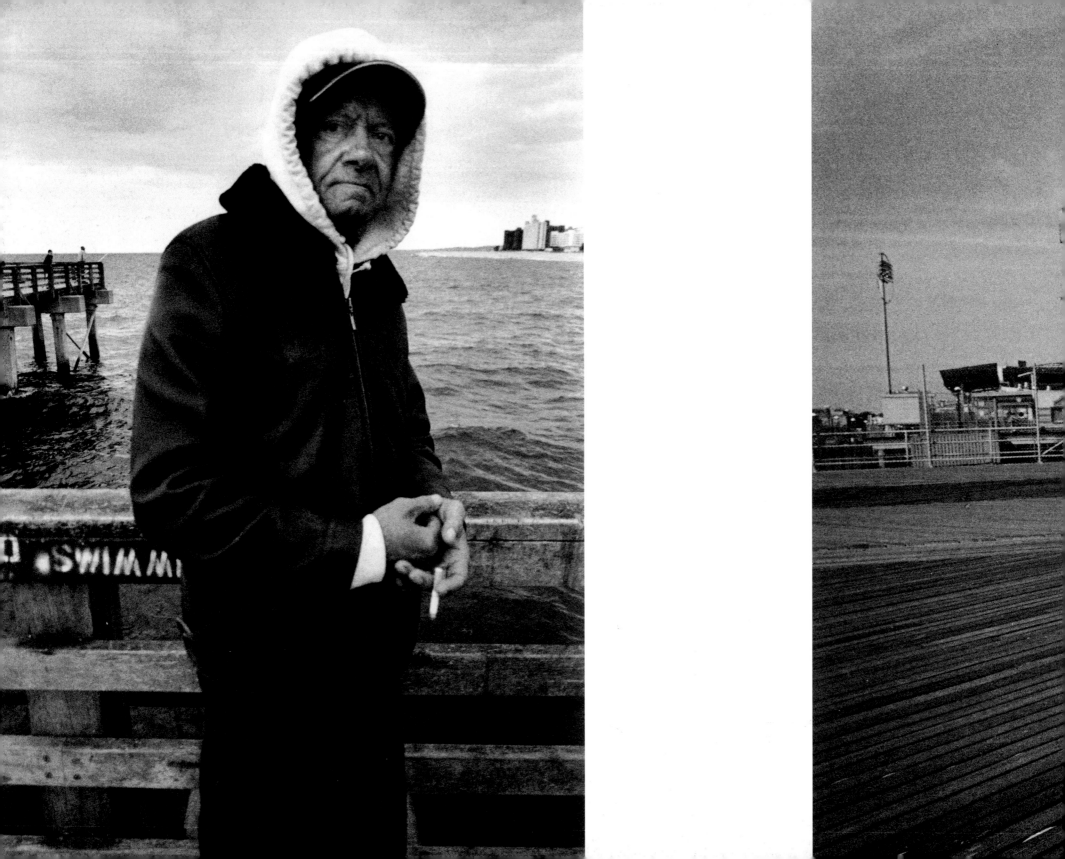

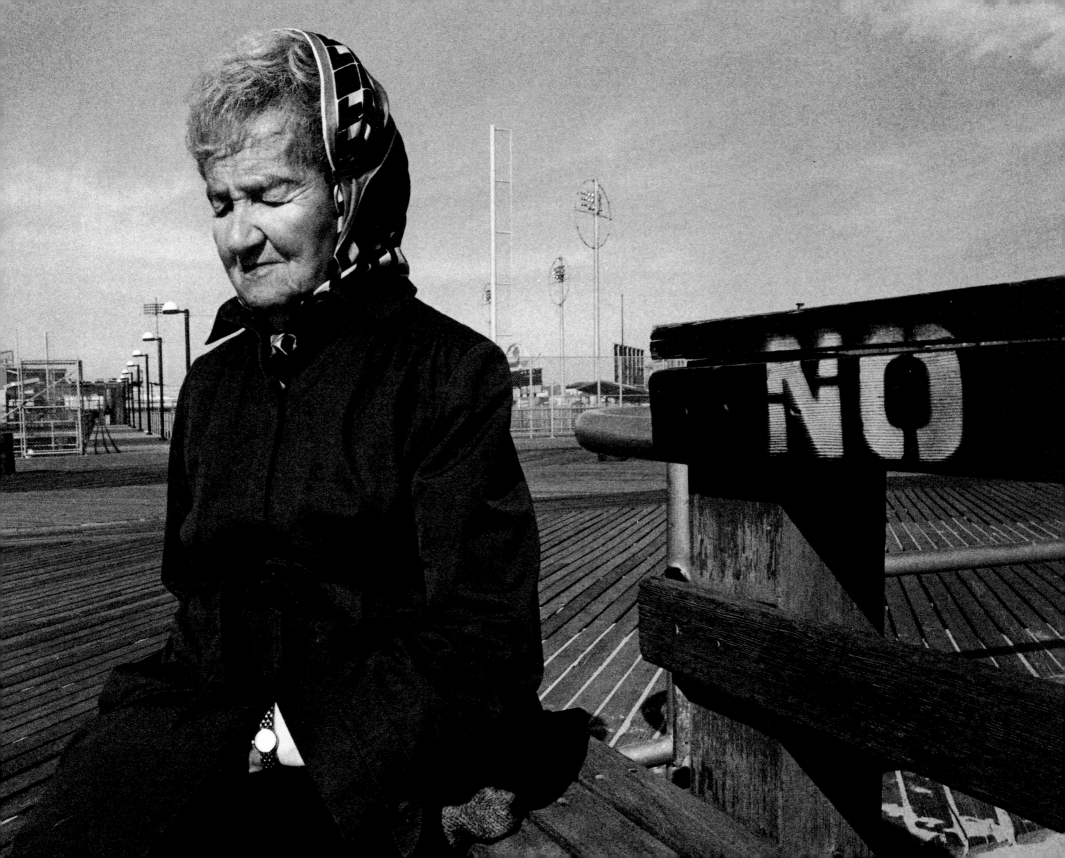

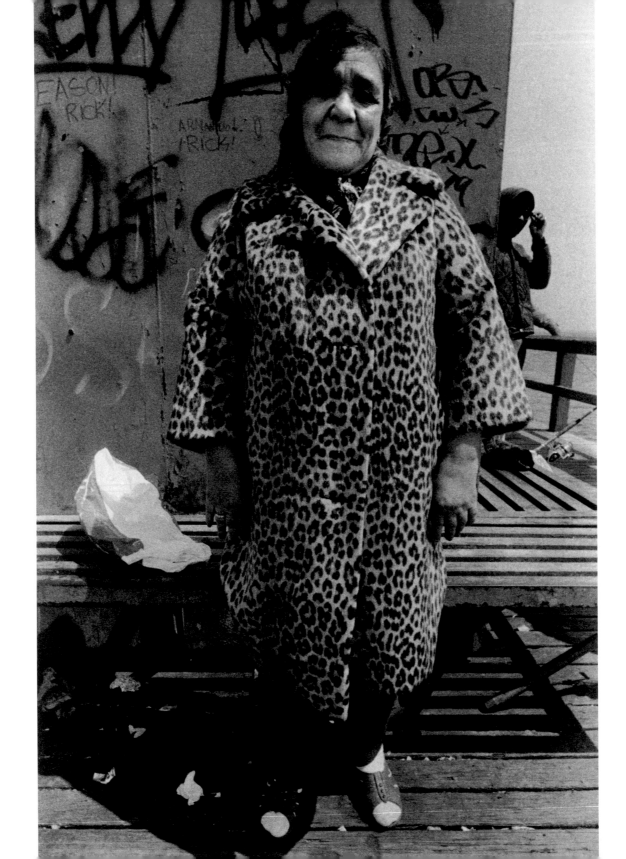

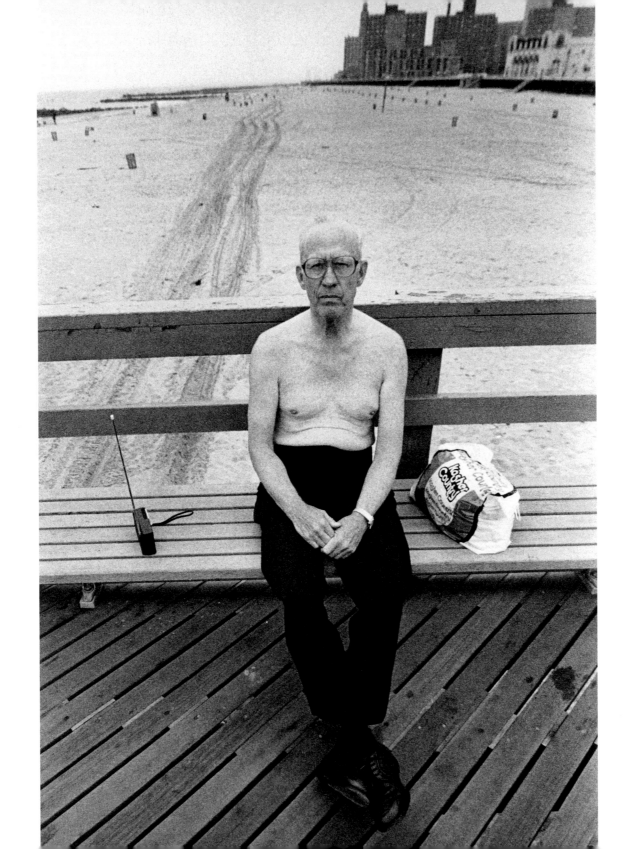

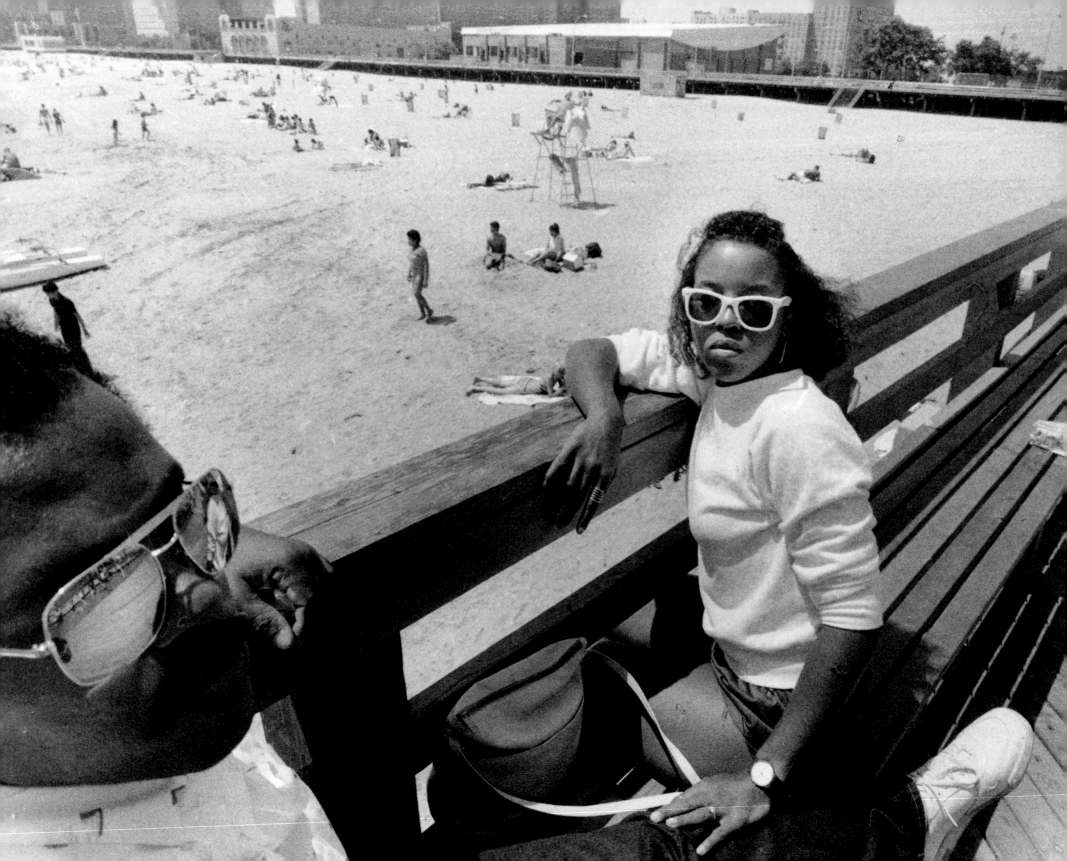

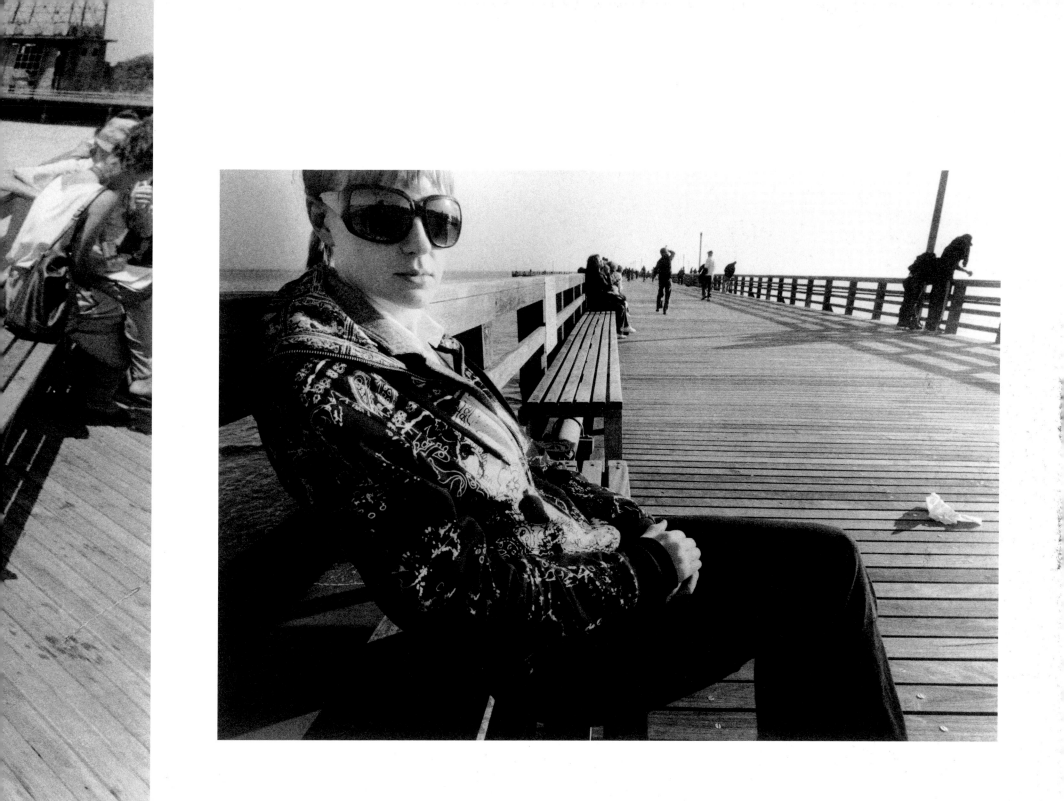

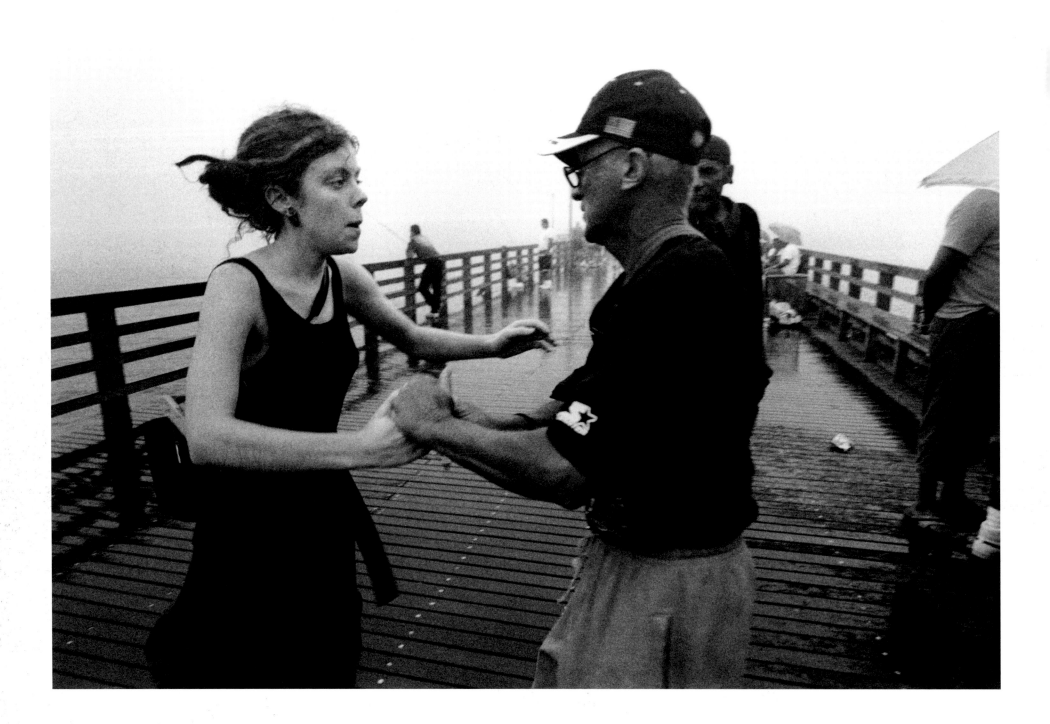

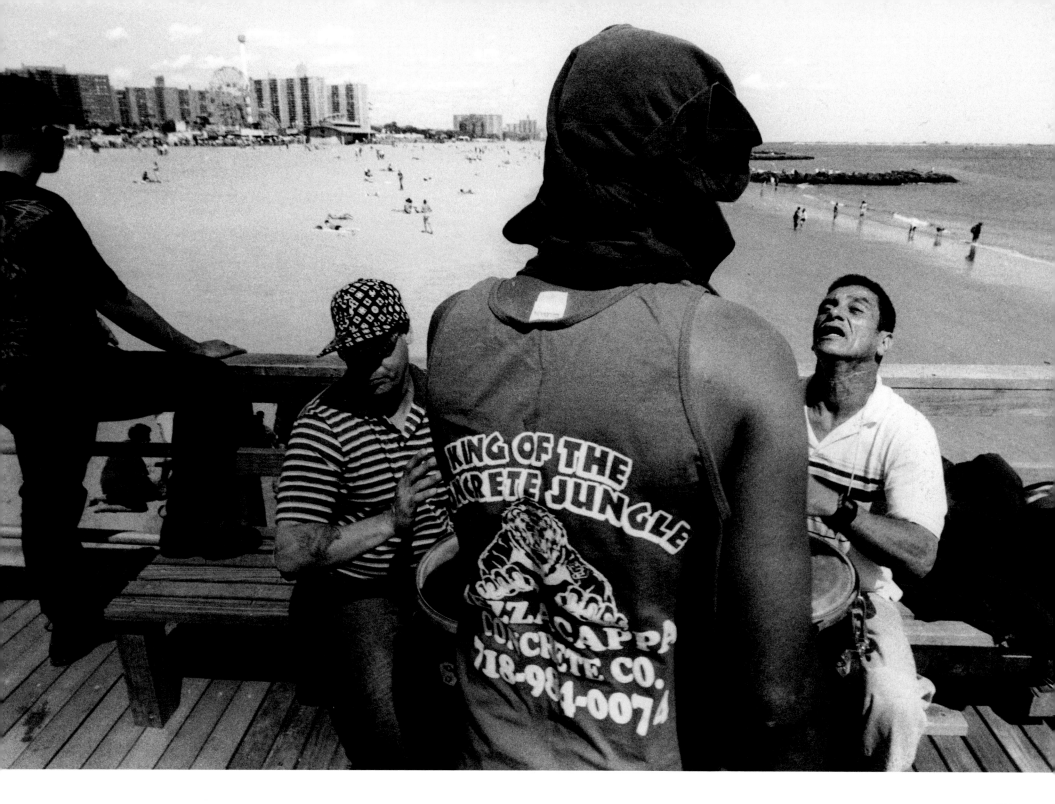

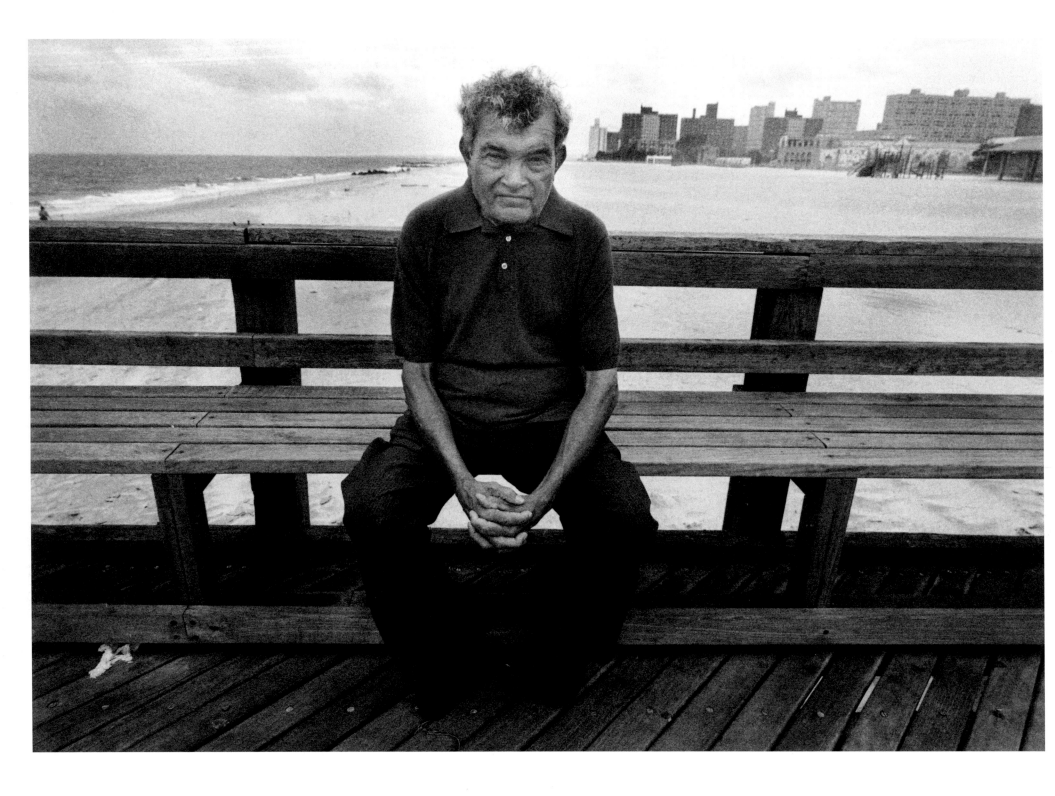

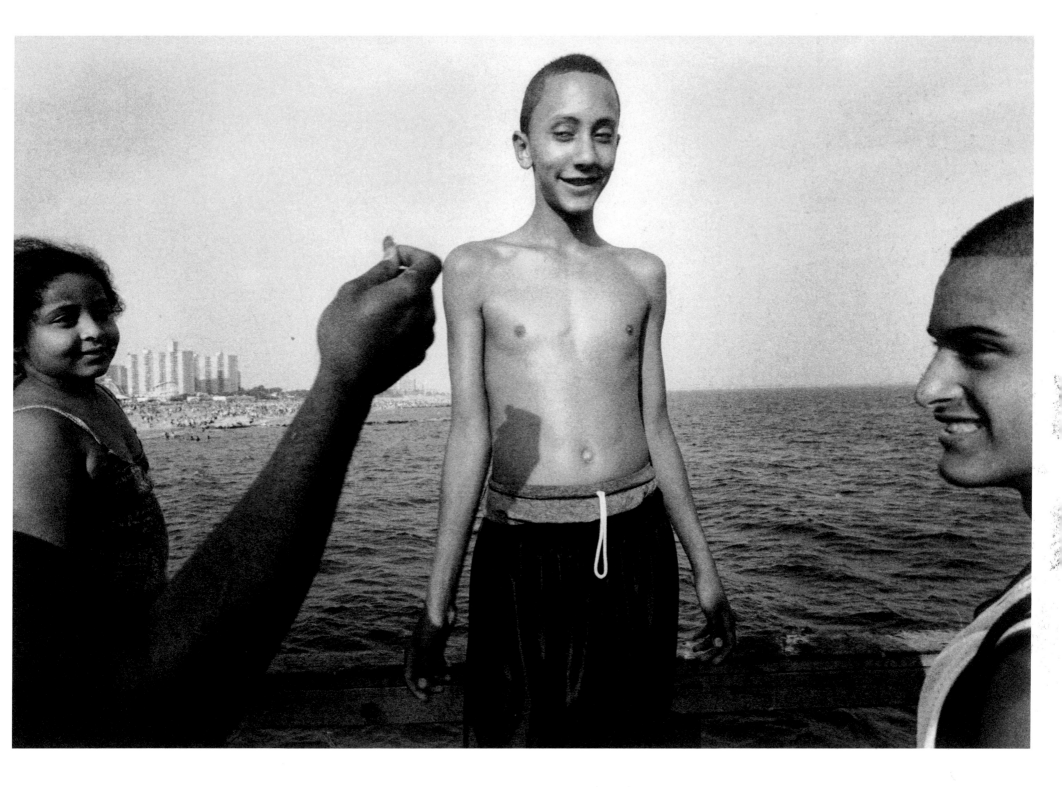

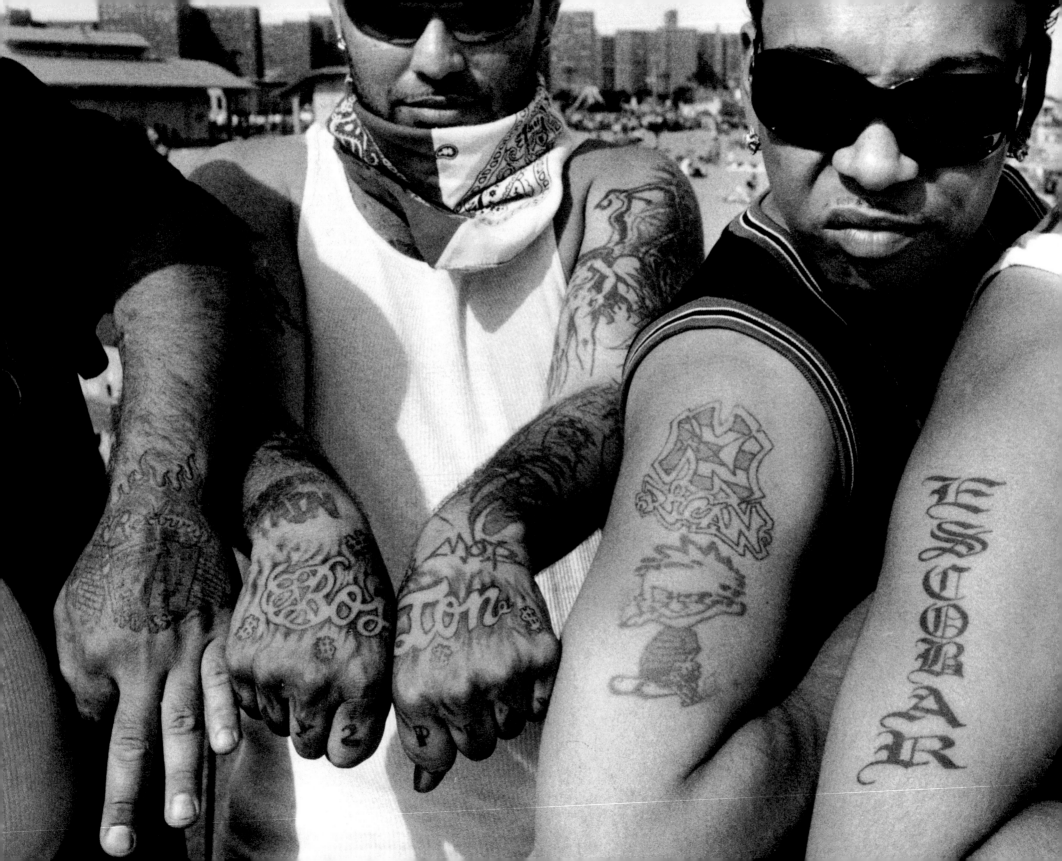

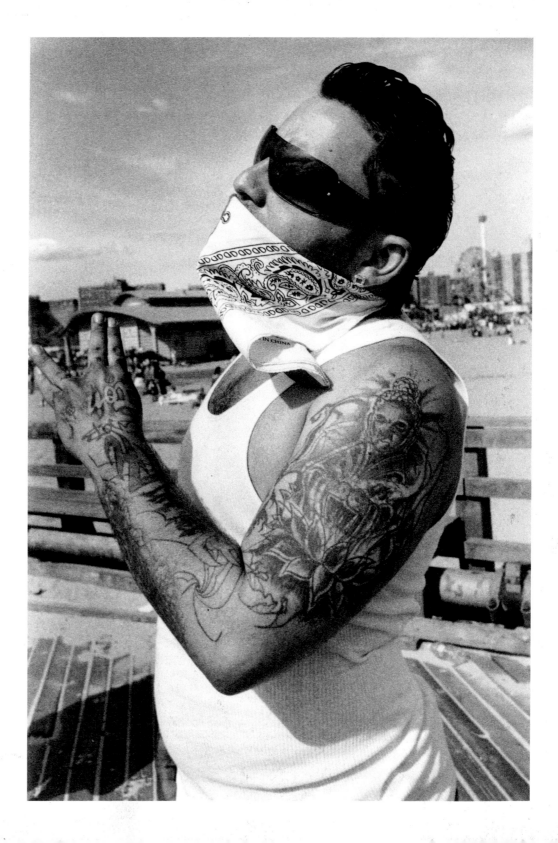

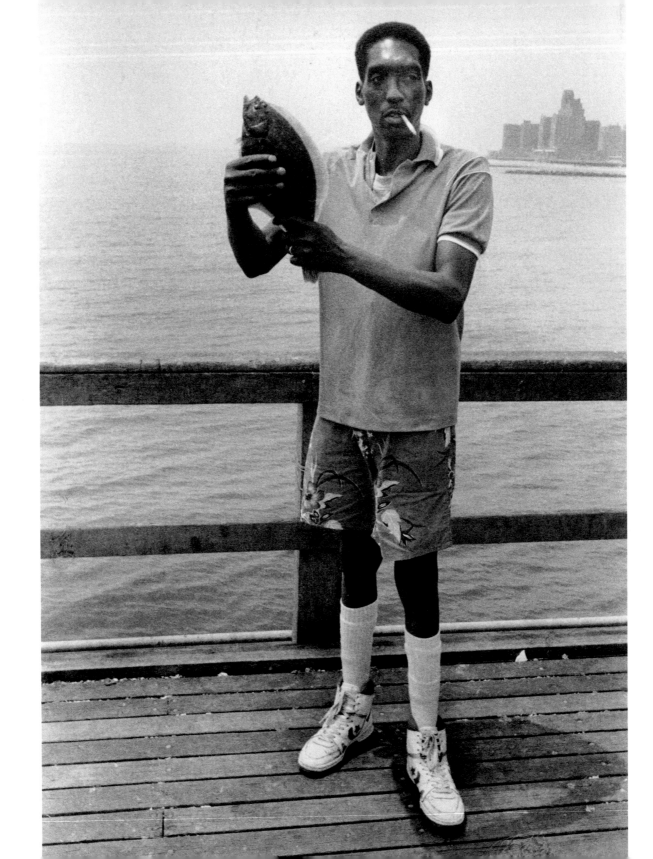

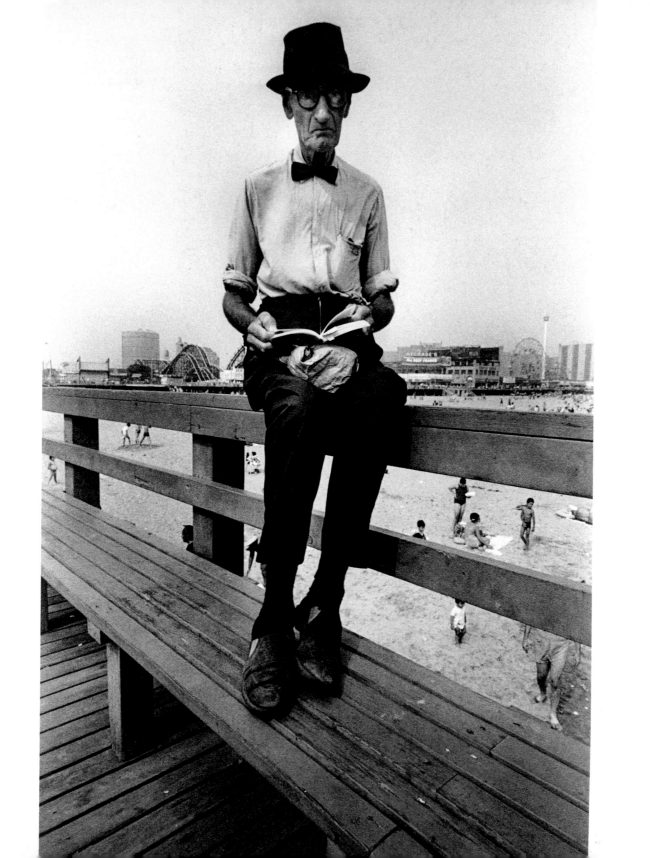

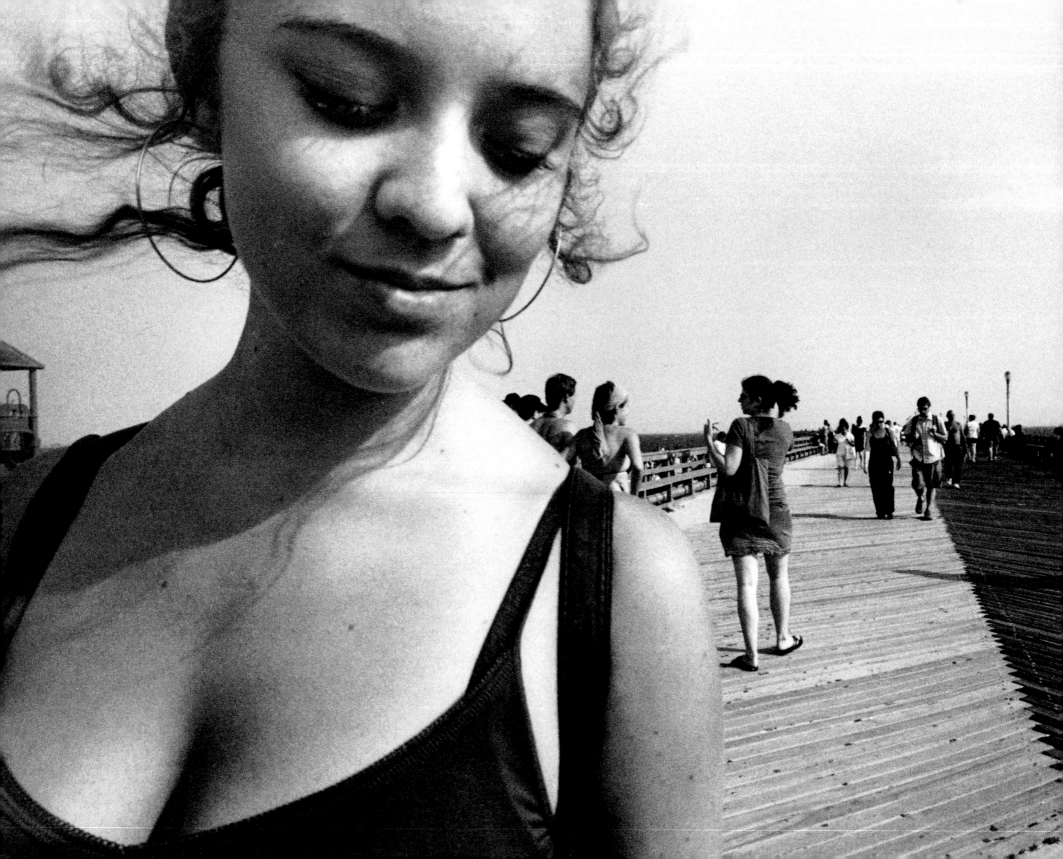

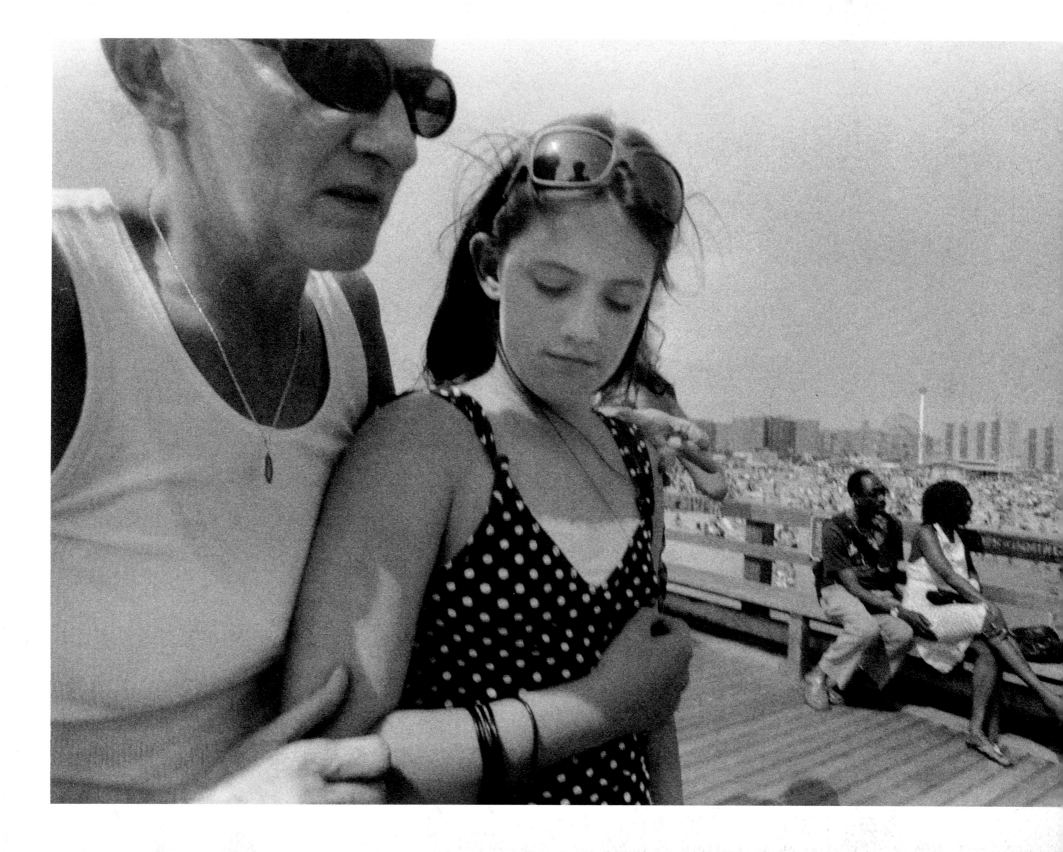

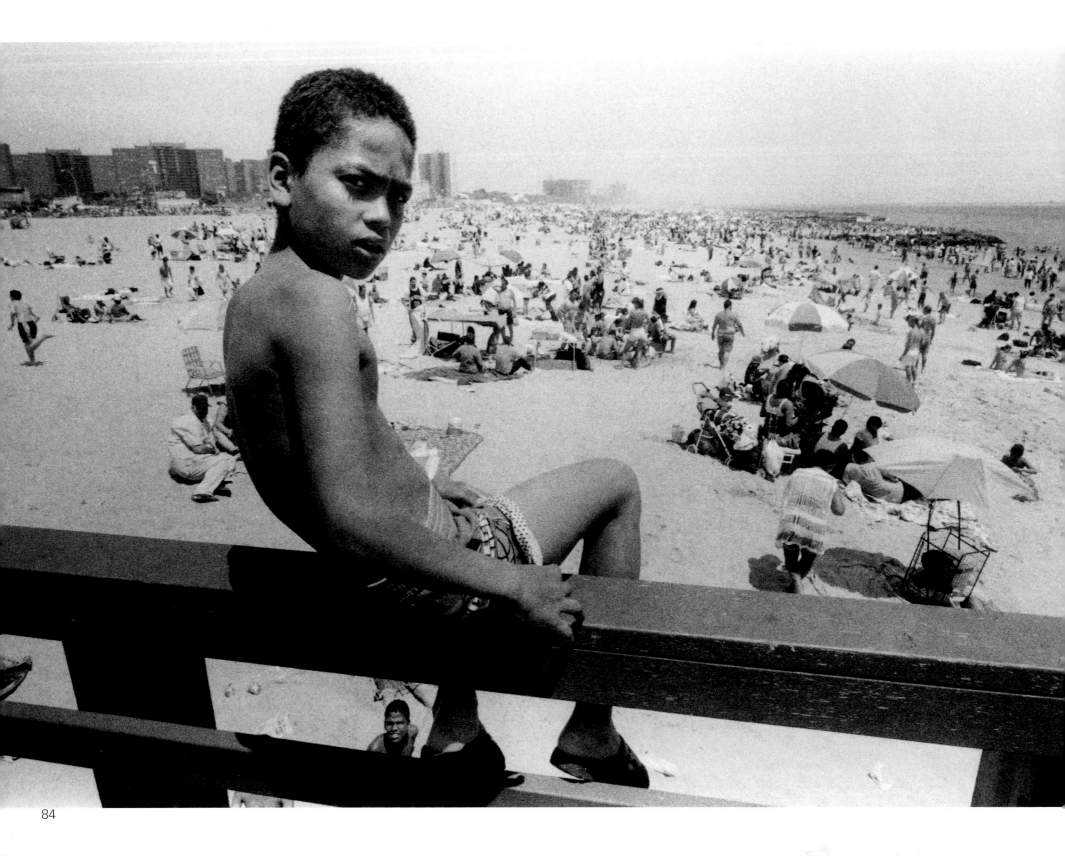

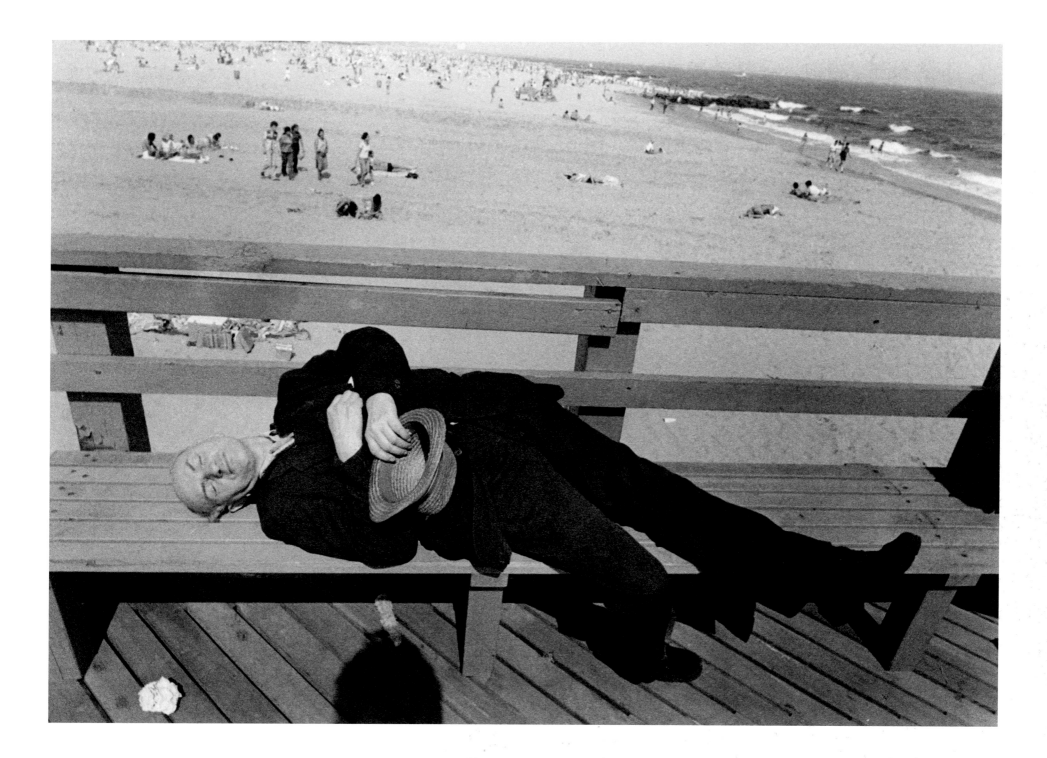

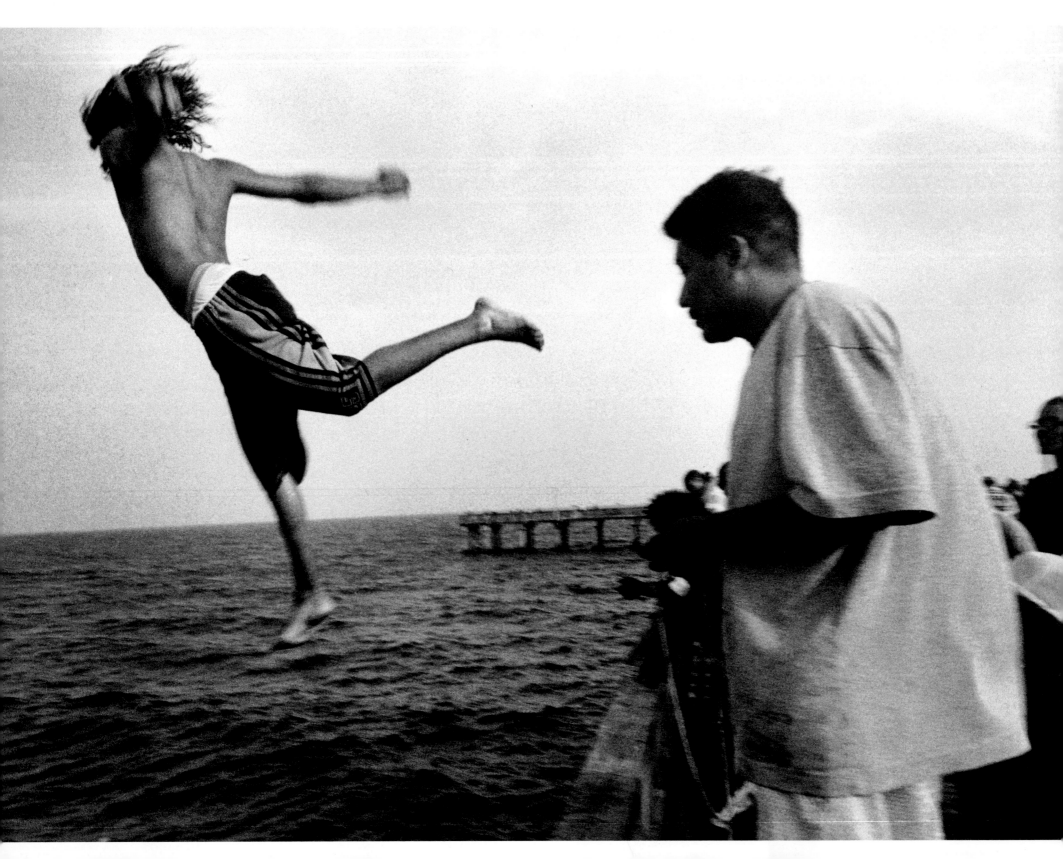

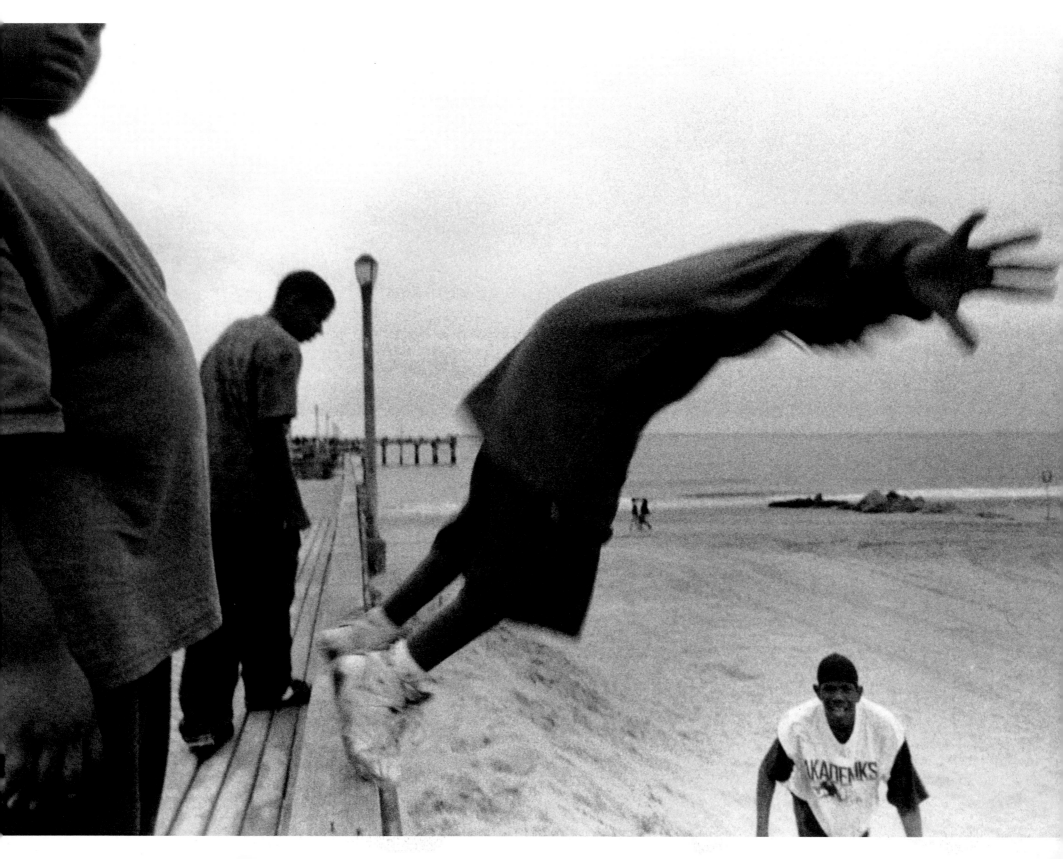

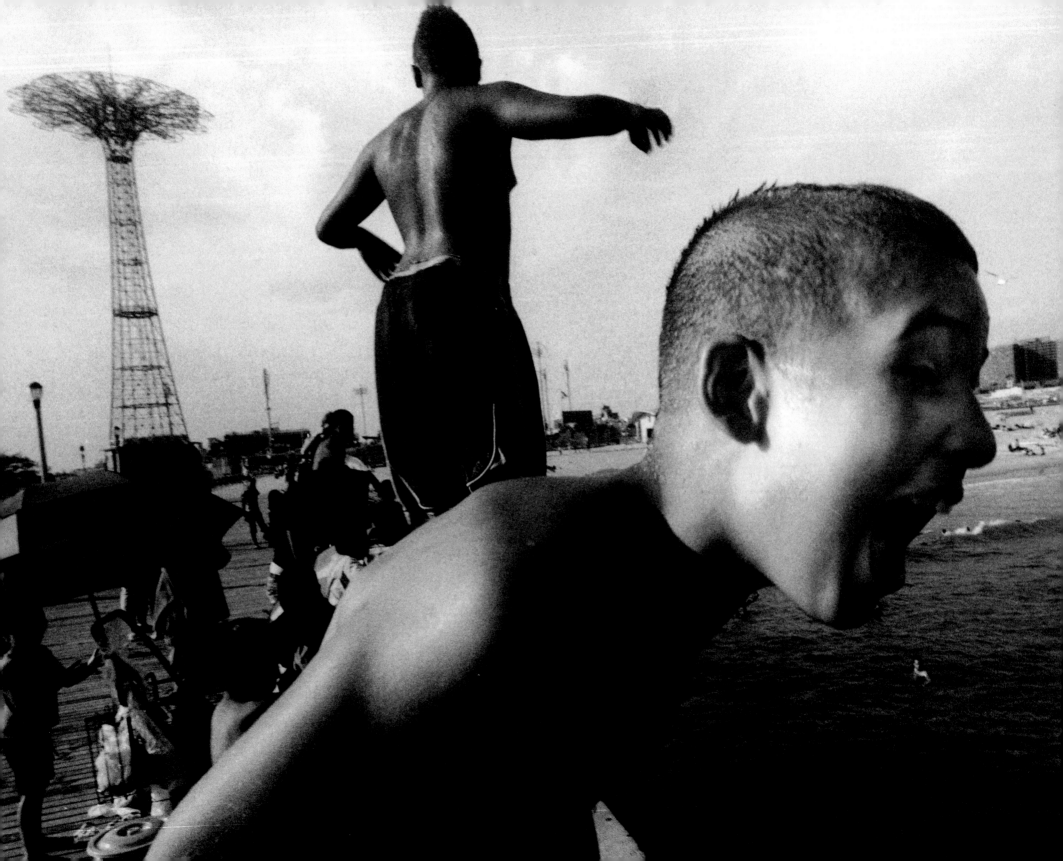

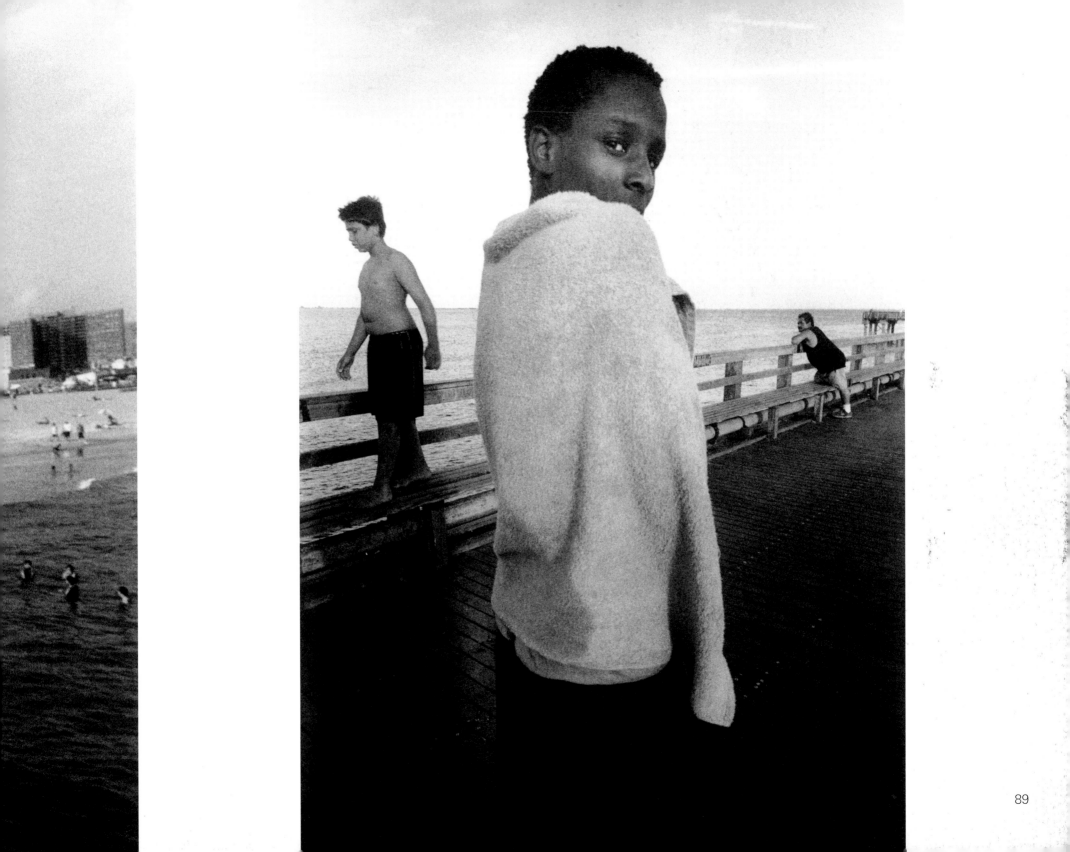

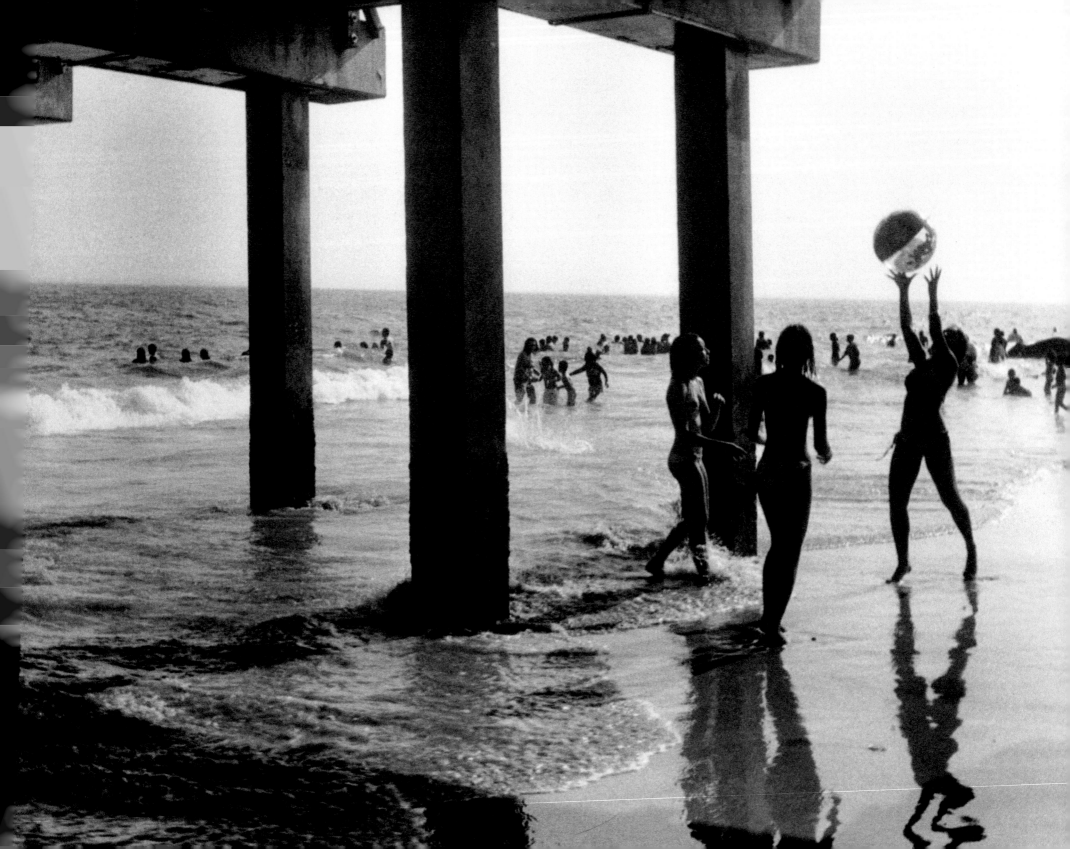

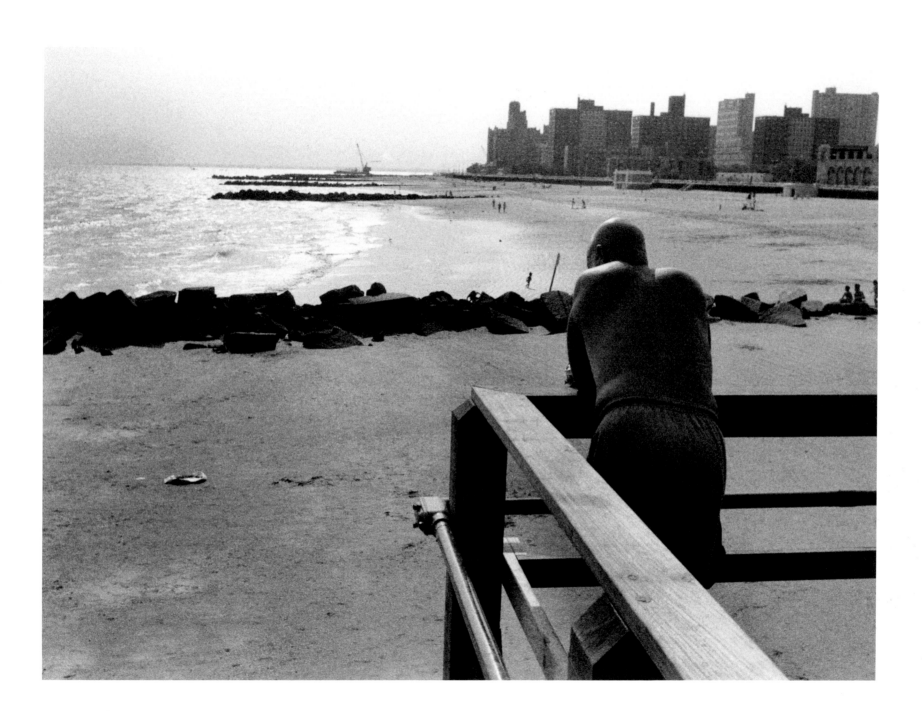

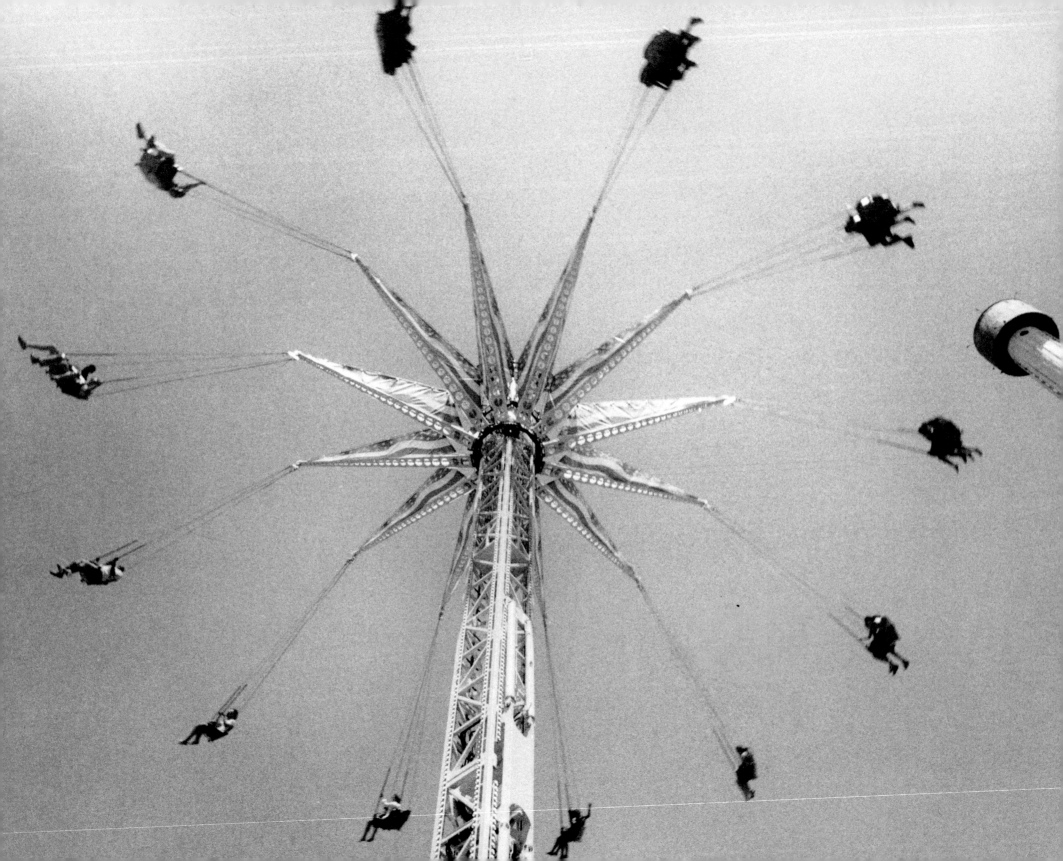

THE AMUSEMENTS

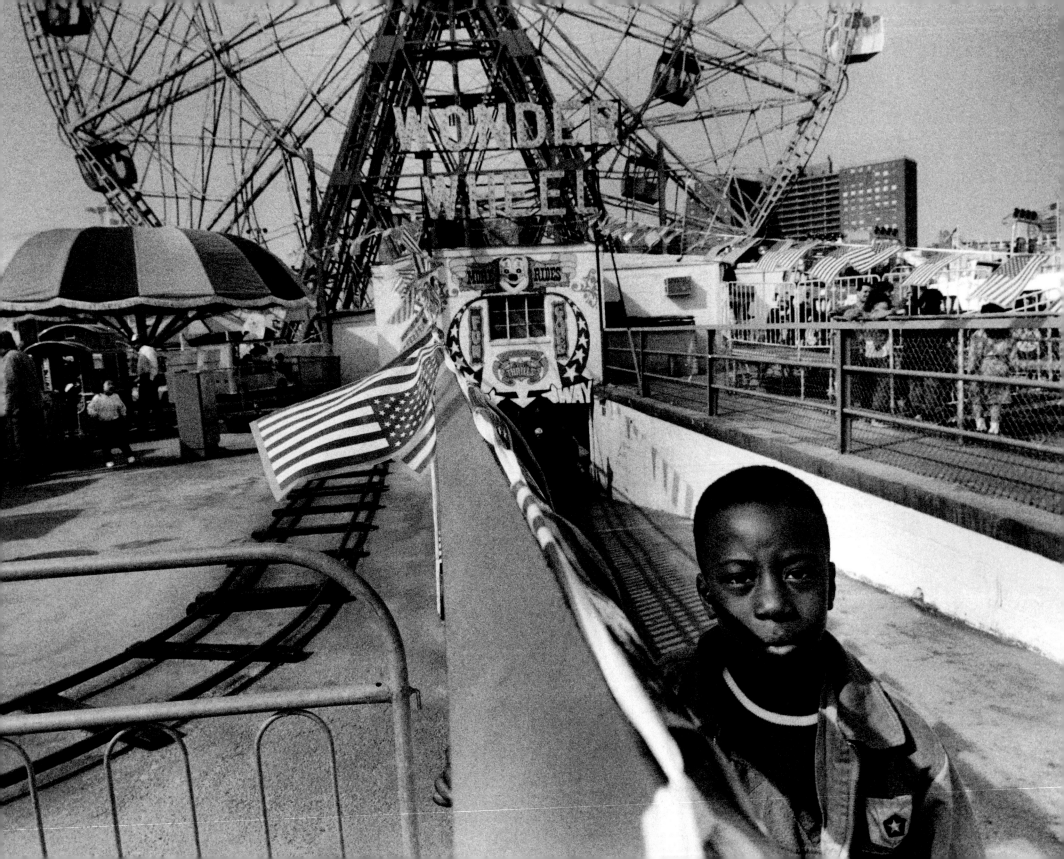

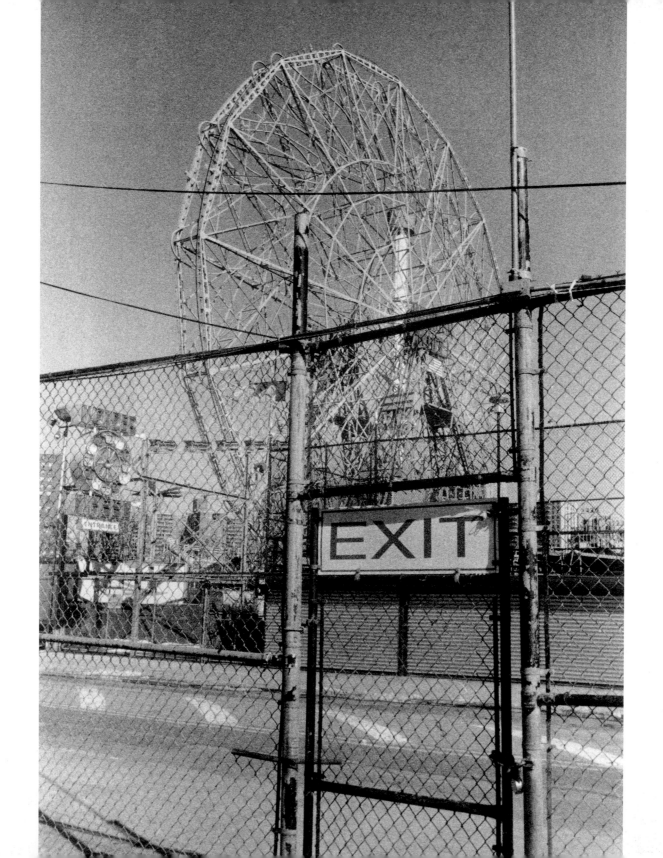

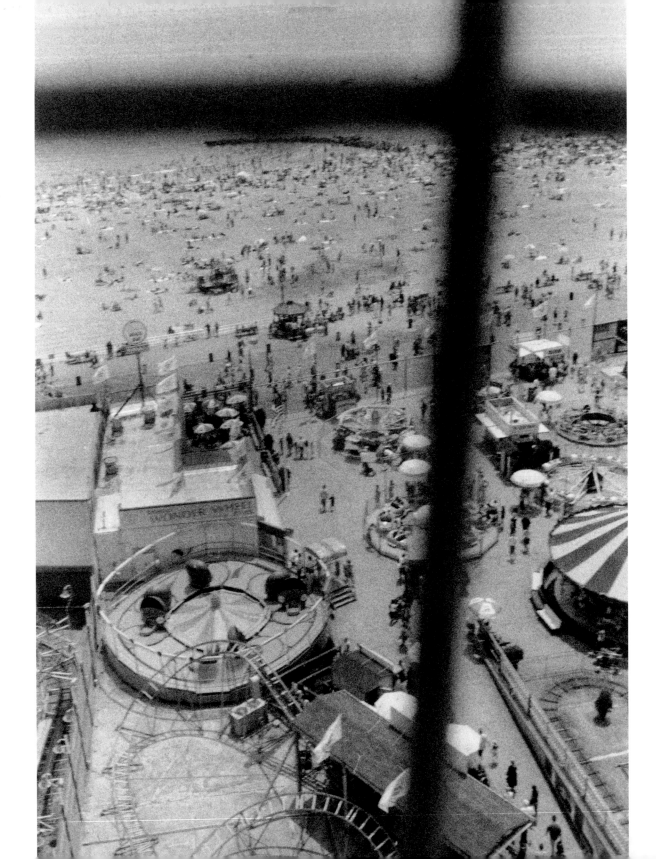

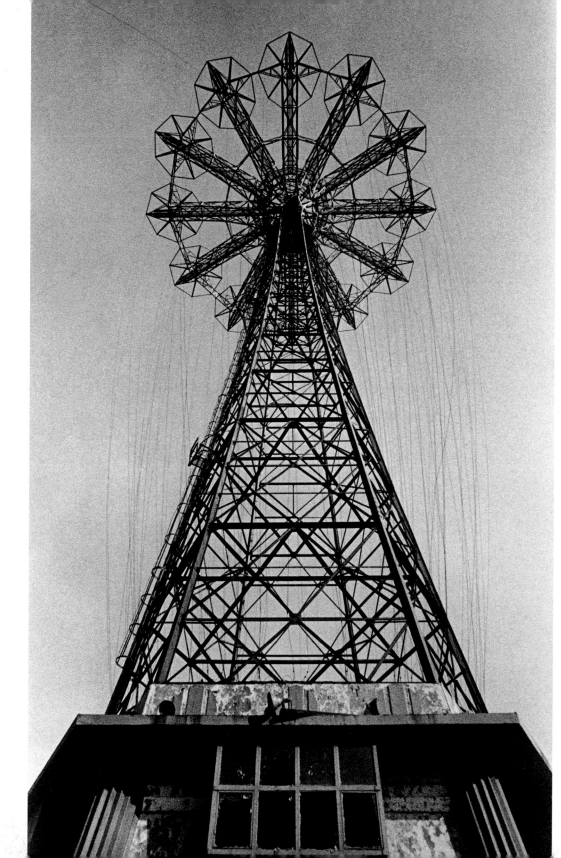

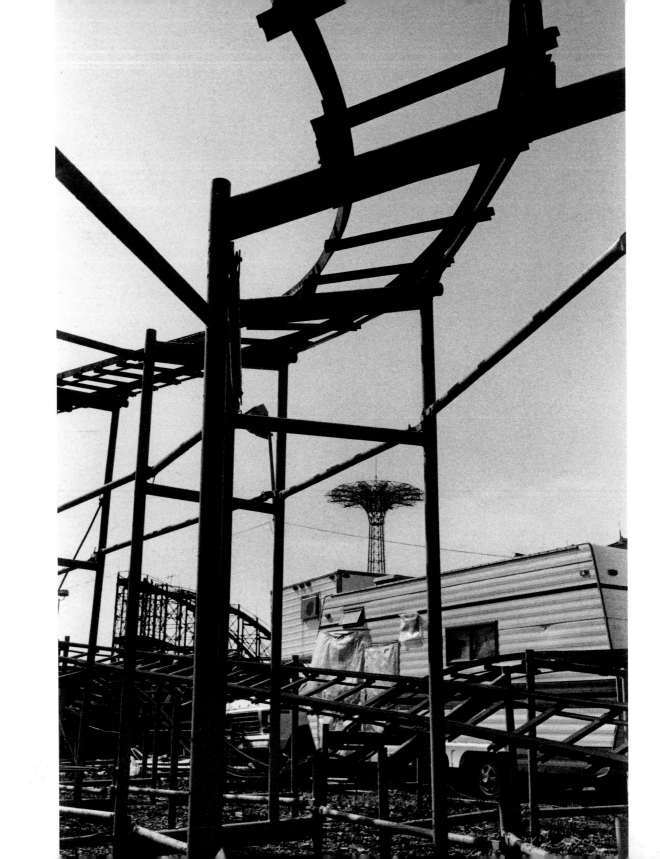

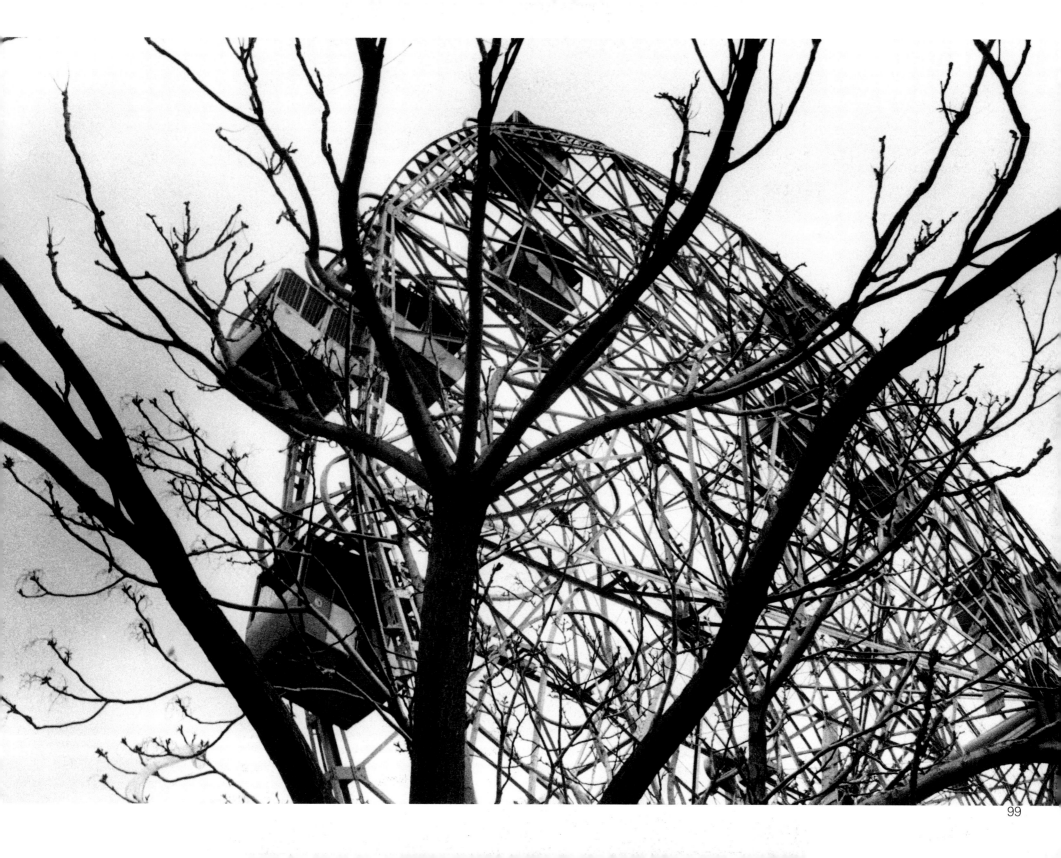

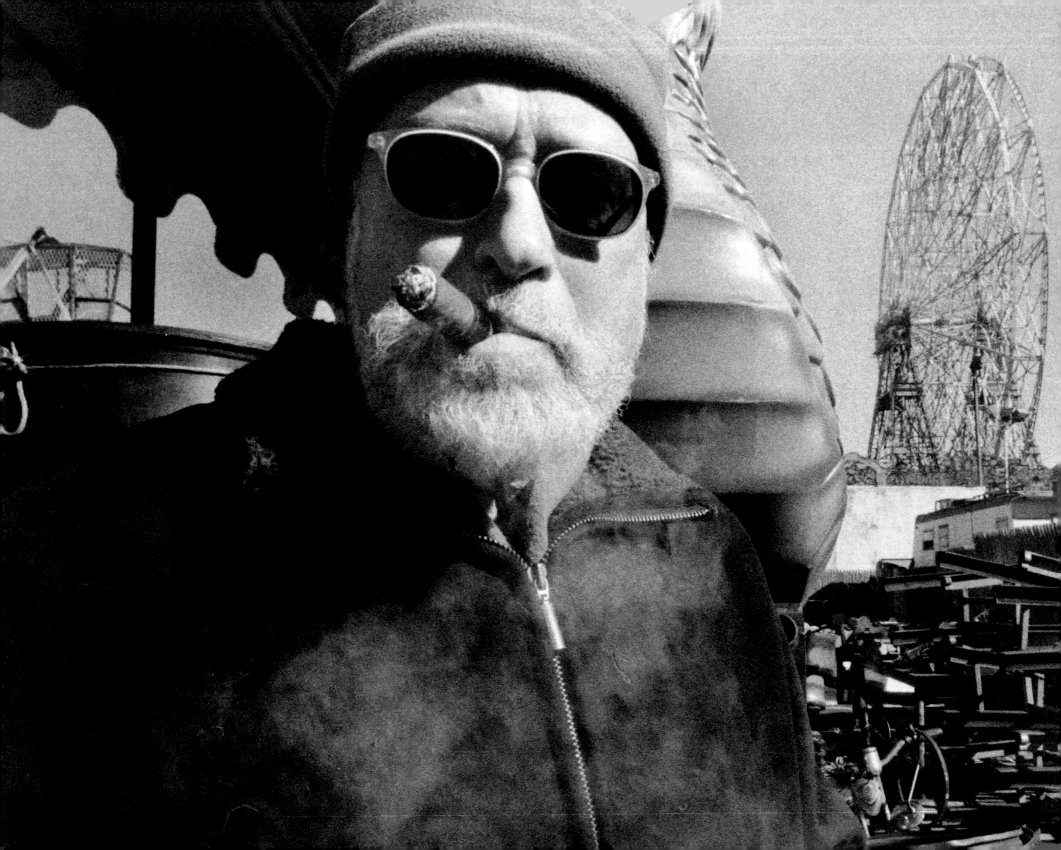

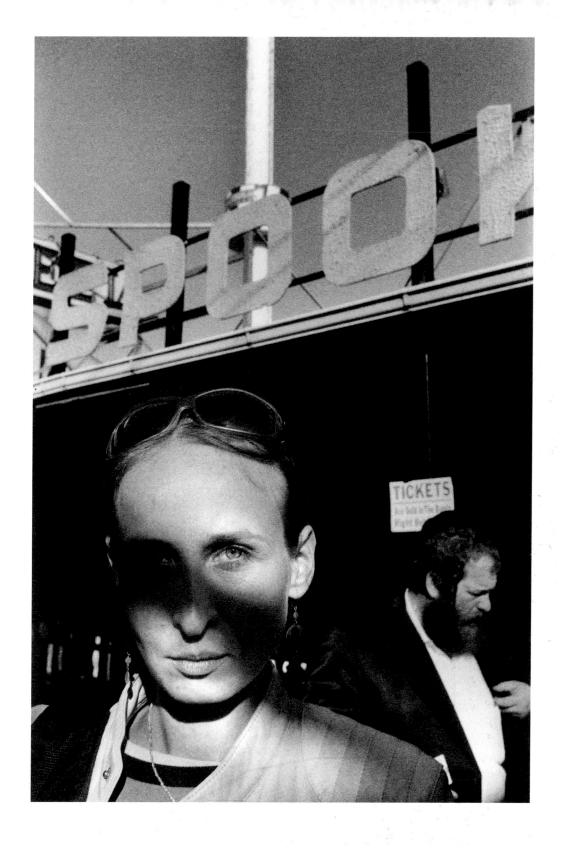

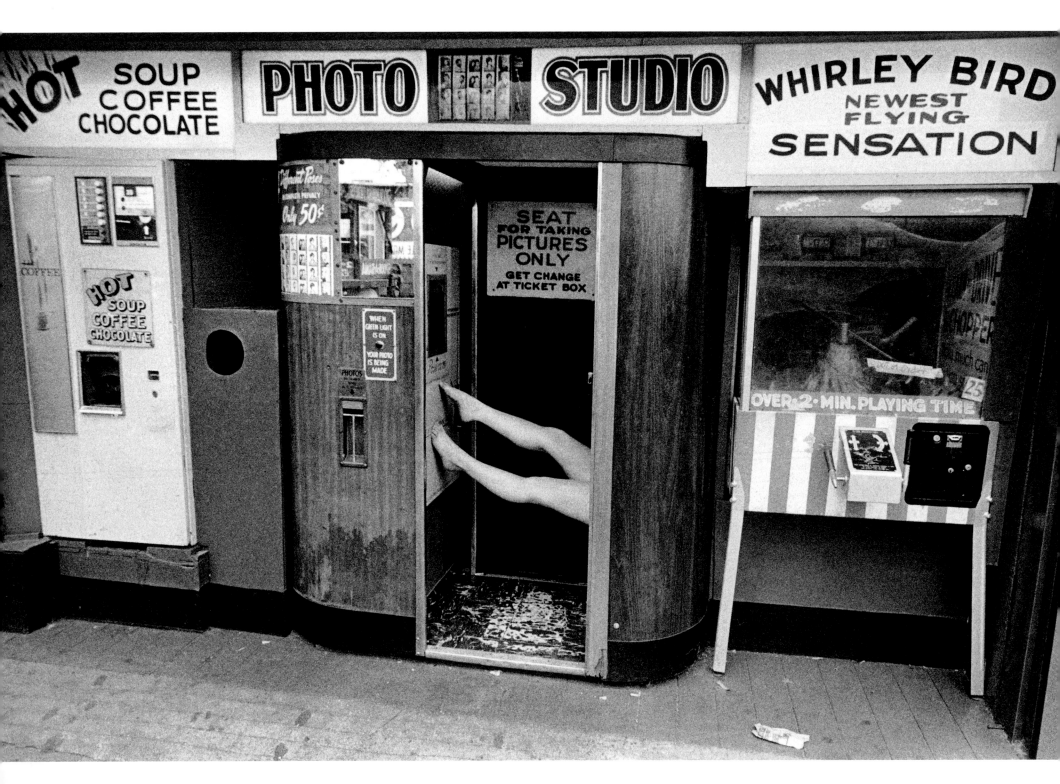

102

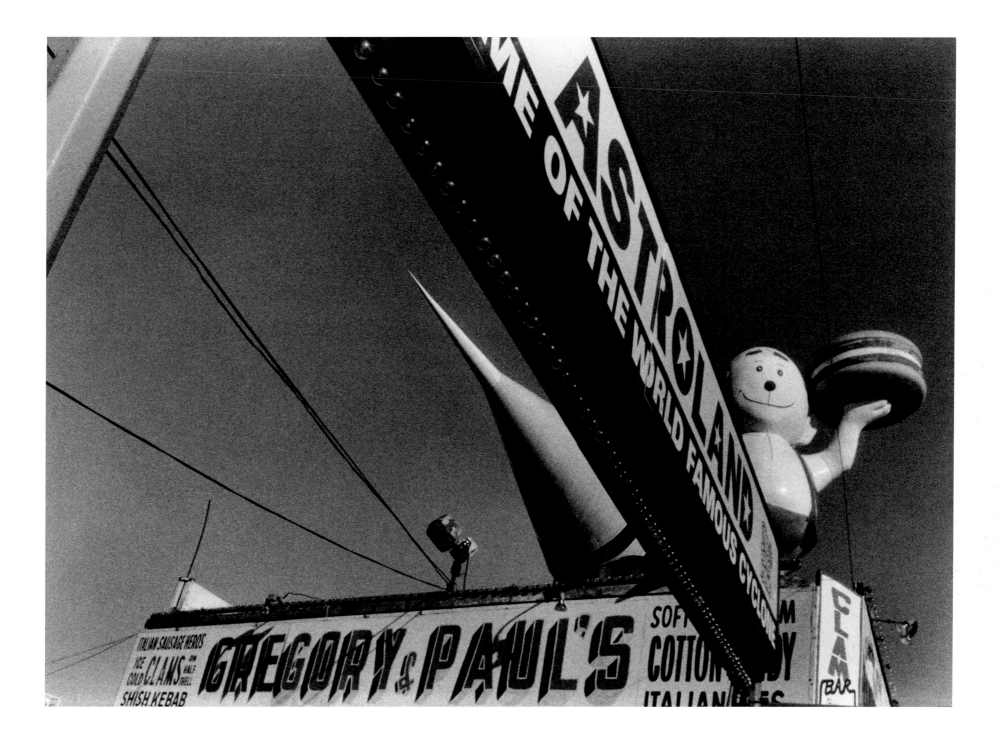

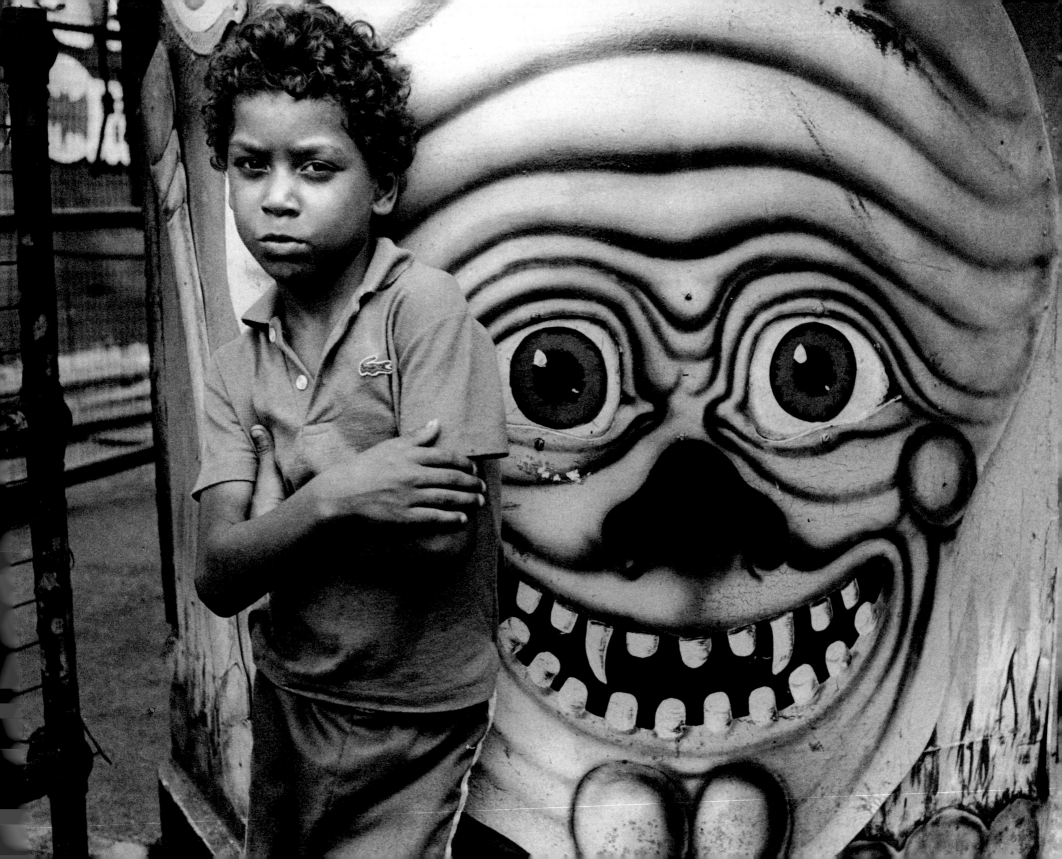

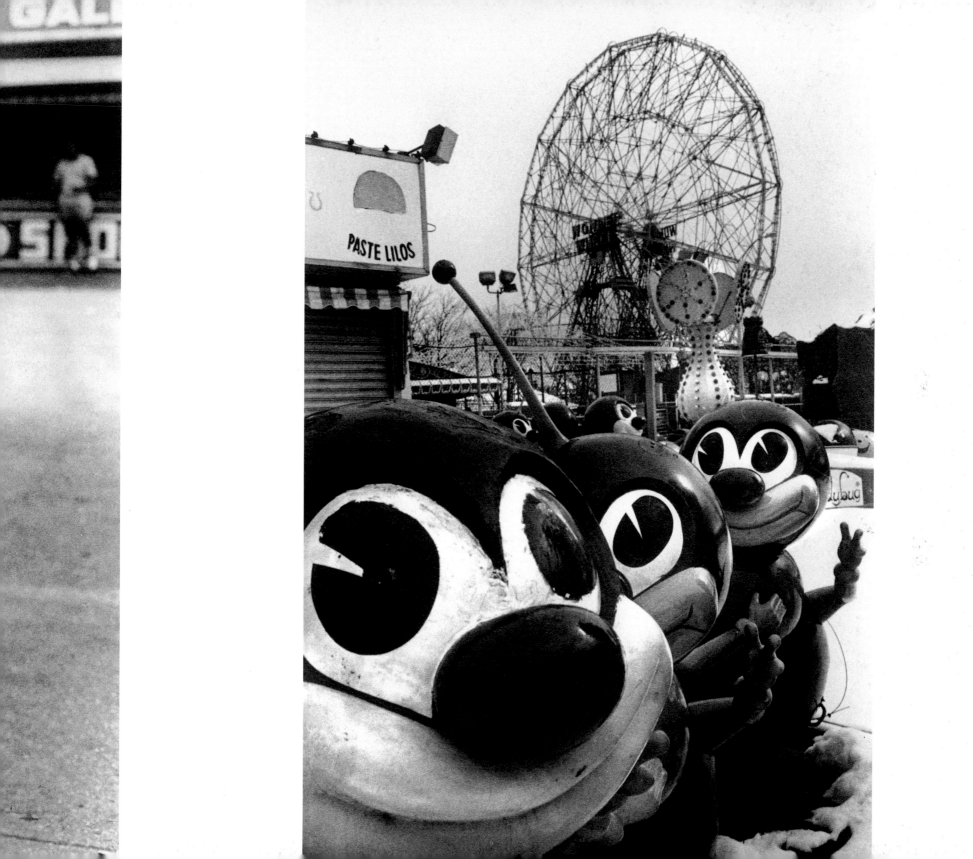

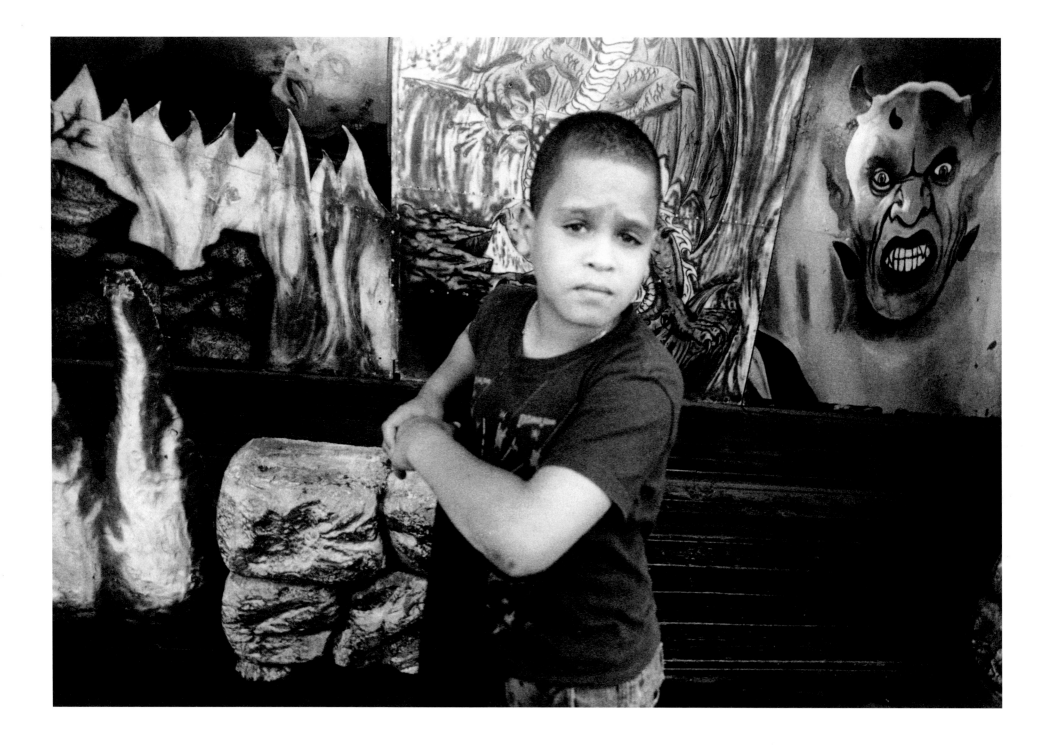

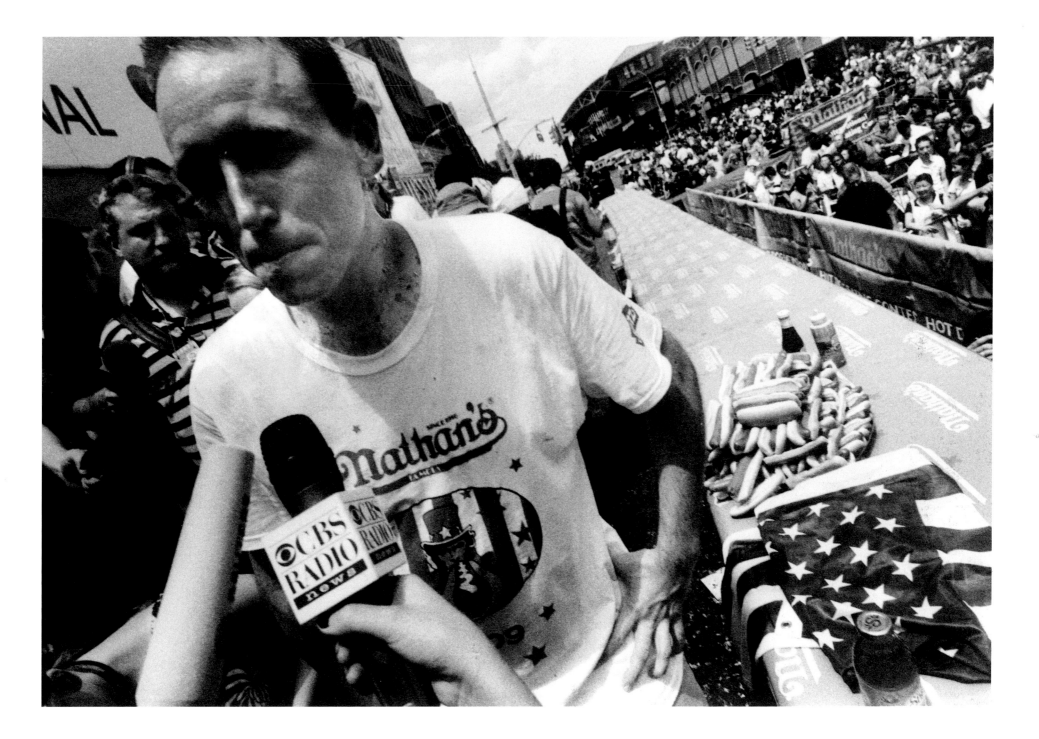

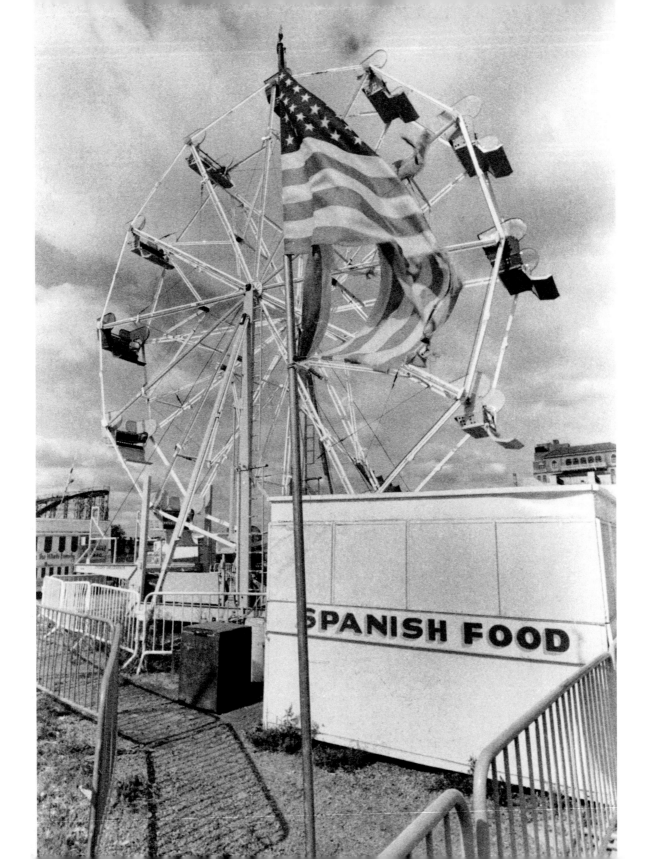

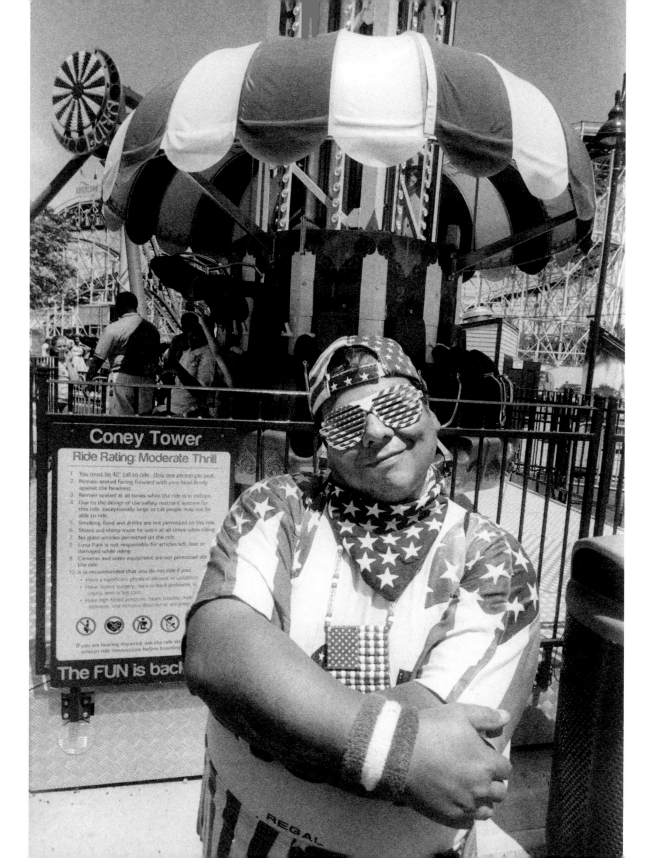

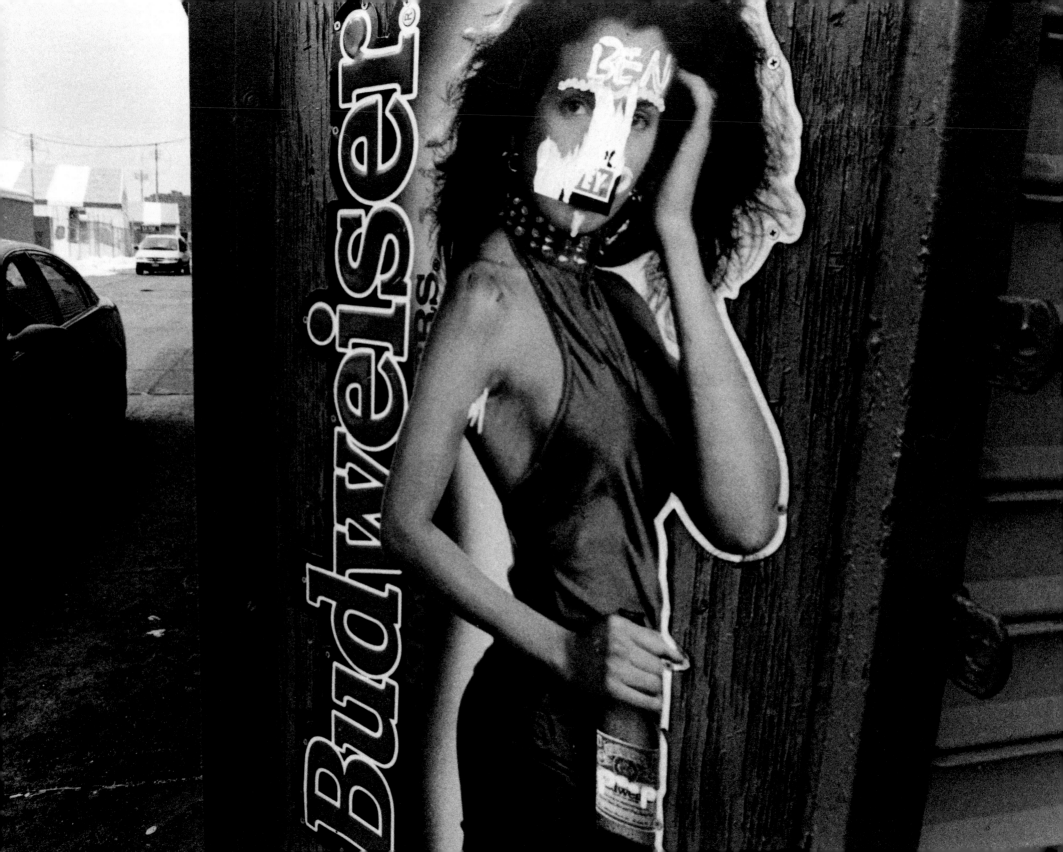

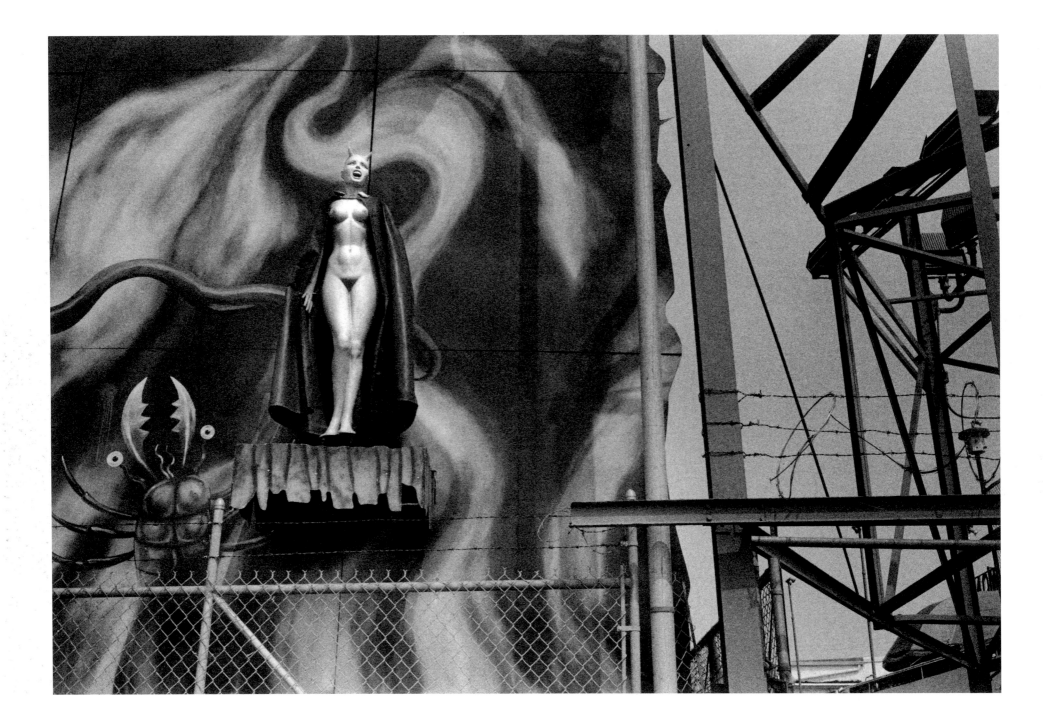

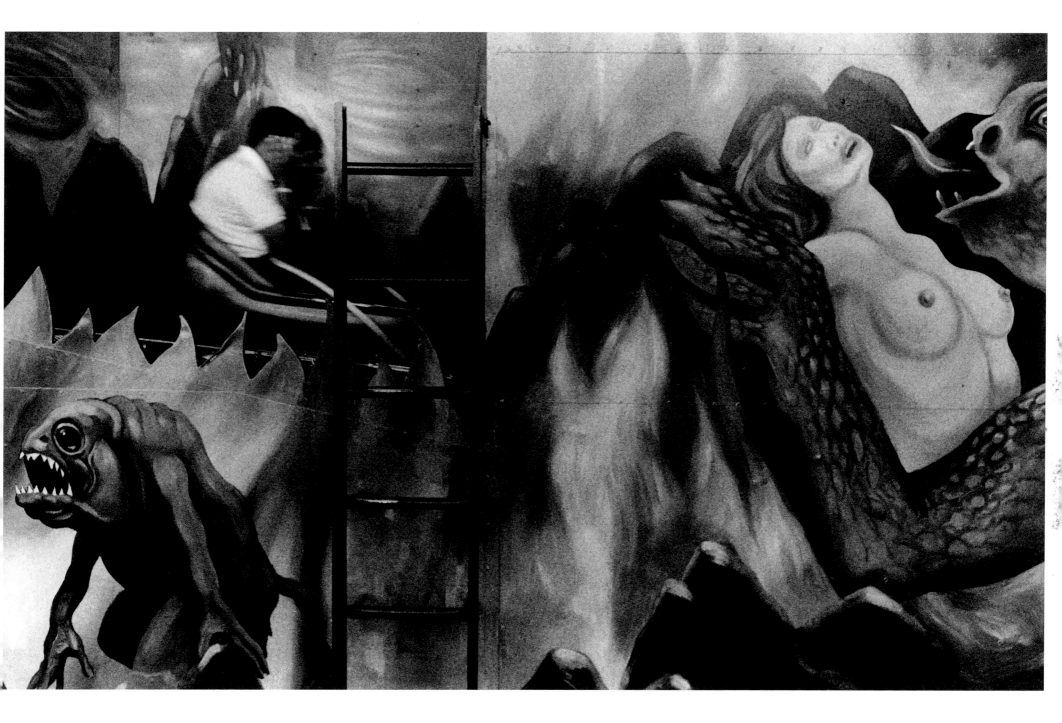

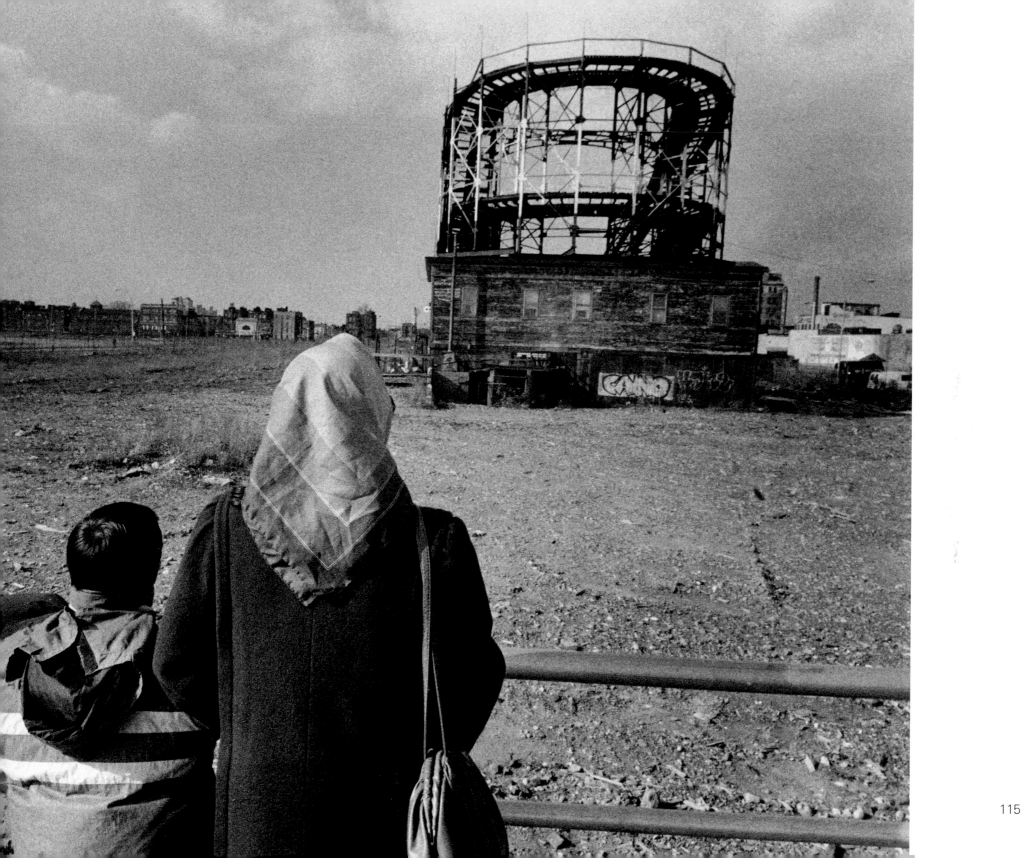

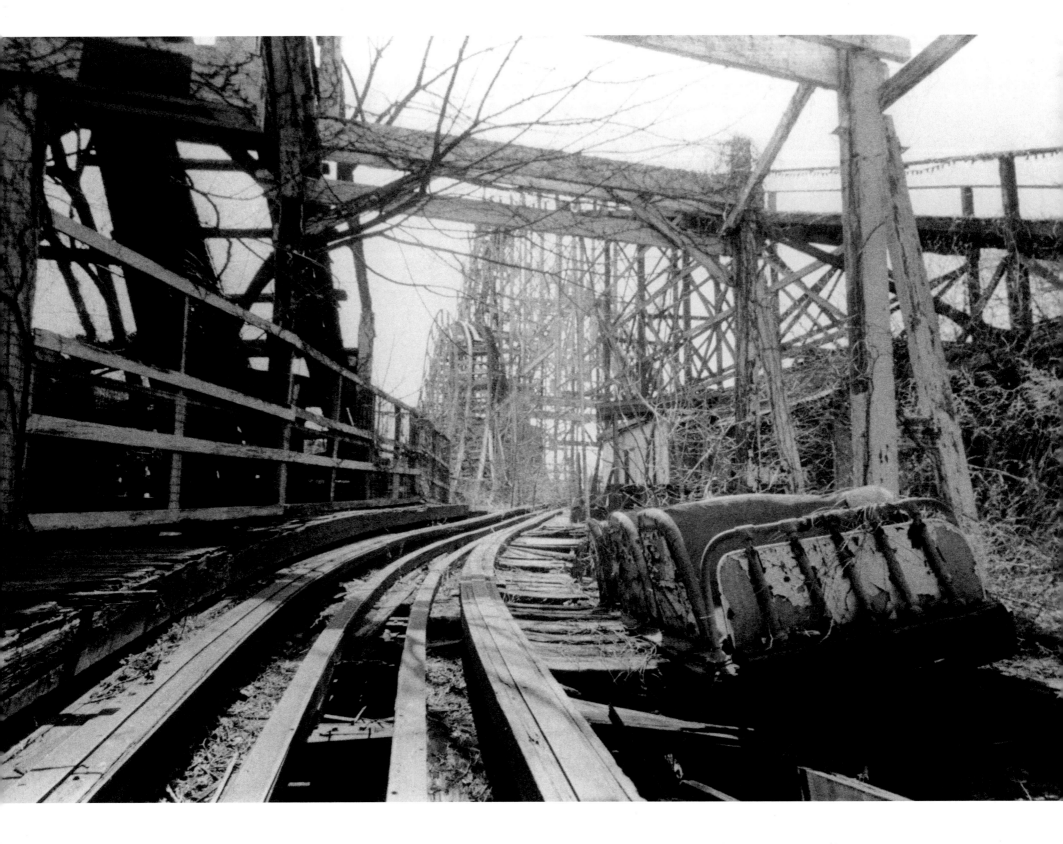

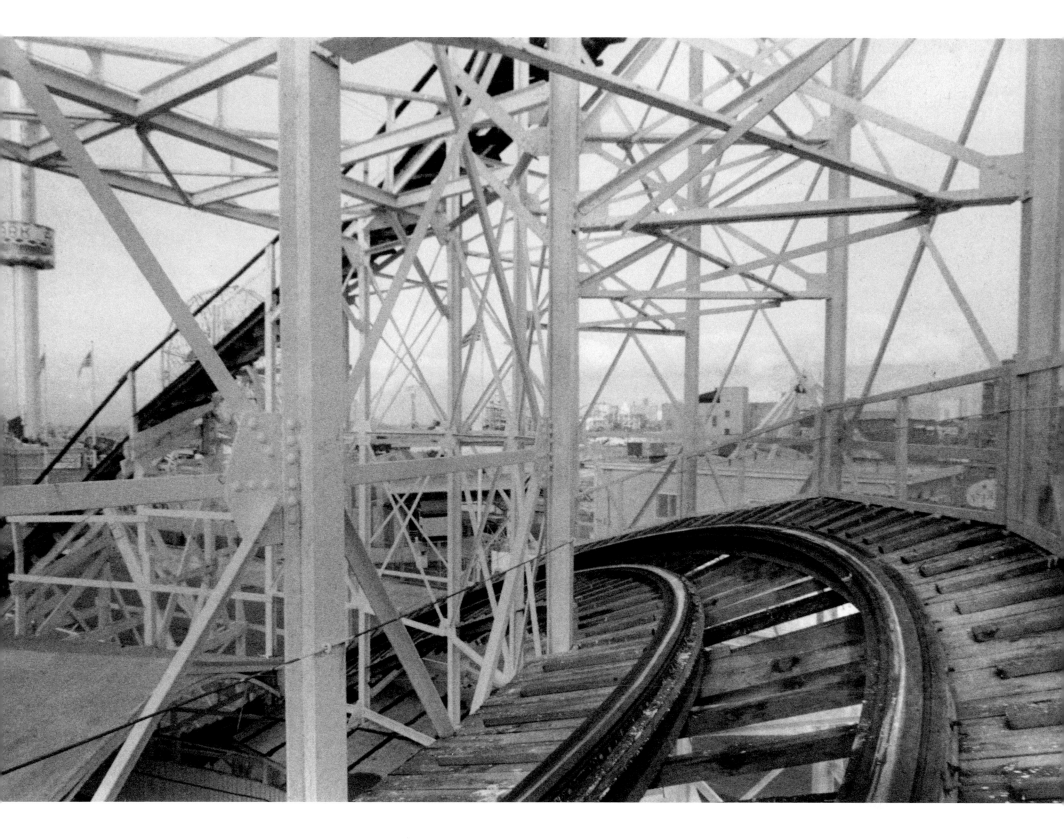

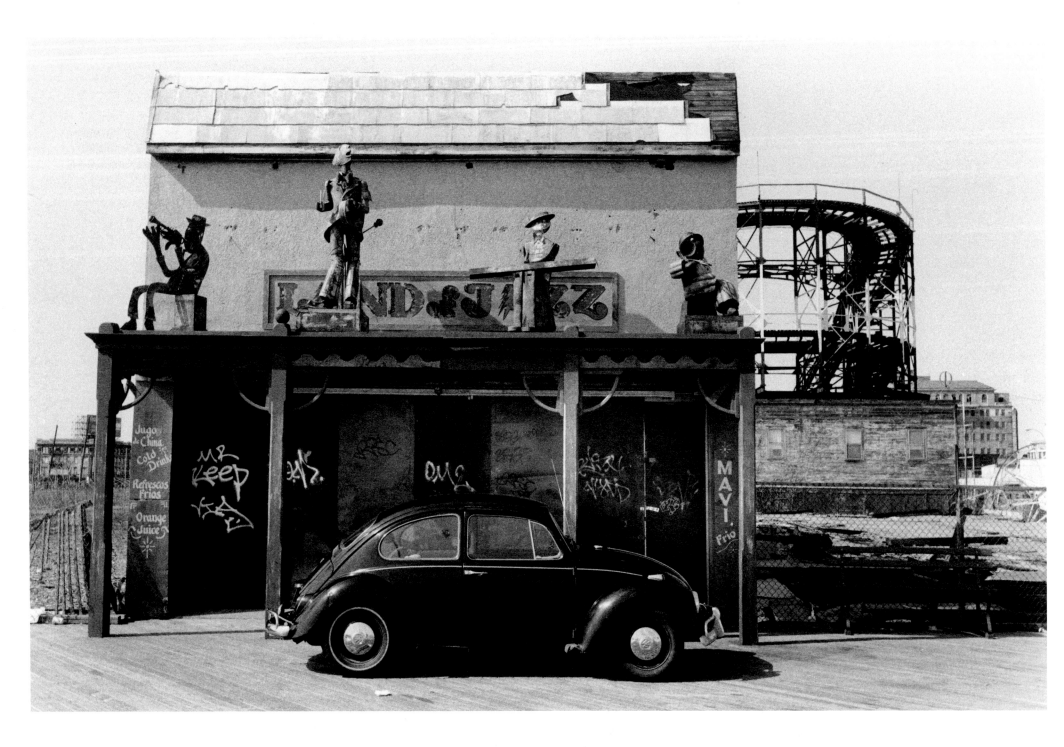

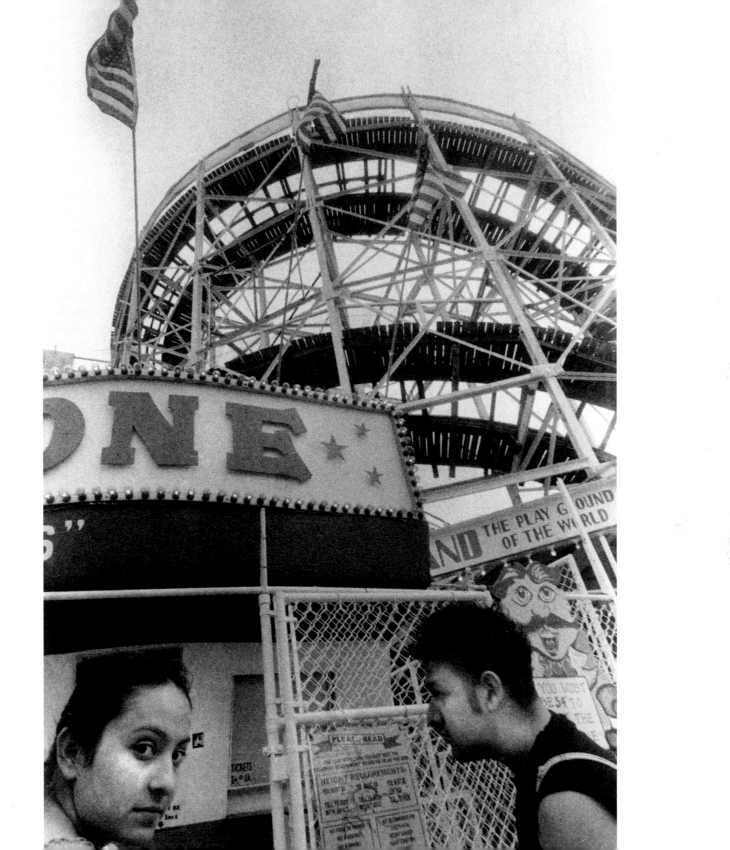

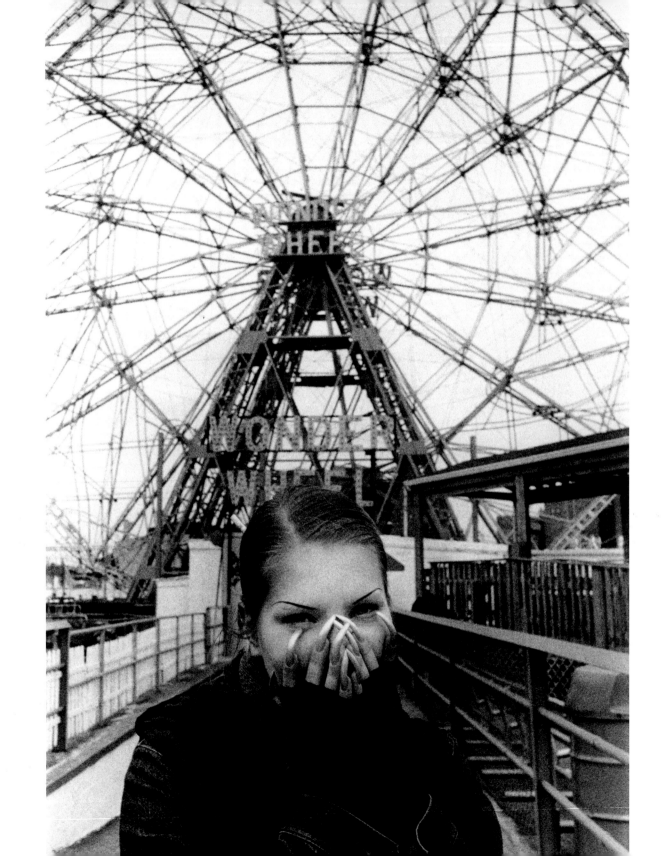

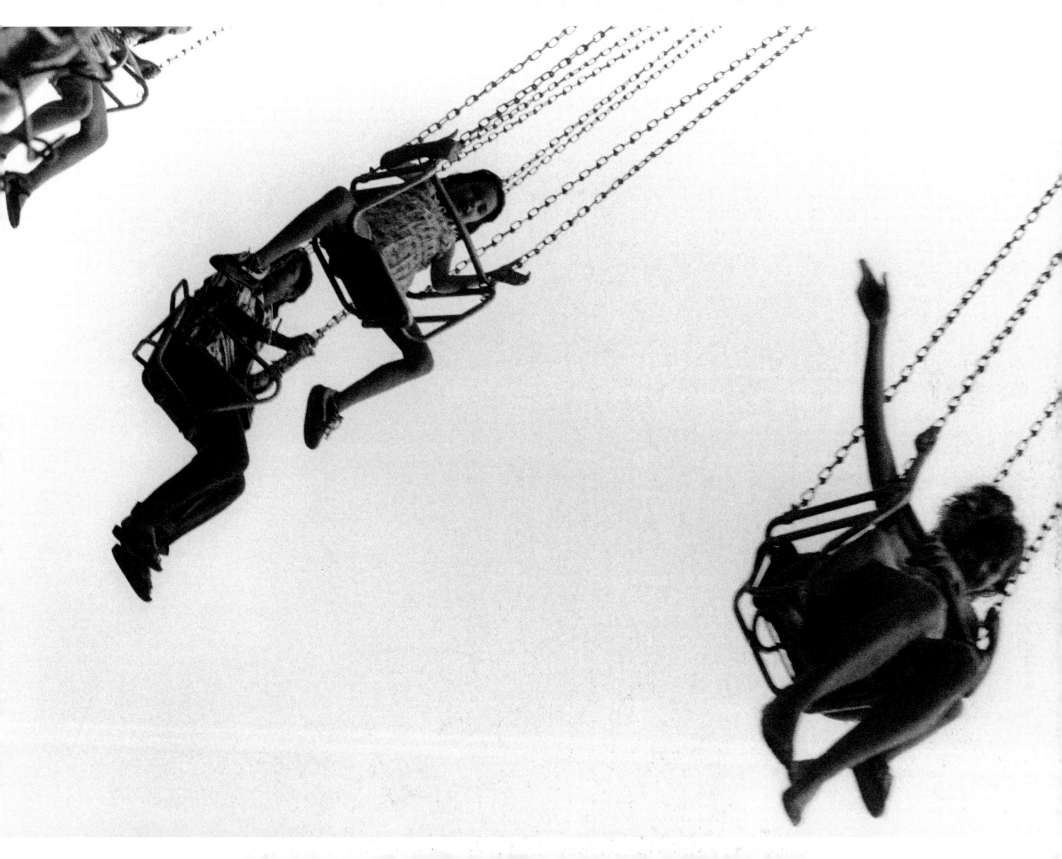

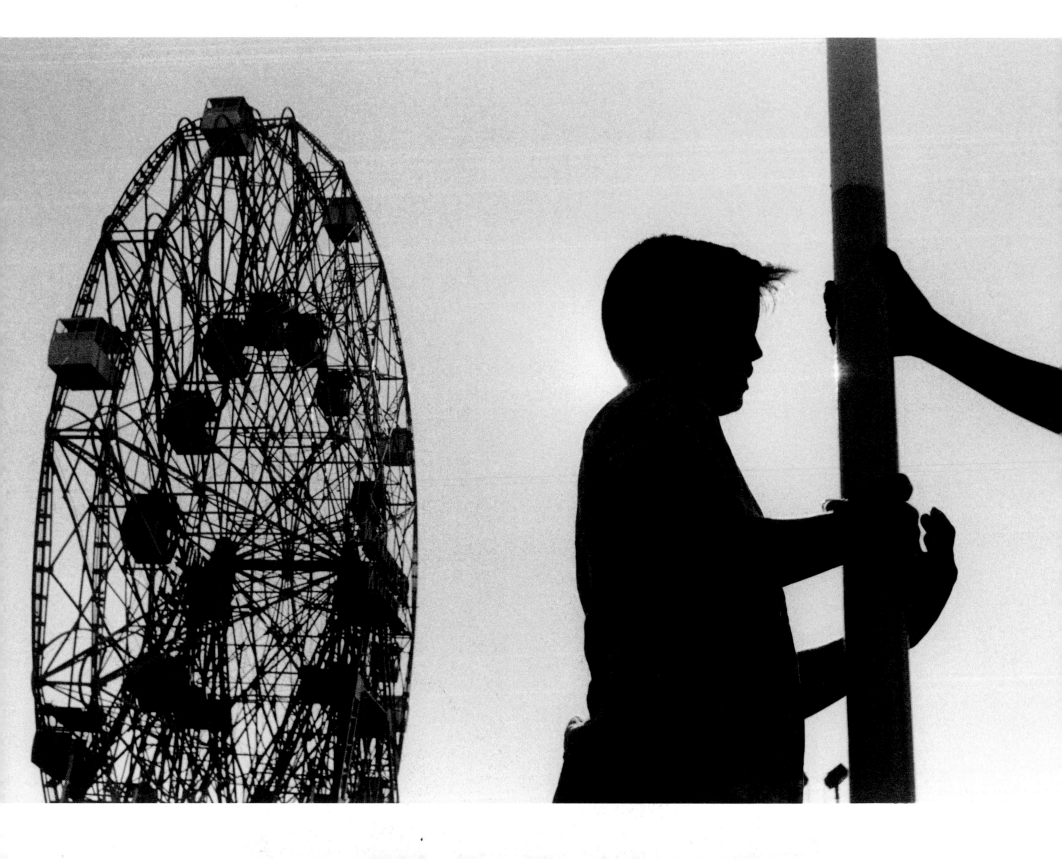

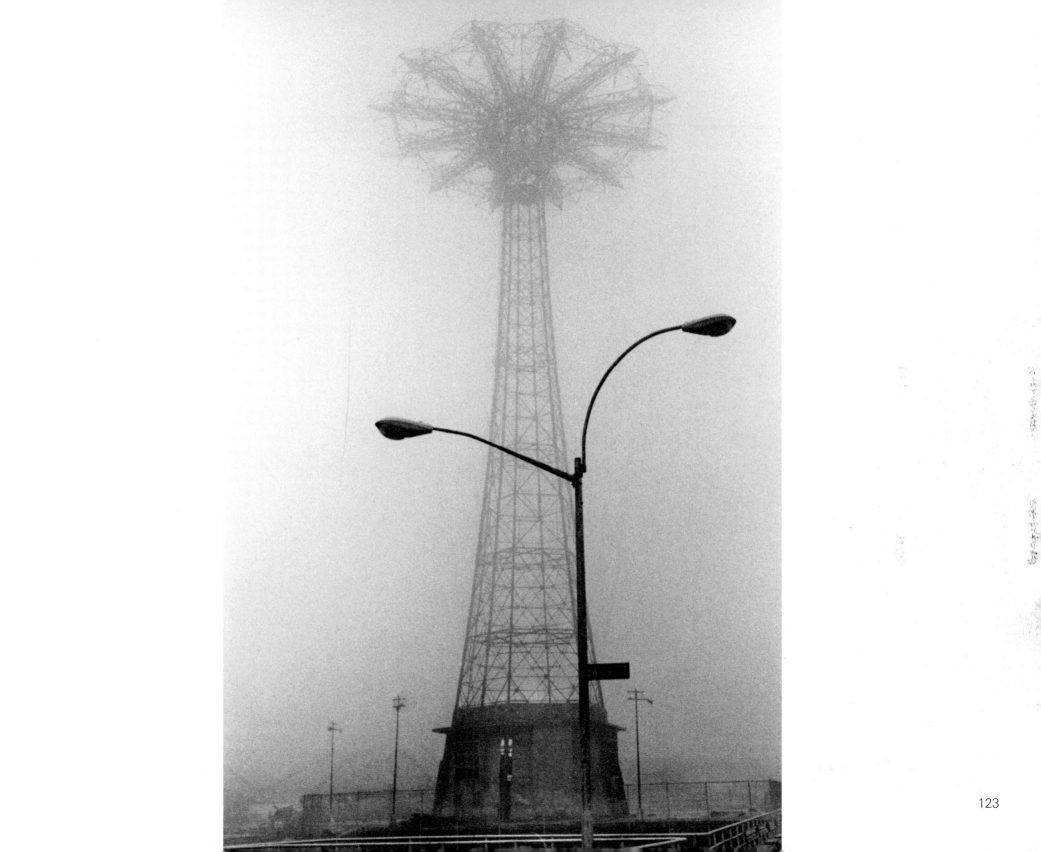

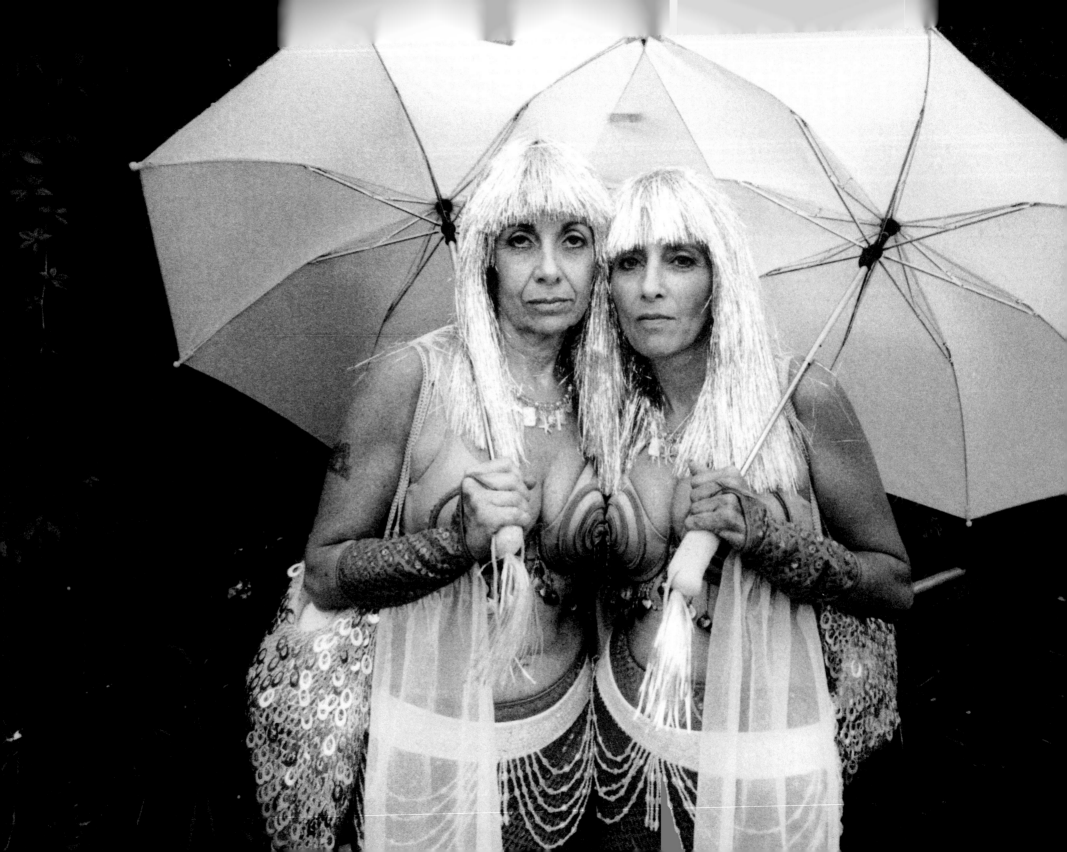

THE MERMAID PARADE

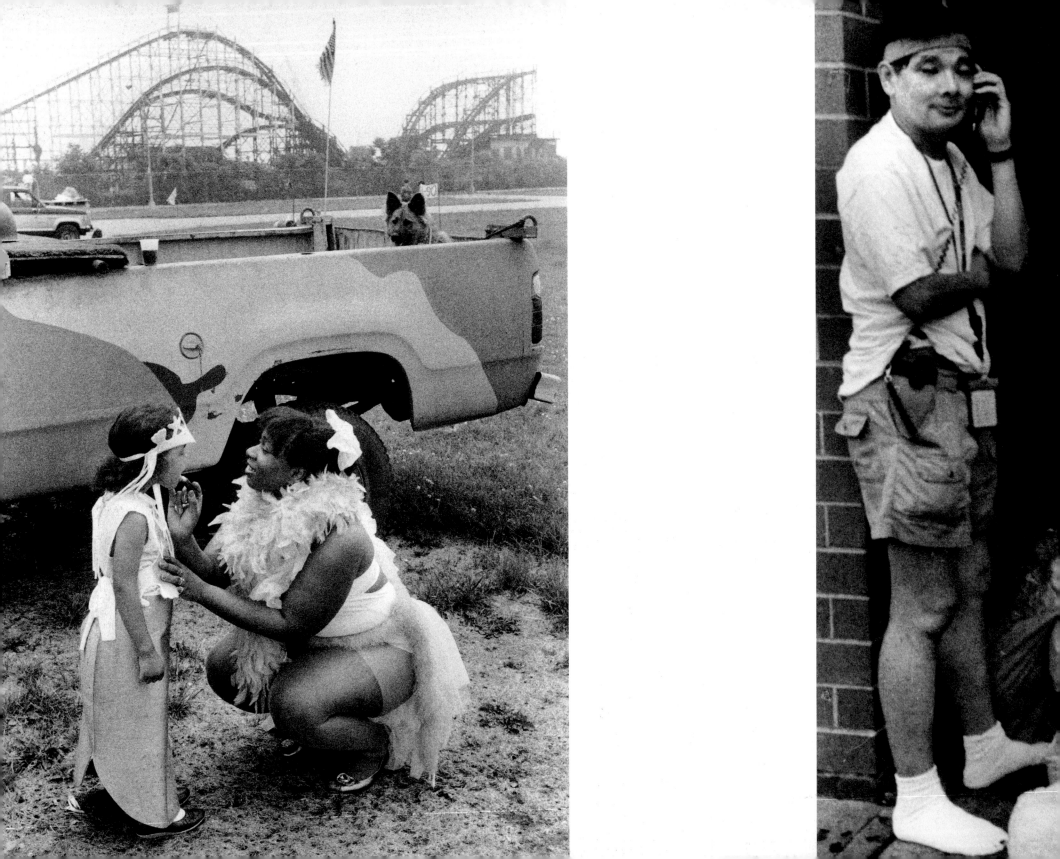

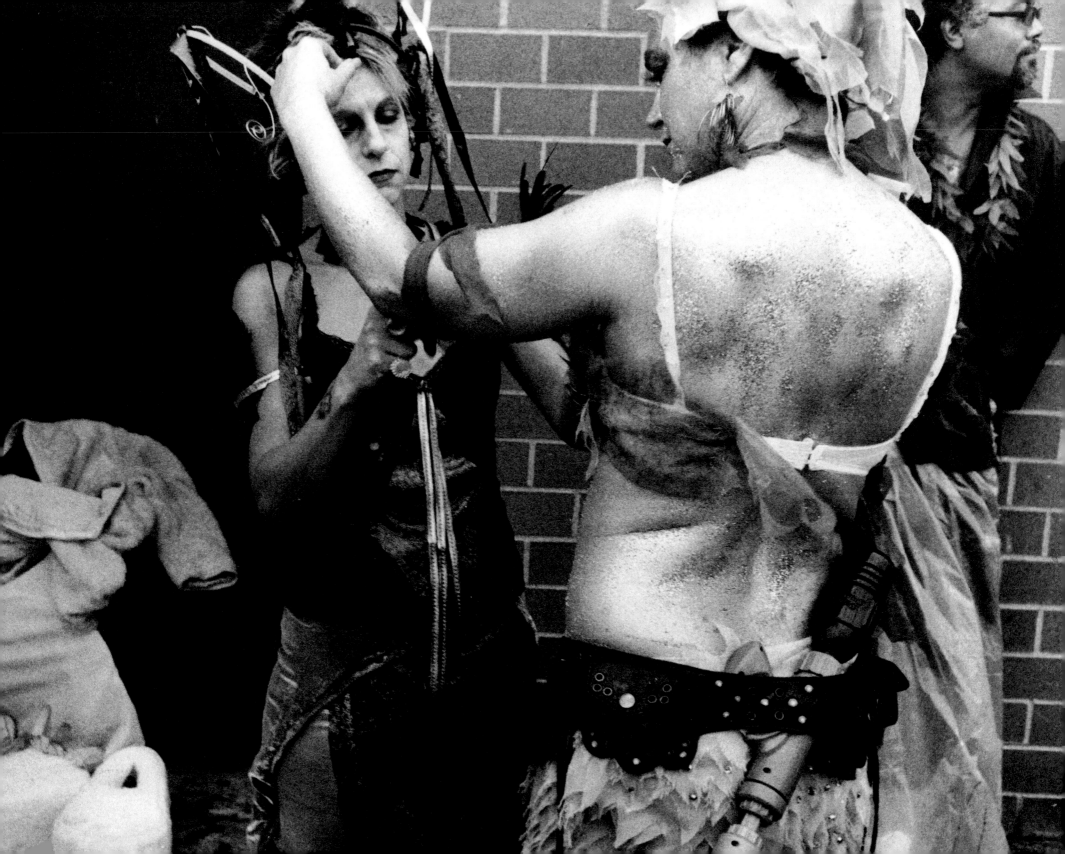

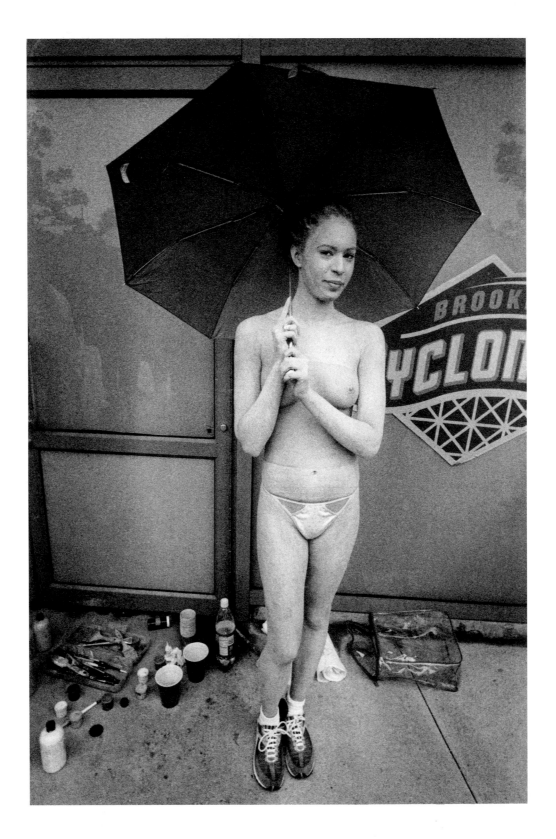

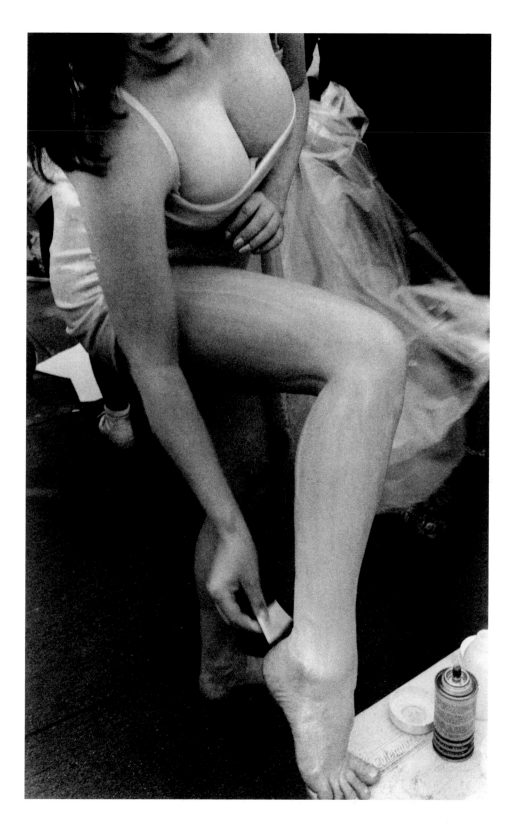

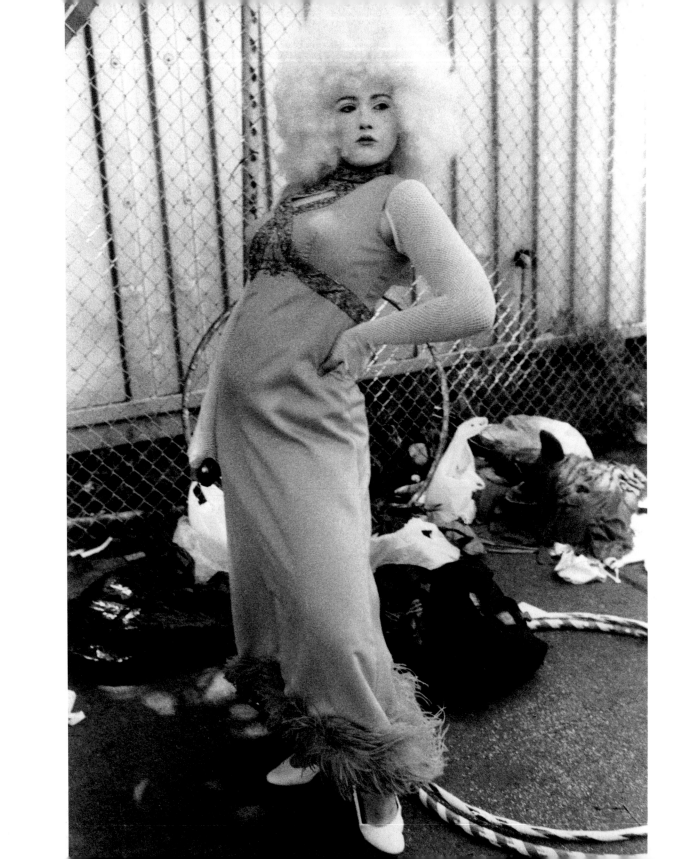

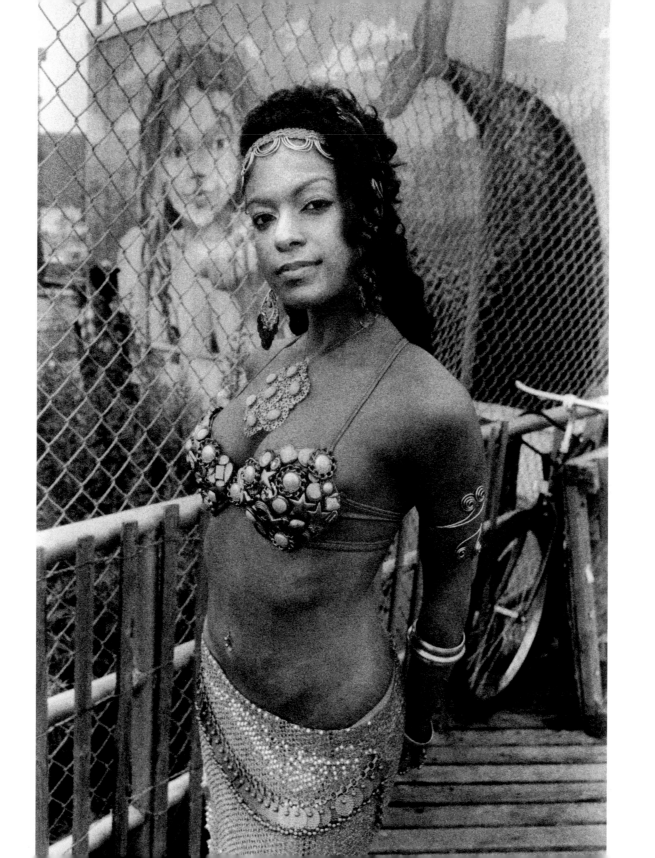

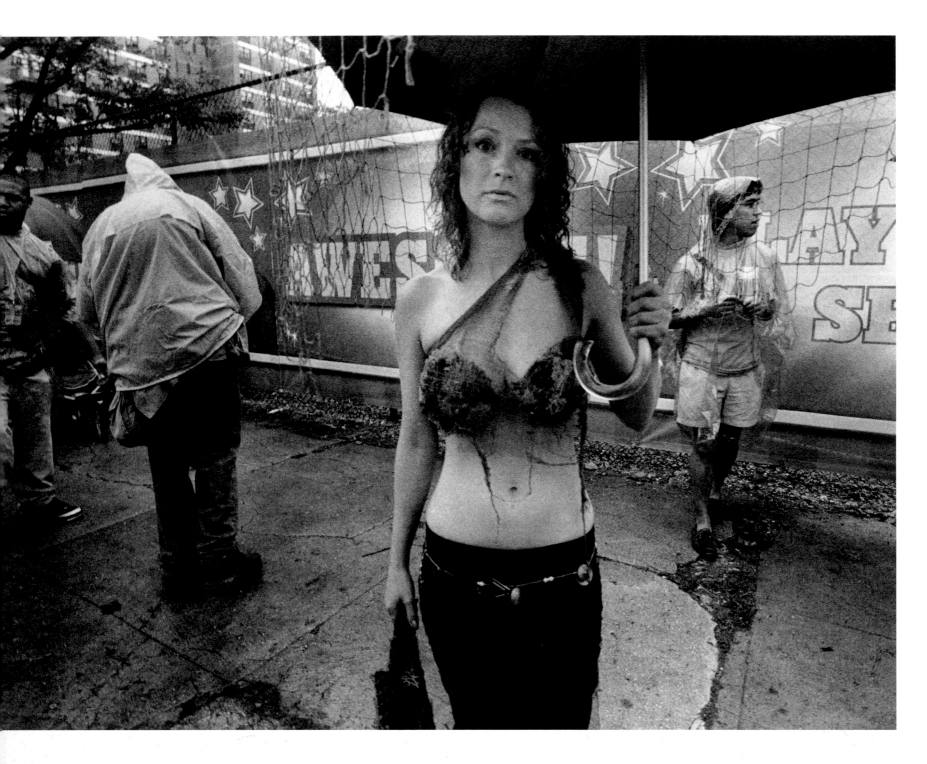

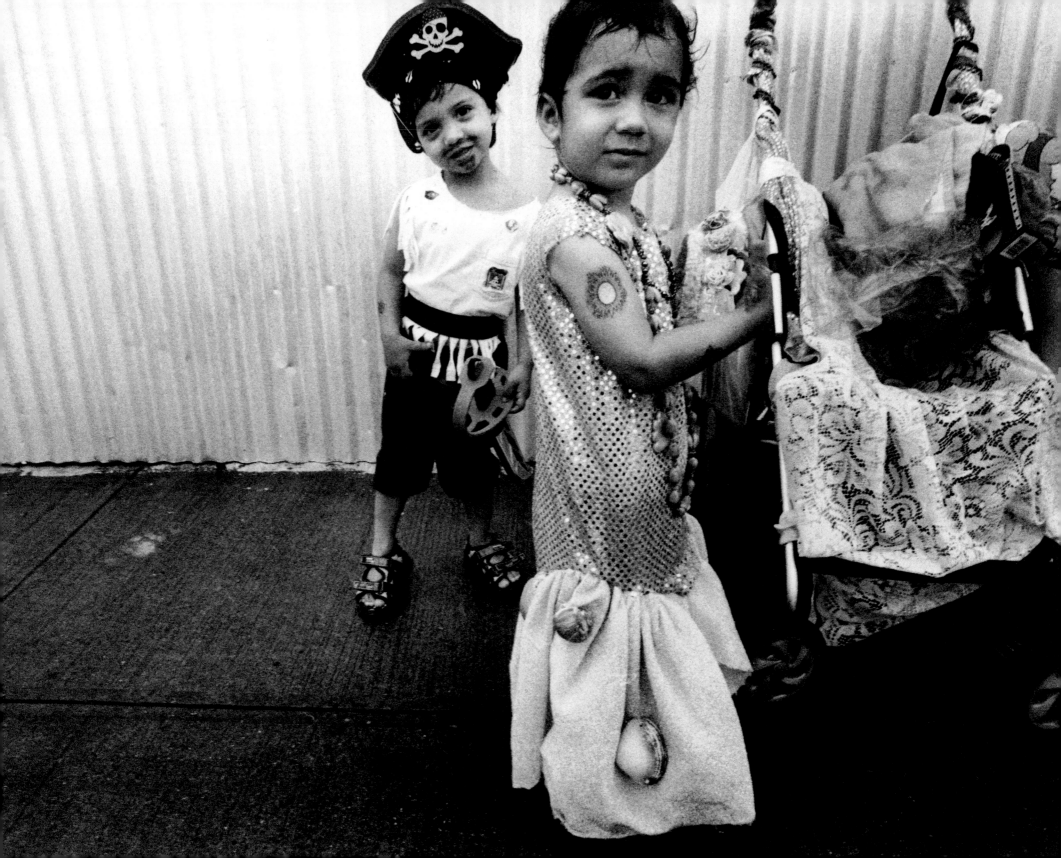

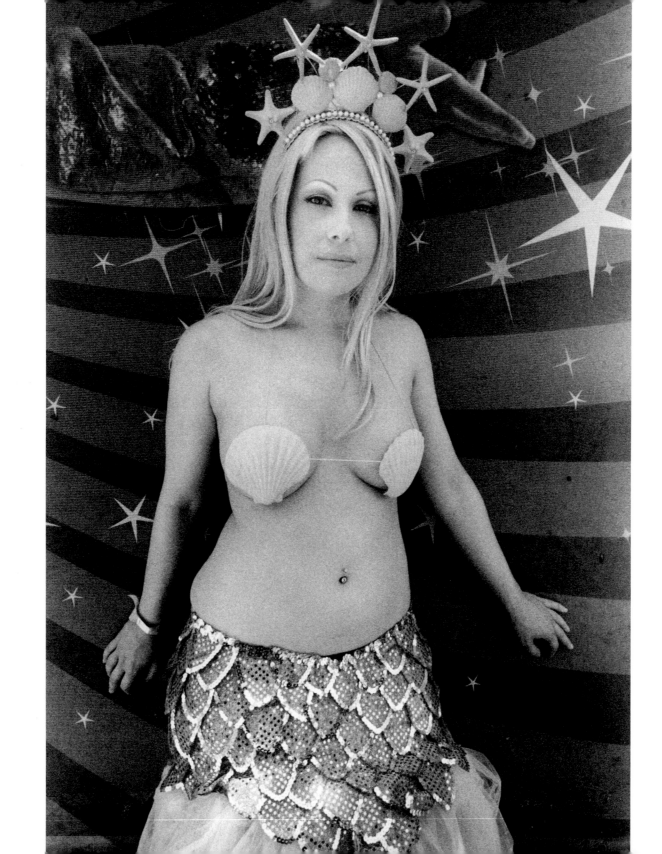

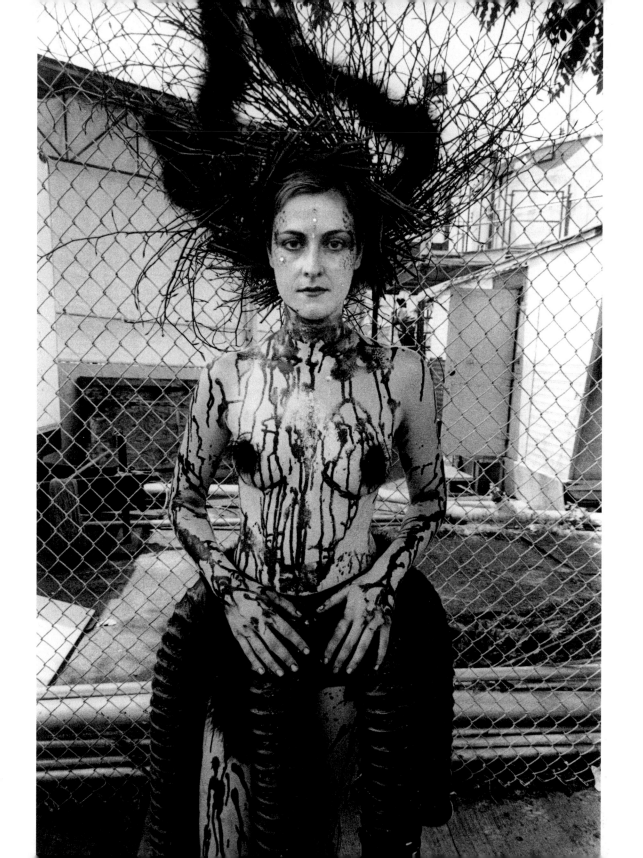

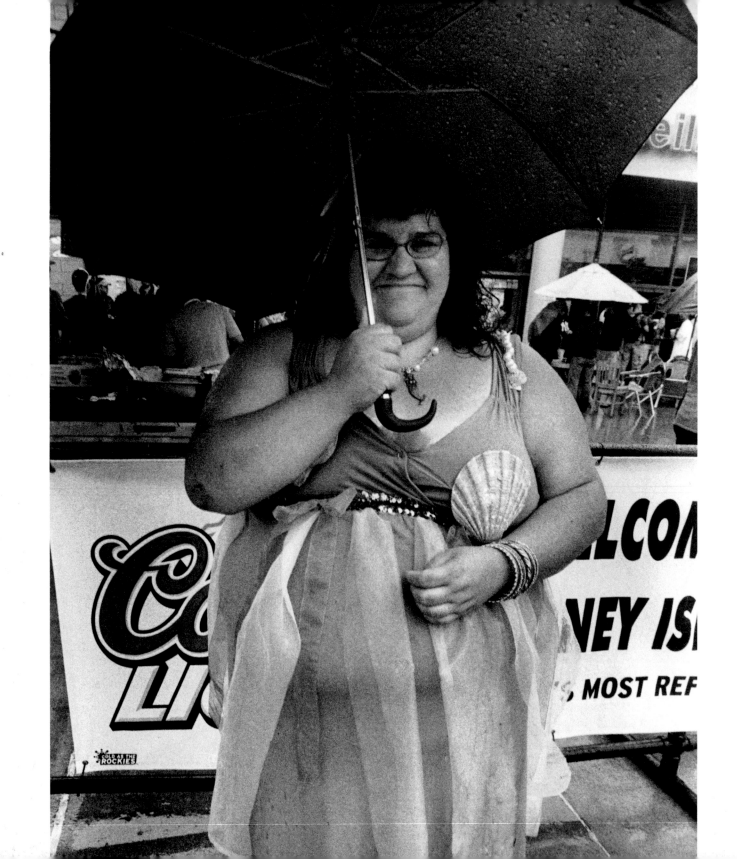

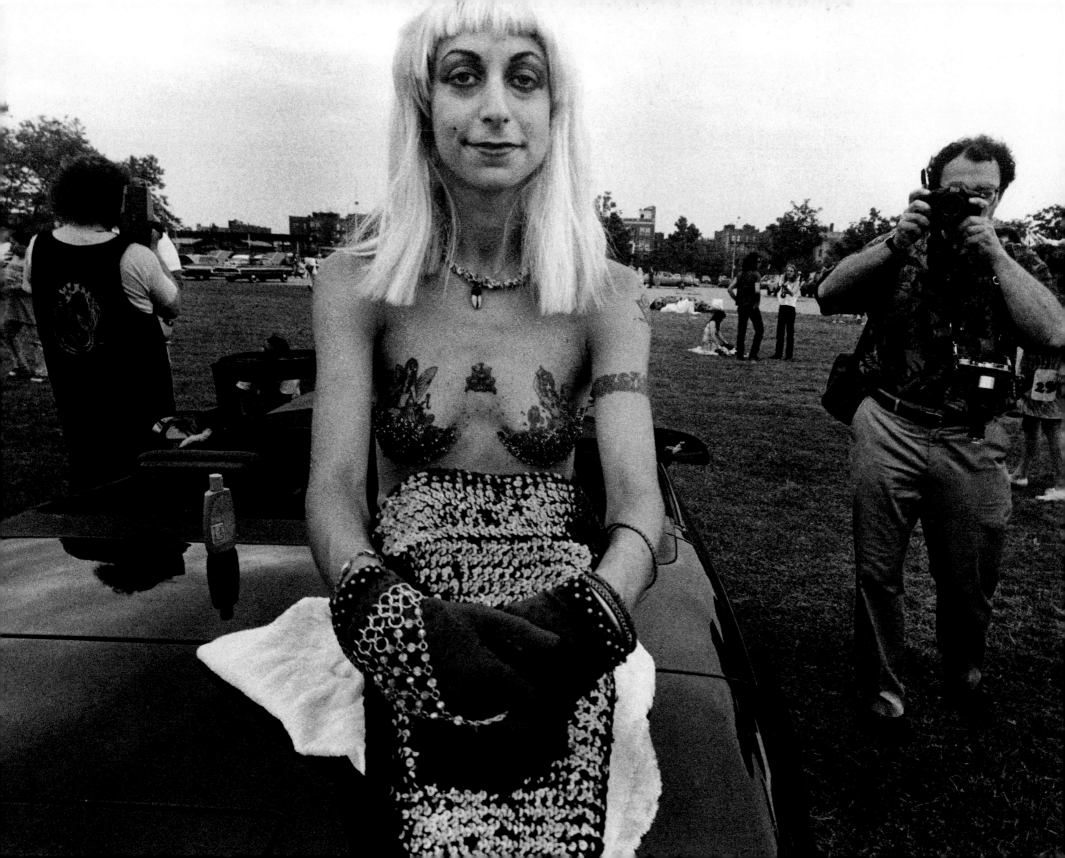

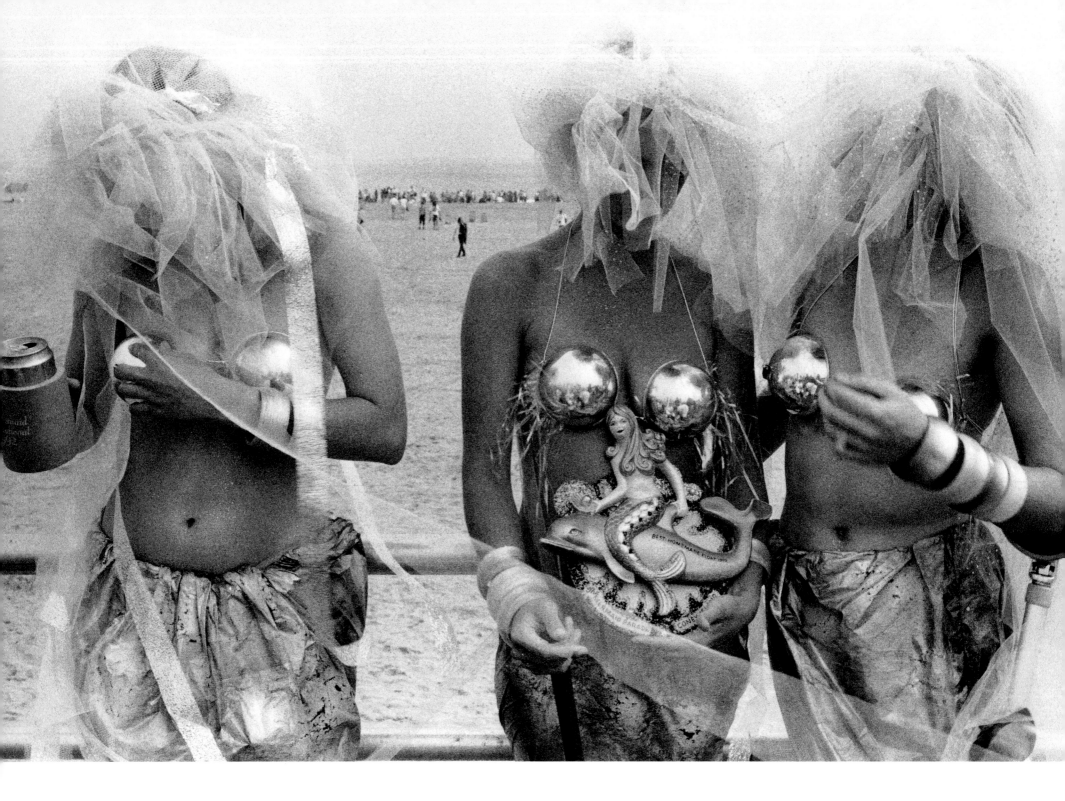

138

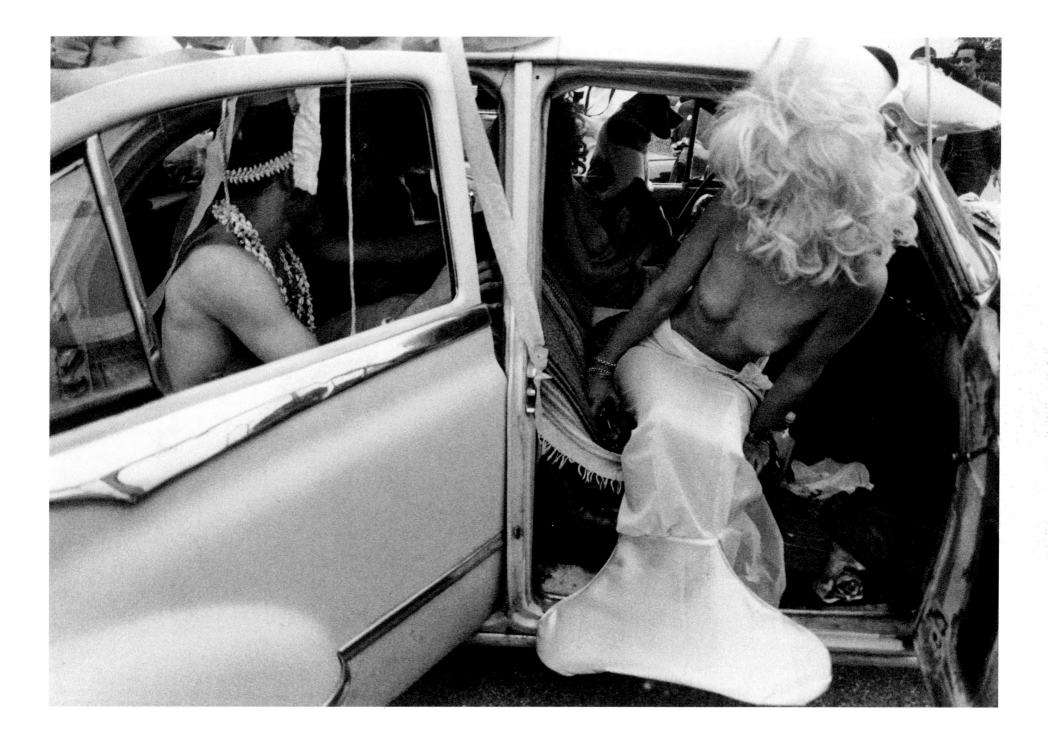

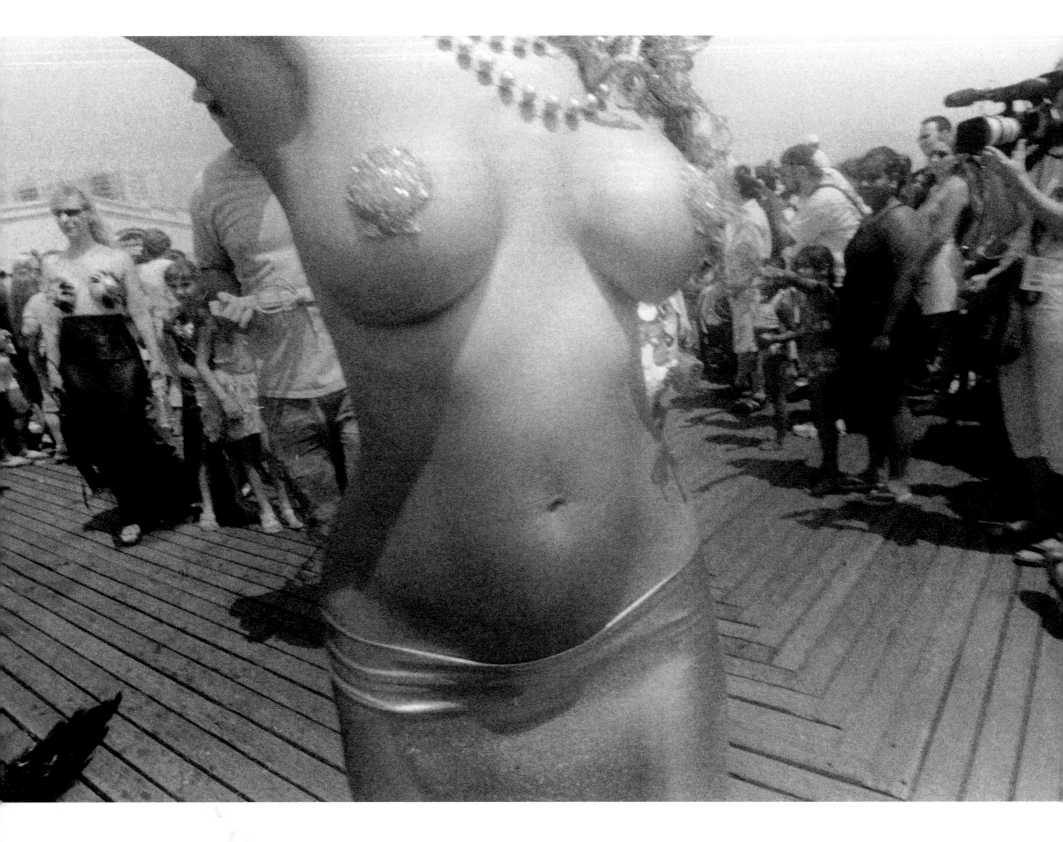

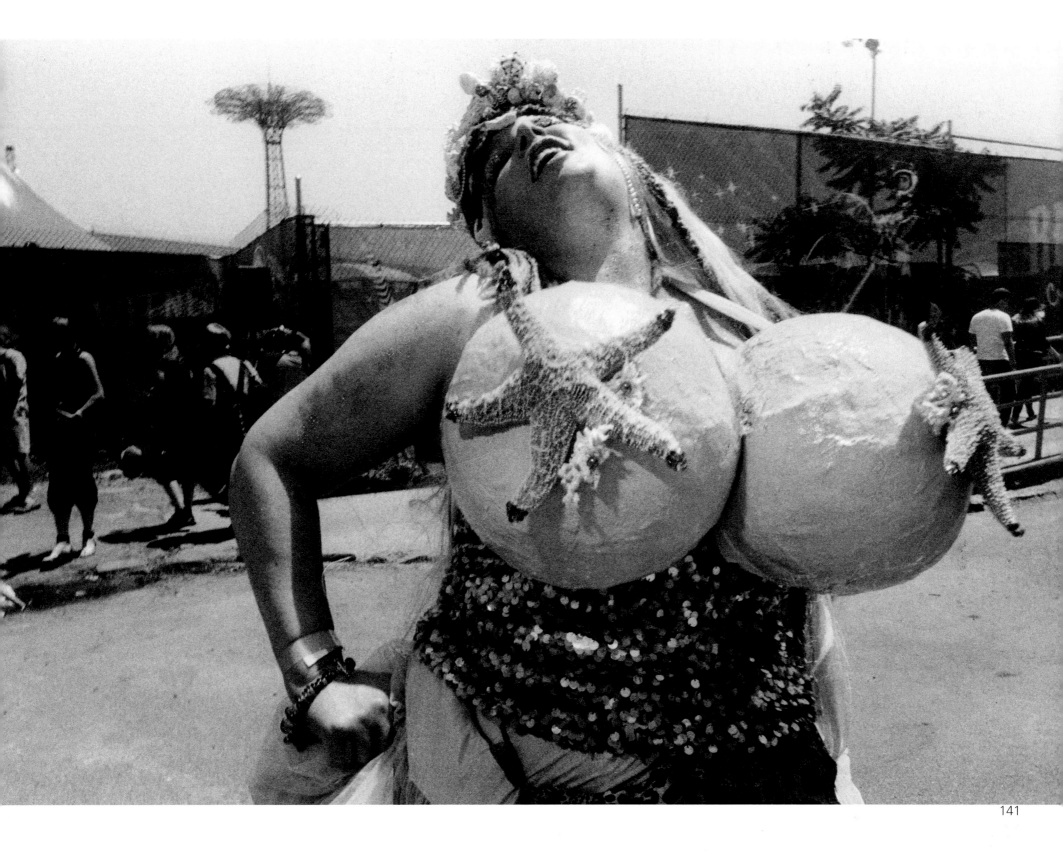

141

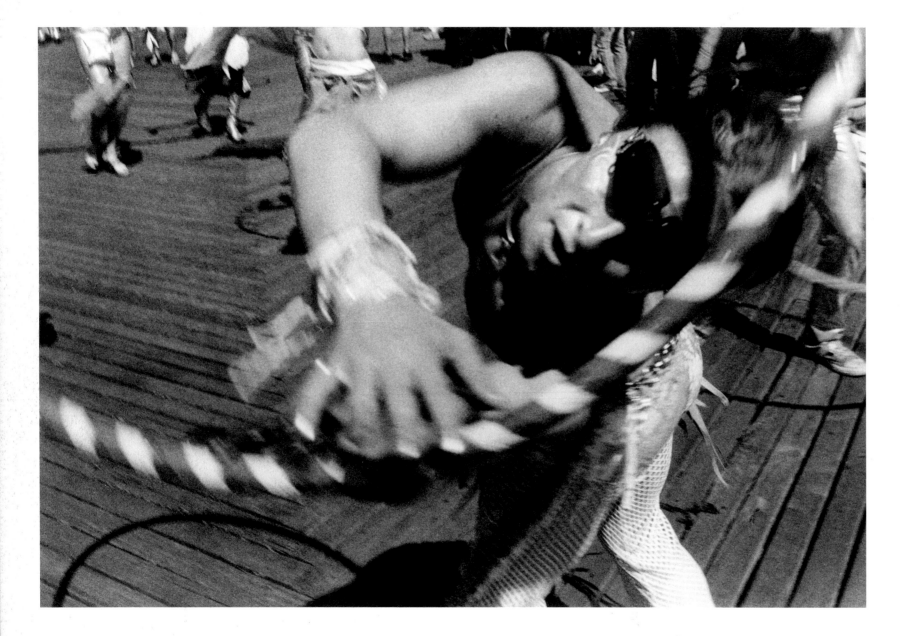

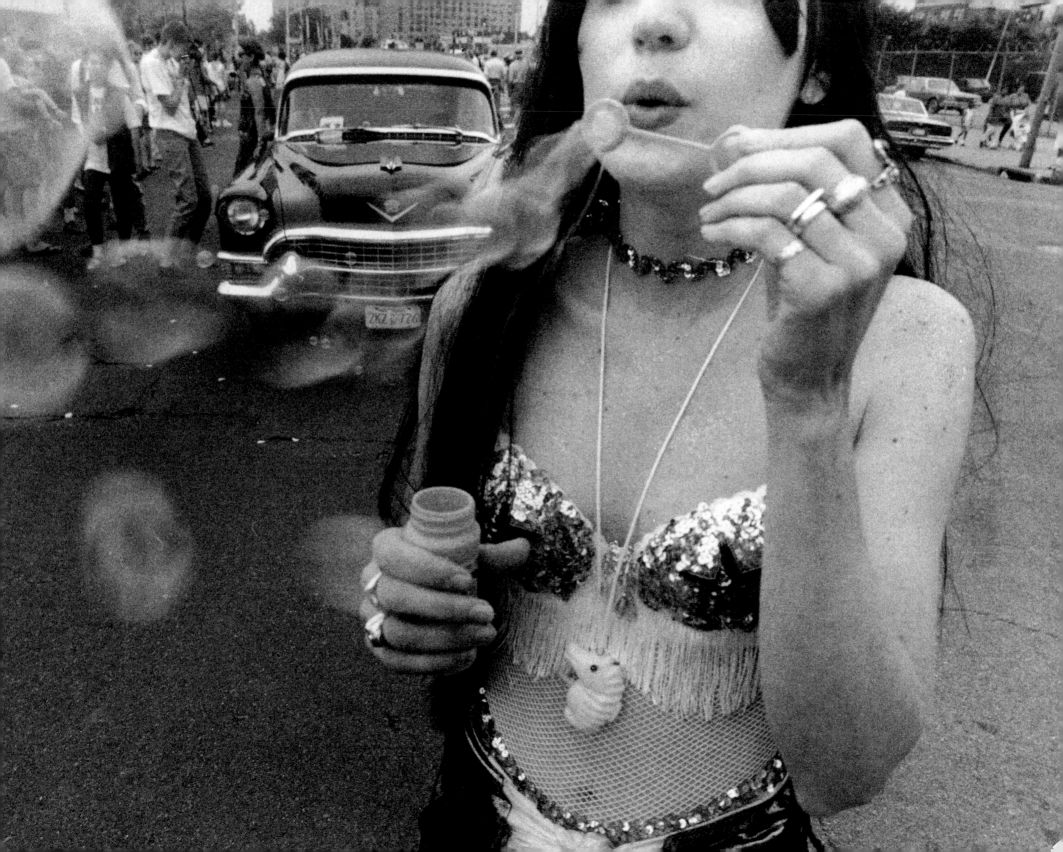

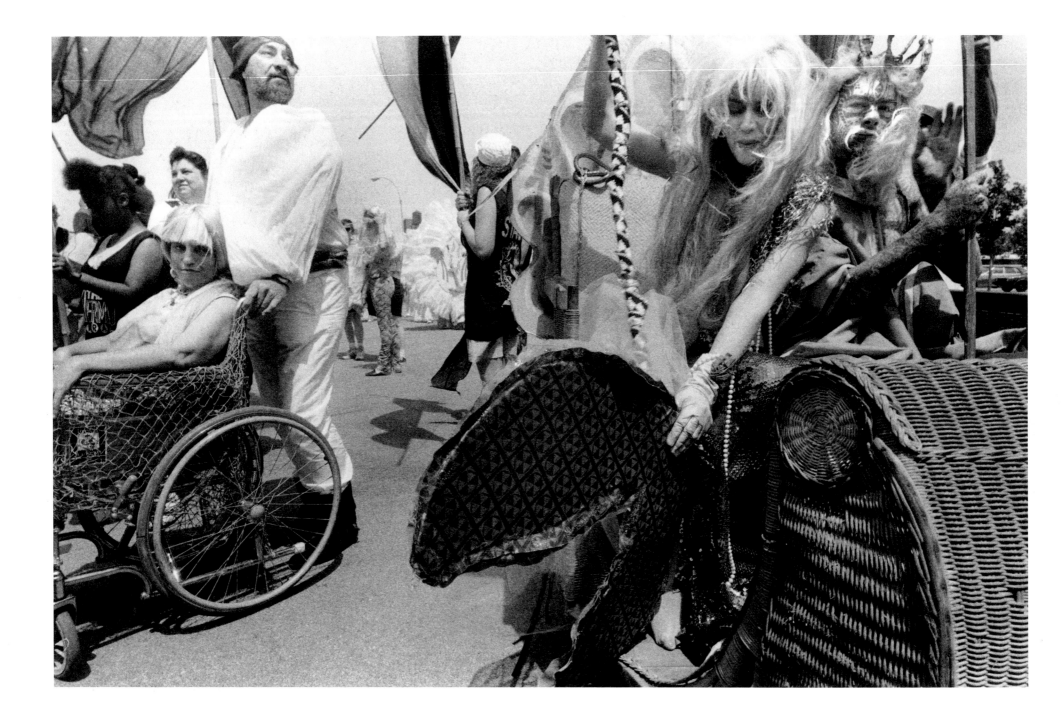

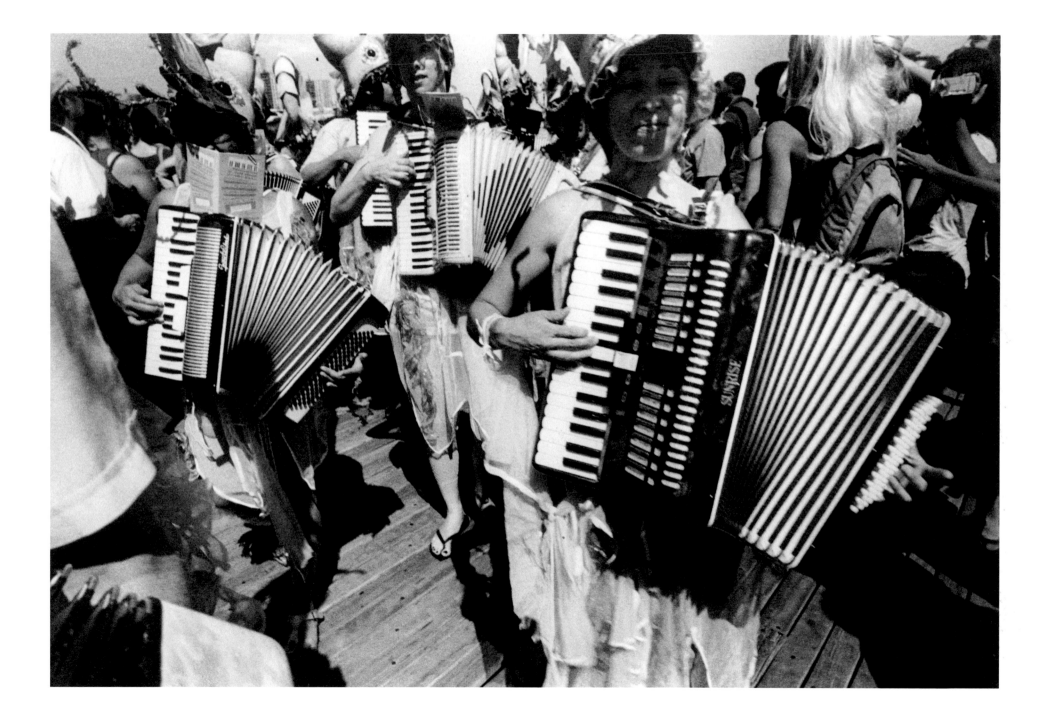

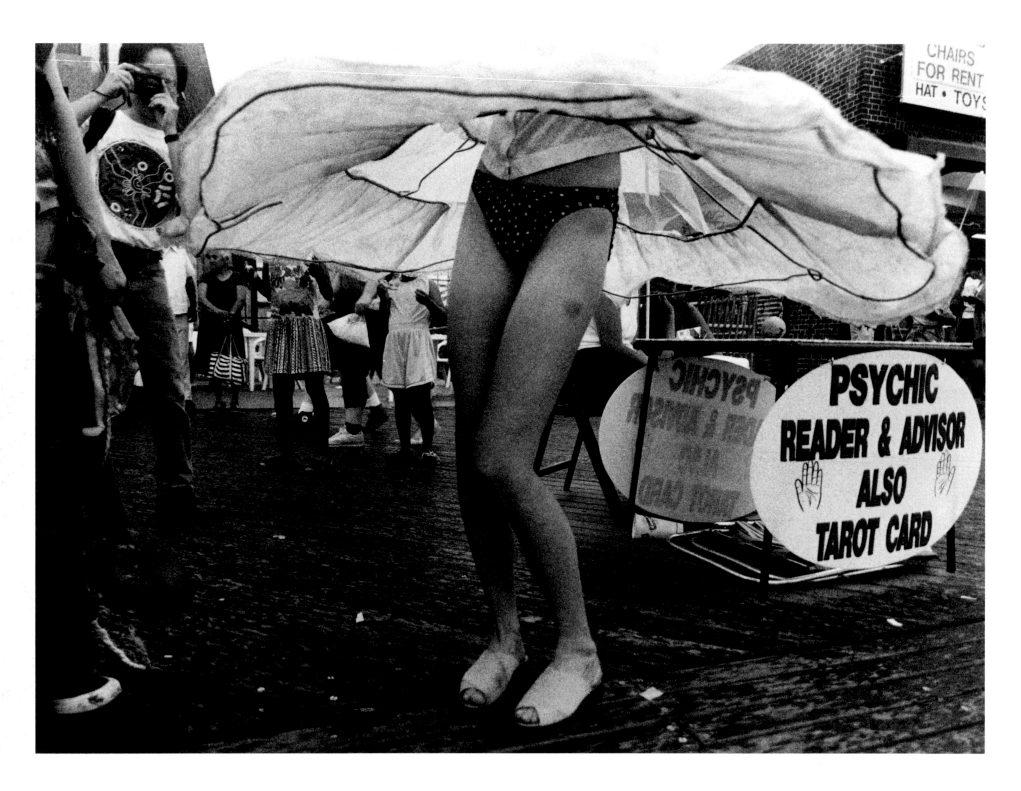

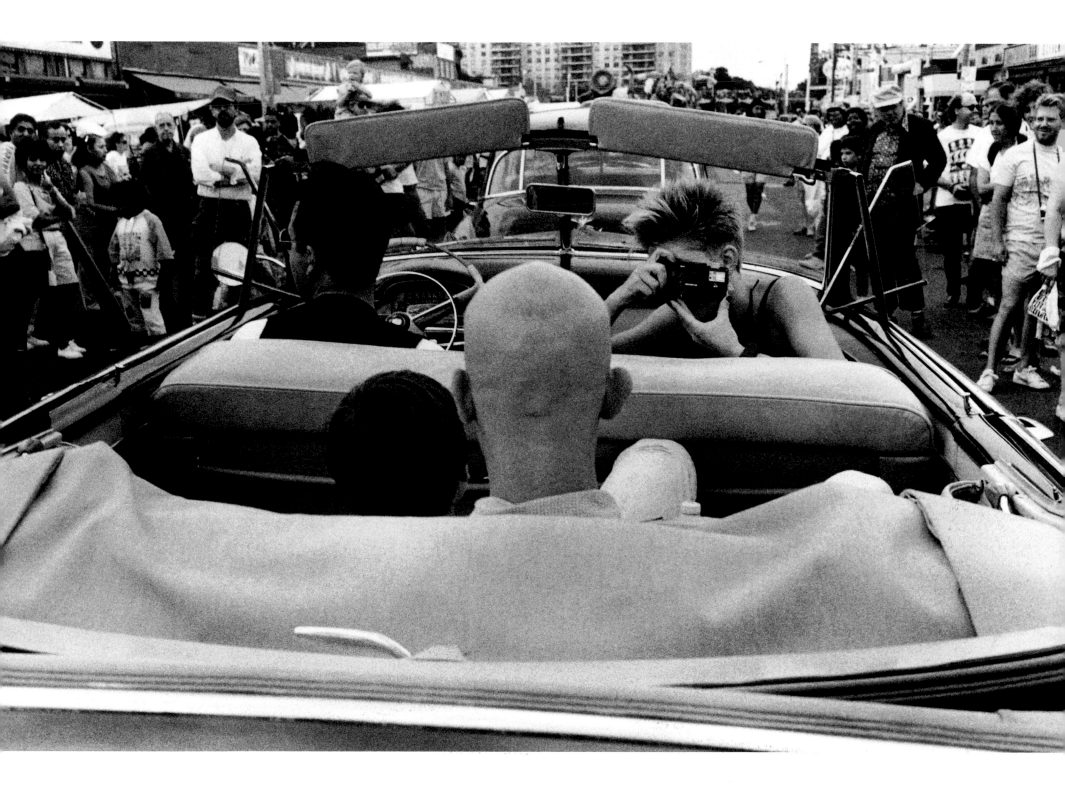

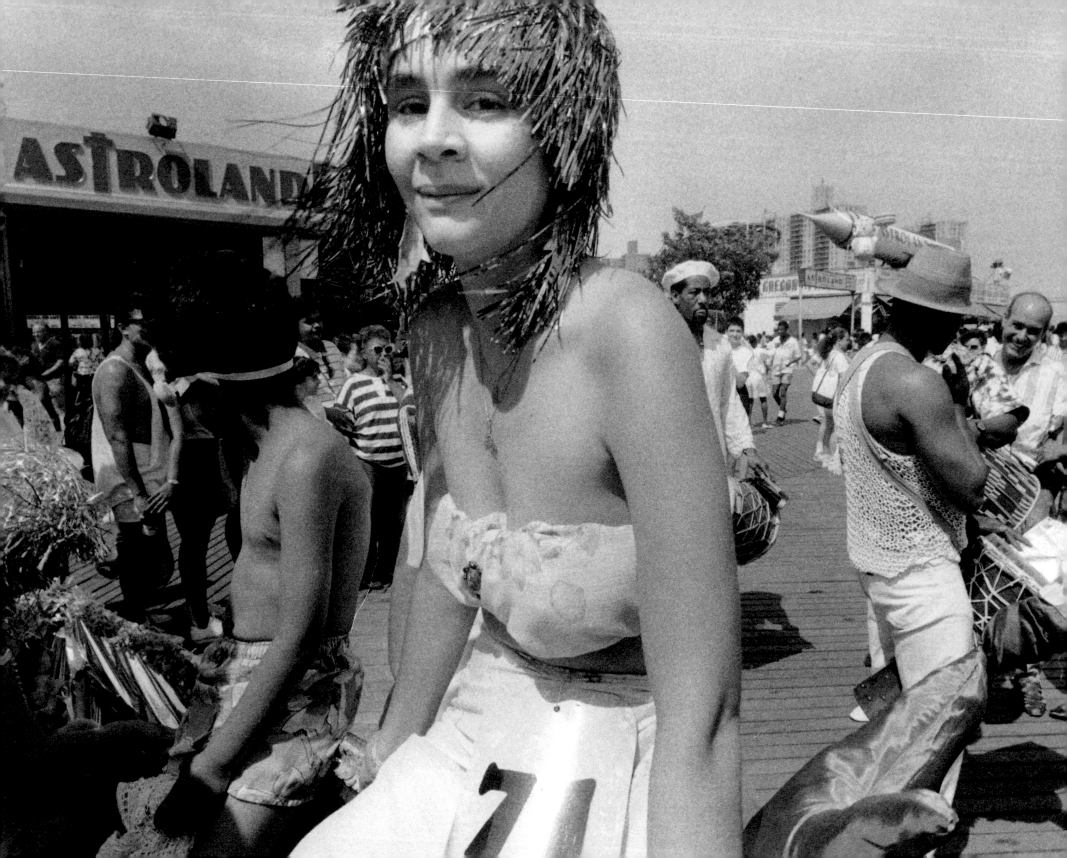

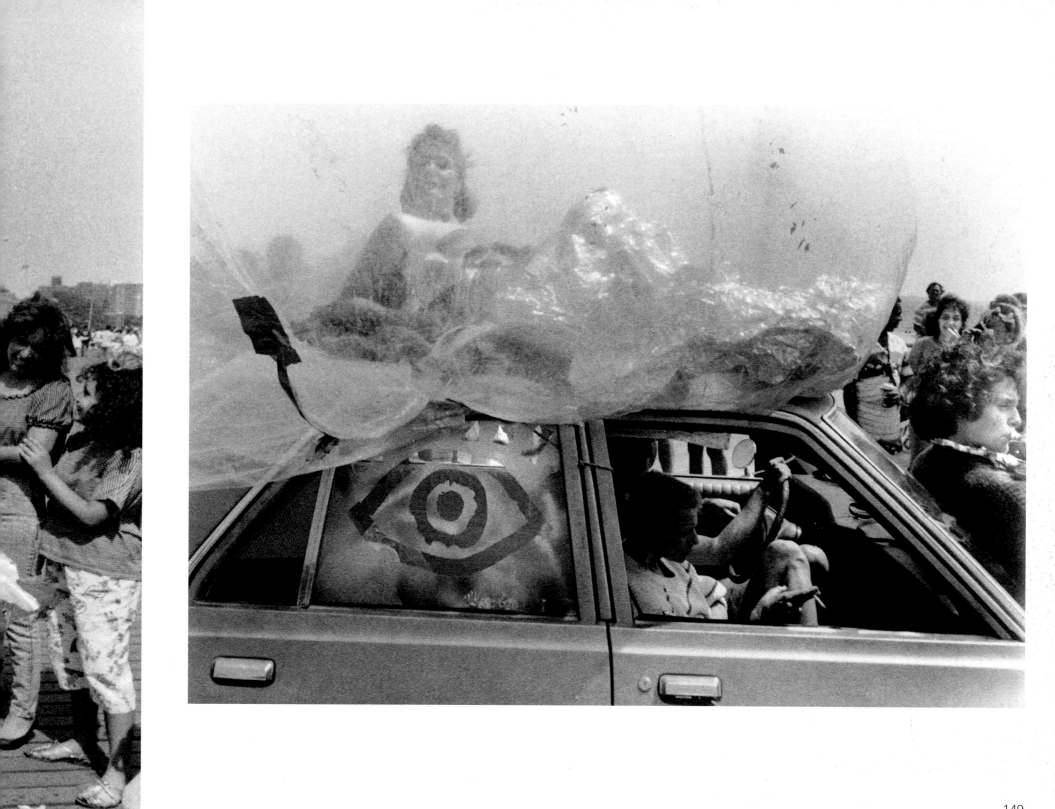

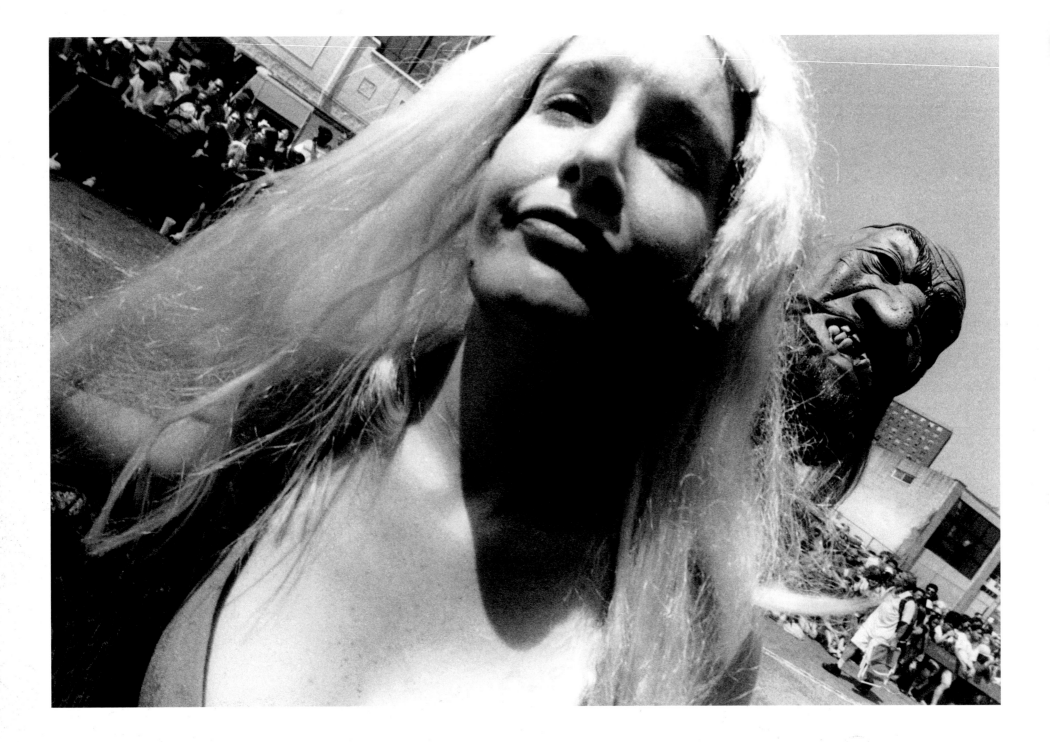

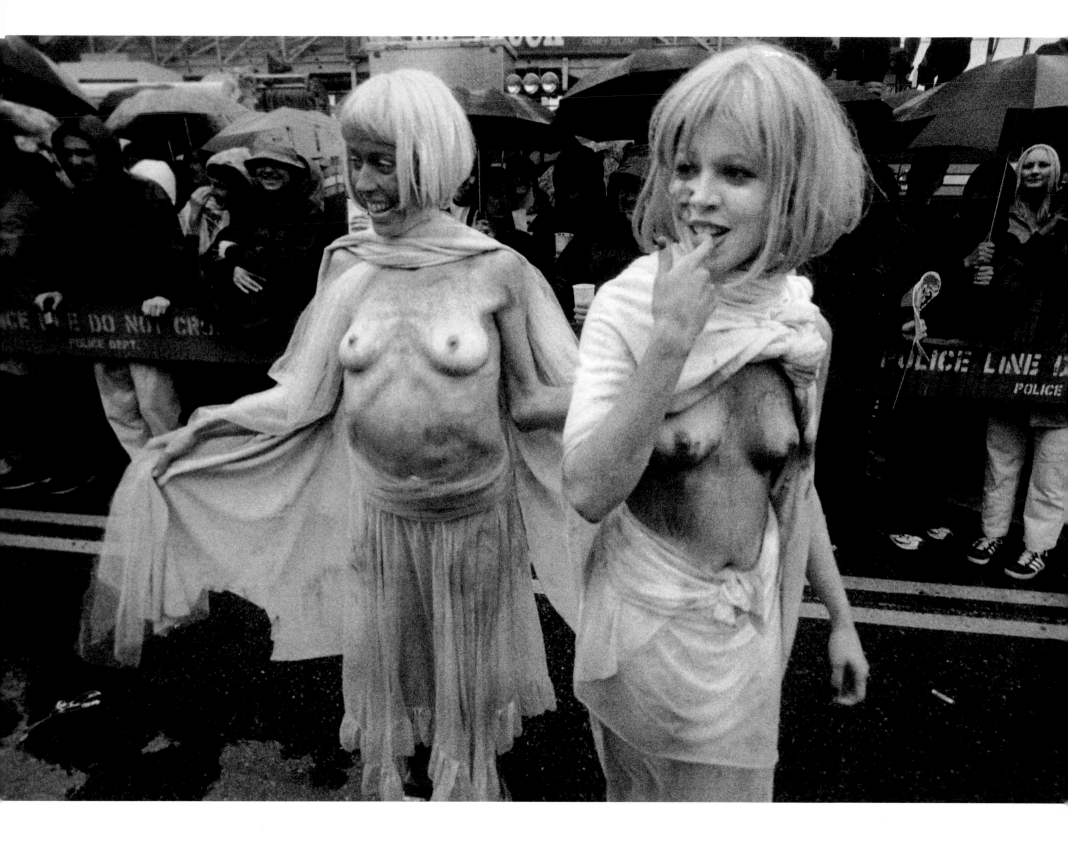

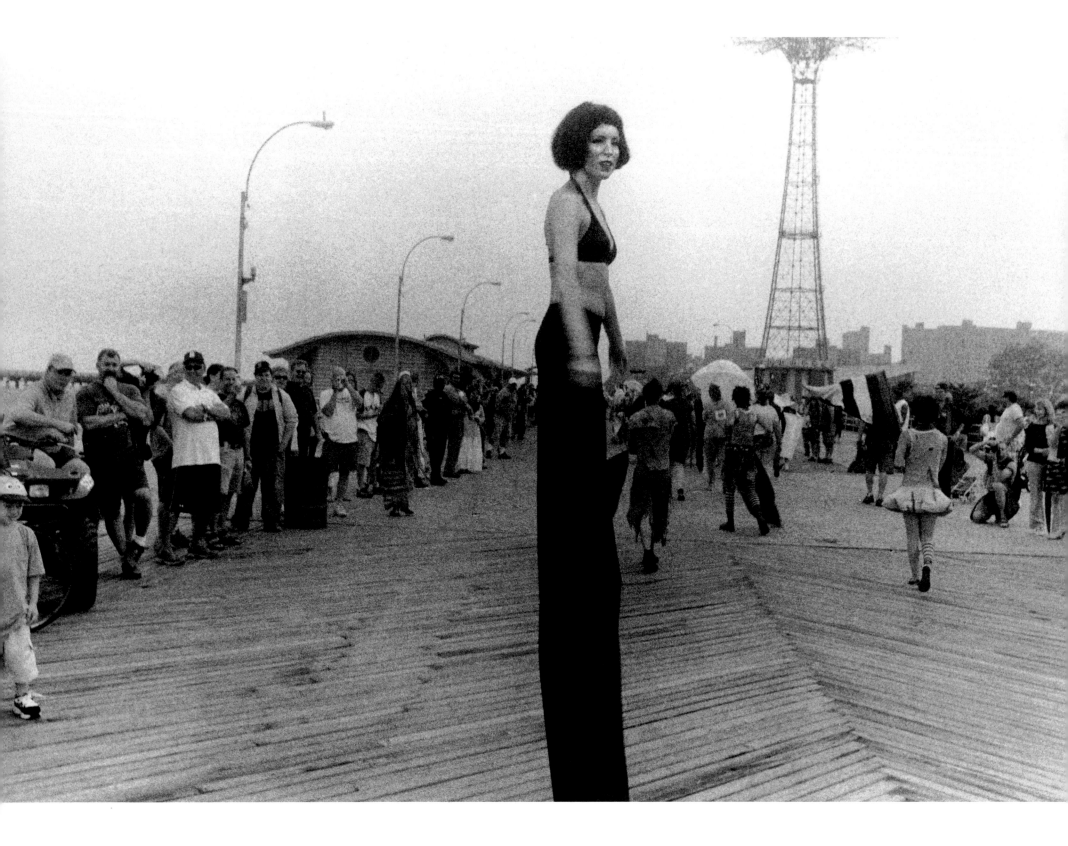

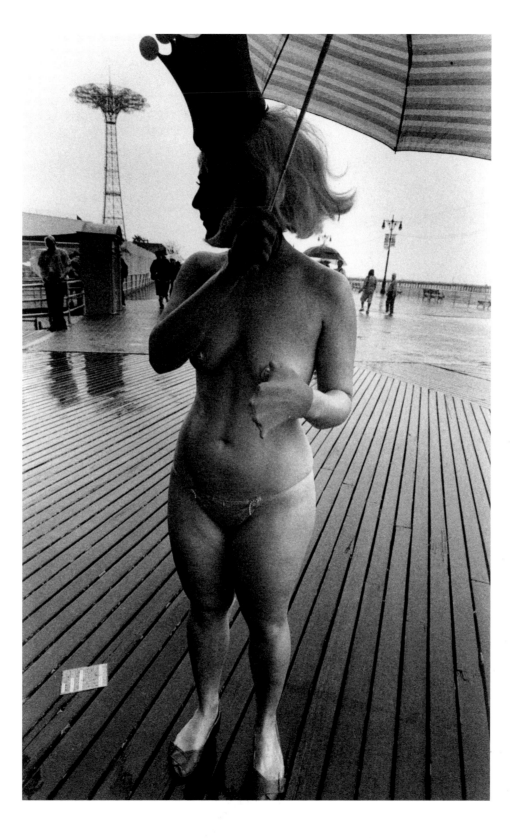

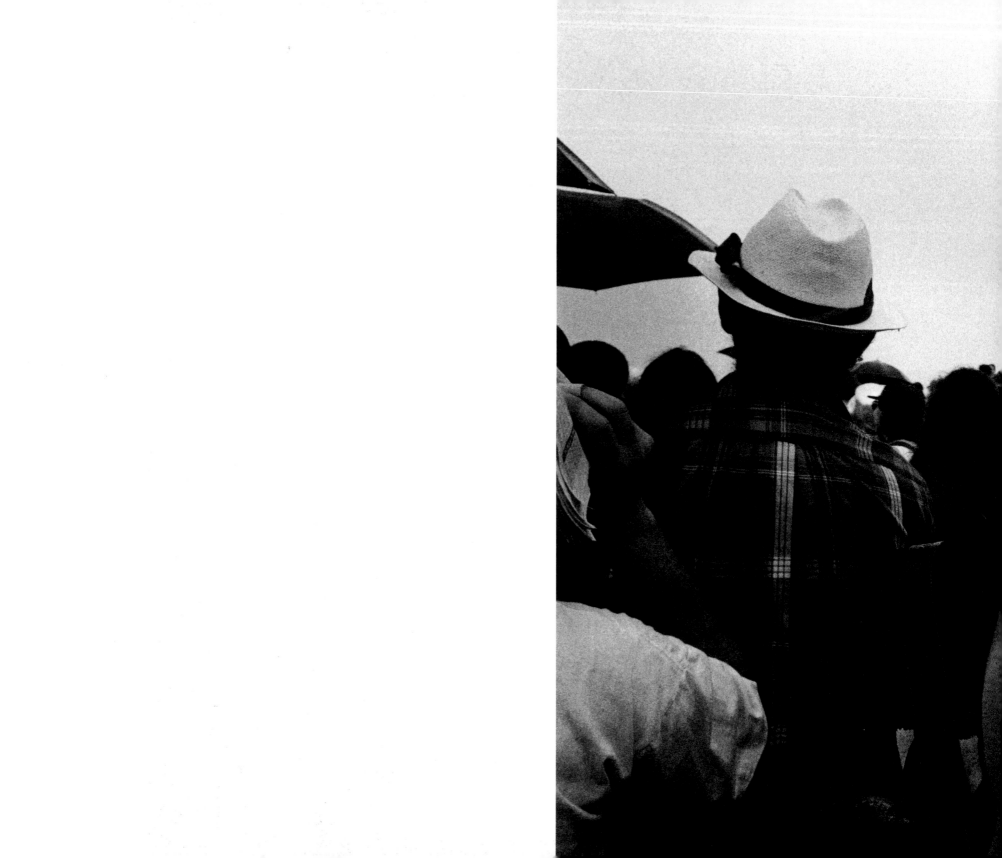

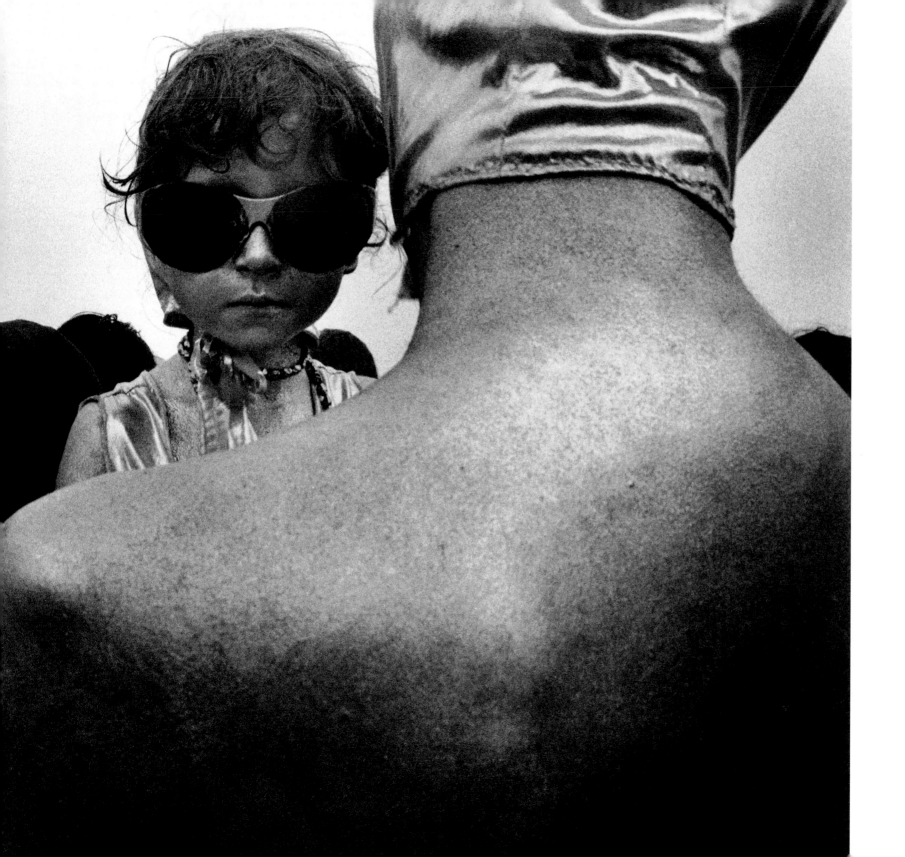

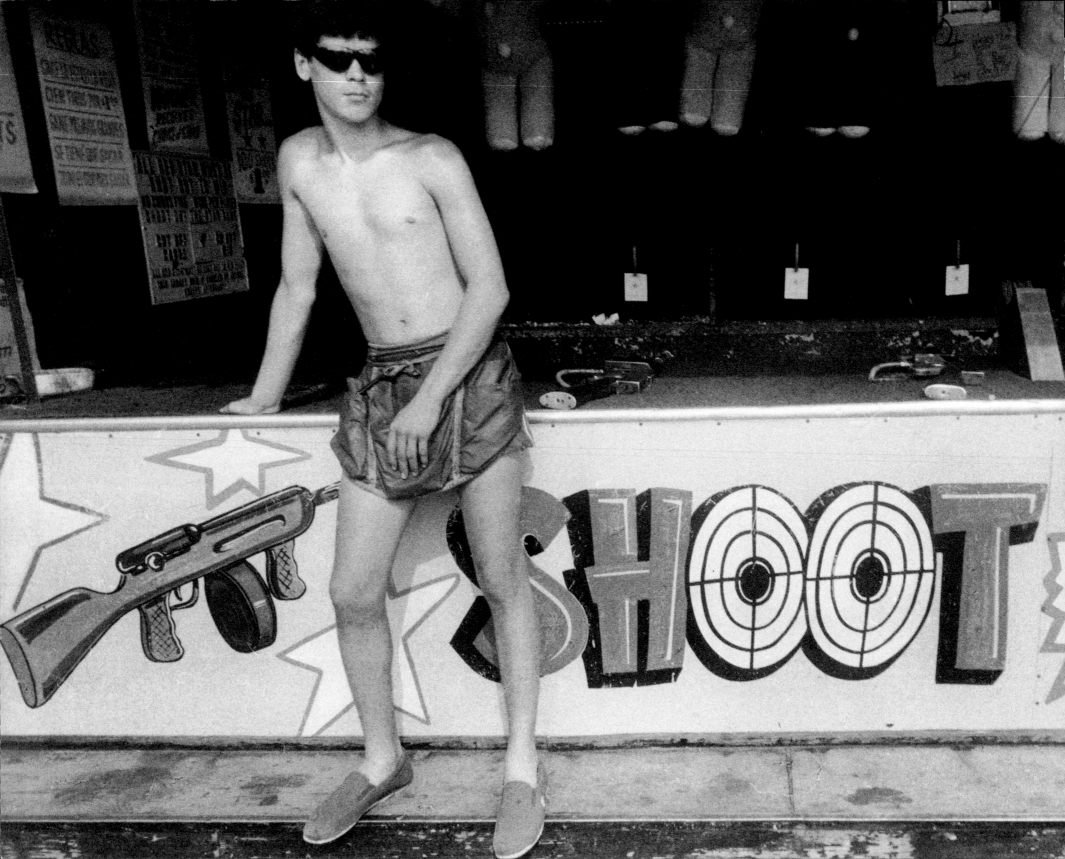

THE WORKERS

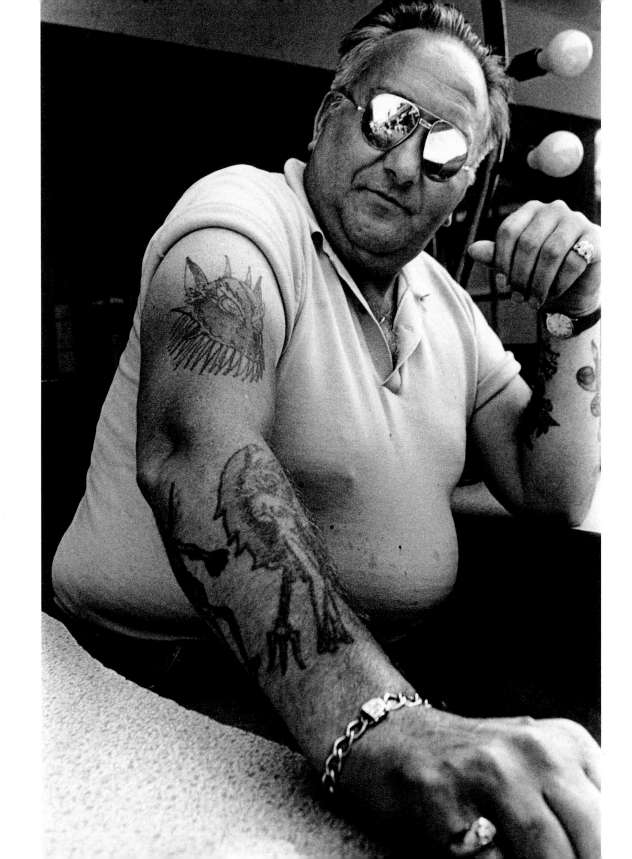

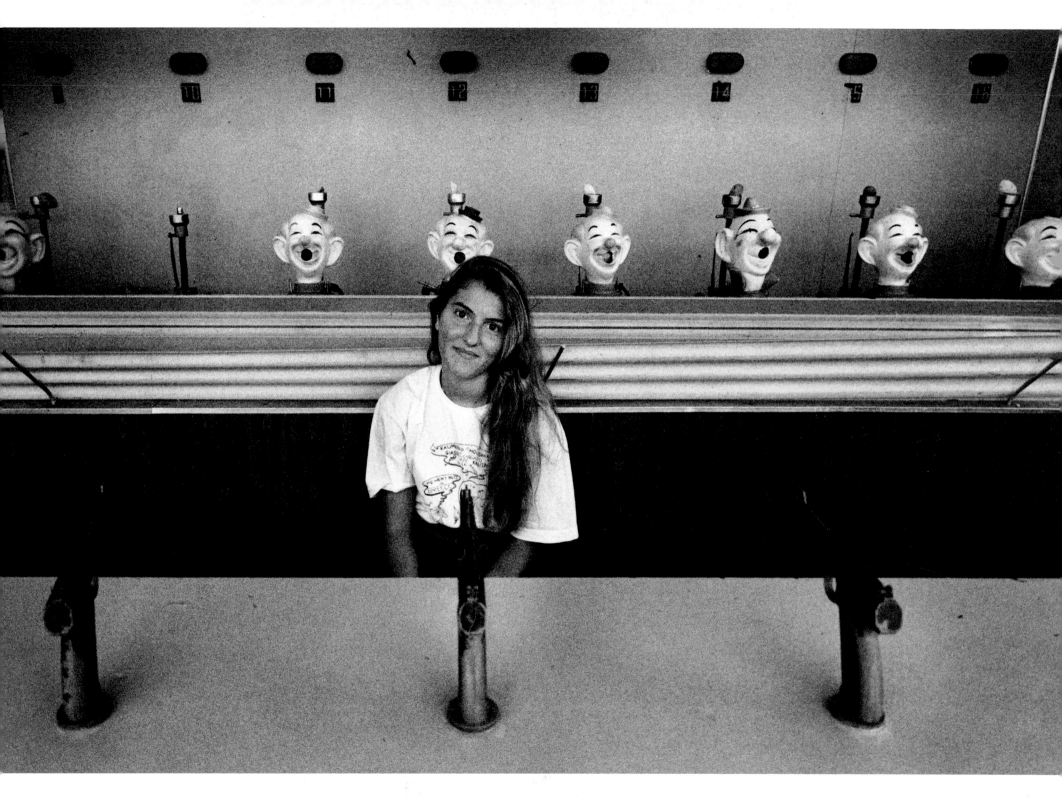

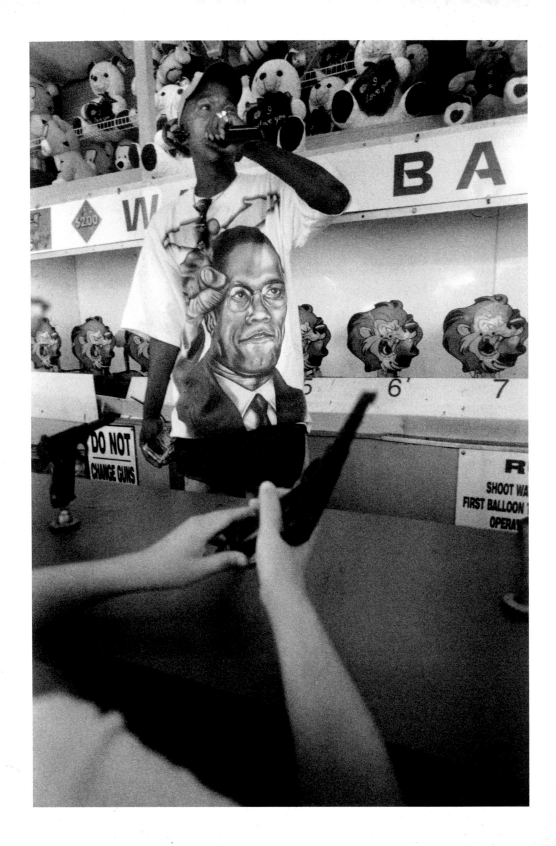

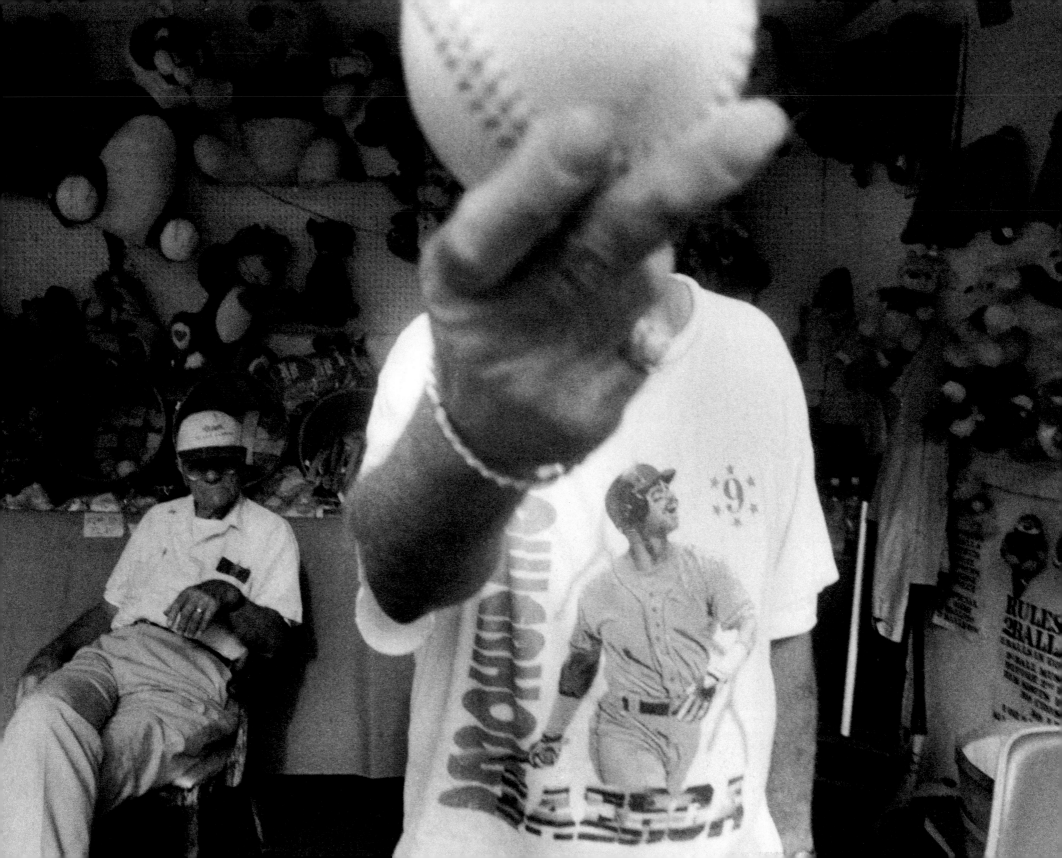

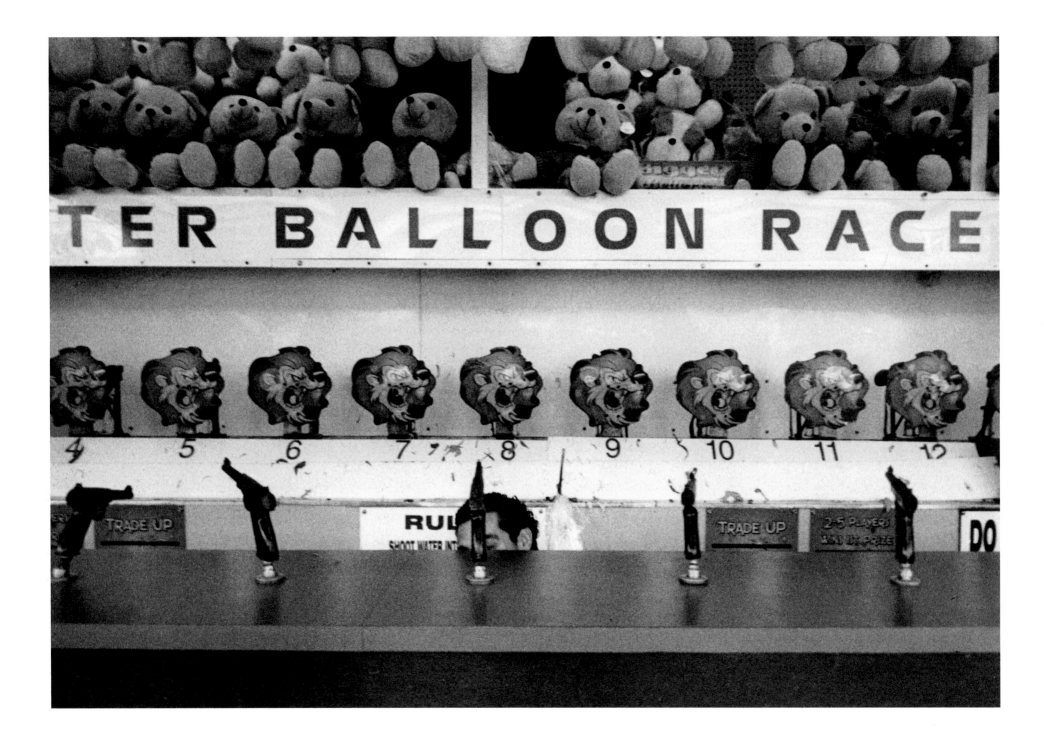

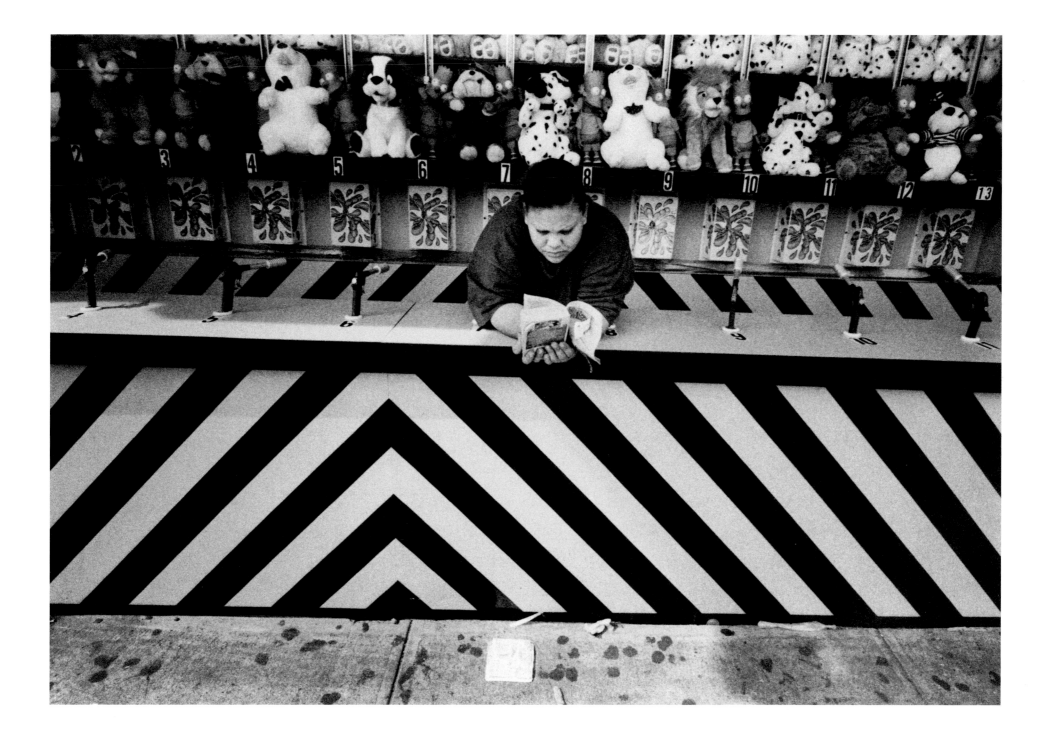

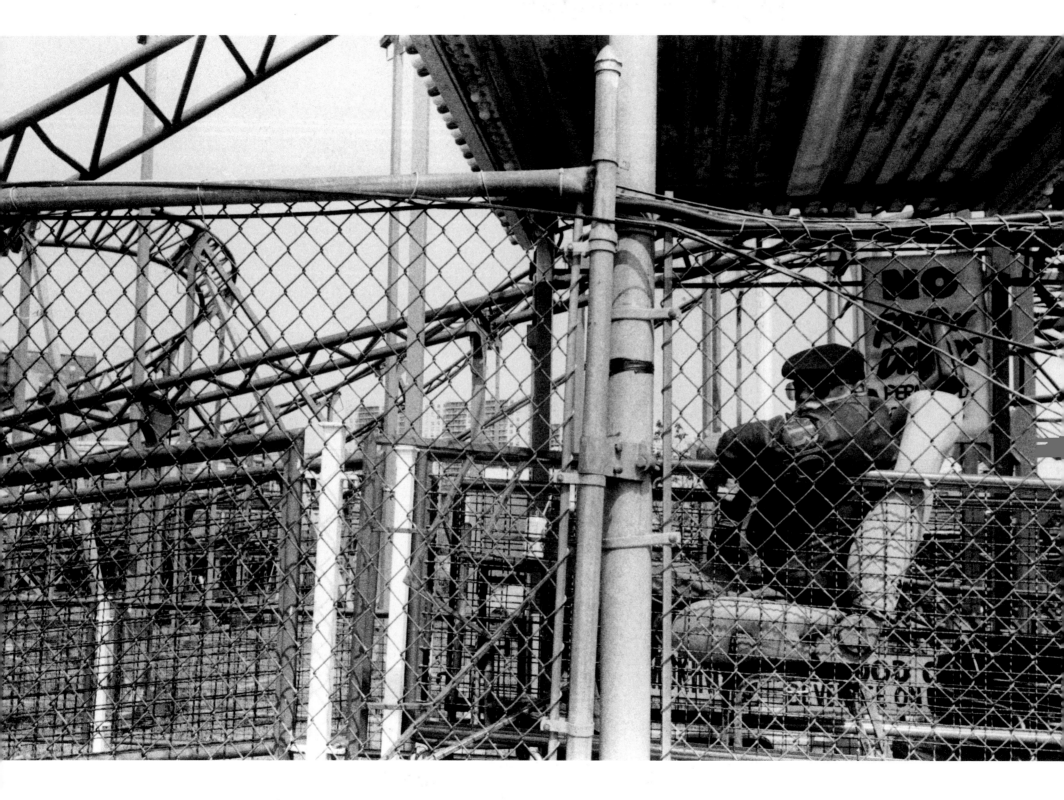

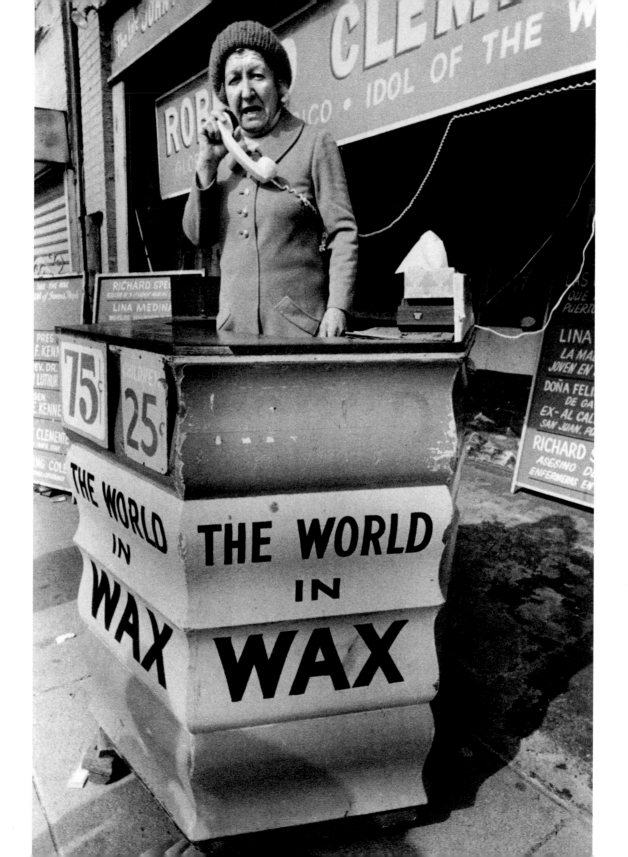

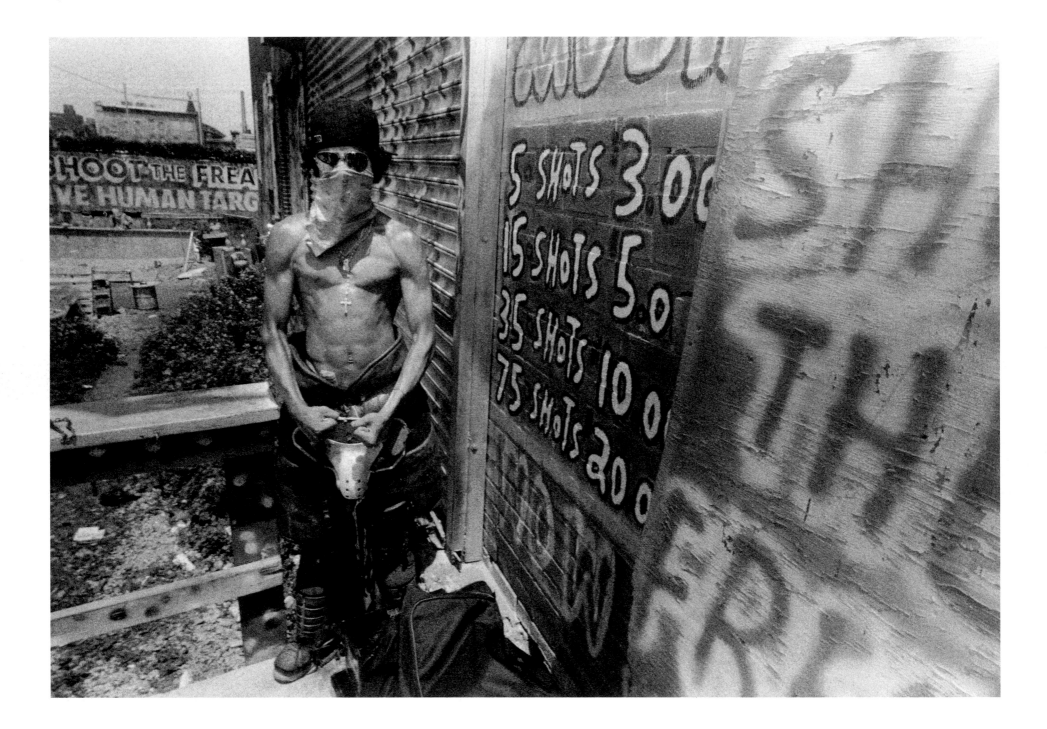

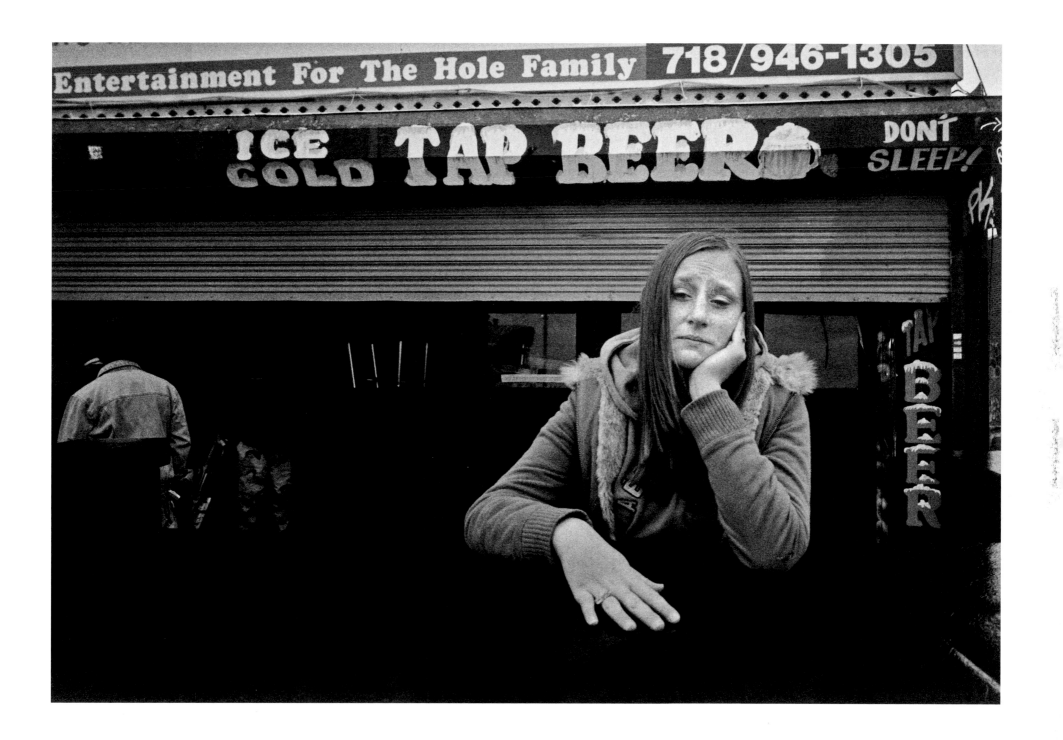

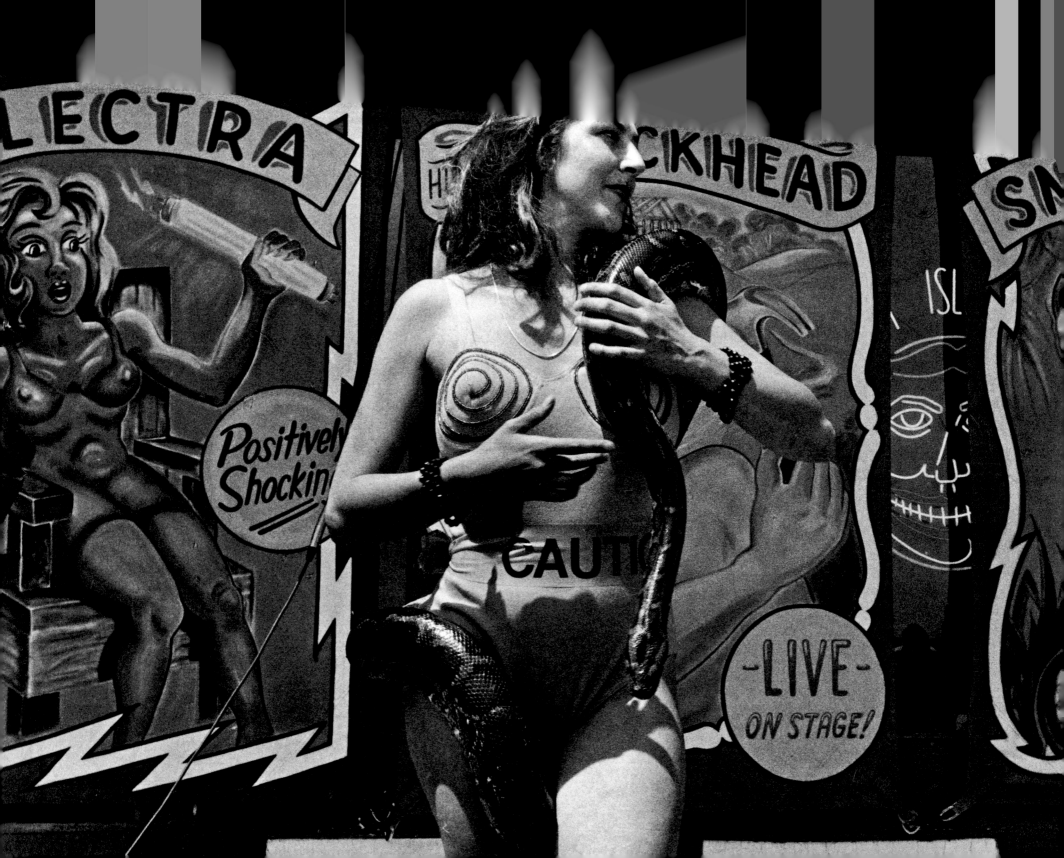

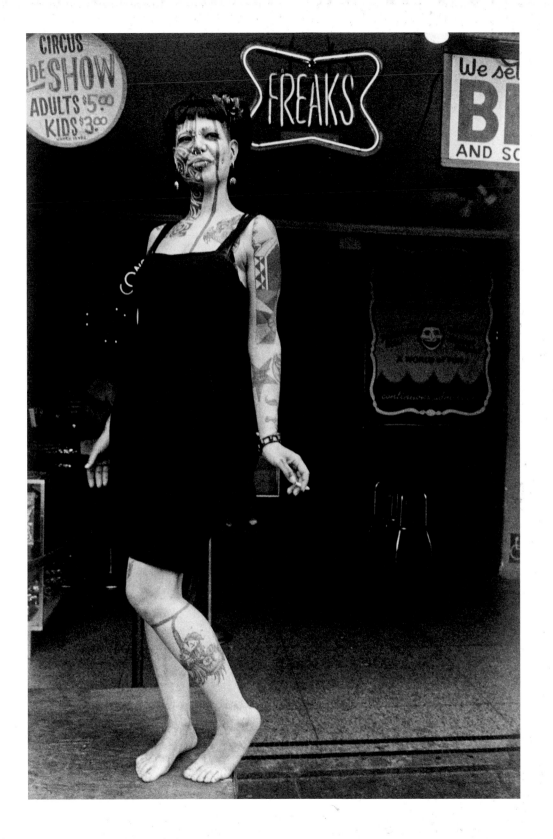

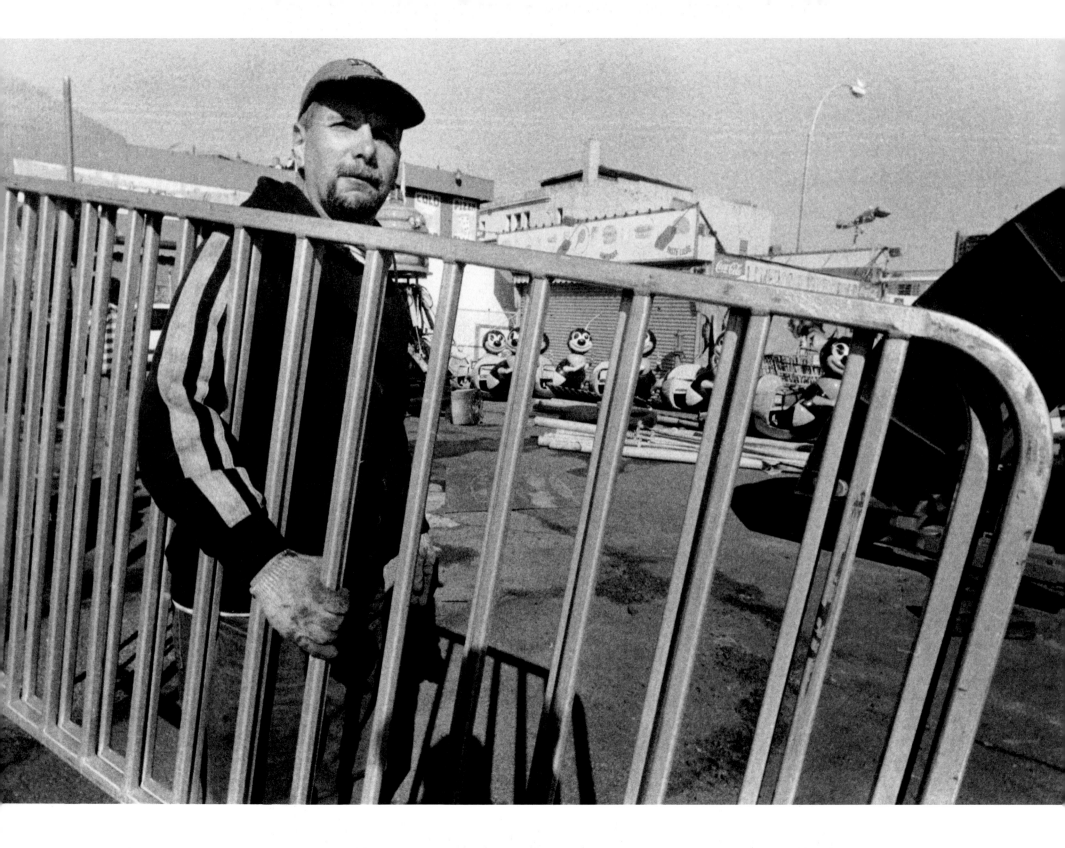

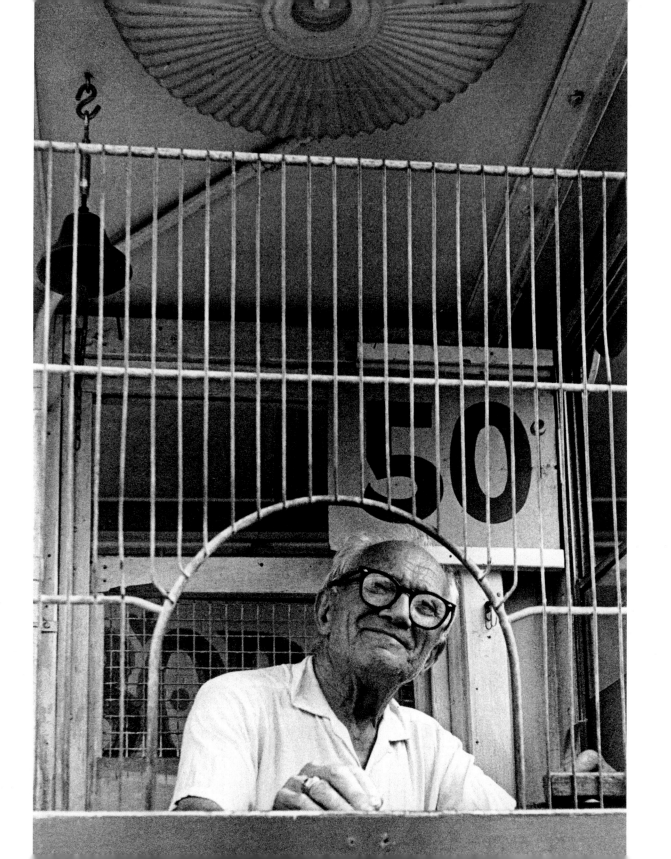

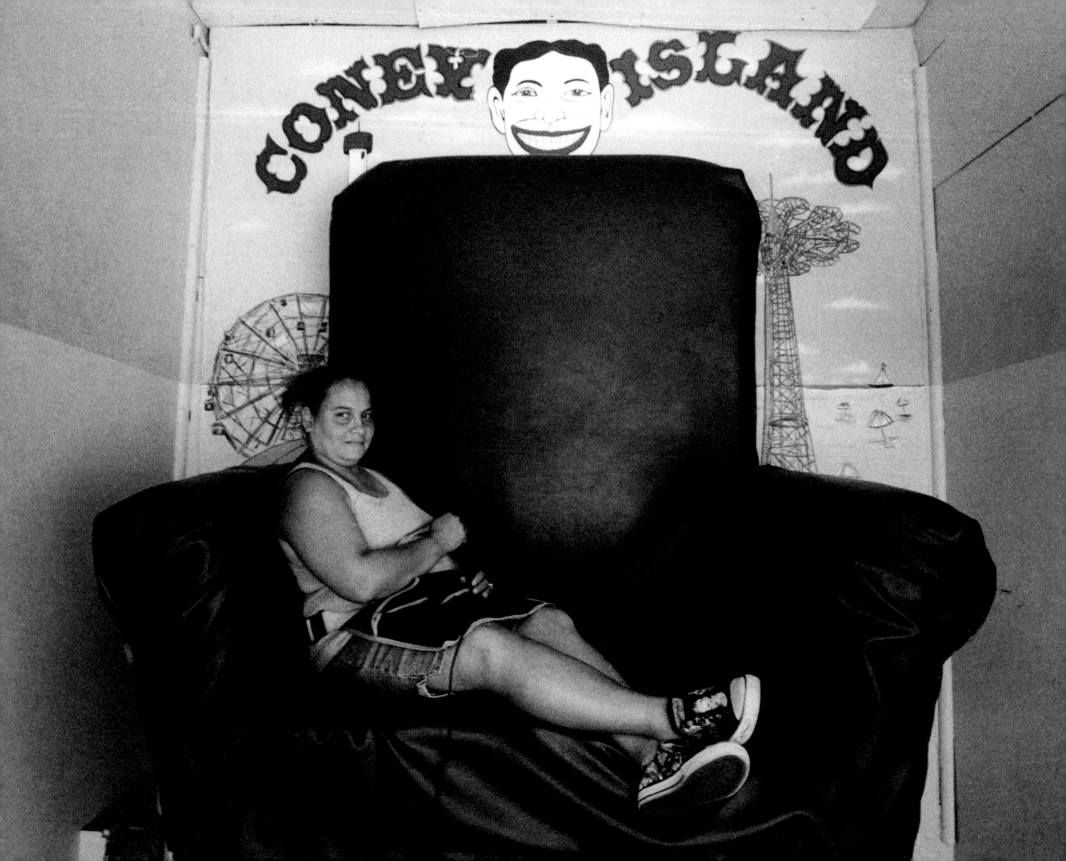

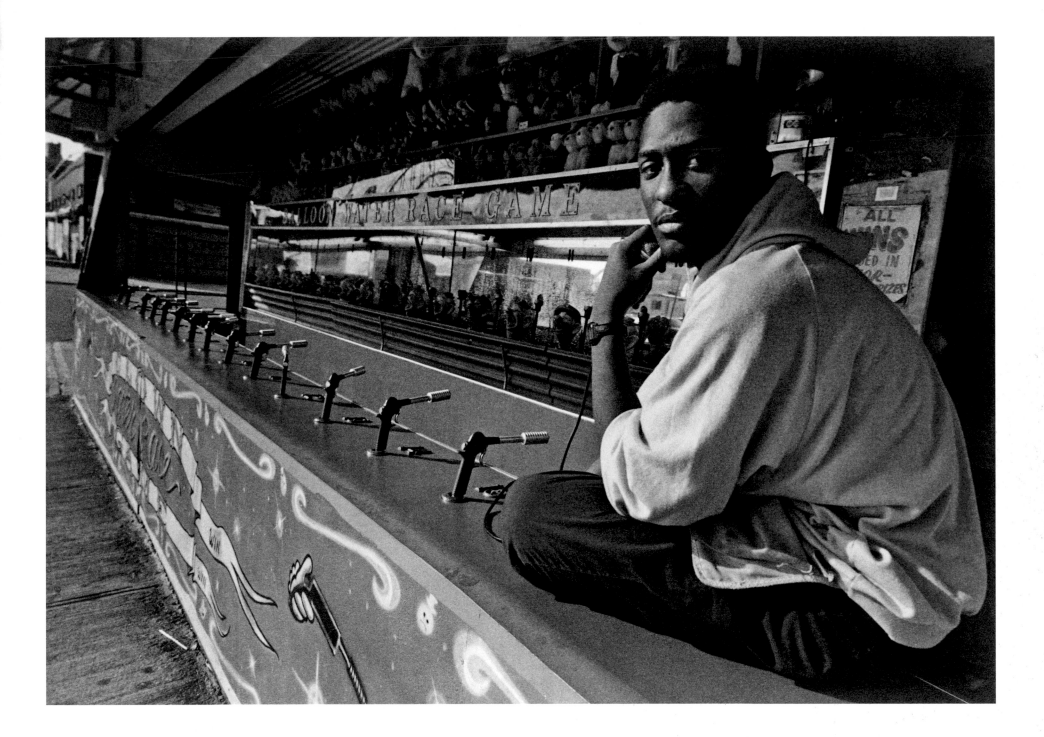

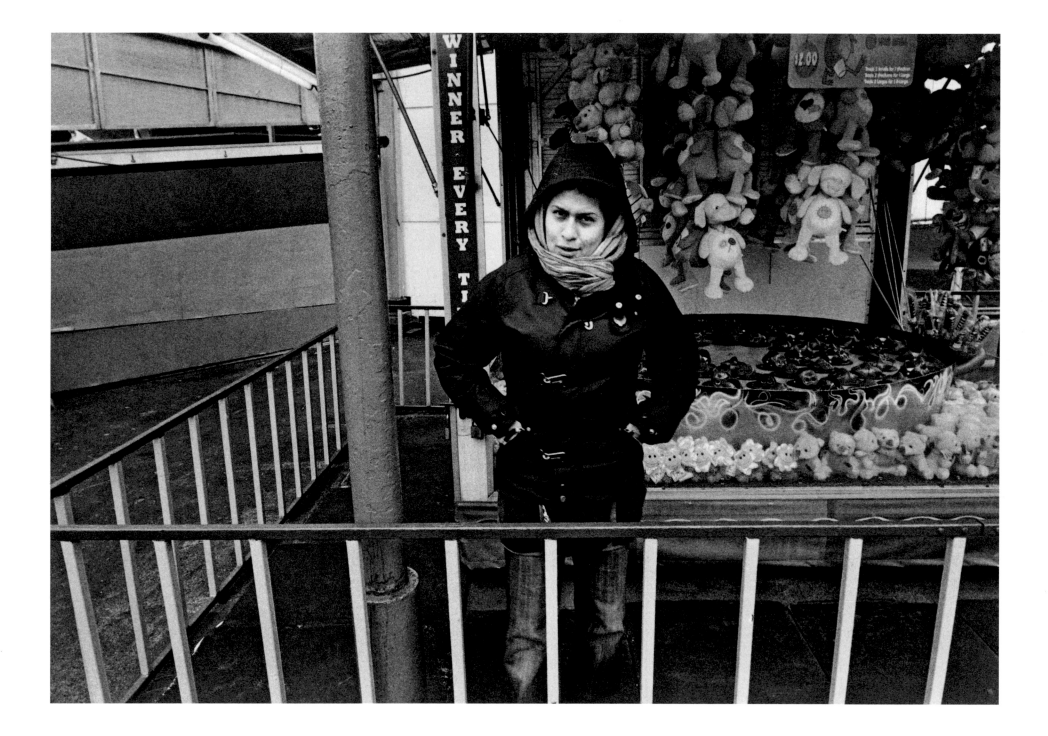

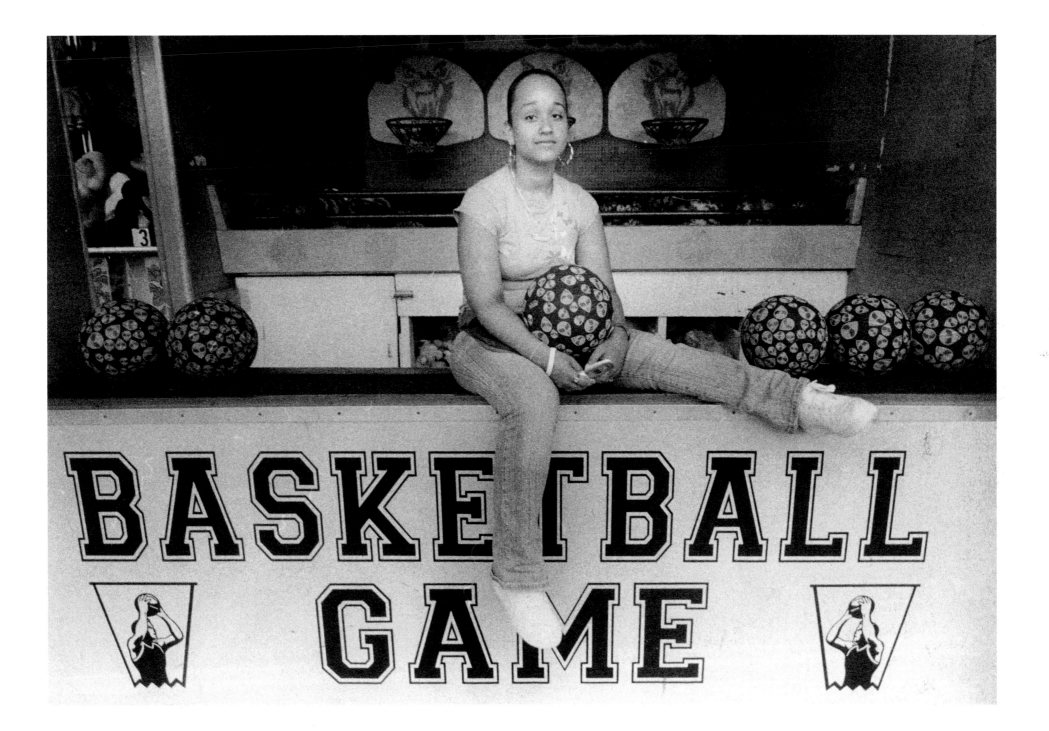

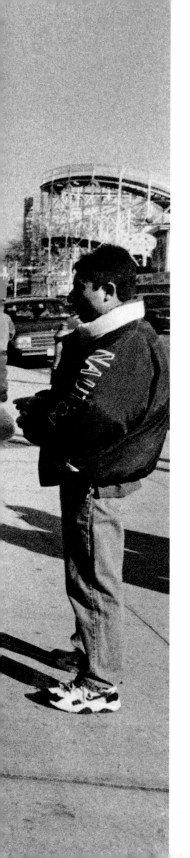
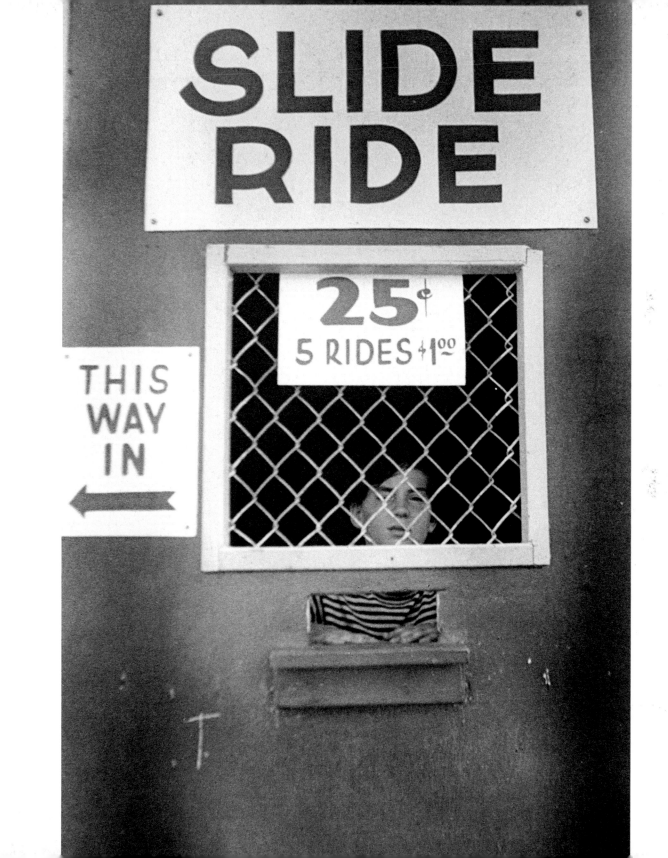

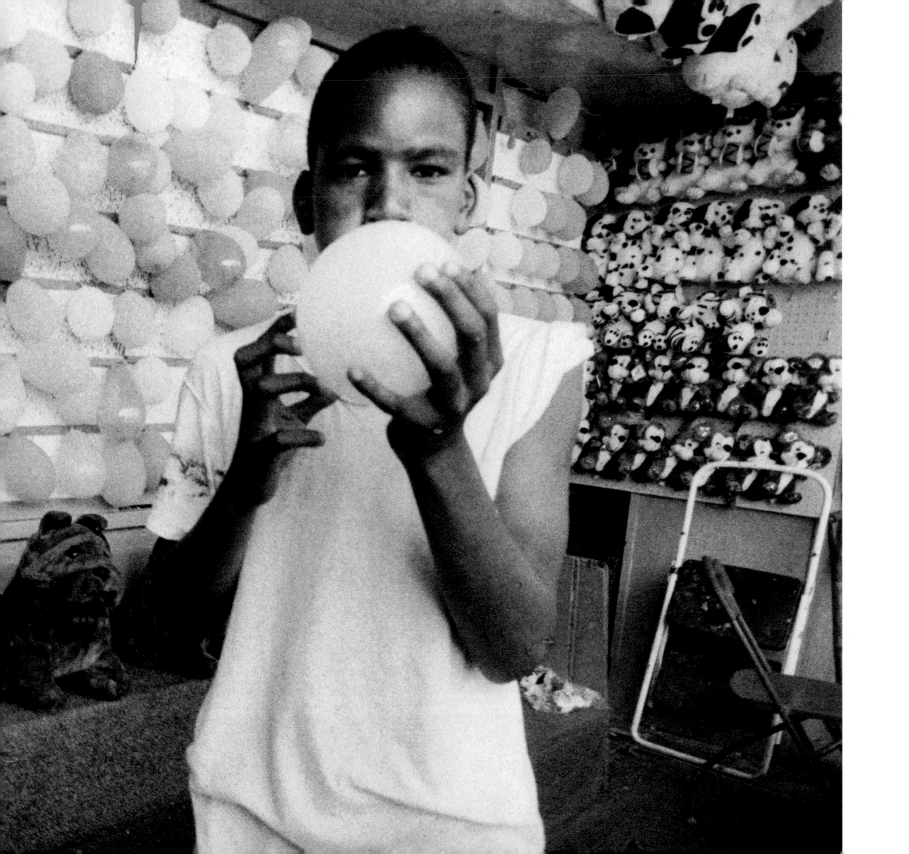

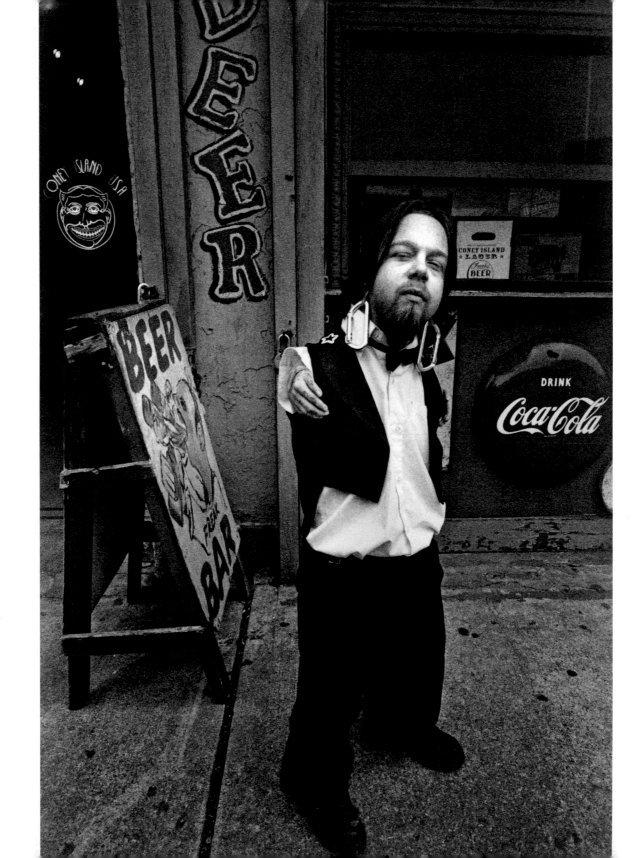

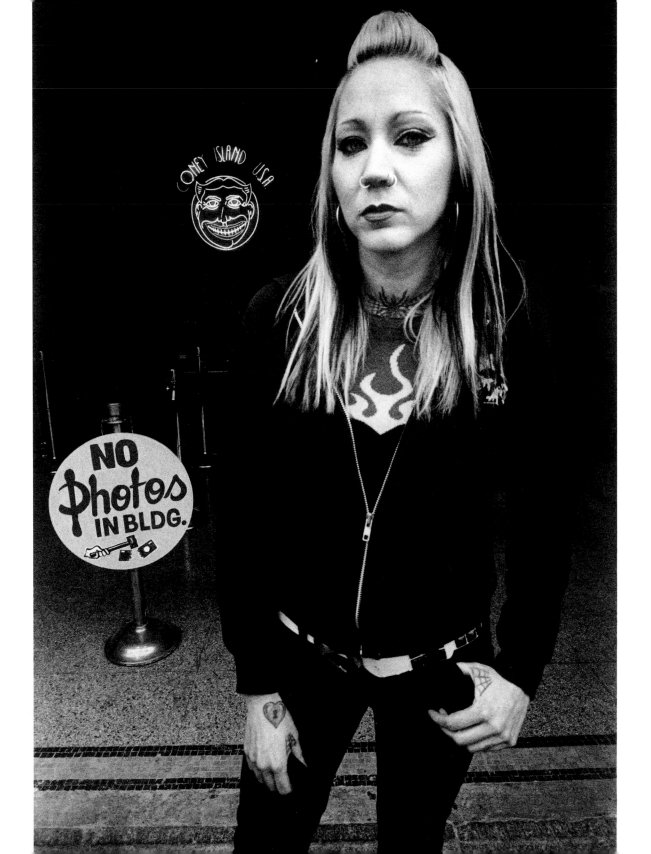

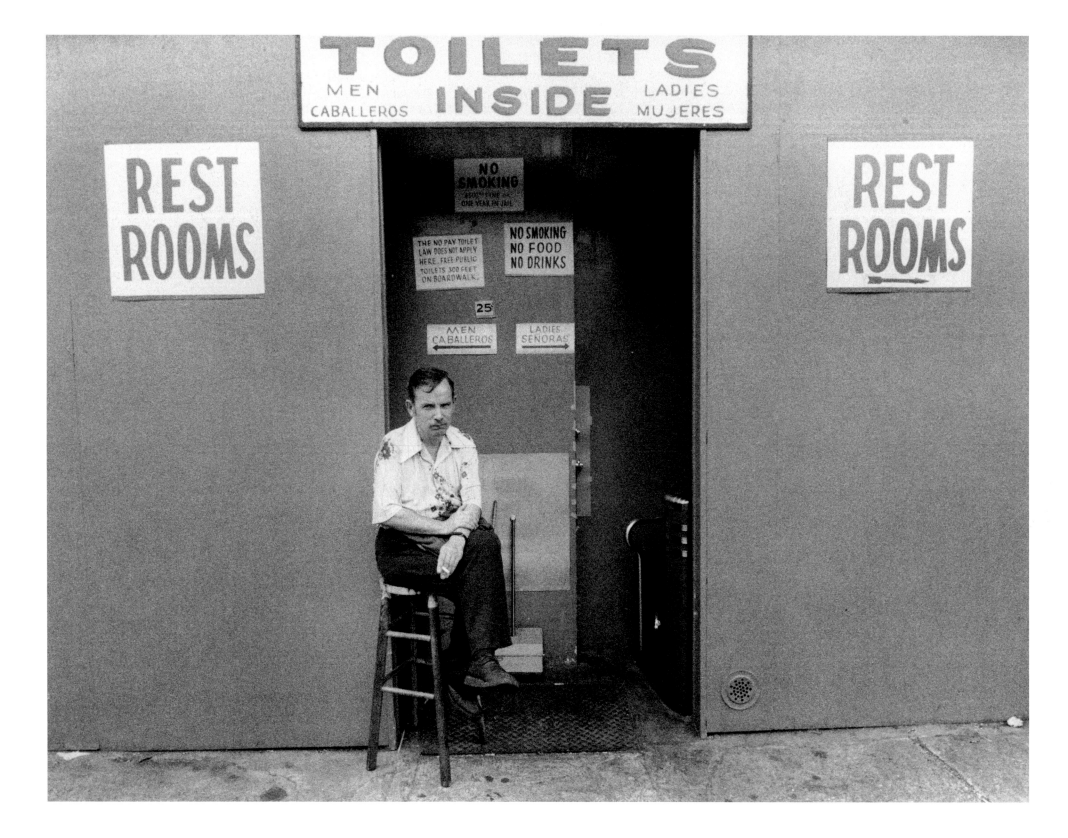

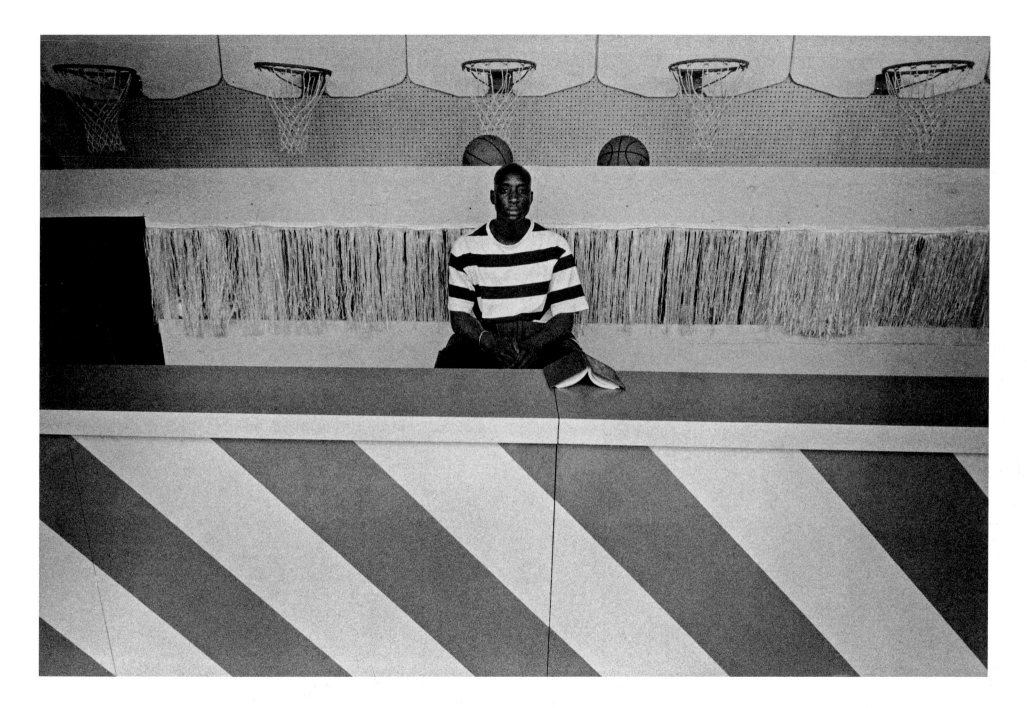

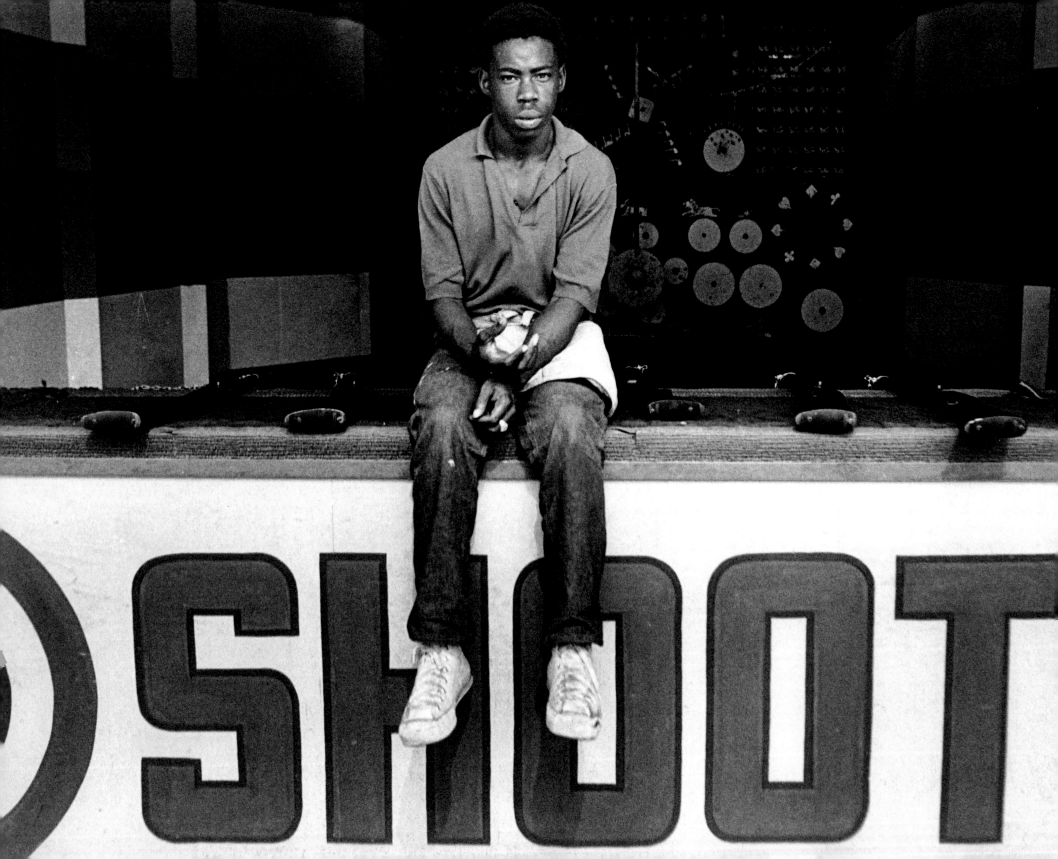

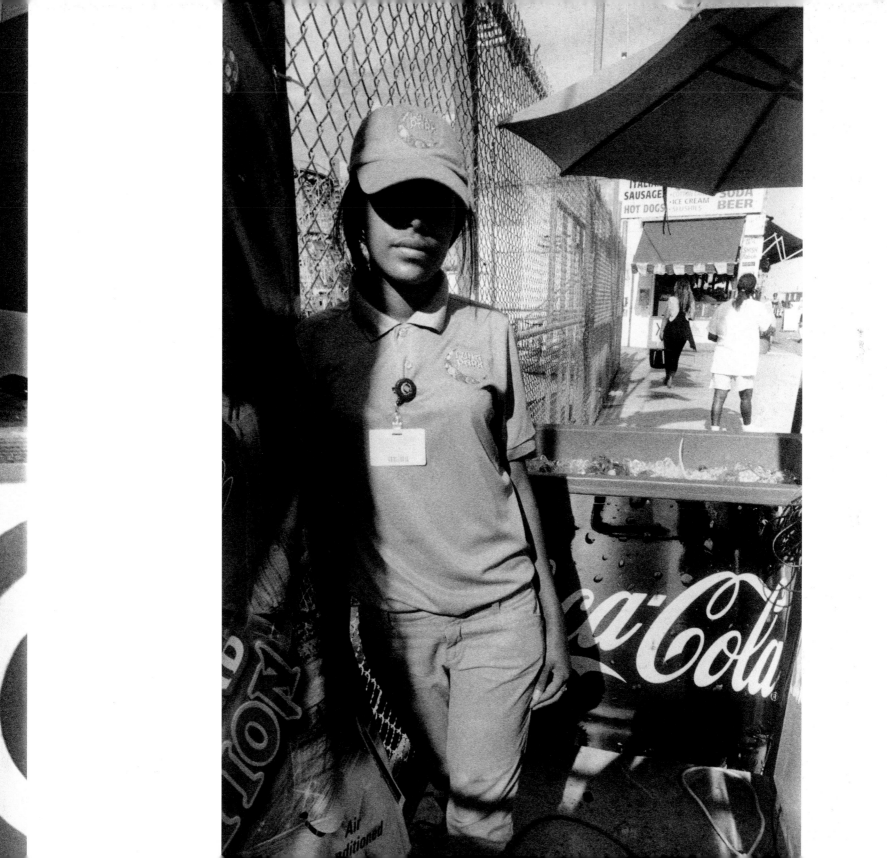

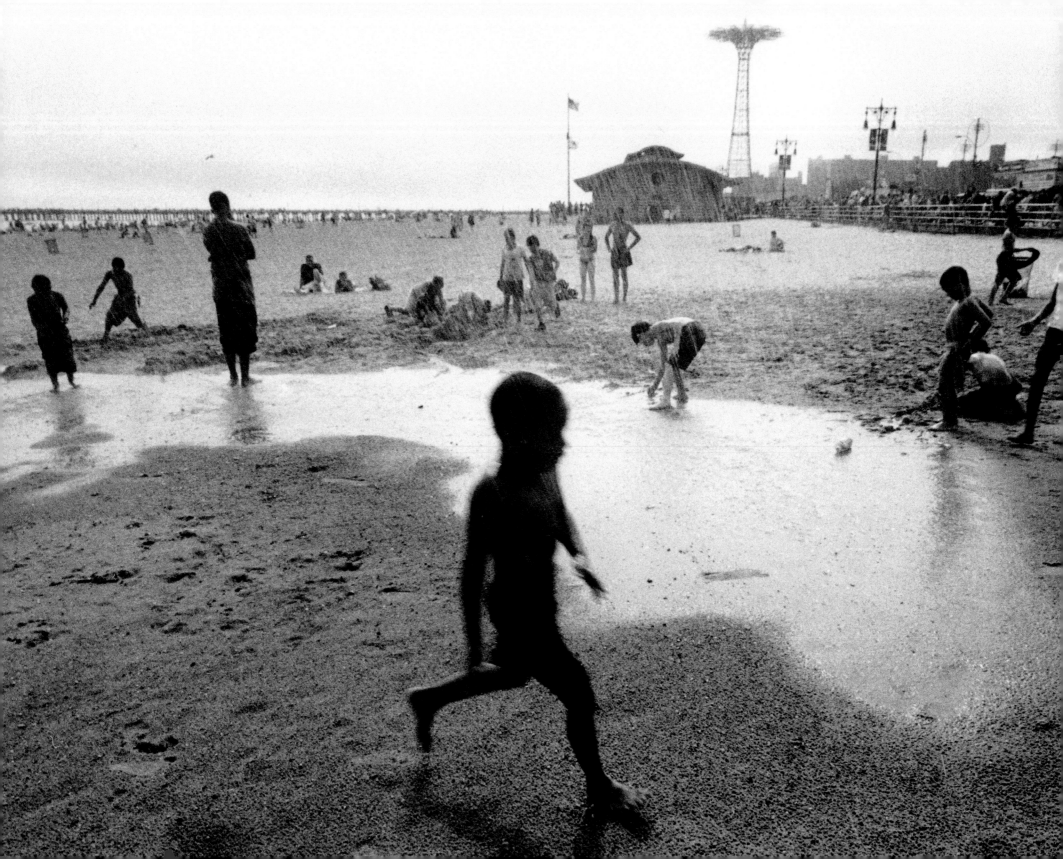

THE BEACH

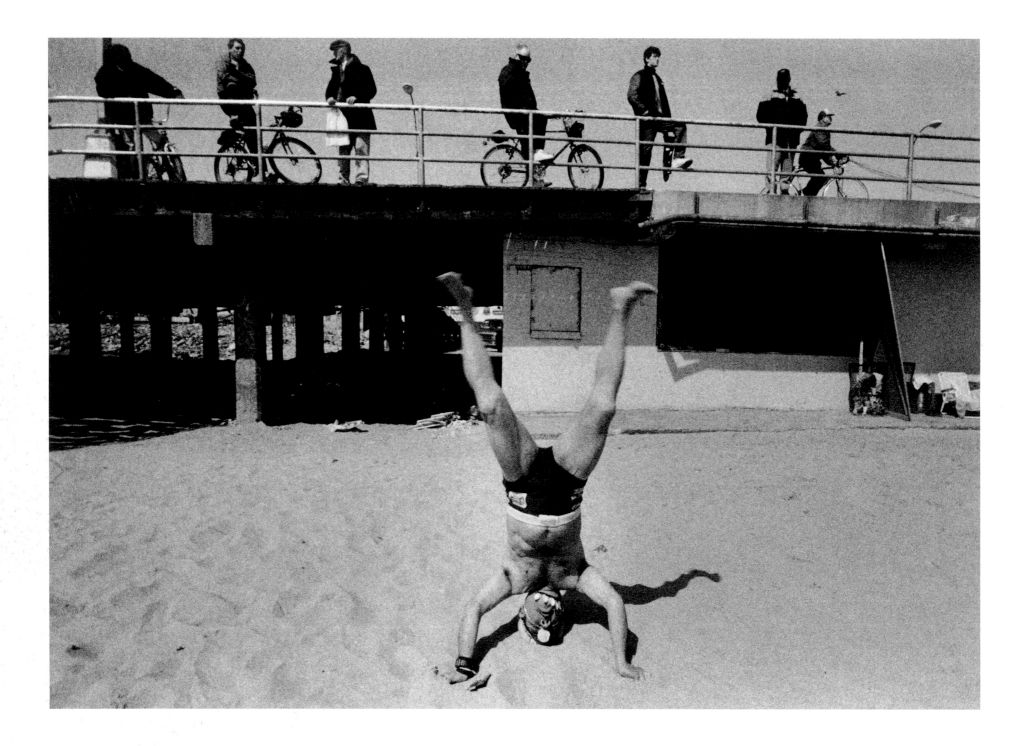

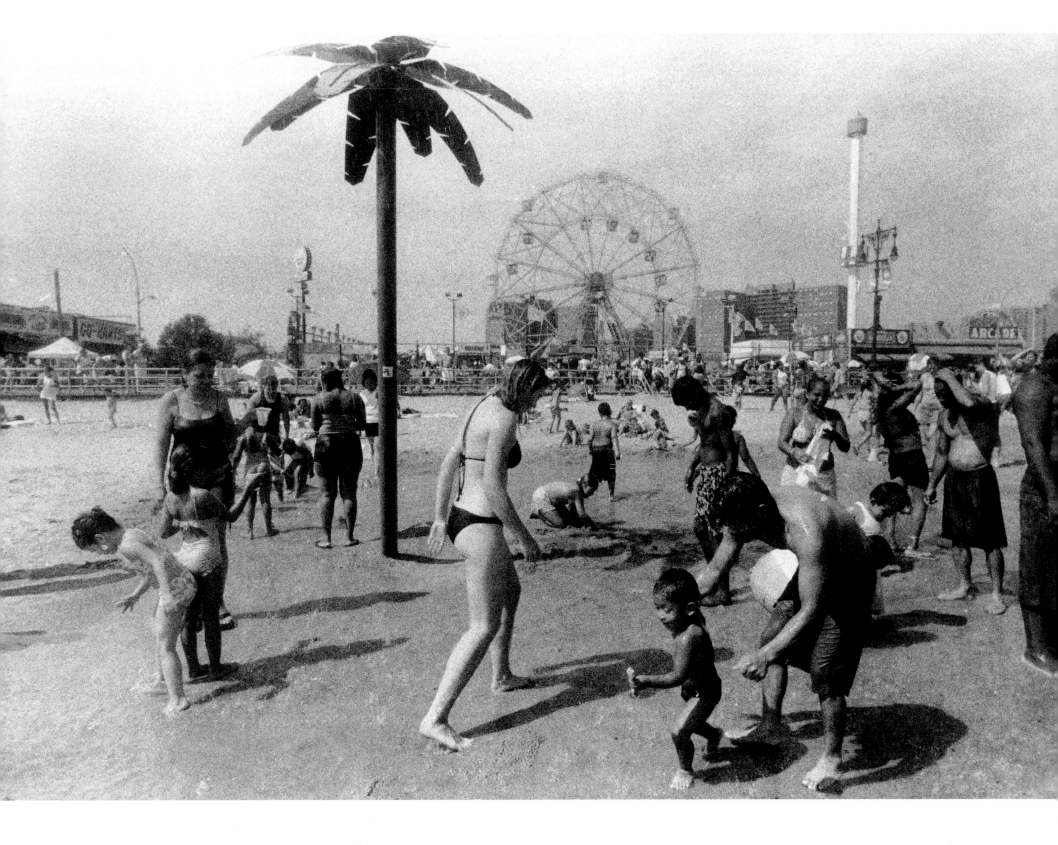

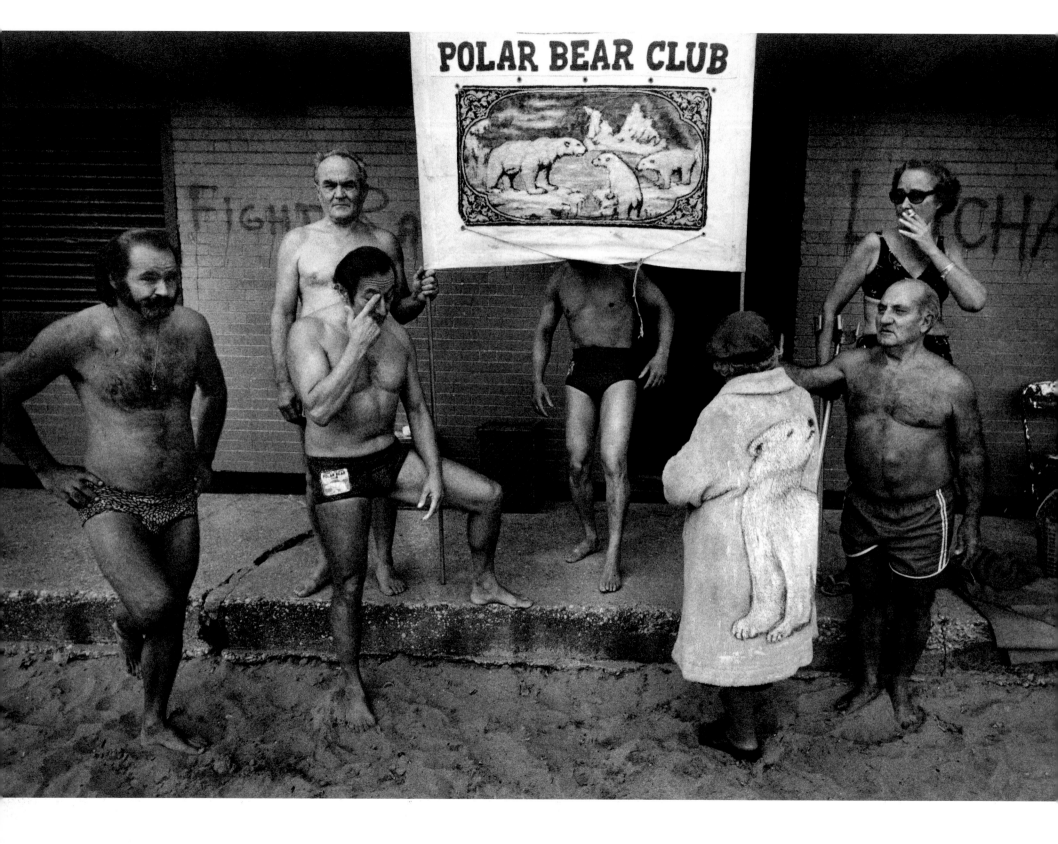

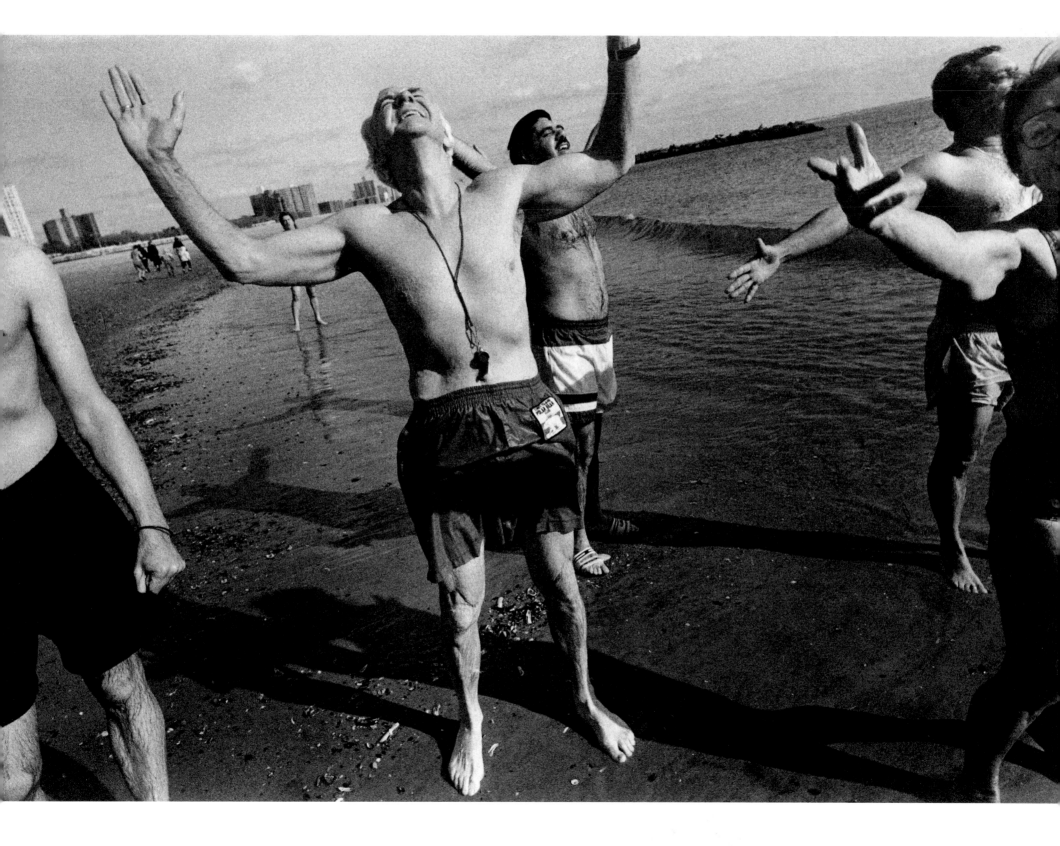

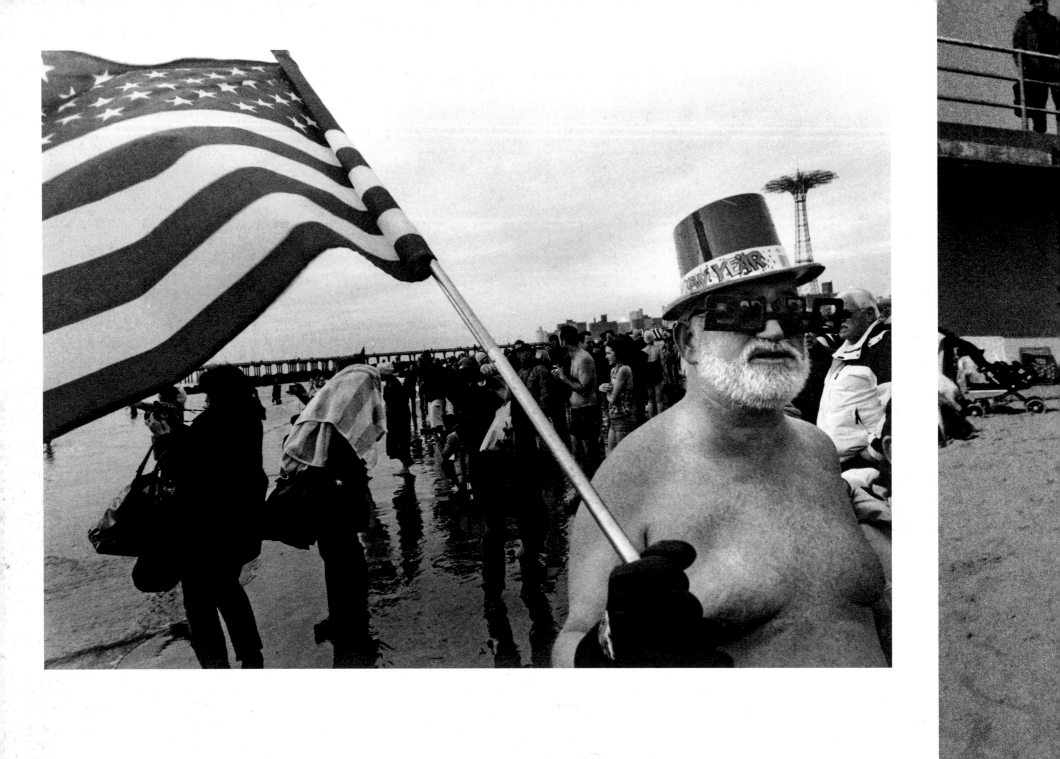

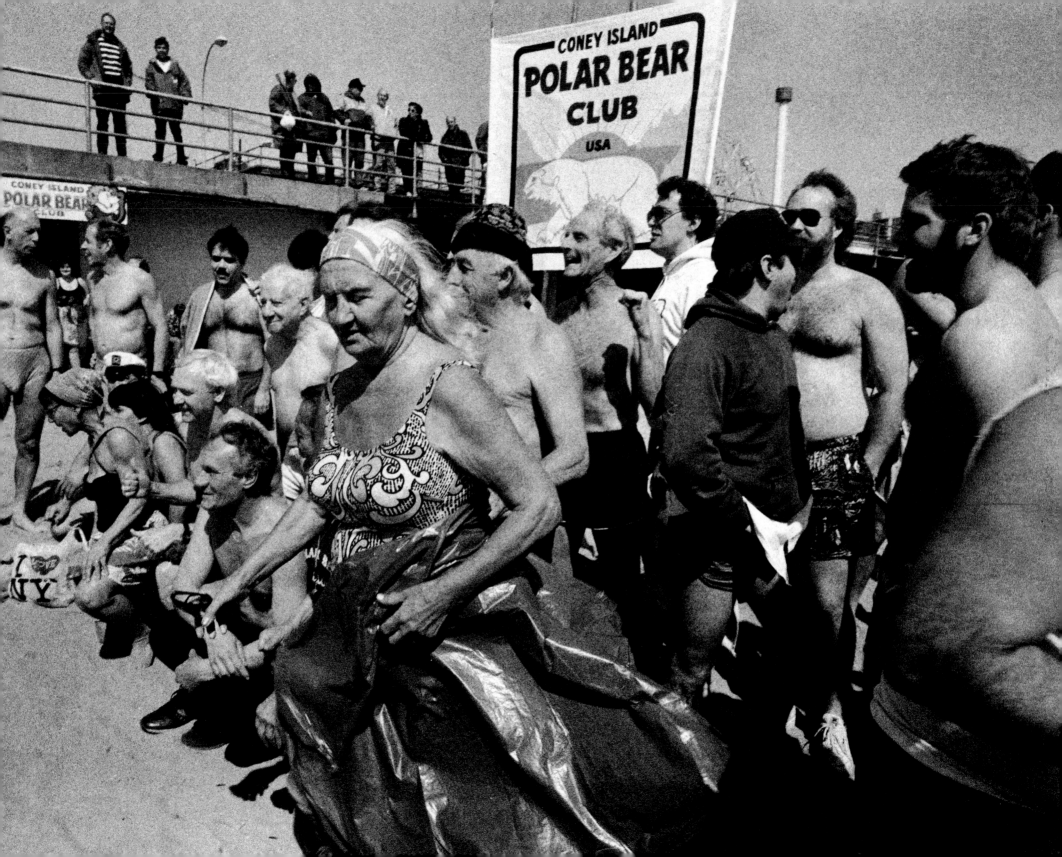

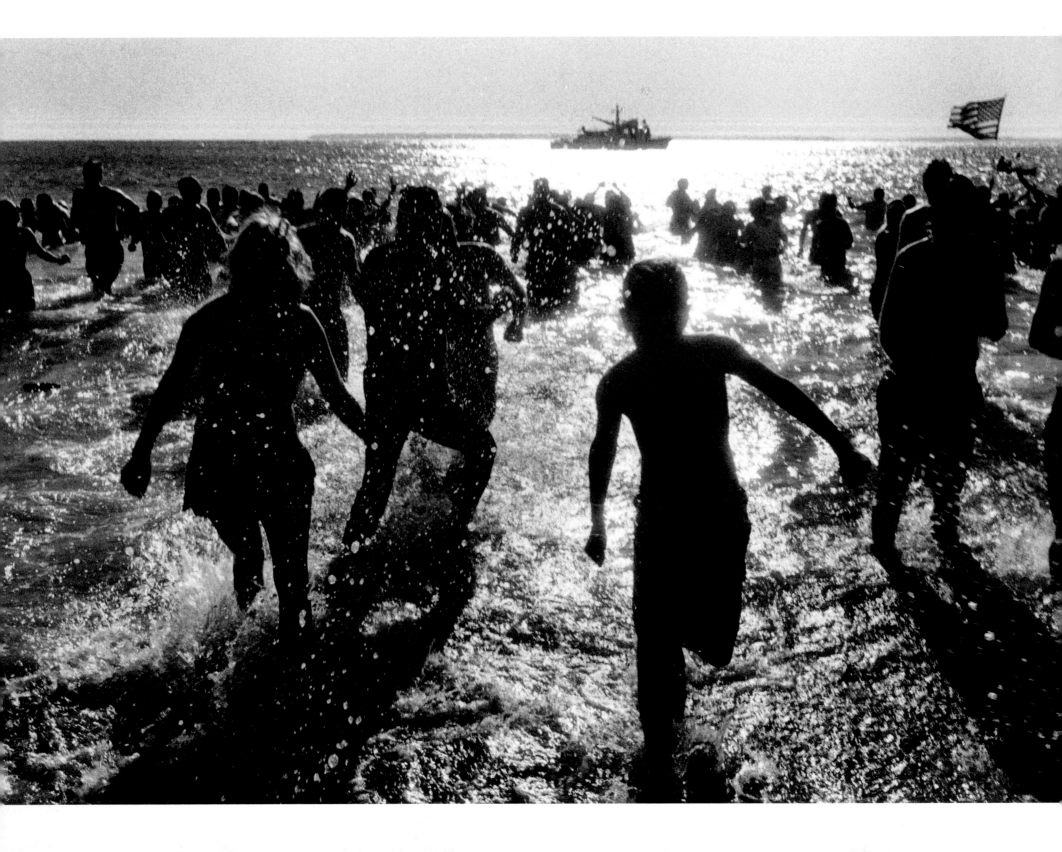

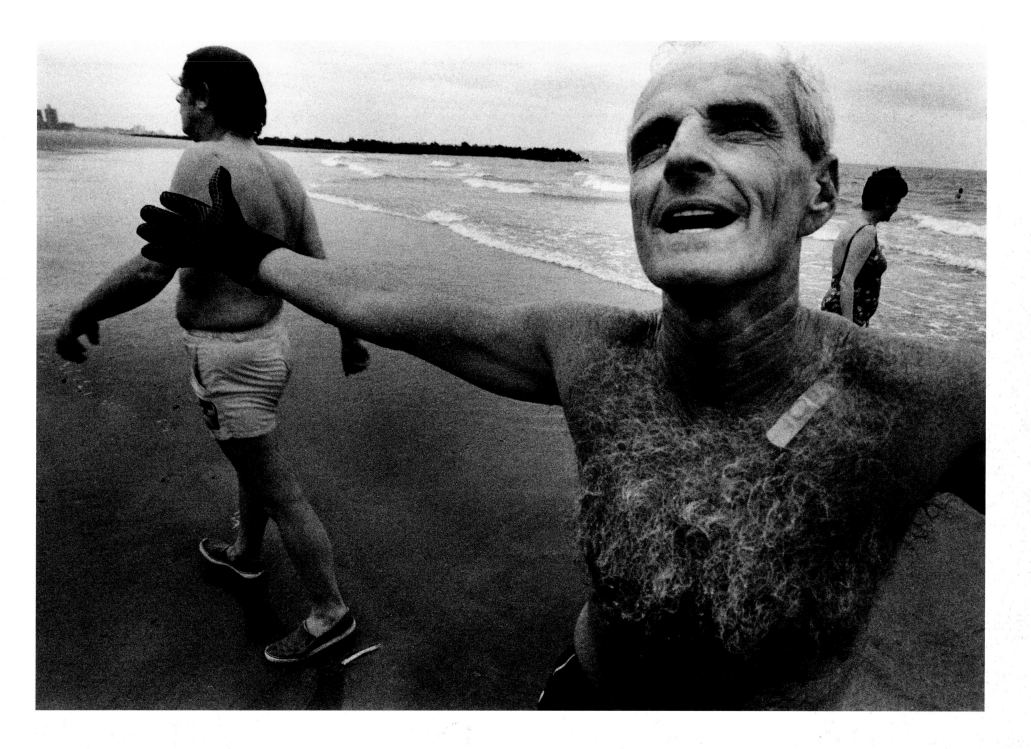

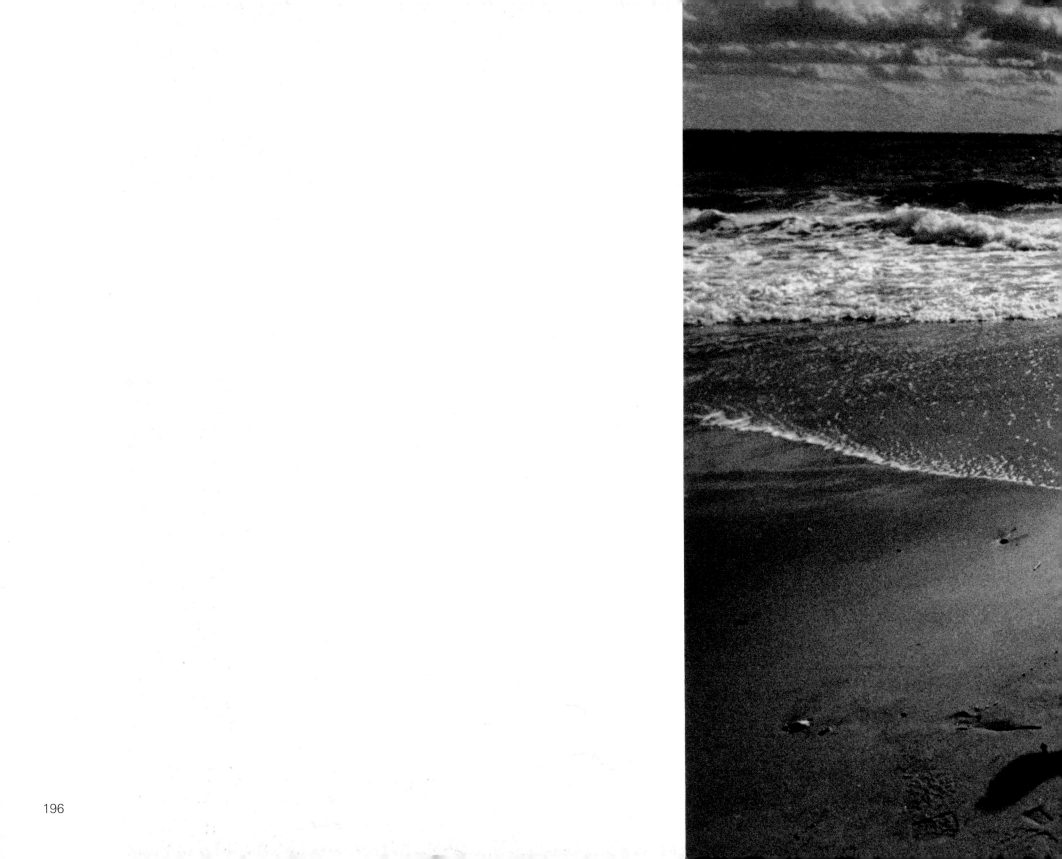

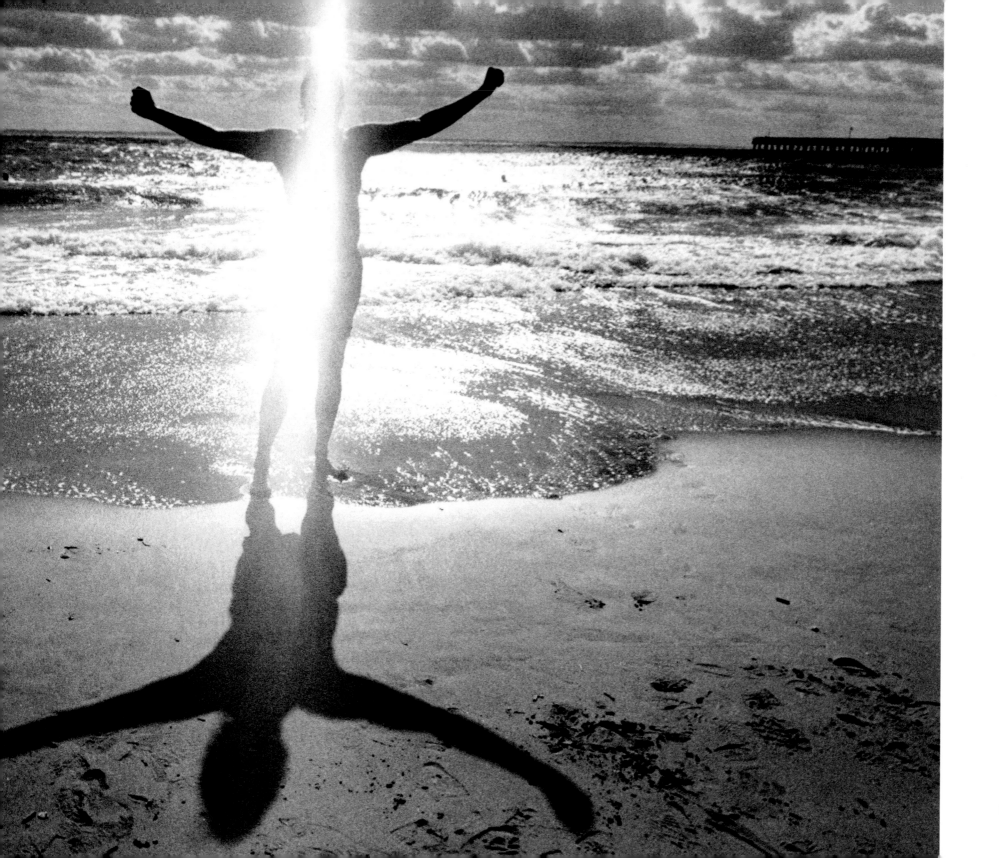

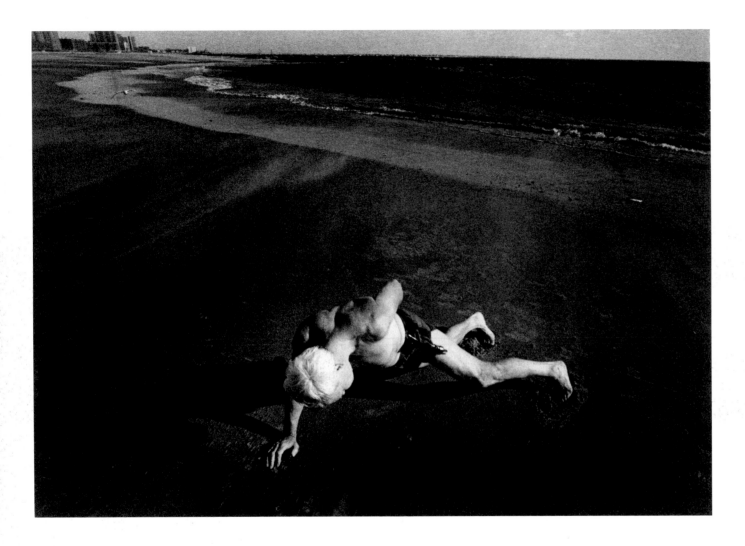

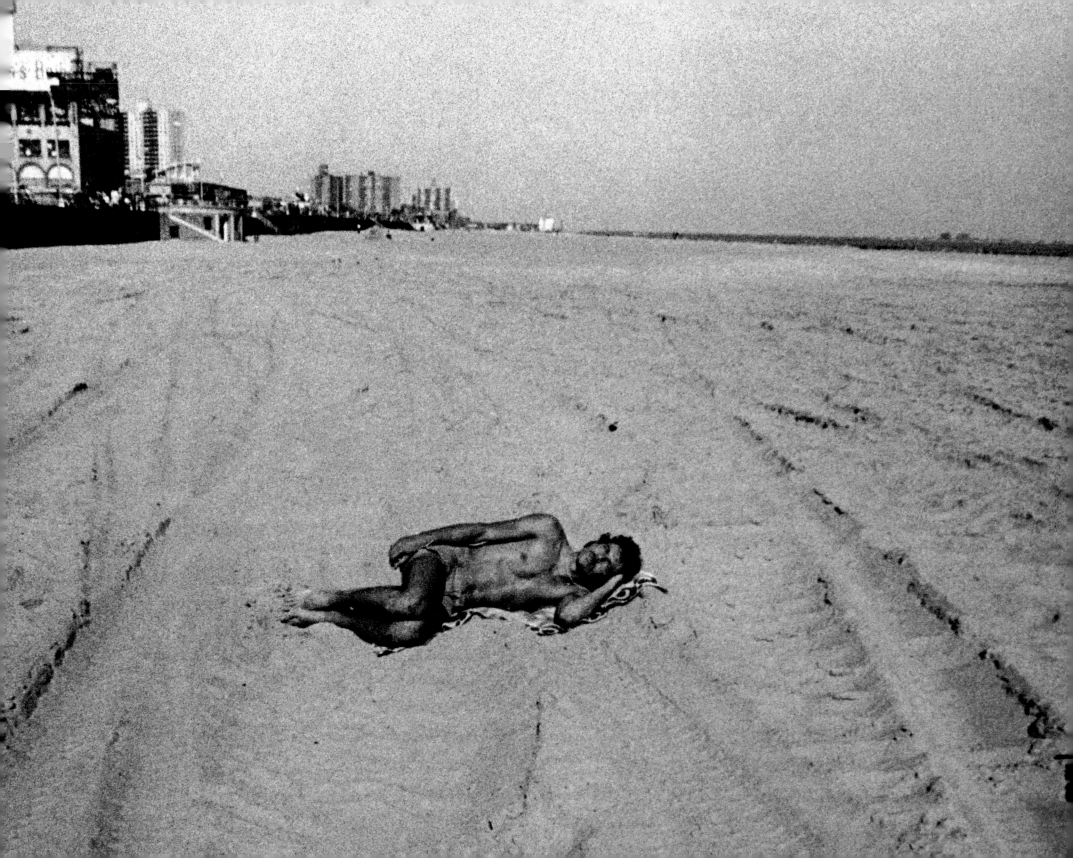

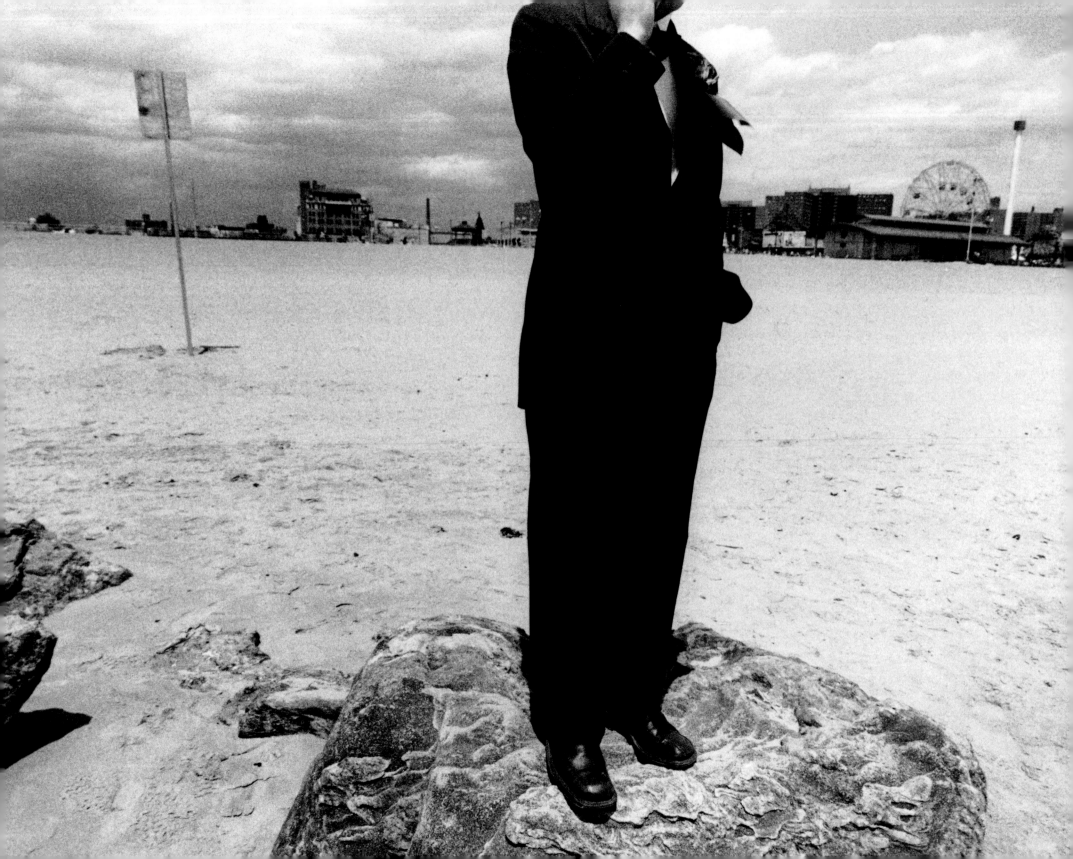

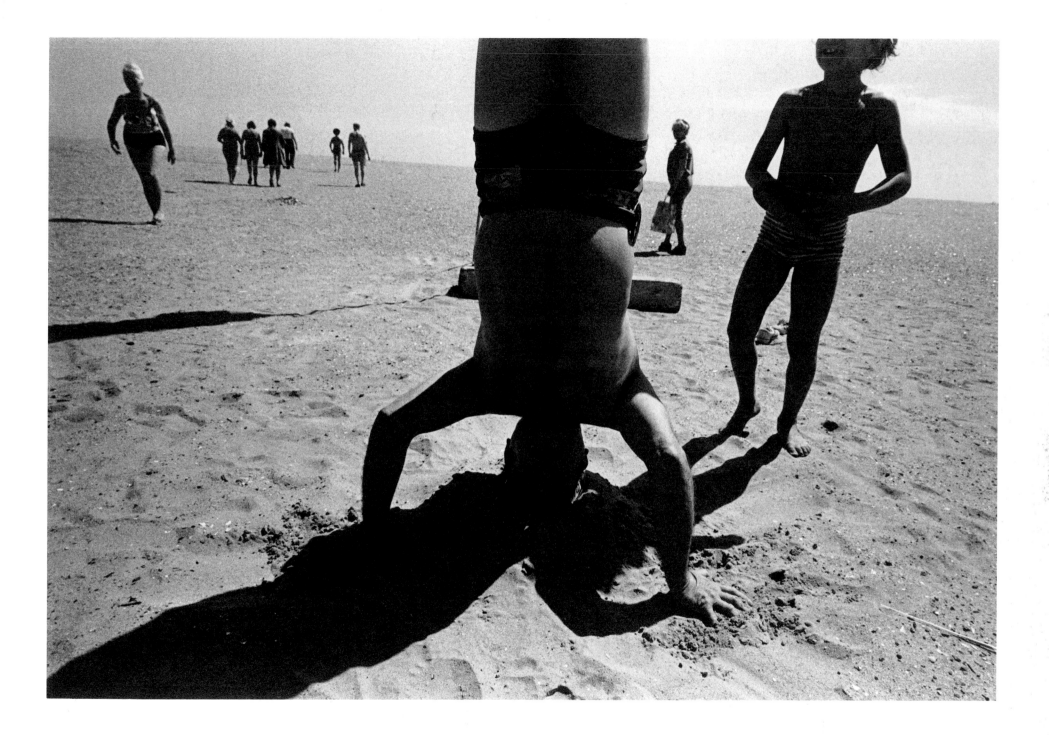

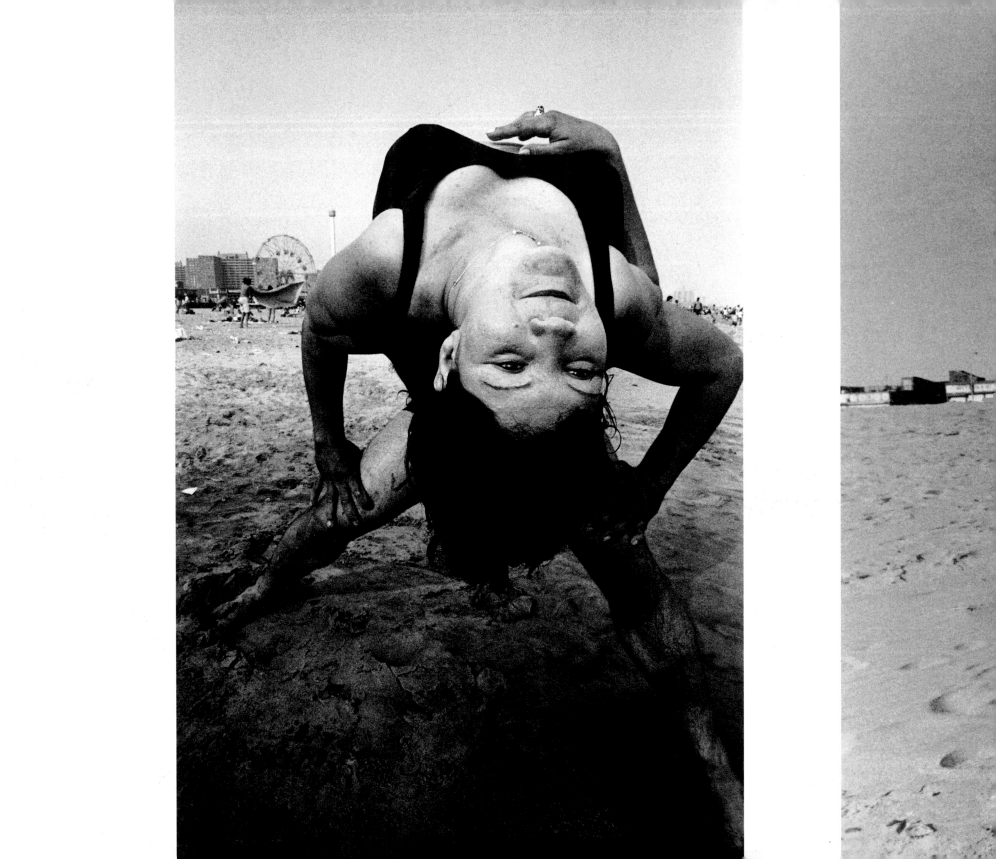

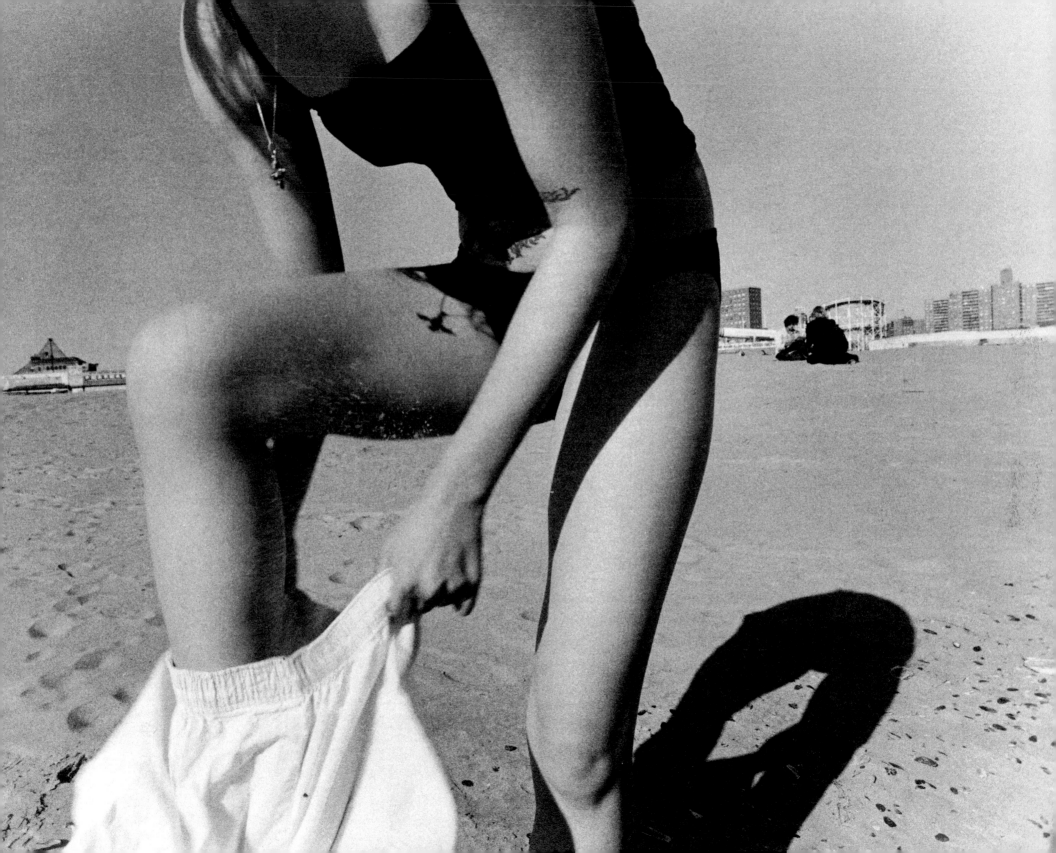

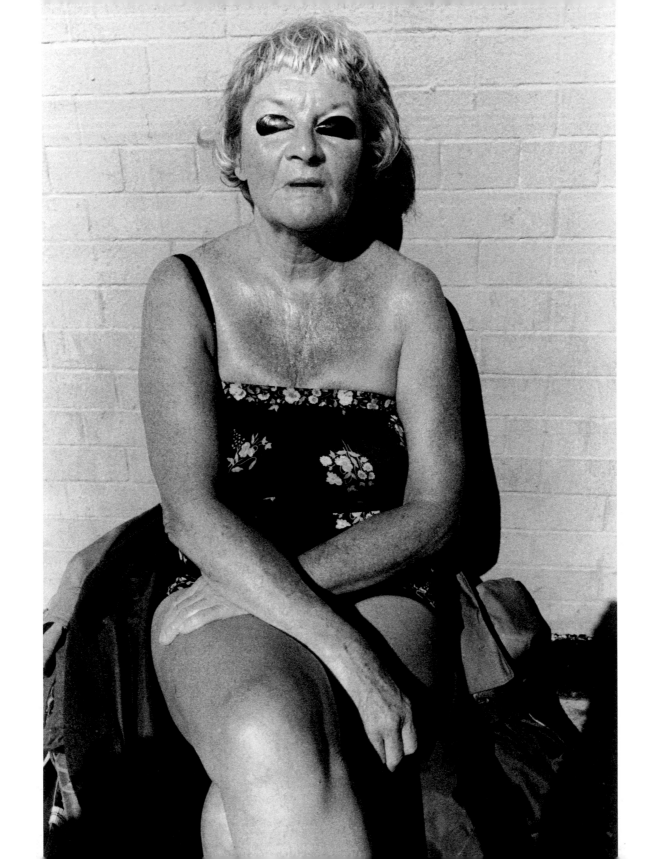

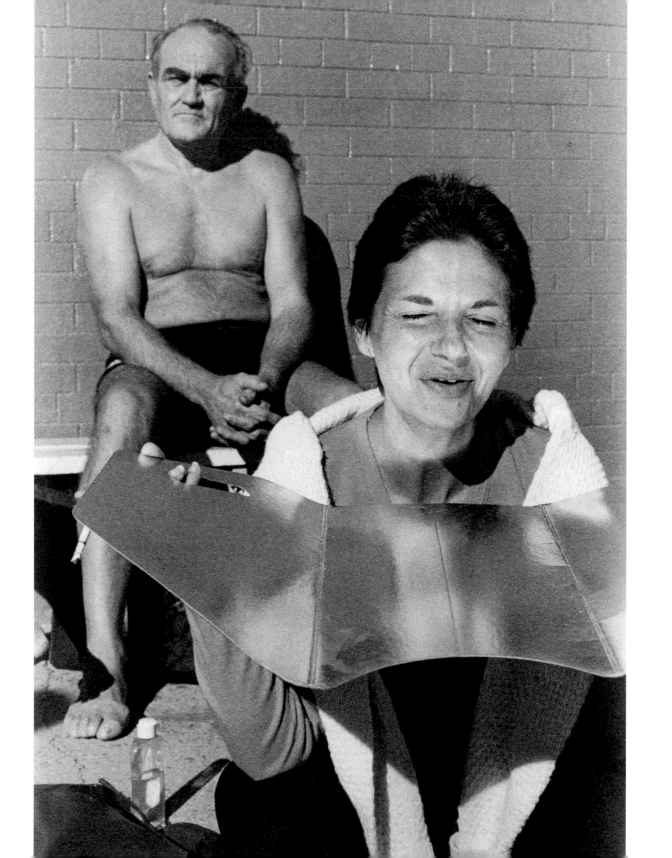

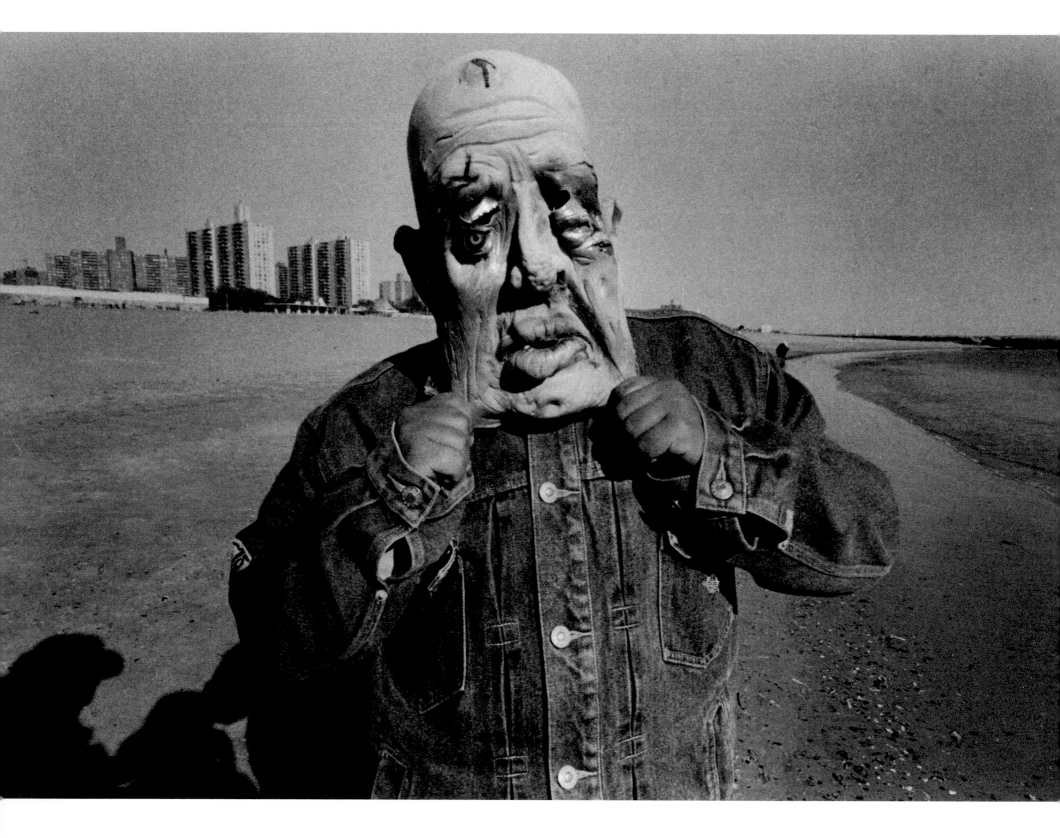

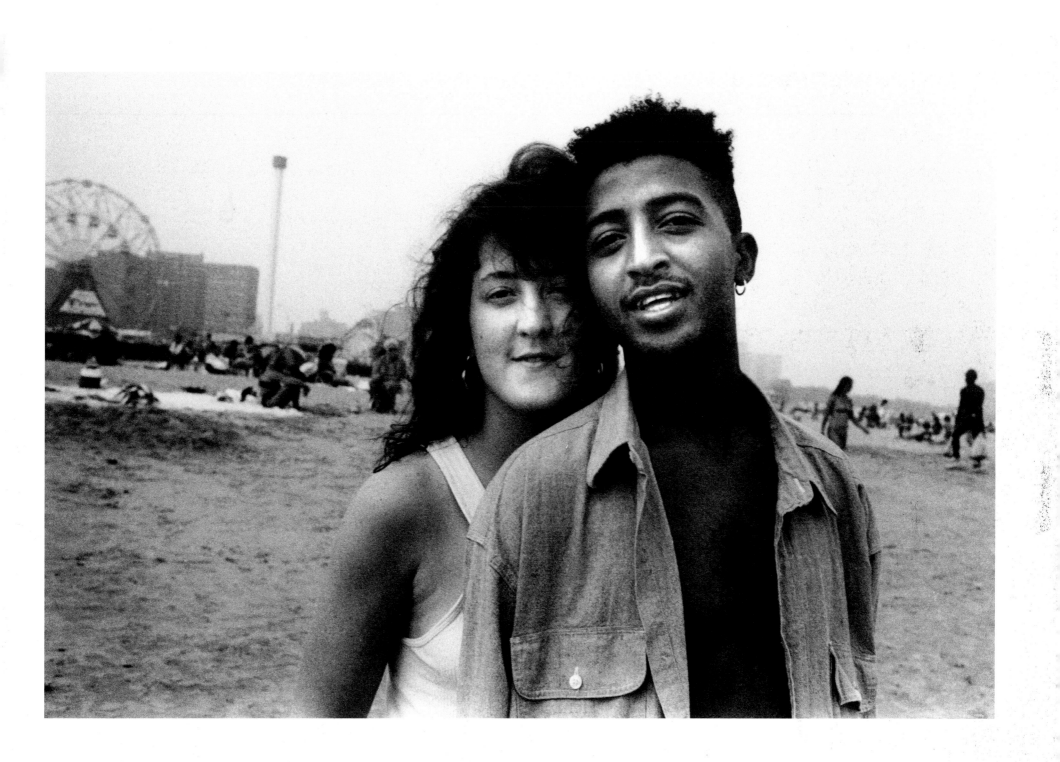

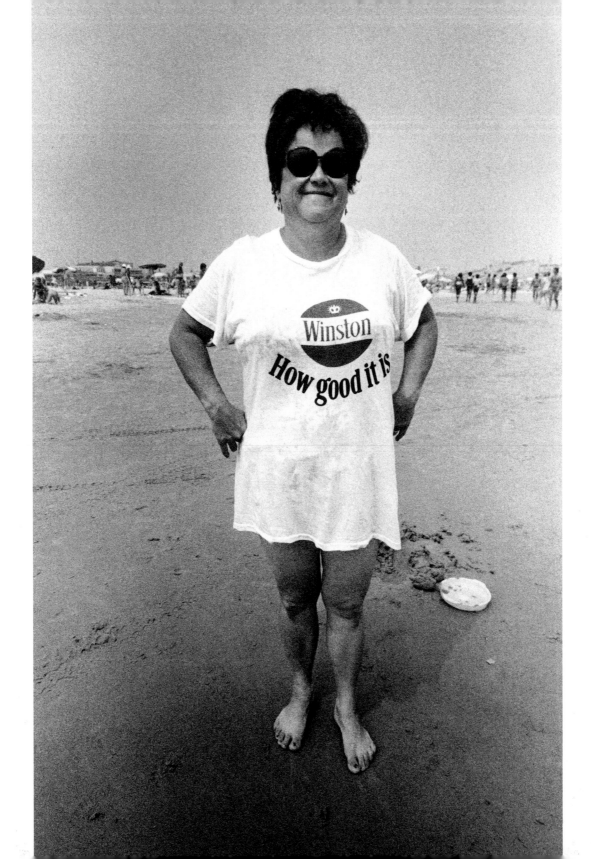

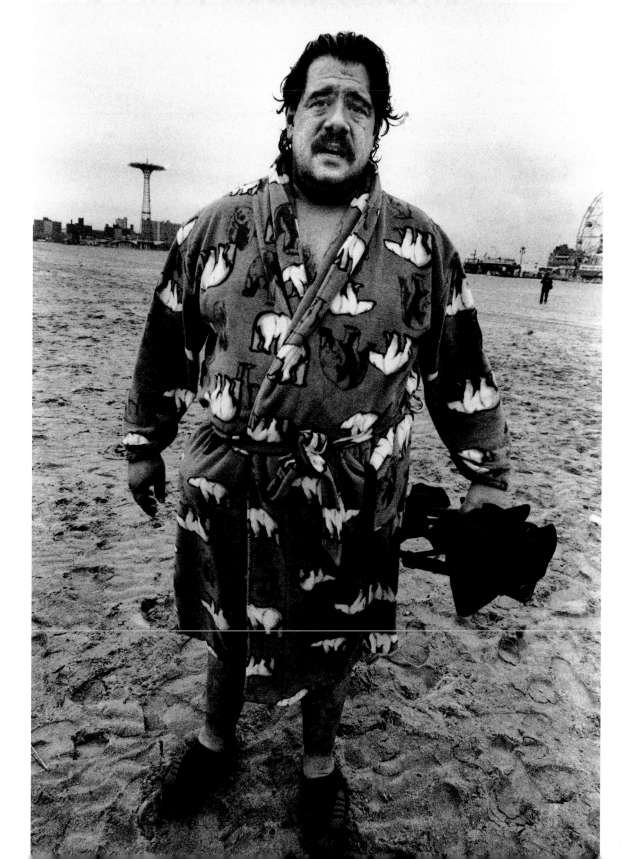

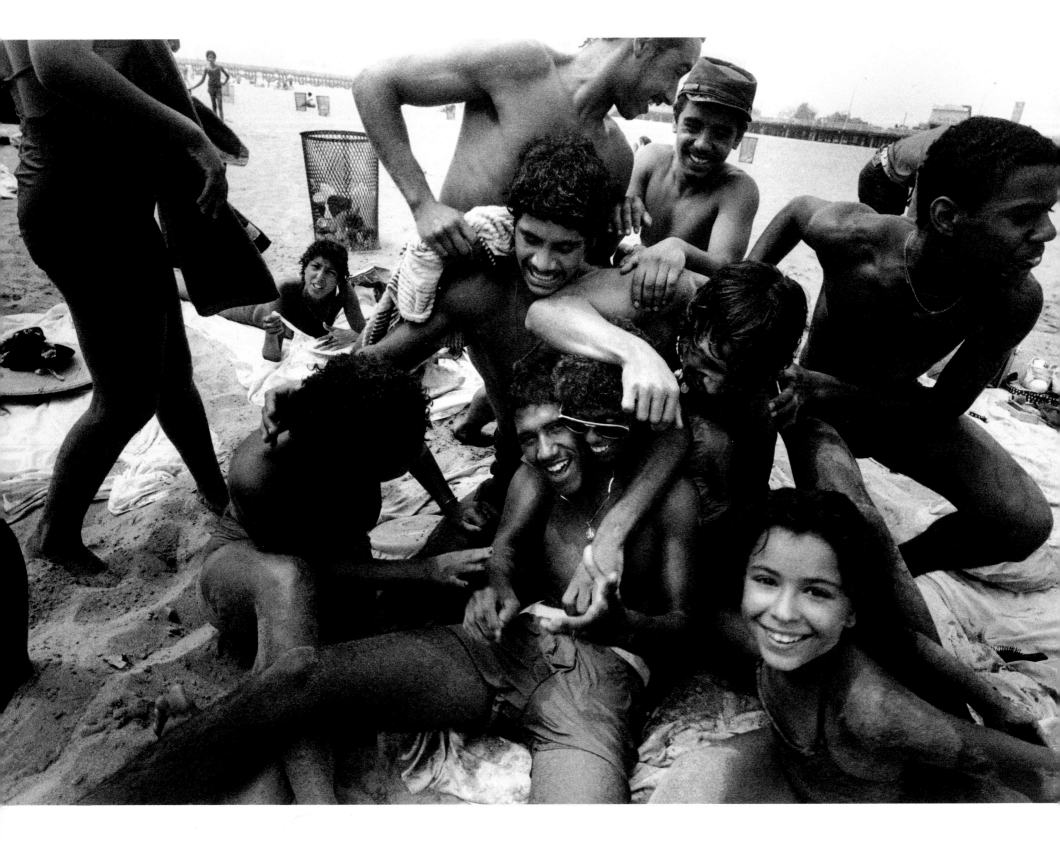

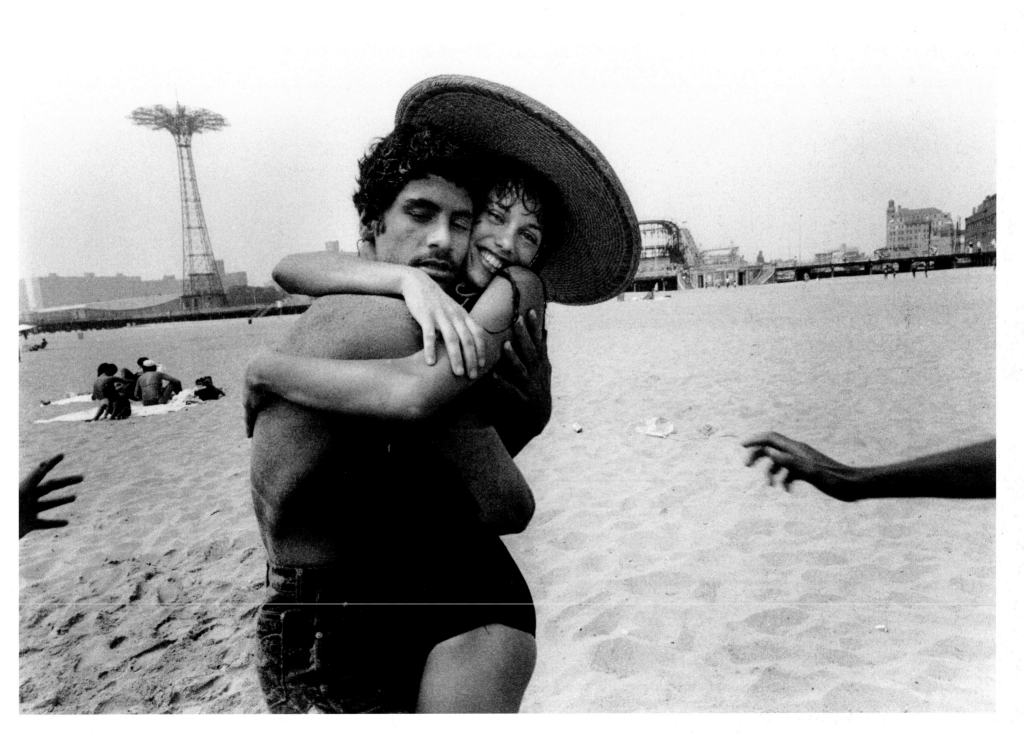

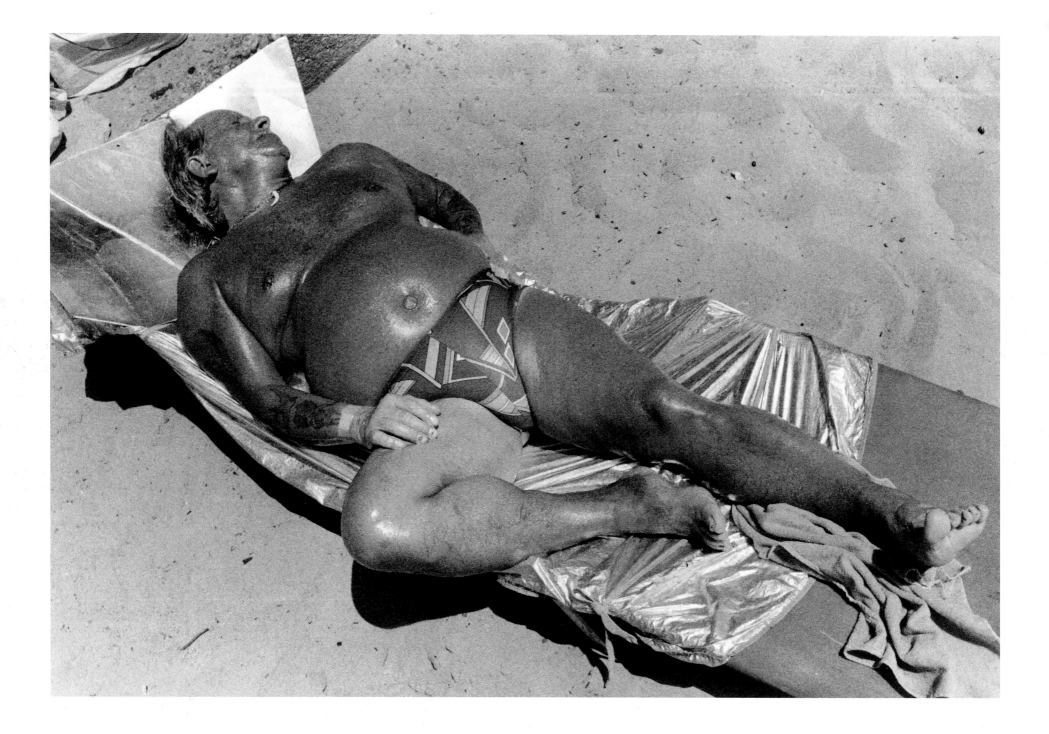

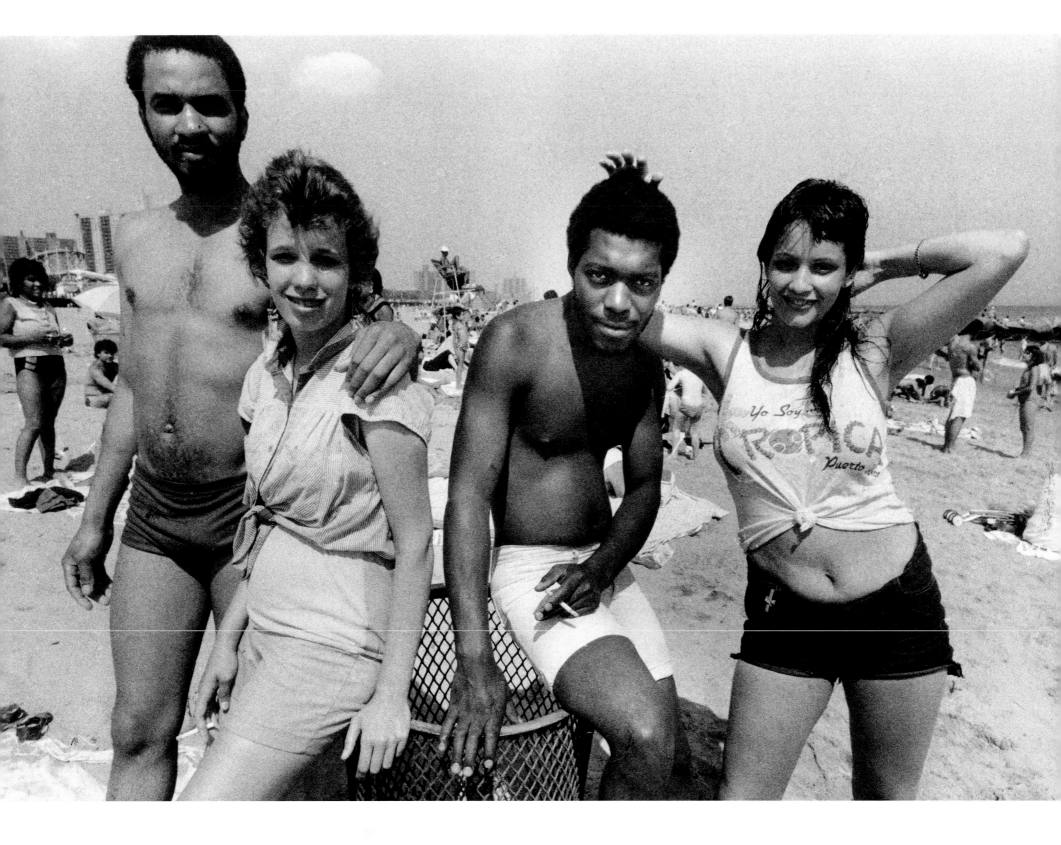

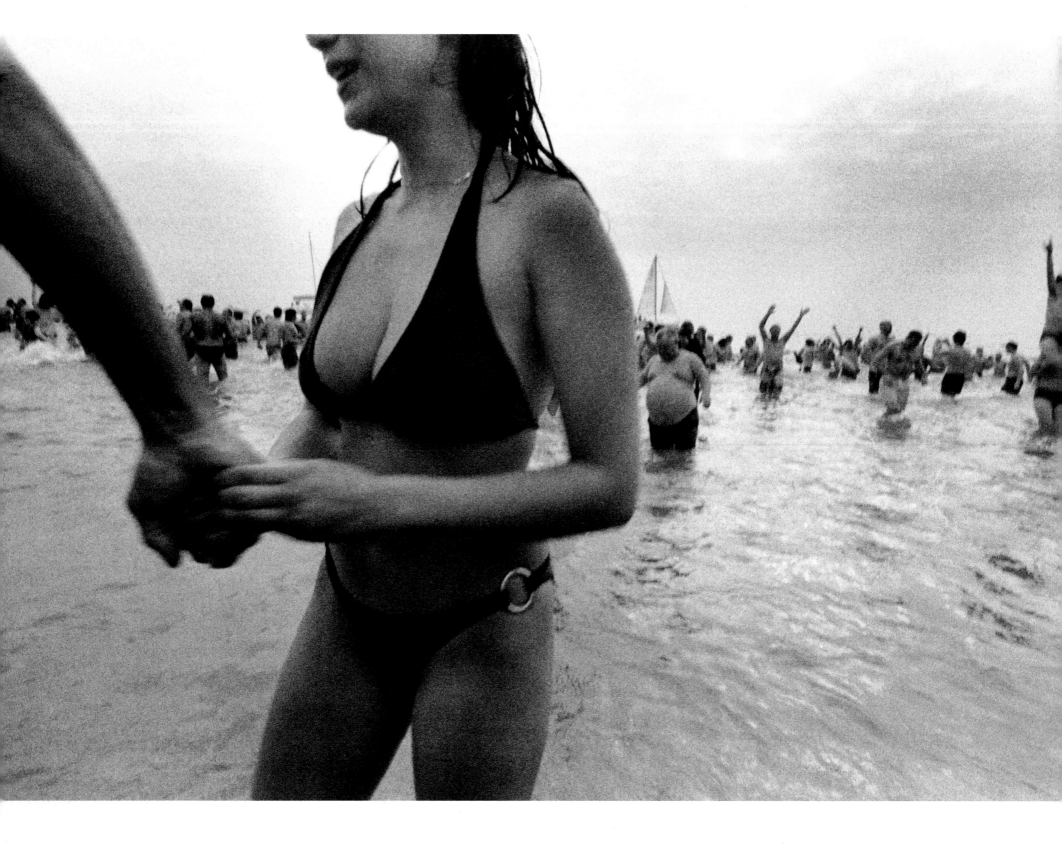

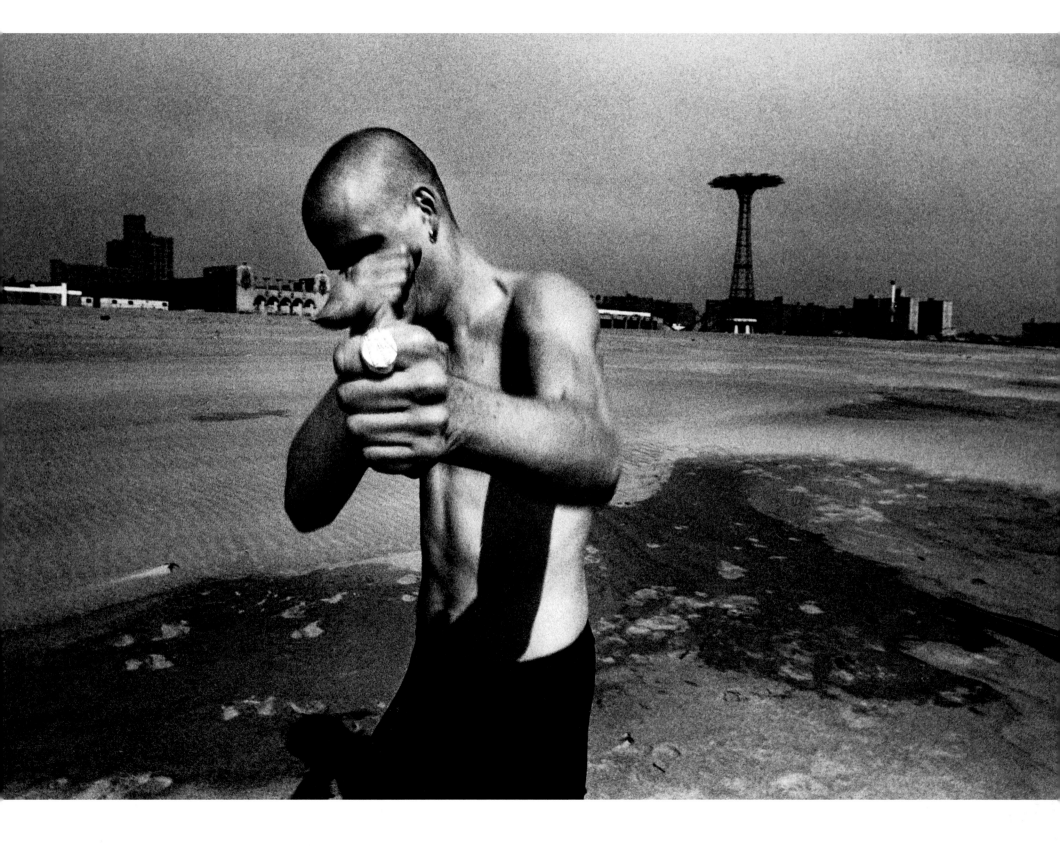

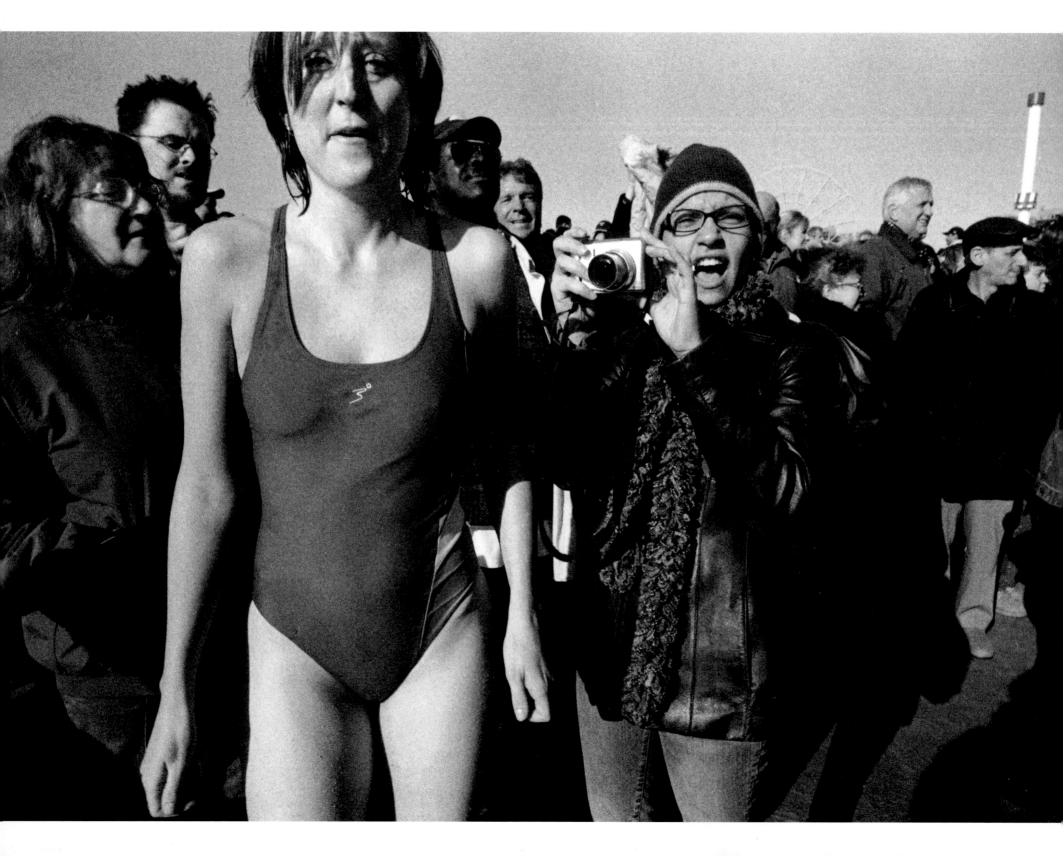

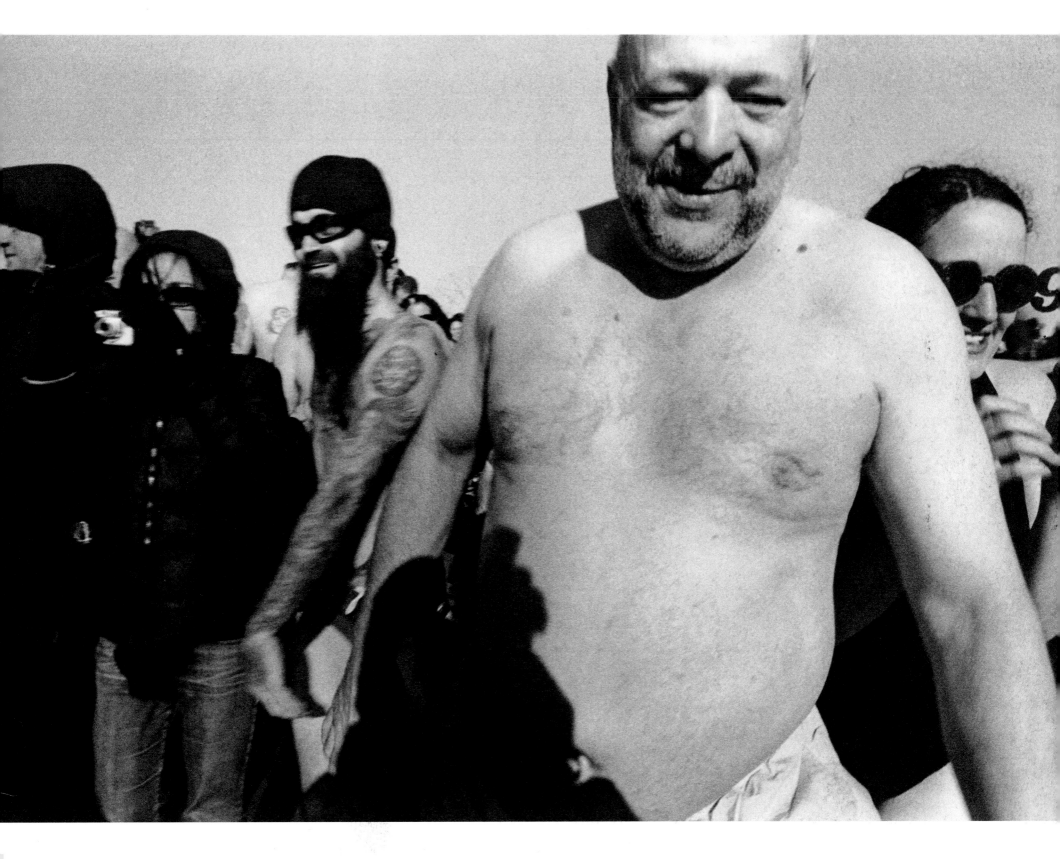

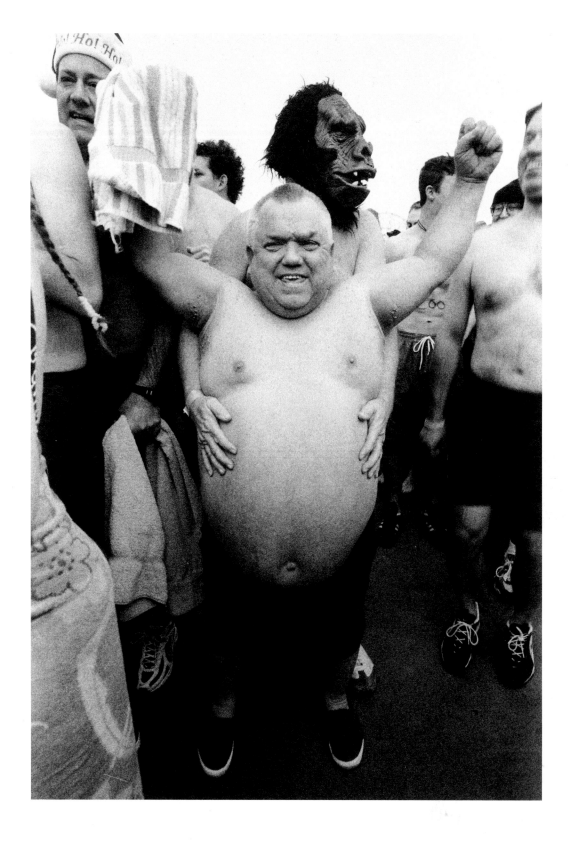

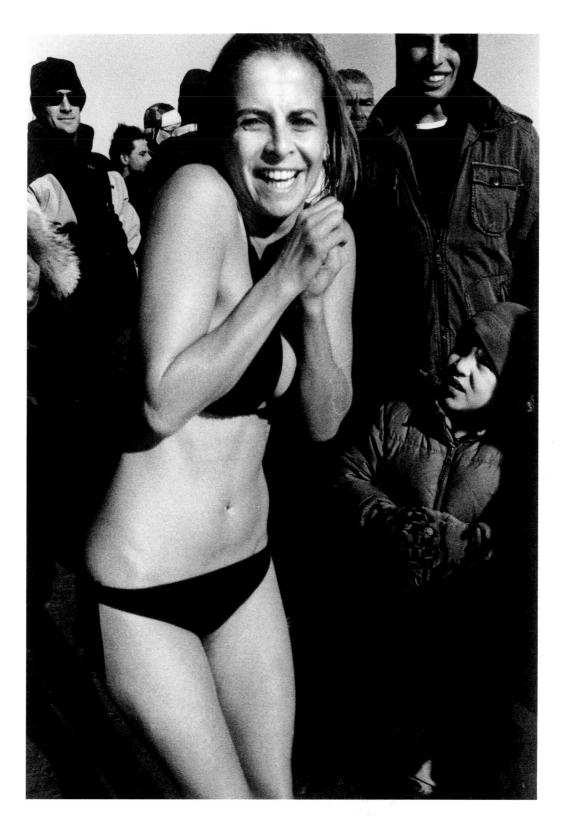

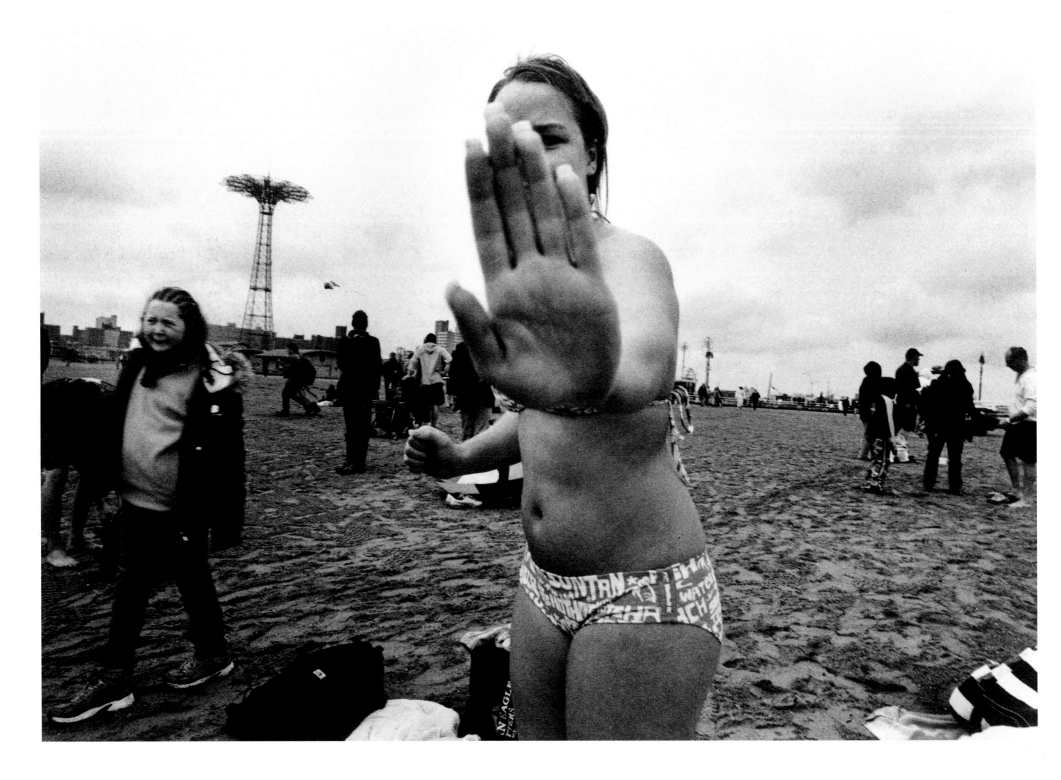

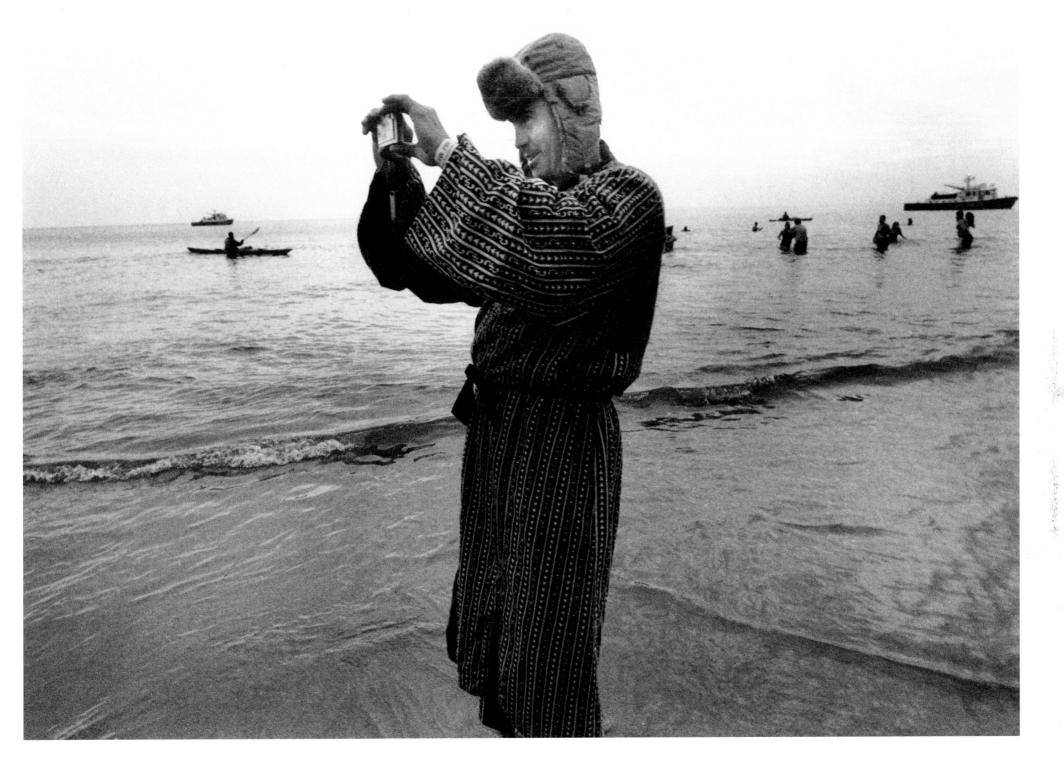

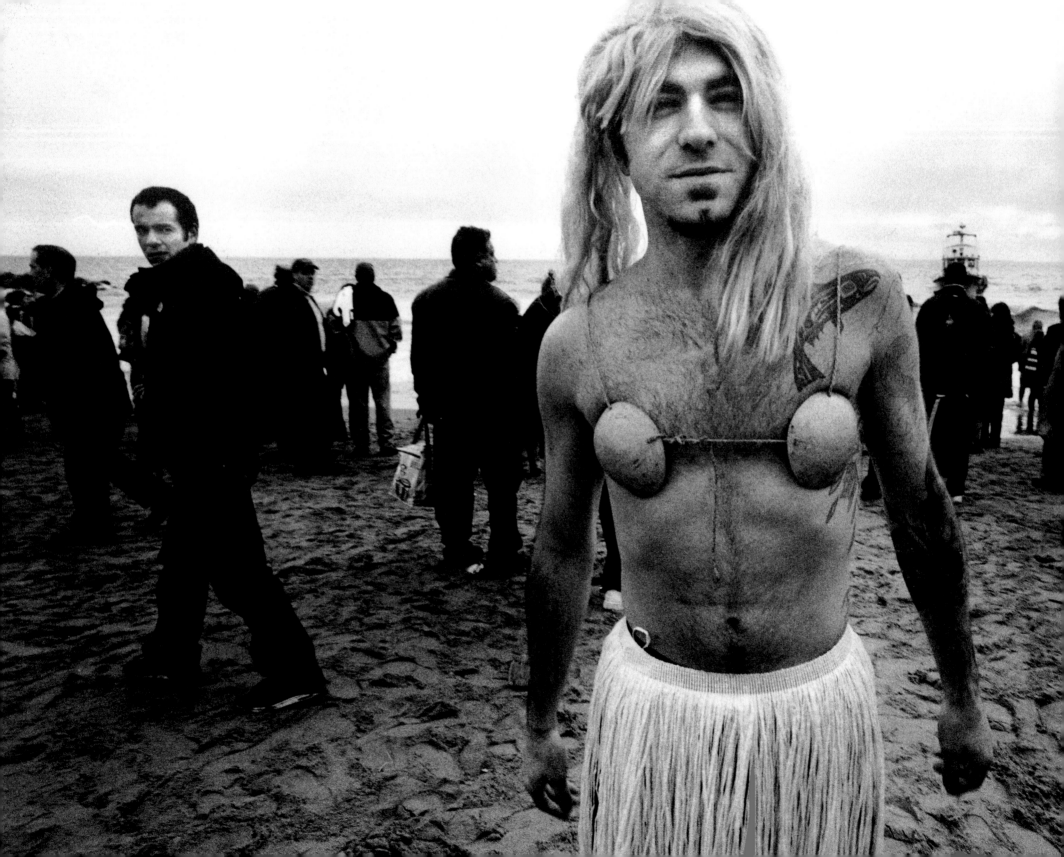

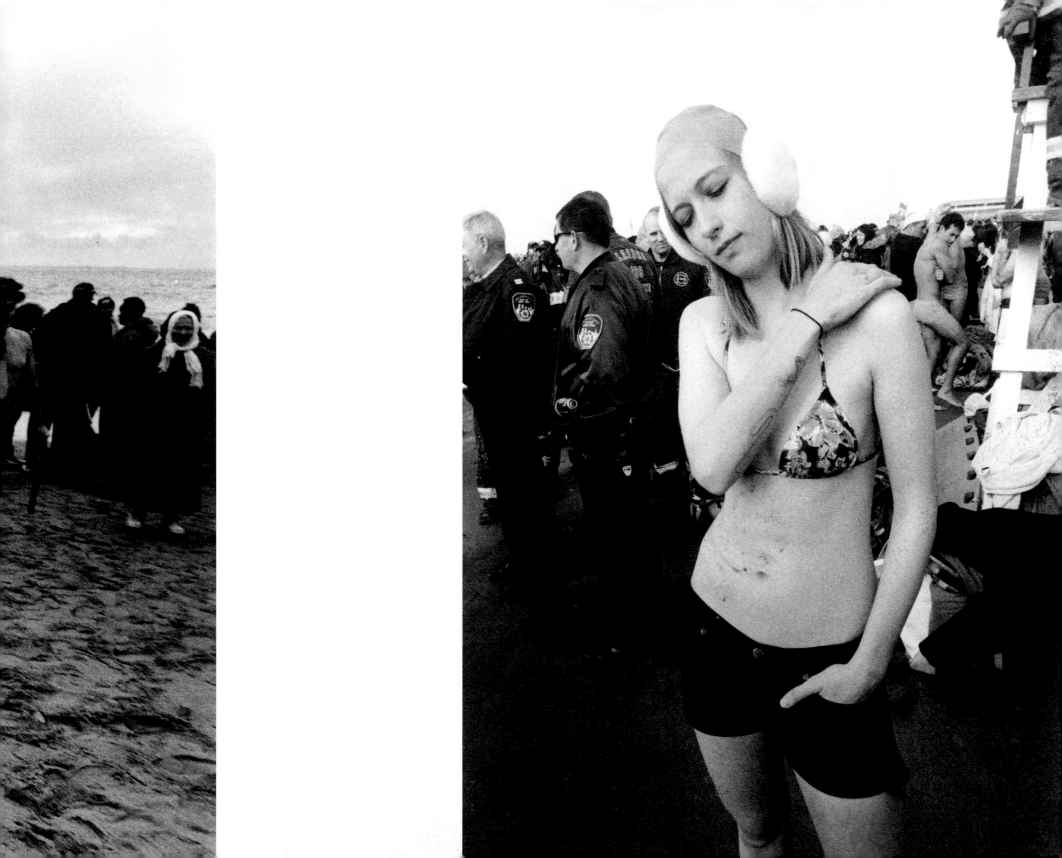

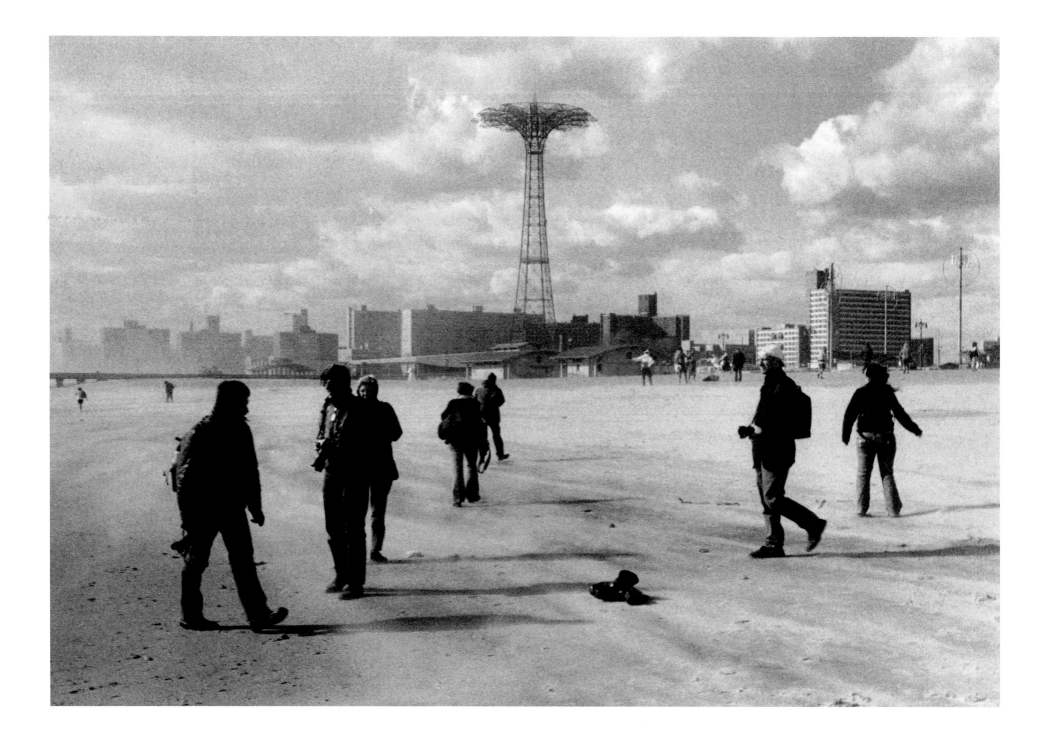

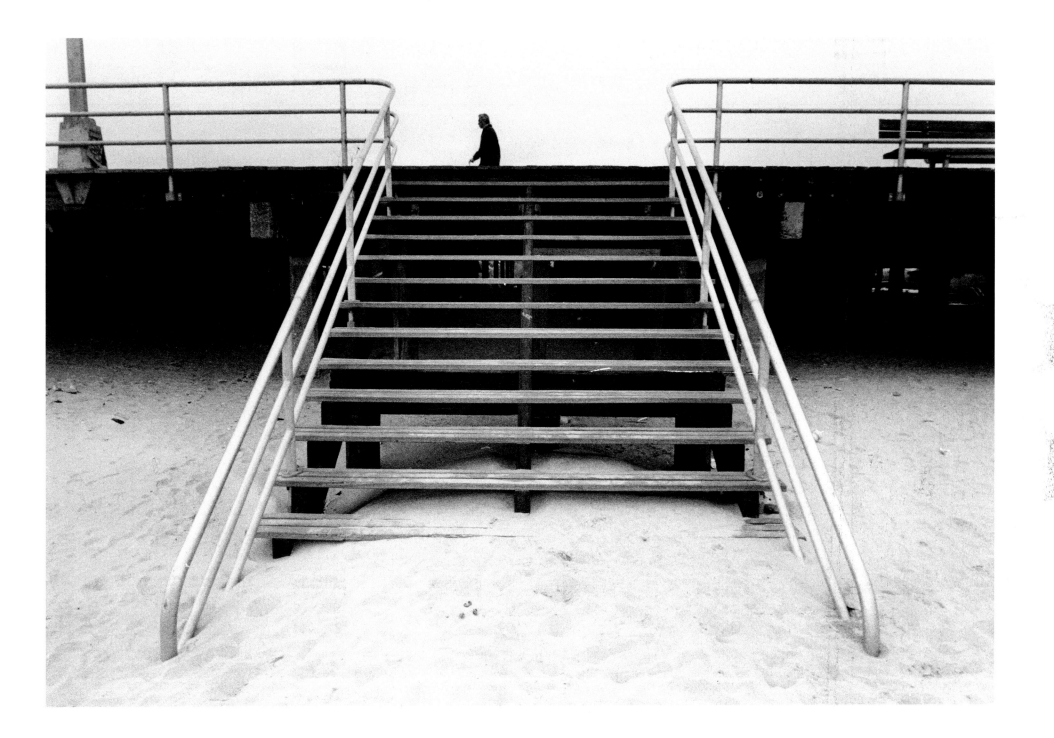

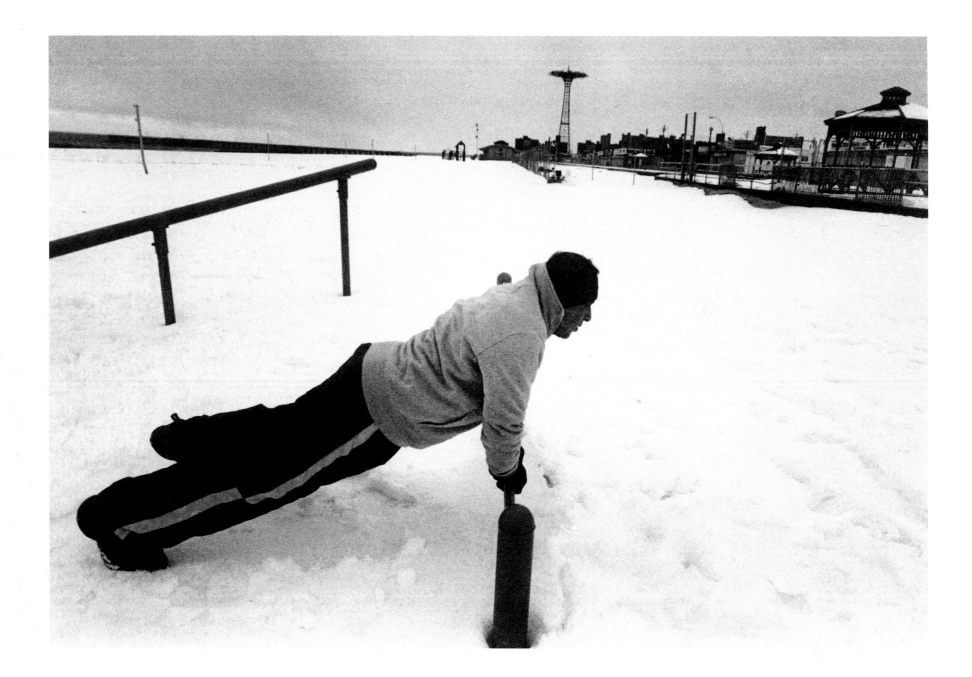

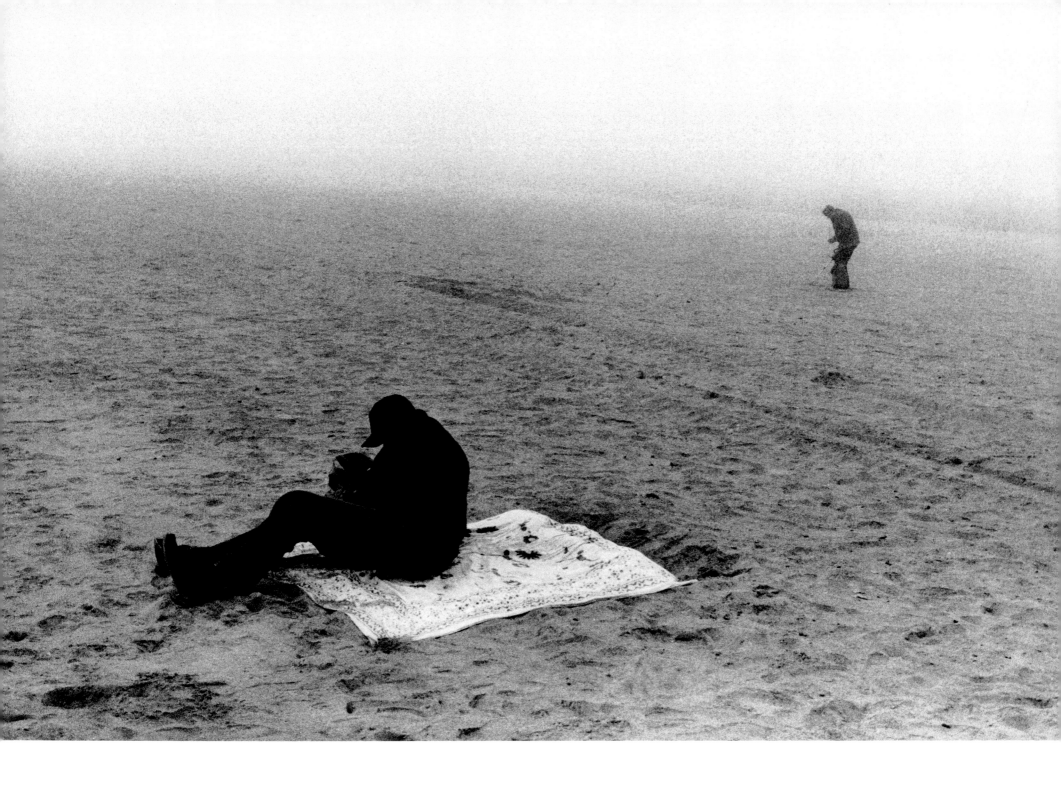

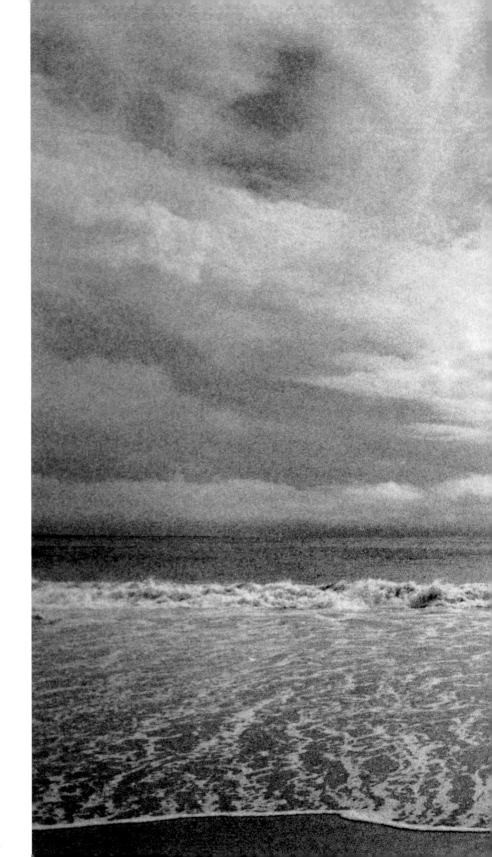

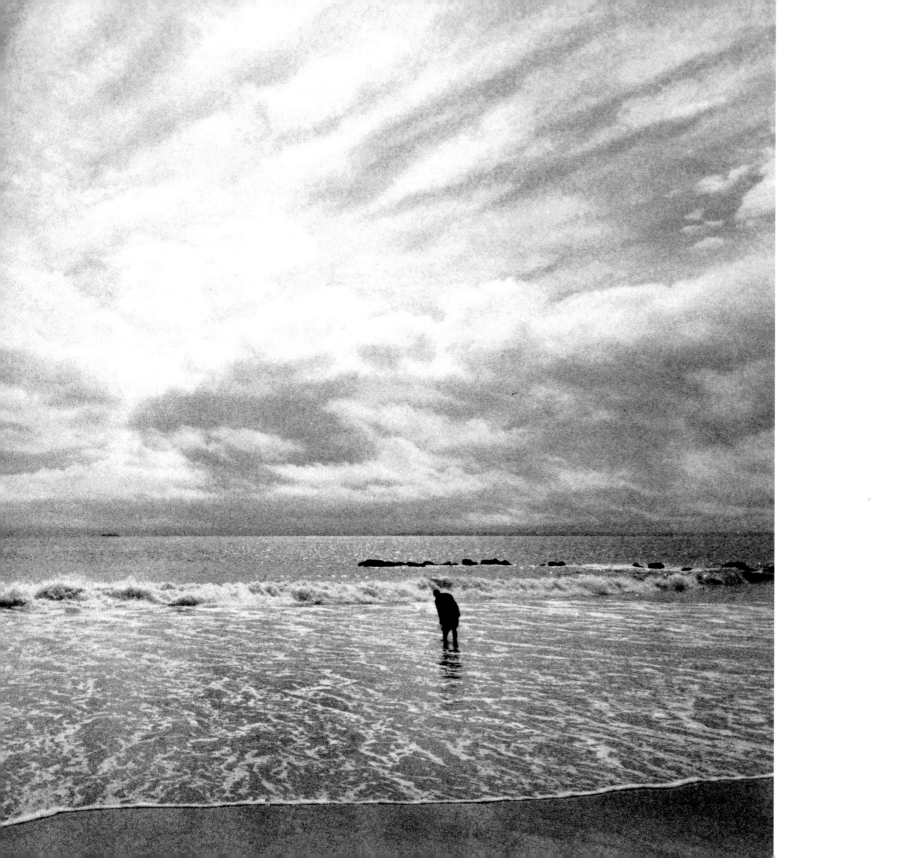

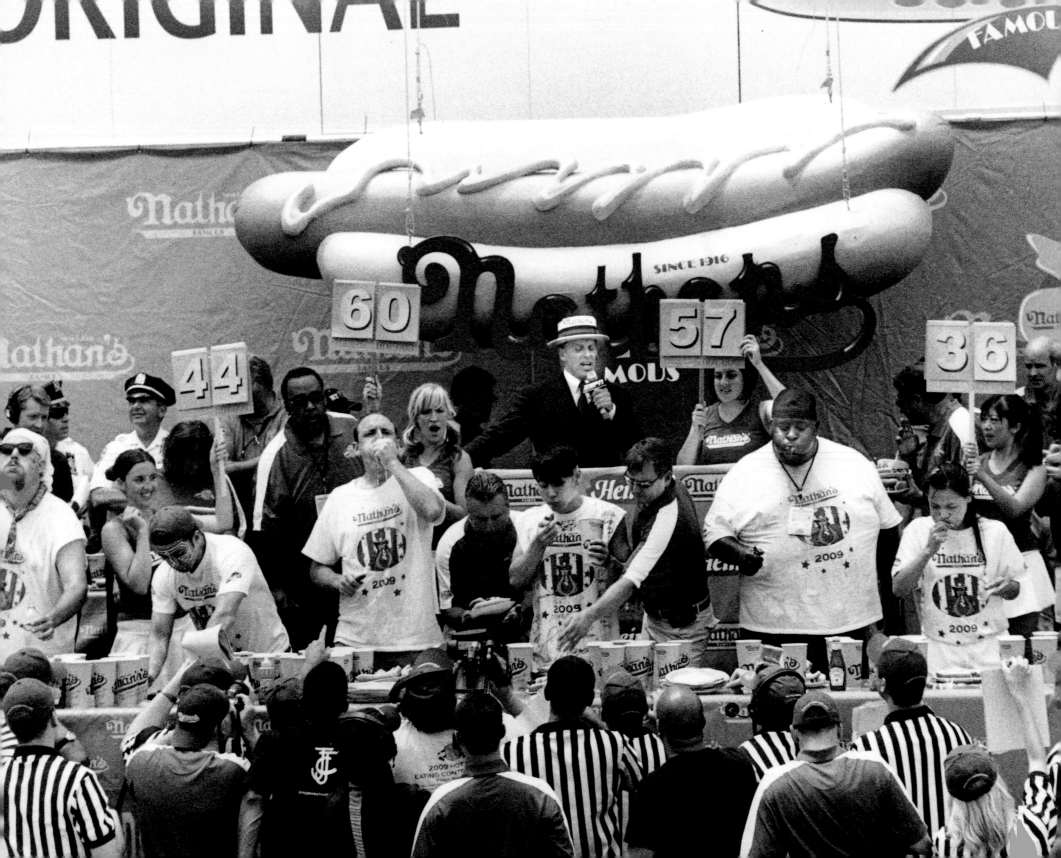

CONEY ISLAND TIMELINE: 1609-2010

JOHN MANBECK

1609 Henry Hudson lands on Coney Island; explores New York Bay and Hudson River

1654 Coney Island is purchased for fifteen fathoms of wampum, two guns, three pounds of powder

1670 Name of "Conye Eylant" first appears on map

1734 Beach Lane, first road built on Coney Island

1817 Early shelters, pavilions

1824 Coney Island Causeway (Shell Road), toll road, opens

1825 Coney Island House, first hotel, opens

1849 Herman Melville visits Coney Island

1850 Jenny Lind, P. T. Barnum, John Calhoun, Henry Clay, Daniel Webster visit at Coney Island House

1862 Coney Island & Brooklyn Railroad opens horse-car 1ine, first direct public transportation to Coney Island

1863 Surf House (Peter Tilyou)-hotel, restaurant, bathhouse, opens

1868 William Engeman purchases Brighton Beach from William Stillwell

1869 Engeman's Pier (William Engeman), first ocean pier is constructed

1871 Feltman's Restaurant & Cafe (Charles Feltman) opens

1873 Ocean Hotel (William Engeman) opens

1874 Frankfurter is introduced by Charles Feltman

1875 [Thomas] Cable's Ocean House opens

Mrs. [Lucy] Vanderveer's Bathing Pavilion opens

1876 Ocean Park Roadway, a toll parkway designed by Fredrick Law Olmstead, opens for travel between Prospect Park and Coney Island: cost: $300,000.

Coney Island property owners protest use of steam trains to replace horse-drawn cars on route from Prospect Park to the ocean.

Coney Island Concourse opens from Ocean Parkway to Coney Island Avenue

West Brighton Hotel & Casino (Paul Bauer) opens

First carousel in Coney Island (Charles Looff) opens at Mrs. Vanderveer's Bathing Pavilion

1877 Manhattan Beach Hotel (Austin Corbin) opens July 4

1878 Iron Tower: former Sawyer Tower is transferred from Philadelphia Centennial Exposition to Coney Island by Andrew Culver

Old Iron Pier, with bathhouses, shops, restaurants, opens

1879 Sea Side Aquarium opens in Coney Island

1880 Surf Avenue opens from Brighton Beach to West Brighton (today's Coney Island)

Sheepshead Bay Race Track (Coney Island Jockey Club: Leonard Jerome, August Belmont, William Vanderbilt) starts

New Iron Pier, with bathhouses, entertainment, restaurants opens on site of Engeman`s Pier by Jacob Lorillard

Charles Looff builds second carousel for Feltman's

The Brooklyn Dance Hall opens in Coney Island

1881 Brighton Beach Race Track (William Engeman) opens

1882 Surf Theater (George Tilyou), Coney Island's first theater, opens

1883 Sea Beach Palace-a rail terminal, hotel, dining rooms, shops, carousel, roller skating rink-opens

Camera Obscura Observatory, a periscope attraction, opens

1884 First roller coaster is started in Coney Island by LaMarcus Adna Thompson

Elephant Hotel (aka Colossal Elephant) (James Lafferty) opens

Roller coaster (Charles Alcoke); brought from New Orleans fair by Andrew Culver, opens on Iron Pier

1886 Bungarz carousel at Sea Beach Palace opens

1887 Manhattan Beach Bath House is built

1889 "Johnstown Flood" cyclorama opens

1890 Aerial Slide (George Tilyou) is invented

1892 Coney Island Athletic Club is formed, site of future world championship boxing matches

Brighton Beach Music Hall opens

1892 Smith Street trolley, first Brooklyn trolley, from DeKalb Avenue to Coney Island, begins service

1893 John Philip Sousa starts first of many seasons at Manhattan Beach and Brighton Beach

1894 MacKay-Bennett transatlantic cable completed from Coney Island to Hudson River linking telephones in America to those in Europe

Ferris wheel (George Washington Ferris) is introduced to Coney Island from Chicago`s Columbian Exposition by George Tilyou

1895 Sea Lion Park opens (Paul Boyton); first enclosed amusement park with Shoot-the-Chutes, Flip-Flap

Channel Chute roller coaster is erected around deserted Elephant Hotel

1896 Elephant Hotel is burned, destroying Channel Chute Coaster

Brighton Beach Music Hall is wrecked in winter storm; end of Iron Pier disappears; last of the Metropolitan Opera concerts

1897 Steeplechase Park (George Tilyou) opens

1898 City of Brooklyn is consolidated into Greater New York

1899 Gravity Steeplechase Race Course at Steeplechase Park opens

Robert Fitzsimmons, world heavyweight champion, is defeated by Jim Jeffries at Coney Island Athletic Club; Jeffries-Tom Sharkey fight is filmed in Coney Island

1900 Coney Island & Gravesend Railroad, trolley along Surf Avenue from Sea Gate to Manhattan Beach, starts

1901 Loop-the-Loop roller coaster opens

1902 A Trip to the Moon (Frederick Thompson and Skip Dundy) is brought from Buffalo`s Pan American Exposition to Steeplechase Park

Sea Lion Park closes

Seaside Park, seventy acres, opens

1903 Luna Park (Frederick Thompson and Skip Dundy) opens with A Trip to the Moon, Shoot-the-Chutes

Topsy the elephant is electrocuted at Luna Park site

Mardi Gras parade is started by Louis Stauch to rebuild the Coney Island Rescue Home (for way-ward girls)

1904 Electric Tower is added in Luna Park

Dreamland (William Reynolds, Samuel Gumpertz) opens with Liliputia. Beacon

Tower, Dreamland Pier: Streets of Cairo, Santos-Dumont Airship No. 9

1905 Isaac Bashevis Singer visits Coney Island

Kaleidoscopic Tower is added to Luna Park

"Funny Face" logo is developed by George Tilyou

"The Creation" (Henry Roltair) is brought from St. Louis world`s fair to Dreamland

Boer War re-creation from St. Louis world's fair opens at Brighton Beach Park for one season only

"Incubator Babies" opens at Dreamland

Thompson and Dundy walk menagerie (elephants, camels, 175 horses, team of bloodhounds) from Luna Park, Coney Island, to Broadway for opening of Hippodrome

1906 Frankfurter is named "hot dog"

Drop the Dip roller coaster (Chris Feucht) opens; is rebuilt in 1908

Maxim Gorky visits Coney Island

1907 Steeplechase fire blazes for eighteen hours; thirty-five acres of buildings are destroyed and are rebuilt the following year

"End of the World According to a Dream of Dante" opens at Dreamland

1908 Ocean Pier at Steeplechase opens

1909 New Brighton Theater opens

Four-hour motorcar and six-day motorcycle racing are introduced at Brighton Beach Race Track

Sigmund Freud visits Coney Island

1910 Sixteen people are hurt on Coney Island roller coaster; twelve people hurt on "double whirl" ride when axle breaks

Pavilion of Fun opens at Steeplechase with swimming pool for men

1911 Dreamland is burned; Iron Tower is destroyed

El Dorado carousel is transferred from Dreamland to Steeplechase; swimming pool for women is added

Dreamland Circus Sideshow (Samuel Gumpertz), freak show, opens

Two women are killed on Giant Racer roller coaster

House Upside Down, a Steeplechase attraction, is burned

1912 Luna Park changes name of A Trip to the Moon to A Trip to Mars by Aeroplane

1913 Titanic Disaster, reproductions in miniature, opens at Luna Park

1914 Fifty men are arrested for "topless" bathing

1915 Velodrome for bicycle racing opens at Sheepshead Bay Race Track

1916 Eden Musee, wax figures, opens at Coney Island Beach

Nathan Handwerker opens Nathan's

The first hot dog eating contest at Nathan's Famous is held on July 4th to settle an argument among four immigrants about who is the most patriotic

1919 First Yiddish theater opens at Brighton Beach Music Hall

1920 Wonder Wheel (Charles Herman; built by

Herman Garms) opens; construction started in 1918

1923 Riegelmann's Boardwalk is opened by borough president

Childs Restaurant, first restaurant on boardwalk, opens

1925 Thunderbolt, roller coaster, is built by George Moran over Kensington Hotel

1927 Half Moon Hotel opens; fourteen stories high

1928 Cyclone, roller coaster (Chris Fuerst and George Kister) opens

1934 Lundy Brothers Restaurant opens in Sheepshead Bay

1938 New York City Parks Department takes over administration of Coney Island from Brooklyn borough president

1941 Parachute jump is transferred from "Lifesavers' Exhibit" at the New York world's fair

1946 Luna Park closes after fire

1947 Coney Island beach attendance tops five million

1954 Feltman's Restaurant is auctioned

1955 New Brighton Theater closes, is demolished

1957 New York Aquarium opens

1964 Feltman's carousel is replaced by Astrotower (250 feet); carousel is moved to Flushing Meadow Park

1965 Steeplechase Park closes

1966 El Dorado carousel is put in storage; sent to Japan in 1969

1967 Parachute jump closes

1975 Astroland takes over operation of city owned Cyclone

1979 Lundy Brothers Restaurant closes

1980 Coney Island USA founded by Dick Zigun

1981 Lundy Brothers Restaurant and land sold for $11million

Thunderbolt closes

1983 First Mermaid Parade staged by Coney Island USA

1985 Sideshows-by-the-Seashore opens

1989 Wonder Wheel and Parachute jump are named 1andmarks

1991 House under Thunderbolt is partially burned

1992 Lundy Brothers Restaurant is declared landmark; Stauch's Baths is demolished

1997 Cyclone roller coaster's seventieth anniversary-celebrations include women's marathon roller-coaster world record of thirty-six straight hours, set by Michelle Cross, eighteen years old, of Clarksburg, West Virginia

Hirofumi Nakajima of Kofu, Japan, sets new world's record in the eighty-second annual Nathan's Famous Fourth of July Hot Dog Eating Contest: twenty-four hot dogs (and buns) eaten in twelve minutes

1999 West Brighton Carousel building (1879) dismantled from Brighton Beach Baths for eventual construction as an information center within the New York Aquarium at Coney Island (the carousel had been removed from the building in 1959)

2000 The Thunderbolt roller coaster is torn down, to much consternation of historians and preservationists, under cover of night by the city "to protect public safety" during nearby construction of the baseball park Keyspan Park. The Thunderbolt was featured in Woody Allen's famous movie, *Annie Hall*

2001 Keyspan Park opens, a baseball stadium for the Brooklyn Cyclones, a Single-A New York-Penn League farm team of the New York Mets

Lola Star Souvenir Boutique opens on the Coney Island boardwalk next to Ruby's Bar

2002 Brooklyn Borough President Marty Markowitz appears in Coney Island's Mermaid Parade as King Neptune

2002- The Parachute Jump is completely dismantled,

2004 cleaned, painted and restored at a cost of five million dollars by the city, but it remains inactive

2003 The Childs Restaurant (1923) building on the boardwalk is the fourth Coney Island site land marked (besides the Parachute Jump, the Cyclone, and the Wonder Wheel)

The Jumbo Jet, a major Coney Island ride, is disassembled and sold to a Chinese amusement park

2003- Thor Equities, a real estate company, quietly

2005 spends $150 million to buy from multiple owners 10 acres of land mostly along Coney Island's boardwalk. Their hope is to build a $2 billion entertainment destination

2005 A new $240 million subway terminal (the most expensive ever) opens at Surf and Stillwell Avenues, Coney Island's main intersection. This is the last/first stop for the D, F, Q, and N subway lines

2006 Thor Equities purchases 3.3 acres under Astroland for $30 million

2007 Save Coney Island is formed as a non-profit organization (now with over 4,000 members) to pressure the City to buy as much land as possible for outdoor amusements, to push for the land marking of historic Coney Island buildings that are at risk, to fight the construction of planned high-rise towers within the amusement area and to resist the privatization of parkland, insisting that it remain devoted for public use

The Coney Island History Project opens a booth built into the base of the Cyclone Roller Coaster as an exhibition space

2008 Astroland closes after 46 years as Coney Island's largest amusement park when Thor Equities, its landlord, refuses to grant a lease for the 2009 season

2009 The 71 foot long, 12,000 pound Astroland Park rocket that is atop Gregory & Paul's food stand since 1962, is dismantled. As much a symbol of Coney Island as the parachute jump and Nathan's Famous, the rocket is donated to New York City;

plans are to eventually relocate it to Coney Island's new amusement and entertainment district

Ringling Brothers and Barnum & Bailey Circus opens for the summer at Coney Island for the first time ever. The circus returns for the 2010 season with a new show

Joey Chestnut of San Jose, California sets a new world's record in the 94th annual Nathan's Famous Fourth of July Hot Dog Eating Contest: 68 hot dogs and buns eaten in ten minutes

New York City signs a contract with Thor Equities to acquire 6.9 acres in Coney Island for $96.6 million, which allows the City to expand, enhance and make permanent Coney Island's historic amusement district. The City plans to create a 12.5-acre outdoor amusement park within a new 27-acre amusement and entertainment district

2010 Luna Park opens at the former Astroland sight with 19 rides made by the Italian amusement giant Zamperia. The company spends $30 million recreating a three-acre amusement area.

More people visit the Coney Island amusement district this summer than during any since Steeplechase Park closed in 1964. Estimated attendance, made by the city, is more than 400,000 visitors taking 1.7 million rides. The new Luna Park is credited for the success. More rides are planned for 2011.

LIST OF PLATES

ACKNOWLEDGMENTS

Many individuals have helped me in my quest to make some sense of Coney Island and to show some of its amazing endurance, history, fascination, and excitement. I've had a great deal of support from my home away from home, the International Center of Photography, where I have taught since 1976. From Buzz Hartshorn, ICP's Director, to the education staff including Phil Block, Suzanne Nicholas, and Donna Ruskin, I have had much encouragement. I want to thank the more than 1500 students from ICP that I've taken to Coney Island to photograph. I often see Coney Island anew from their fresh perspective and enthusiasm. It's always been my pleasure to either introduce them to or heighten their experience of this unique place.

Martha Leinroth, a wonderful photographer and teacher, has been invaluable to me with the editing and sequencing of the photographs. Her insights and intelligence has added significantly to this book. Dick Zigun, the founder of Coney Island USA and the Mermaid Parade and the unofficial mayor of Coney Island, merits all our praise and thanks for being a tireless spokesman for the preservation of Coney Island's history, present, and future. Likewise, Diana Carlin (a.k.a. Lola Star) deserves much credit for keeping the boardwalk vibrant with her boutique and roller rink and the founding of Save the Coney Island Organization. Her love and vision for Coney is one of the reasons its future is so bright. And thanks Lola, for your funny and touching essay that enhances the book.

A special thank you to John Manbeck, a former historian of the Borough of Brooklyn, for the use of his very informative Coney Island timeline. And to Mat Thorne, who helped with the design and structure of the book; his contributions have been considerable. Many thanks to my editor at Schiffer Publishing, Douglas Congdon-Martin, for his wise counsel and guidance during the book making process, and to Peter Schiffer, my publisher, for his vision and faith in the project.

Finally, my heartfelt thanks to my wife, Hilda Chazanovitz, for her immense patience in listening to my many stories of Coney Island, for enduring my too many absences while photographing there (often on holidays such as New Year's Day and the Fourth of July), and for her perceptive advice with editing both text and images. She makes all of this worth doing.

BIOGRAPHIES

HARVEY STEIN is a professional photographer, teacher, lecturer, curator, and author based in New York City. He teaches at the International Center of Photography and in the Master of Professional Studies Program in Digital Photography at the School of Visual Arts. Stein is a frequent lecturer on photography both in the United States and abroad. He has curated sixteen exhibits since 2007 and is the Director of Photography at Umbrella Arts Gallery in New York City's East Village.

He has also been a member of the faculty of the New School University, Drew University, Rochester Institute of Technology, and the University of Bridgeport. A recipient of a Creative Arts Public Service (CAPS) fellowship and numerous artist in residency grants, Stein's other photography books include *Movimento: Glimpses of Italian Street Life* (2006), *Coney Island* (1998), *Artists Observed* (1986) and *Parallels: A Look at Twins* (1978). Stein's photographs and portfolios have been published in such periodicals as *The New Yorker, Time, Life, Esquire, American Heritage, Forbes, Smithsonian*, and all the major photography magazines.

Stein's photographs have been widely exhibited in the United States and Europe—more than 70 one-person and over 145 group shows to date. His photographs are in more than 50 permanent collections, including The George Eastman House, the Bibliotheque Nationale, the Art Institute of Chicago, the Museum of Fine Arts, Houston, the Brooklyn Museum of Art, the New Orleans Museum of Art, the Carnegie Museum of Art (Pittsburgh), the Denver Museum of Art, and the International Center of Photography.

Some of Stein's work can be seen on his web site, www.harveysteinphoto.com

JOHN MANBECK is the author/editor of seven books on the history, culture, and people of Brooklyn, New York. He was the official Brooklyn Borough Historian from 1993 to 2002. In 1999, he was named a Centennial Historian of the Year. He taught English and Journalism at Kingsborough Community College in Brooklyn for 32 years. His weekly column, "Historically Speaking," appears in *The Brooklyn Daily Eagle* in print and online. It deals with Brooklyn neighborhoods, historical events, individuals and places.

LOLA STAR was established by Dianna Carlin in 1998. Carlin graduated from the University of Michigan with Magna Cum Laude honors. Carlin founded and is the Director of the Save Coney Island Organization (now with over 4,000 members). Through this organization she has produced highly publicized events and successful fundraising benefits. Carlin designs, manufactures and distributes the Lola Star line of merchandise, an original line of Coney Island-themed clothing, accessories, and collectibles. She has also owned and operated the Lola Star Souvenir Boutique on Coney Island's boardwalk since 2001.

ALSO BY HARVEY STEIN

Parallels: A Look at Twins, E.P. Dutton , 1978
Artists Observed, Harry N. Abrams, Inc. 1986
Coney Island, W.W. Norton & Company, Inc., 1998
Movimento: Glimpses of Italian Street Life, Gangemi Editore, 2006

Photographs and text copyright ©Harvey Stein 2011
Library of Congress Control Number:

Book design: Mat Thorne and Harvey Stein
Essay © Lola Star 2011
Timeline © John Manbeck 2011
Type set in Zurich Lt BT/ Zurich BT

iSBN: 978-0-7643-3796-3
Printed in China

Published by Schiffer Publishing Ltd.
4880 Lower Valley Road
Atglen, PA 19310
Phone: (610) 593-1777; Fax: (610) 593-2002
E-mail: Info@schifferbooks.com

For the largest selection of fine reference books on this and related subjects, please visit our website at **www.schifferbooks.com**
We are always looking for people to write books on new and related subjects. If you have an idea for a book please contact us at the above address.

This book may be purchased from the publisher.
Include $5.00 for shipping.
Please try your bookstore first.
You may write for a free catalog.

In Europe, Schiffer books are distributed by
Bushwood Books
6 Marksbury Ave.
Kew Gardens
Surrey TW9 4JF England
Phone: 44 (0) 20 8392 8585; Fax: 44 (0) 20 8392 9876
E-mail: info@bushwoodbooks.co.uk
Website: www.bushwoodbooks.co.uk

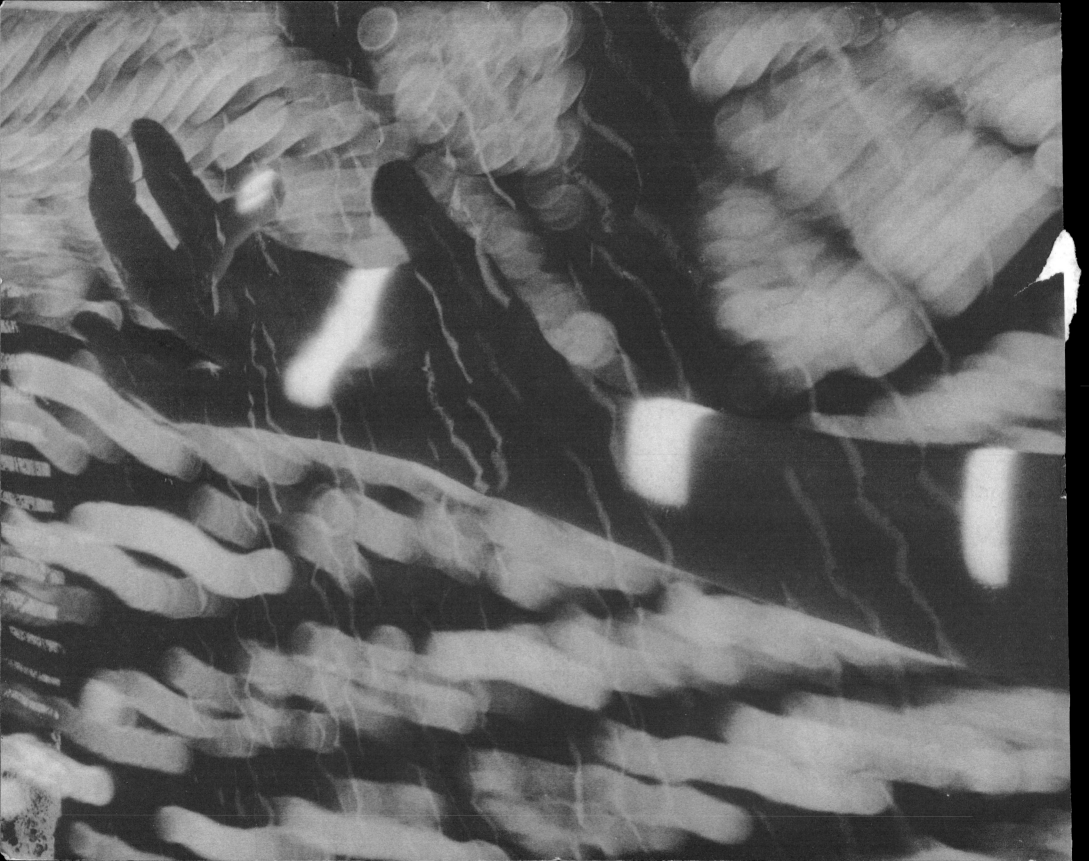